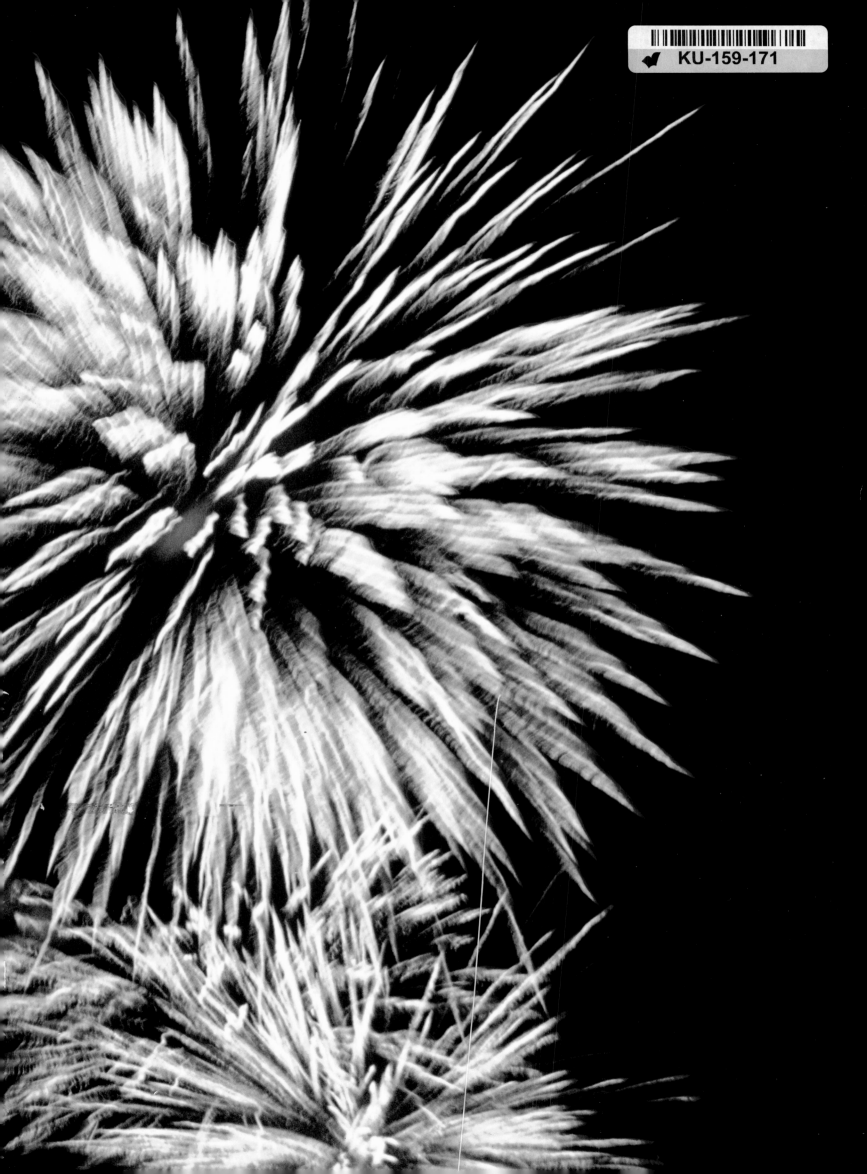

MARIO

ALI

TESTINO

IVE

A BULFINCH PRESS BOOK · LITTLE, BROWN AND COMPANY · BOSTON · NEW YORK · LONDON

FOREWORD

The photographs of Mario Testino, one finds in describing them, are much like the man himself. Irreverent, assertive, and most of all full of life—brimming over with life, as if to push its very essence at you. Mario's photos always seem to connect you with the truest and lightest aspect of yourself. The aspect that thrives on spontaneity, passion, and a perspective void of judgments.

Mario is intoxicating. When Mario takes your hand and brings you into his world, it is a brighter and edgier place. You feel more. You see more. I always note how "in the moment" I feel when I am with Mario. That life is happening right now. That he is helping me to see it and taste it. You somehow feel as if you are at the epicenter of everything lively and new and stylish, whether you are across the table from him at a dinner or you come across a campaign he has done in a magazine. To bring people so startlingly into their "present" is a gift. It is a gift I receive as a friend of Mario's and as a subject of his as well. It is a gift he shares with all of us through his photographs, which let each of us into the world of Mario Testino.

The title of this collection of photographs most aptly and simply characterizes the work contained inside. The *Concise Oxford Dictionary* defines *(a)live* to be: "full of power, energy or importance, not obsolete or exhausted, glowing, unexploded, charged with or carrying electricity; not detached." That is the very essence that each photo in this book shares. Regard the shot of the firework, bisected in its hottest moment; the intensity or unrest in the eyes of various subjects, challenging or questioning the moment that they find themselves in; the ferocity of a wrecked room, or a tropical storm; the lust in the flesh of the young. These images force upon us that kind of life. Even in the still and quiet pictures we find this power, only perhaps in a less combustible way. We find the reaching leafless tree at dusk, tranquil in its solitude. The empty row of pink satin toe

shoes, waiting to be danced in. The unadulterated lines of a man-made space, or a set of footprints in the sand. These images coax us into connecting with that life power, that soundless power within us.

Since I first met Mario in Paris in 1994, he has been infecting me with his life force through a series of adventures. We have laughed and worked in the gardens of Long Island, cavorted and eaten through the raw and dark streets of Naples, and amused each other through parties, always joking in Spanish or taking absurd snapshots of each other. One of these aforementioned snaps appears in the pages to follow. It was at the post-Oscar party that *Vanity Fair* magazine hosted in 1999. I had had quite an evening. I felt overwhelmed and very detached and quite numb, in a sense. As if I was simply attempting to get through the evening and the hordes of people so that I could go home and begin to process. Upon entering the fete, I saw Mario, his green eyes shining, his wide smile beckoning. He swept me up and took me into his arms, and we started to dance to the fantastic Cuban band that was playing. At that moment, I started to come to. I started to feel my girlishness and sense of humor re-emerging. And for the first time that night, I laughed and stopped taking myself so seriously. I had found myself a long way from where I started. I had found myself with Mario Testino. And, most important, I had found myself, alive.

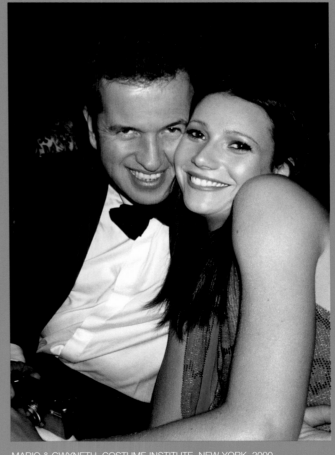

MARIO & GWYNETH, COSTUME INSTITUTE, NEW YORK, 2000

—Gwyneth Paltrow

INTRODUCTION

Somebody once said to me that taking a photograph is like going on a journey. Photography can take you somewhere that you could never go to in your own life, or sometimes even in your own imagination. I am lucky enough to travel a lot, and this book is about both kinds of journeys—about actually being in places I never imagined I would see and making images that reflect what a pleasure it is to be there.

I take a lot of people with me when I travel; friends and all the people who help me to make my pictures. They are often one and the same. Without them my photographs would literally not happen. They make my pictures come alive, the people in front of and behind the camera equally and the places we go together. This book will hopefully take the people who look at it along with us. Anyone who likes my photographs is welcome. I'm a bit obsessed with sharing the things I like with other people—not only in my photographs but in my life—that's why I get into a lot of trouble, because if I get invited to a party, I always show up with at least ten people. I went to a wedding in Germany with a group of friends—it was wonderful when I overheard my hostess being asked by a guest not "Where did you get the food?" or "Who did the flowers?" but "Where did you get the GUESTS?"

For me photographing people and places are very different processes. Here I have mixed a lot of landscape with people, with parties, with ceremonies and chance meetings. But I see landscapes as being like theater sets—they come alive only when someone looks at them or when someone is in them. When I photograph a landscape, I just try to get in as much as possible of what my eyes can see—with people it's more about getting to something hidden inside: what you can see is not enough…. Also, I am very interested in seeing things from several different points of view—so we have tried to assemble

the pictures into a story, each picture leading to the next, rather than juxtaposing violently different kinds of images. It's as if by moving around an idea before moving on, your understanding deepens…. I am so used to plunging from one world to another, day after day, that I suppose this book is a way of pulling themes together, of laying strands side by side to make visual sense of all the things that bombard me. In fashion it has recently been "out" to use narrative—but being fashion, that changes. Now I am alive to the idea of pictures that tell stories again. Fashion is very much about a changing feeling of texture in the clothes and in the pictures, in the visual texture of the world around us. You

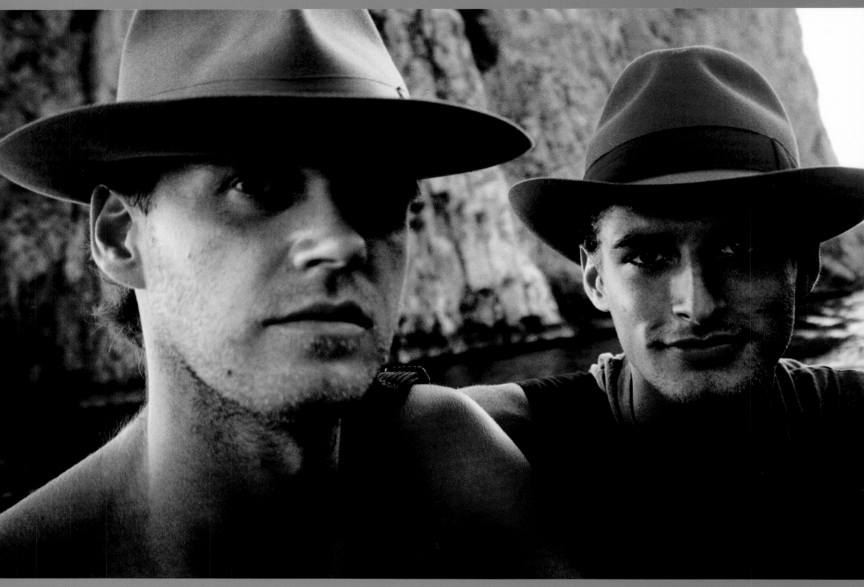

MY ASSISTANTS, THOMAS AND ALEXI, CAPRI, 2000

make selections, and something seems right at one minute and the same thing wrong at another. But while this book is a record drawn from a couple of years of my life, it is really a record of how I feel after twenty years of looking through the camera. I like the fact that pictures mean very different things to each person who looks at them. I suppose that is the text of a good picture, that twenty people will see twenty different things in it. Sometimes it might be a physical point of view that makes the picture. I am amazed by how the world looks from a helicopter, what that does to you as the viewer—takes you high. When I look at the photograph of São Paulo from the air, I imagine the lives of the millions of different people in there … all of their stories are hidden in the photograph.

The challenge as a fashion photographer is to try to get into your pictures an energy that only you could get. An editor said to me, "A picture will only be yours if you get something different out of the girl, because when she goes to work with all the other photographers, she will only do what she does every day—so unless you really instigate something, it will never be your picture." You notice the process between couples in relationships—they have a connection because only they bring out the best in each other as people. Here I have tried to do that with some of my favorite places too—Rio, Seville, London. This book is also a reminder to myself to be open—to be aware of being alive and ready to dis-cover beauty in unexpected places and to see it in fresh ways. I can only hope that you will find something new in its pages now that you have opened them....

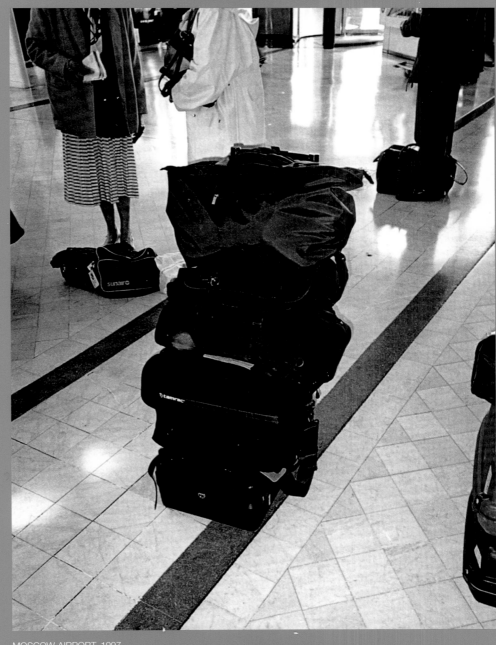

MOSCOW AIRPORT, 1997

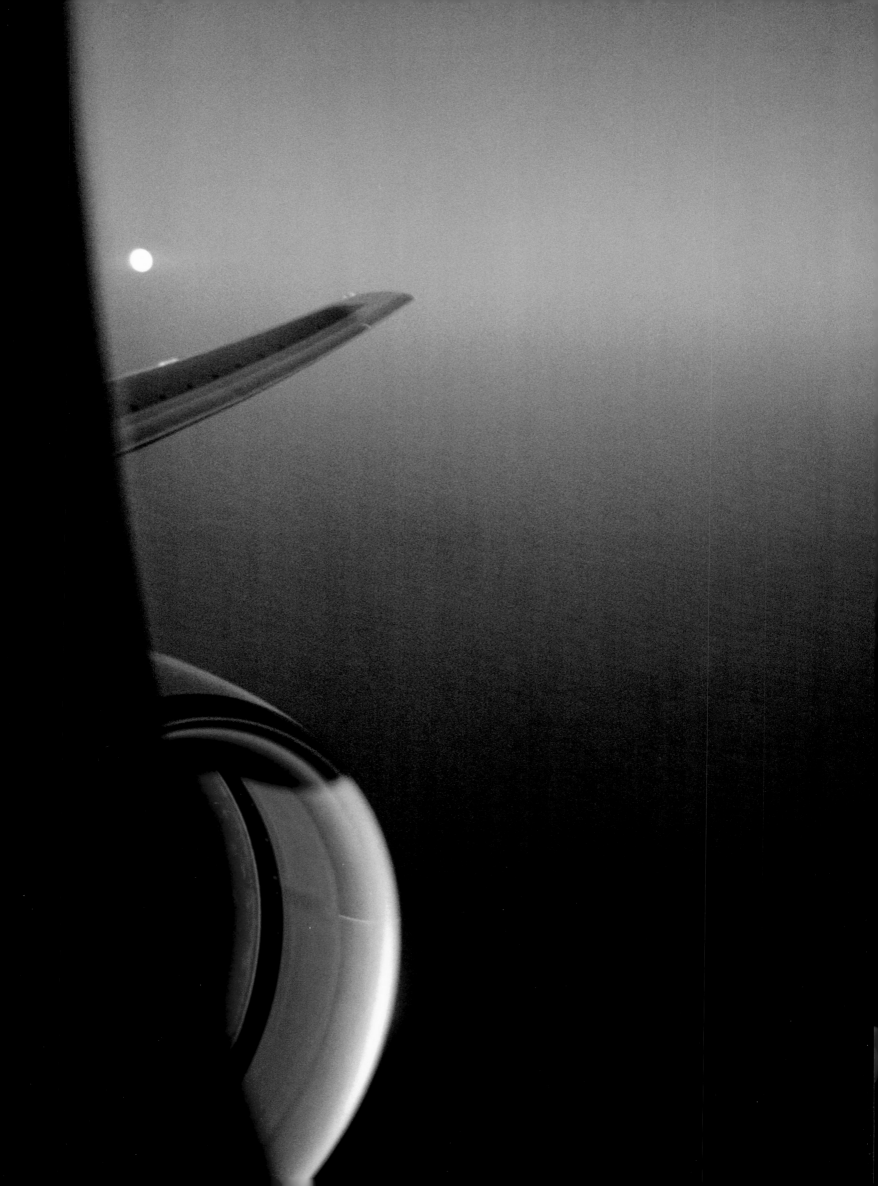

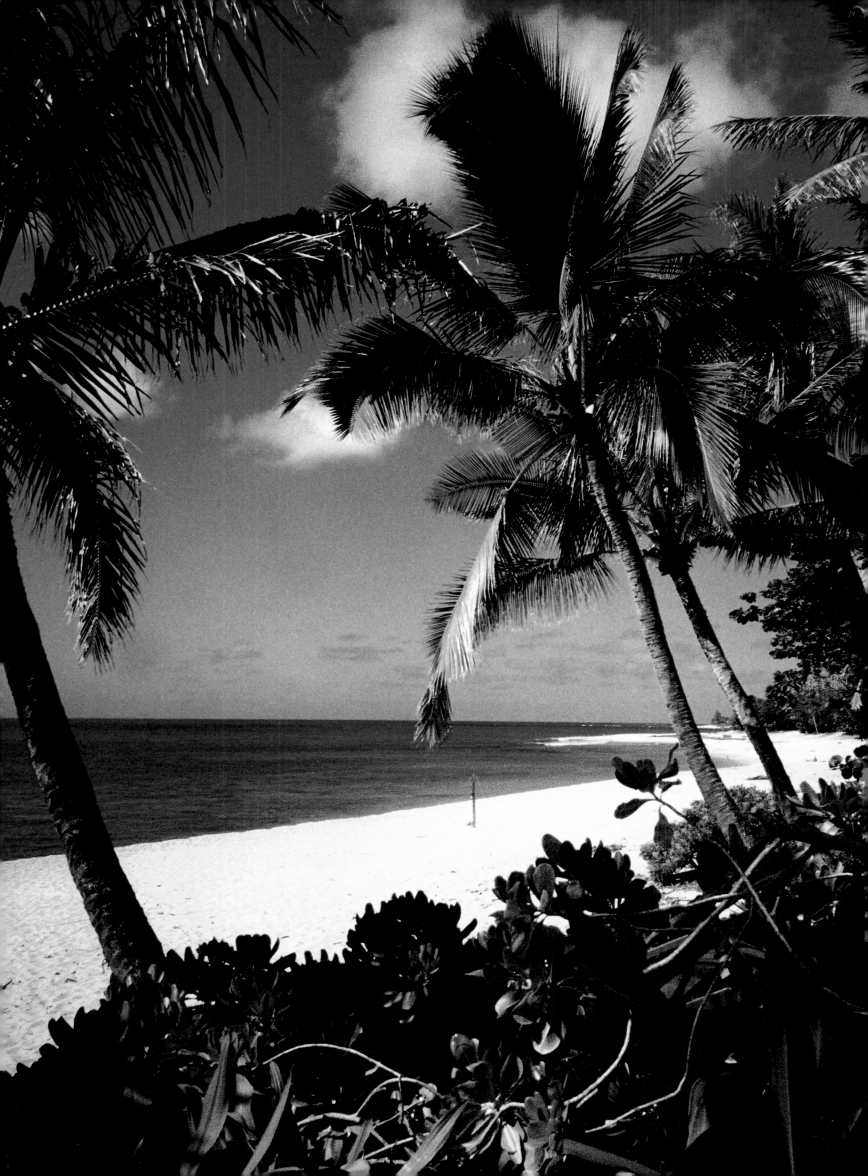

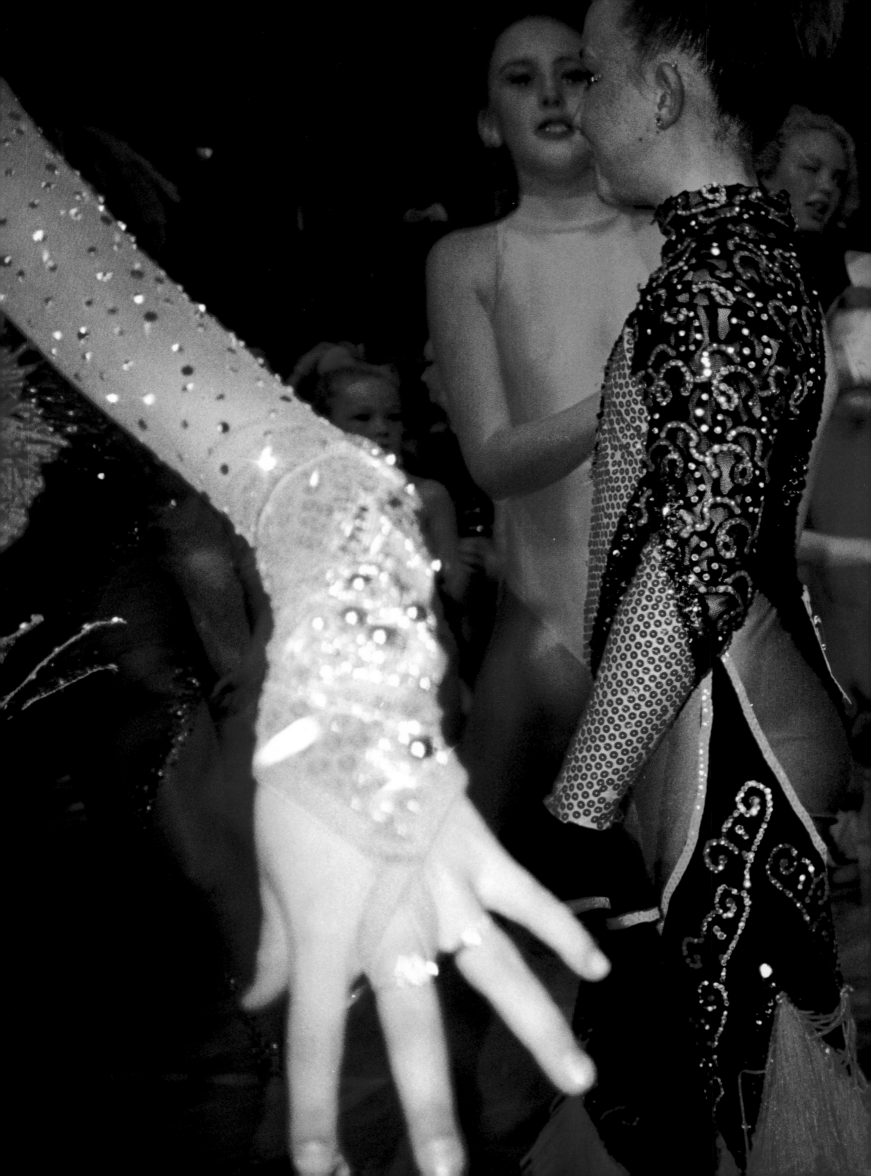

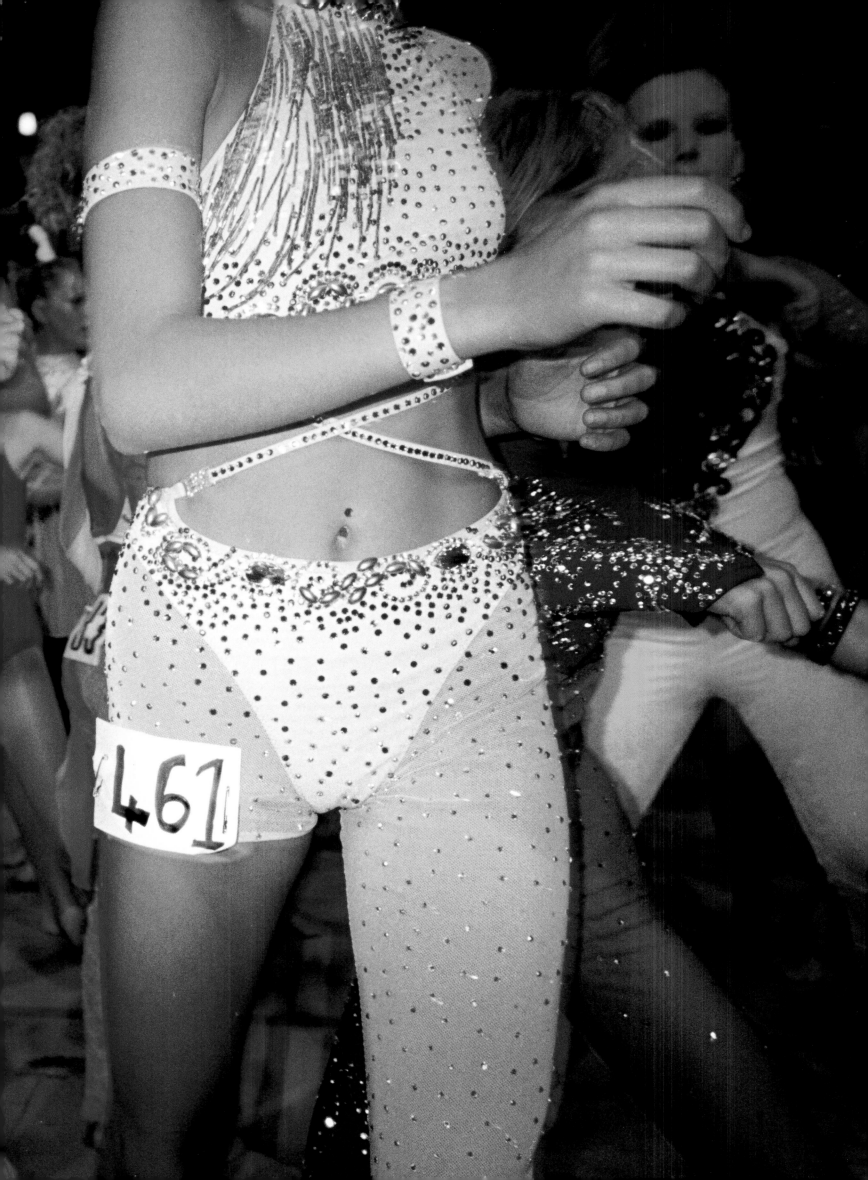

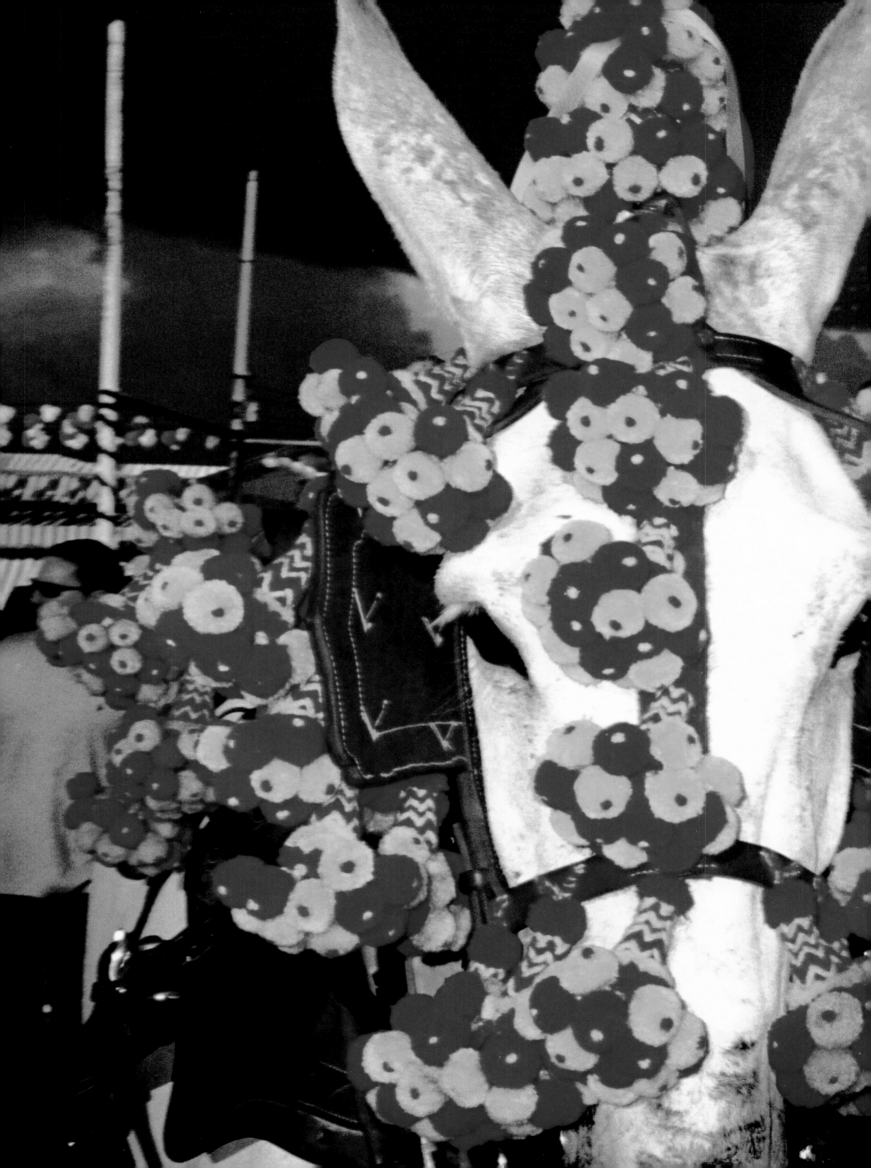

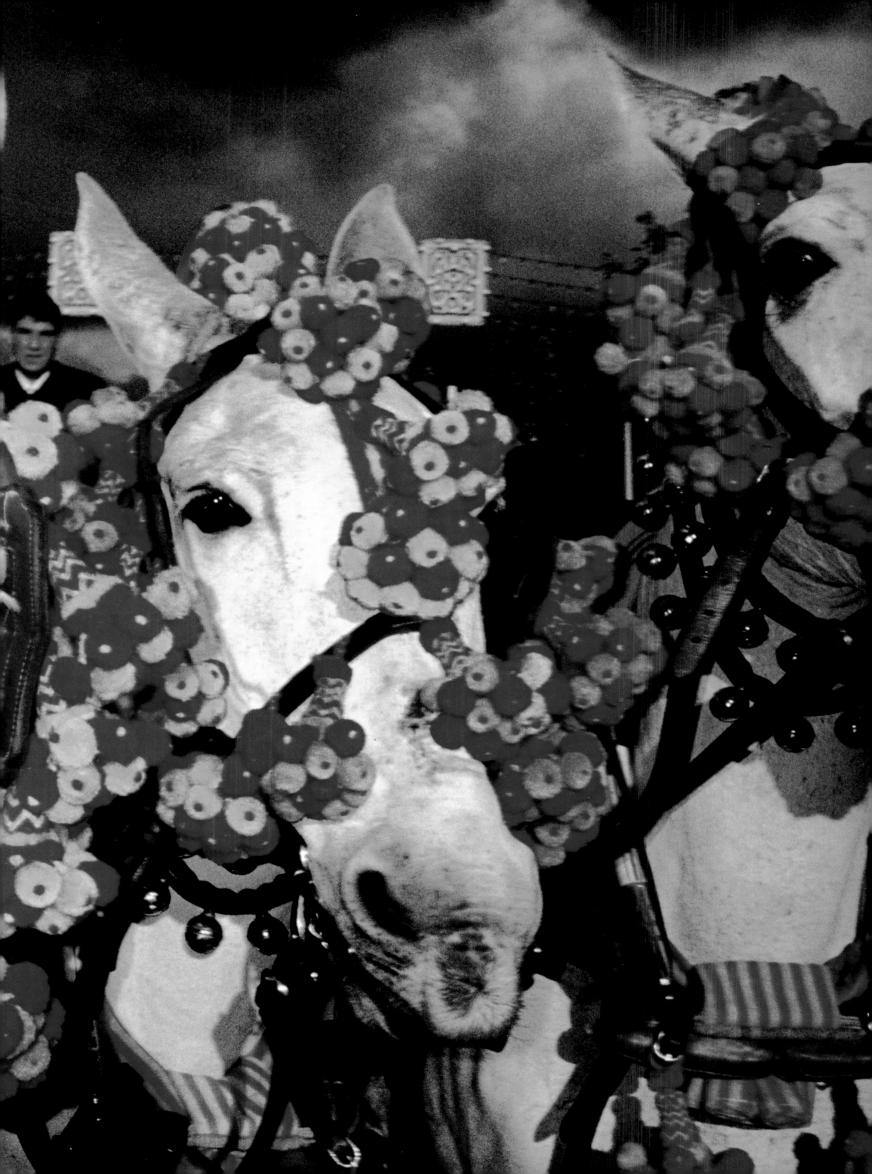

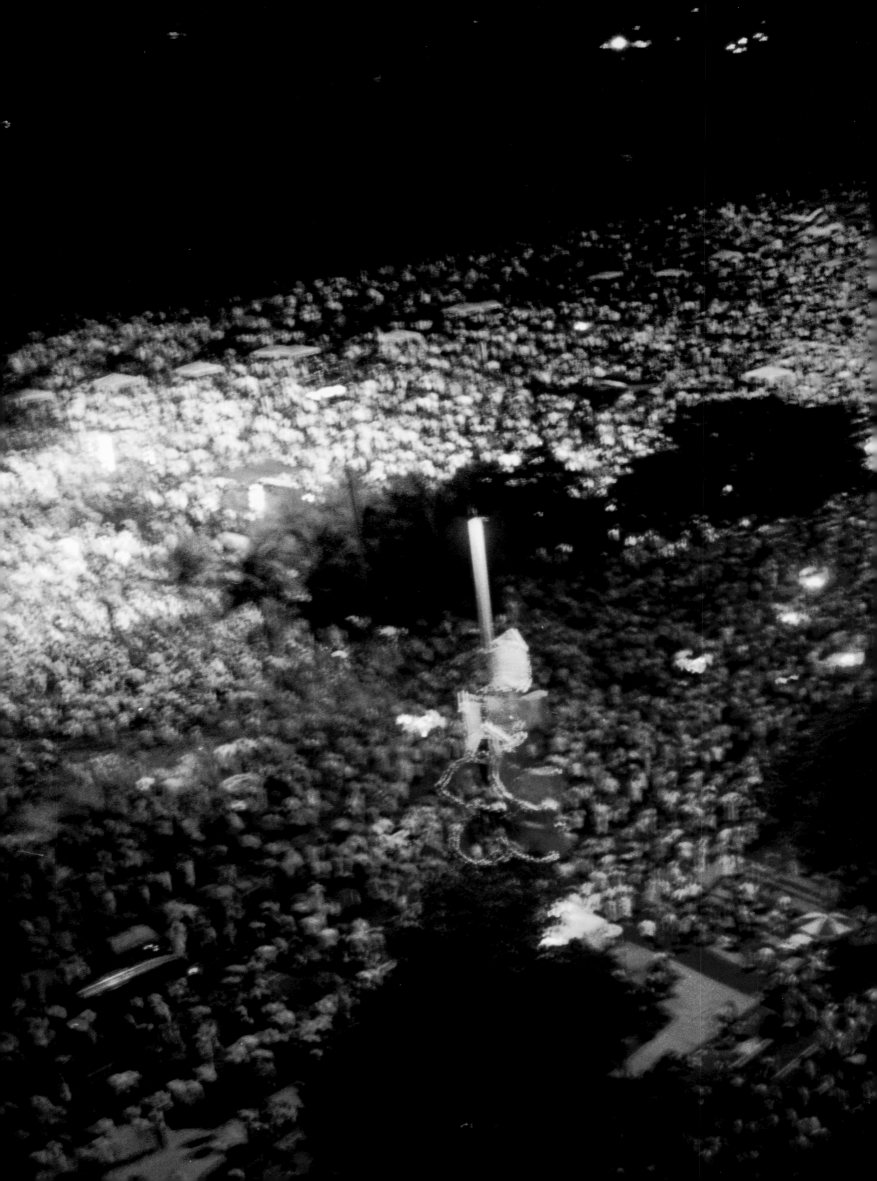

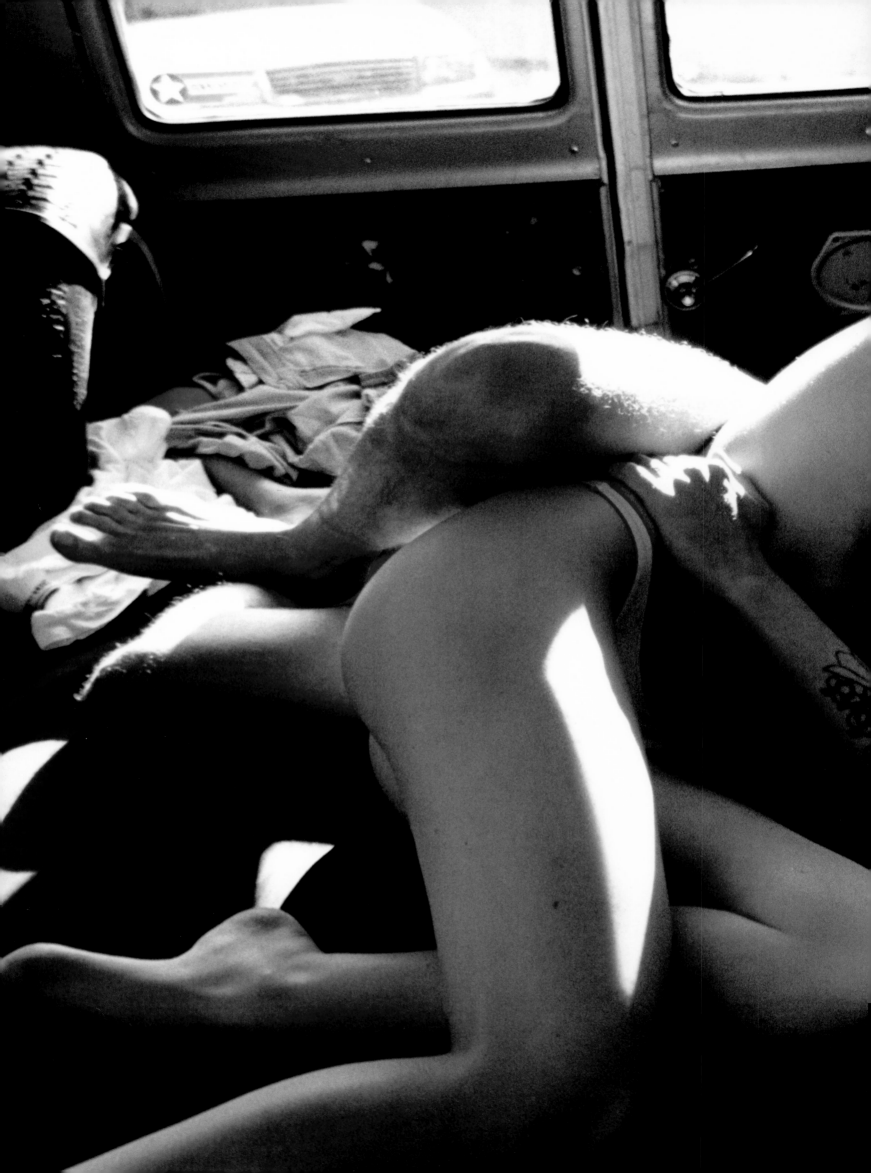

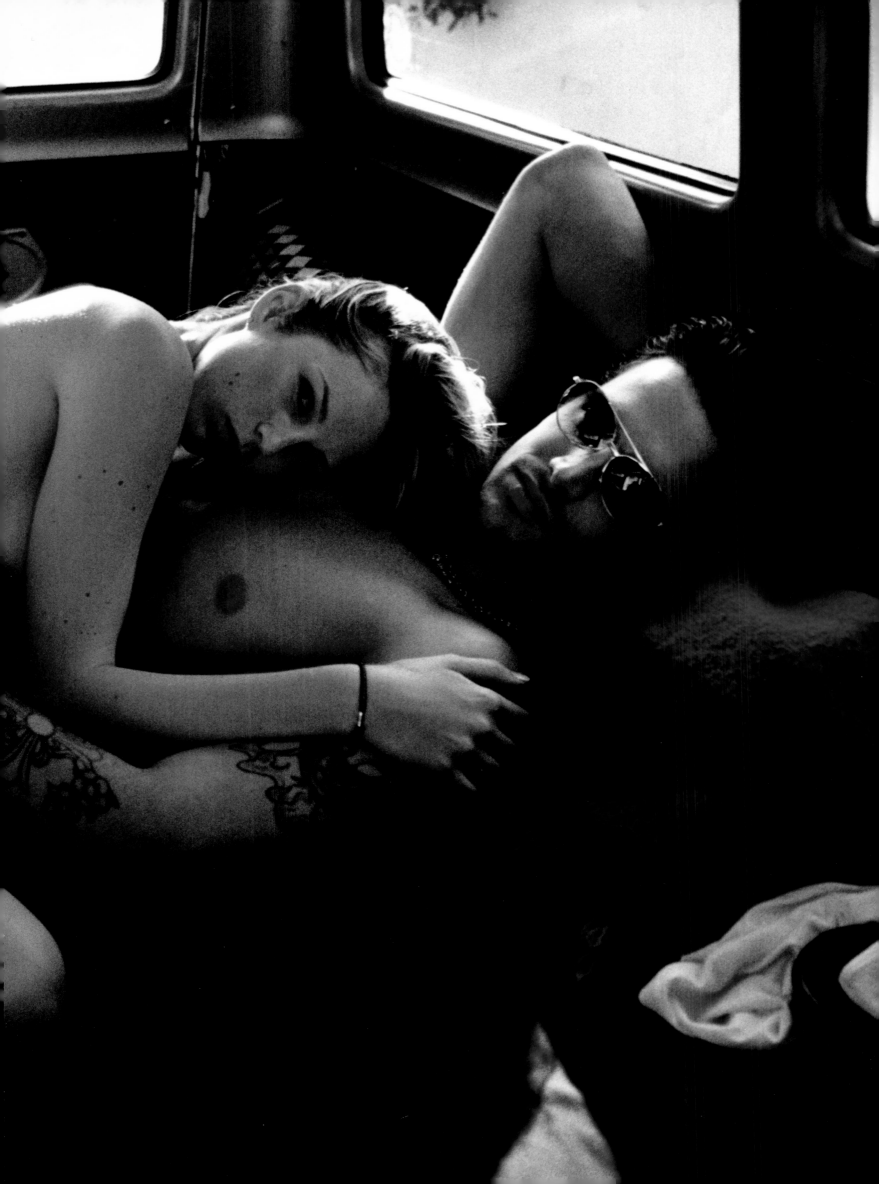

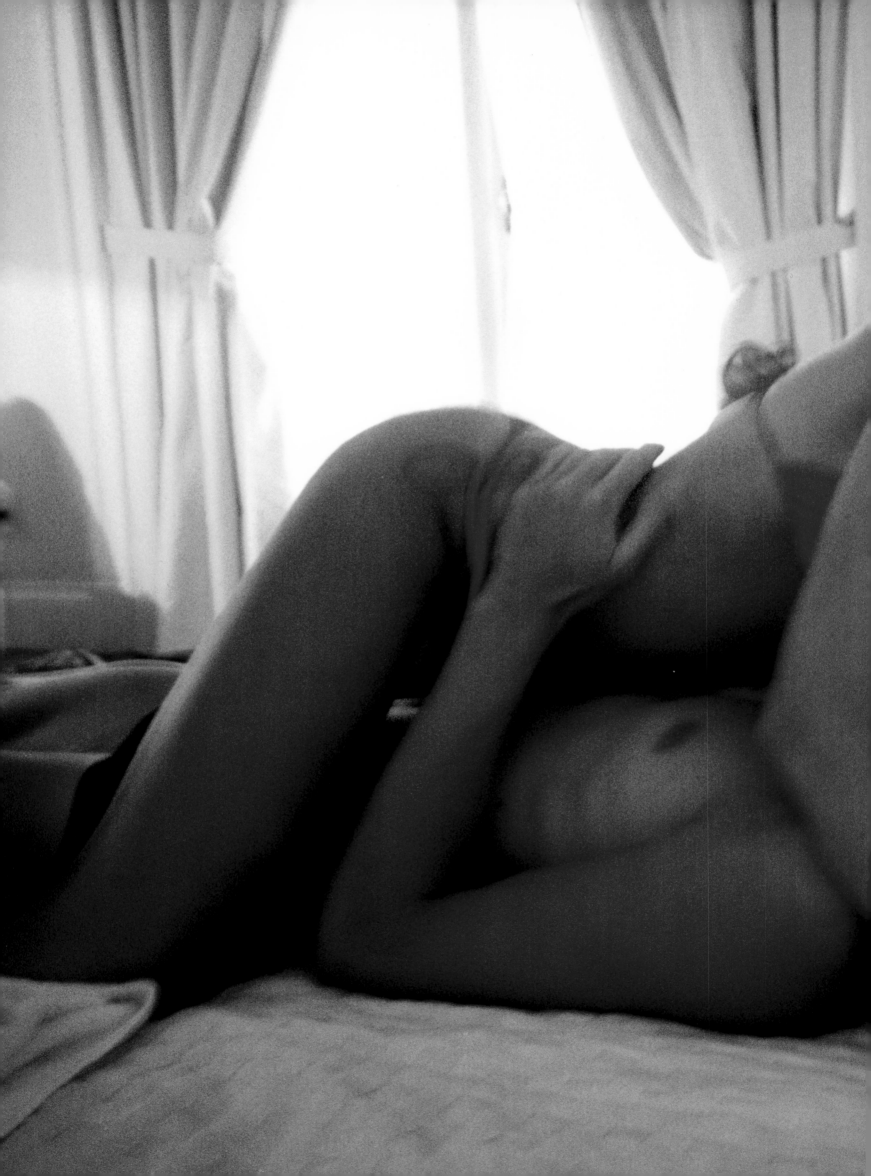

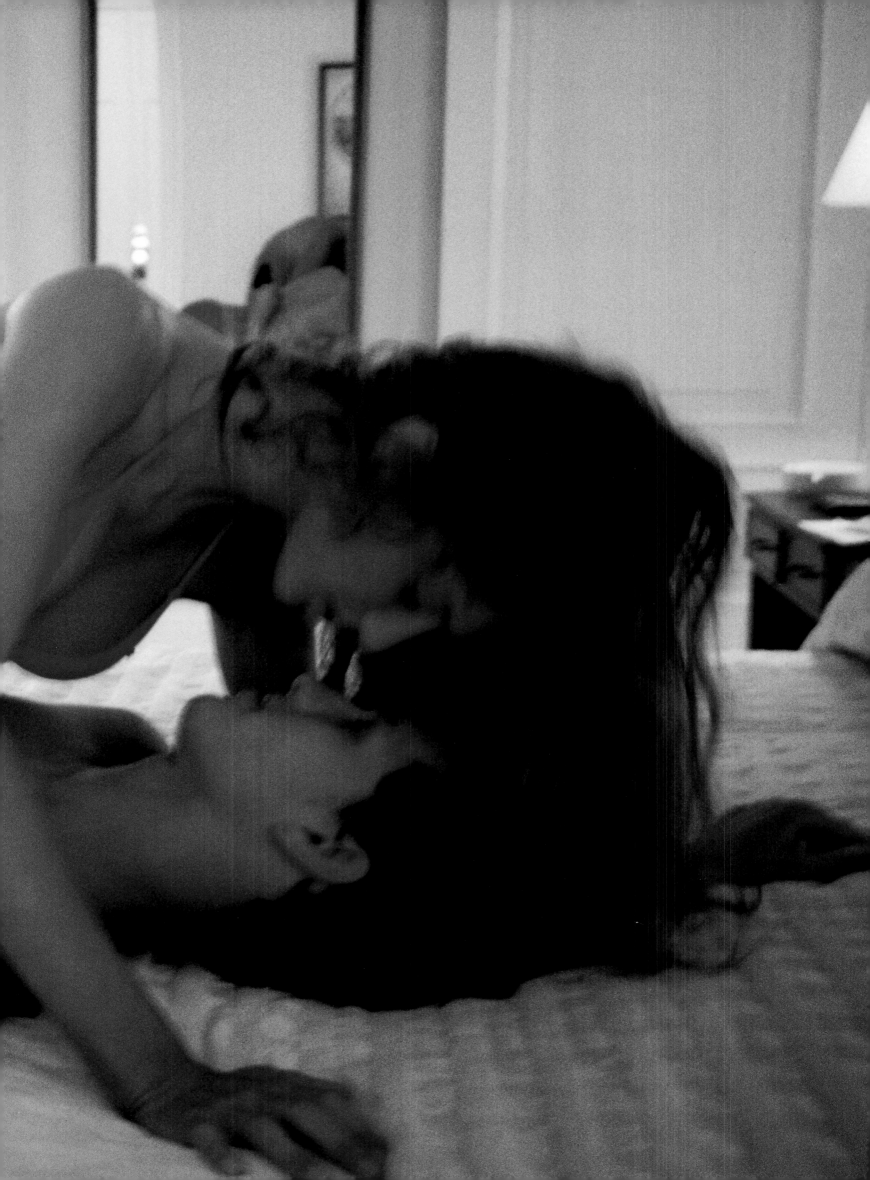

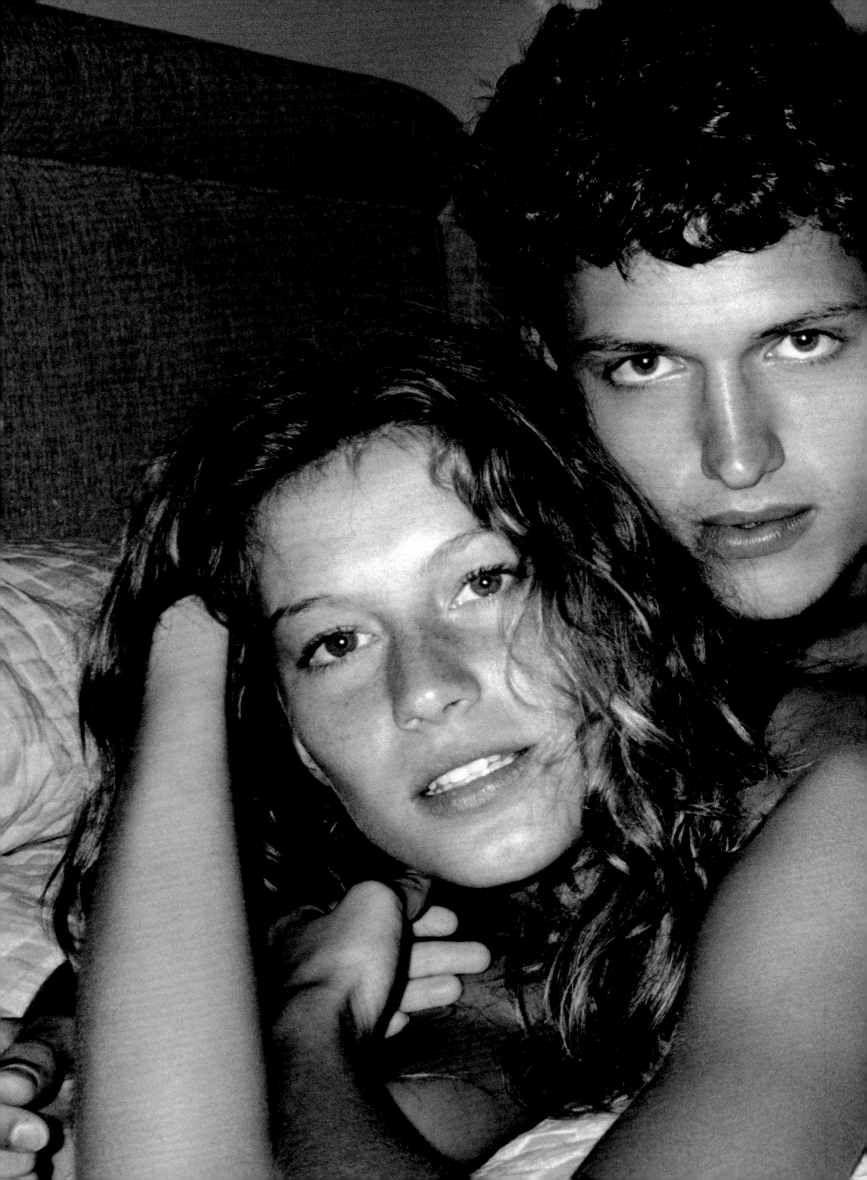

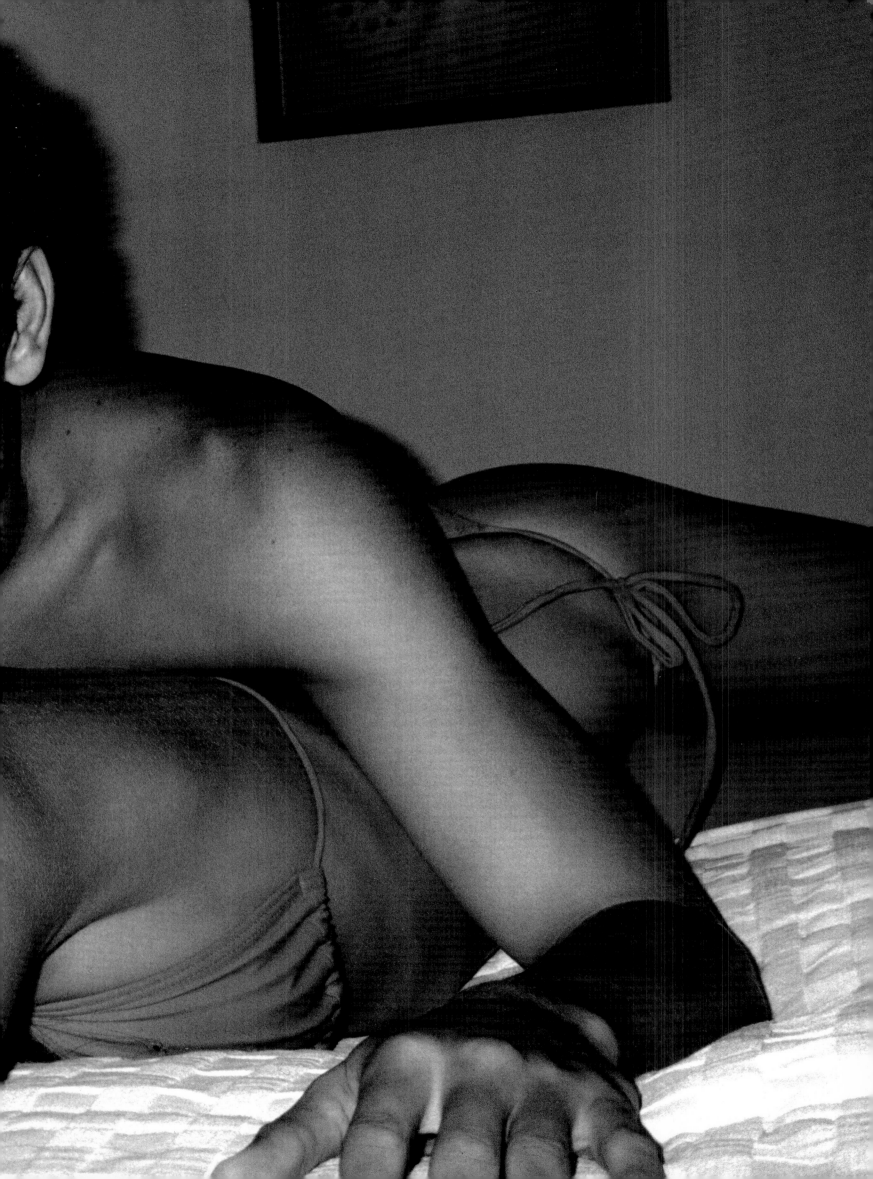

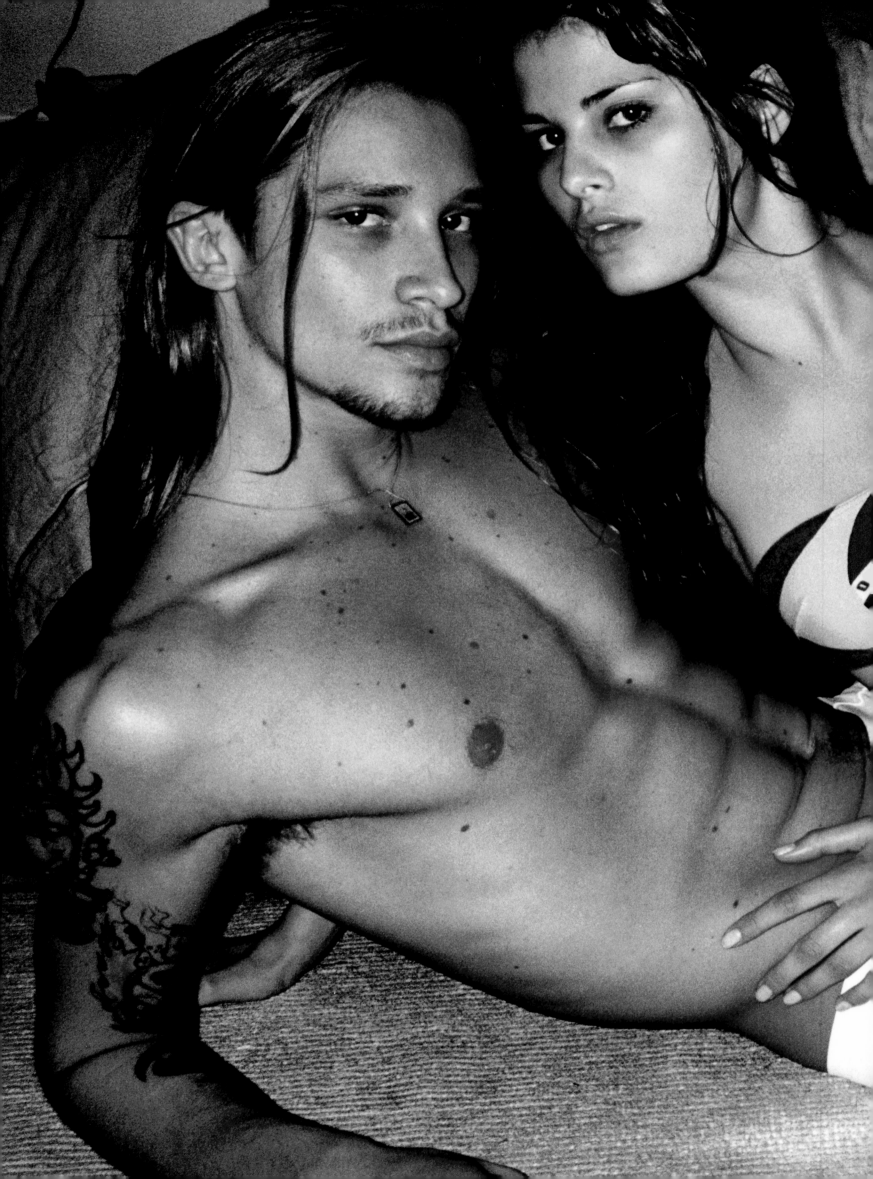

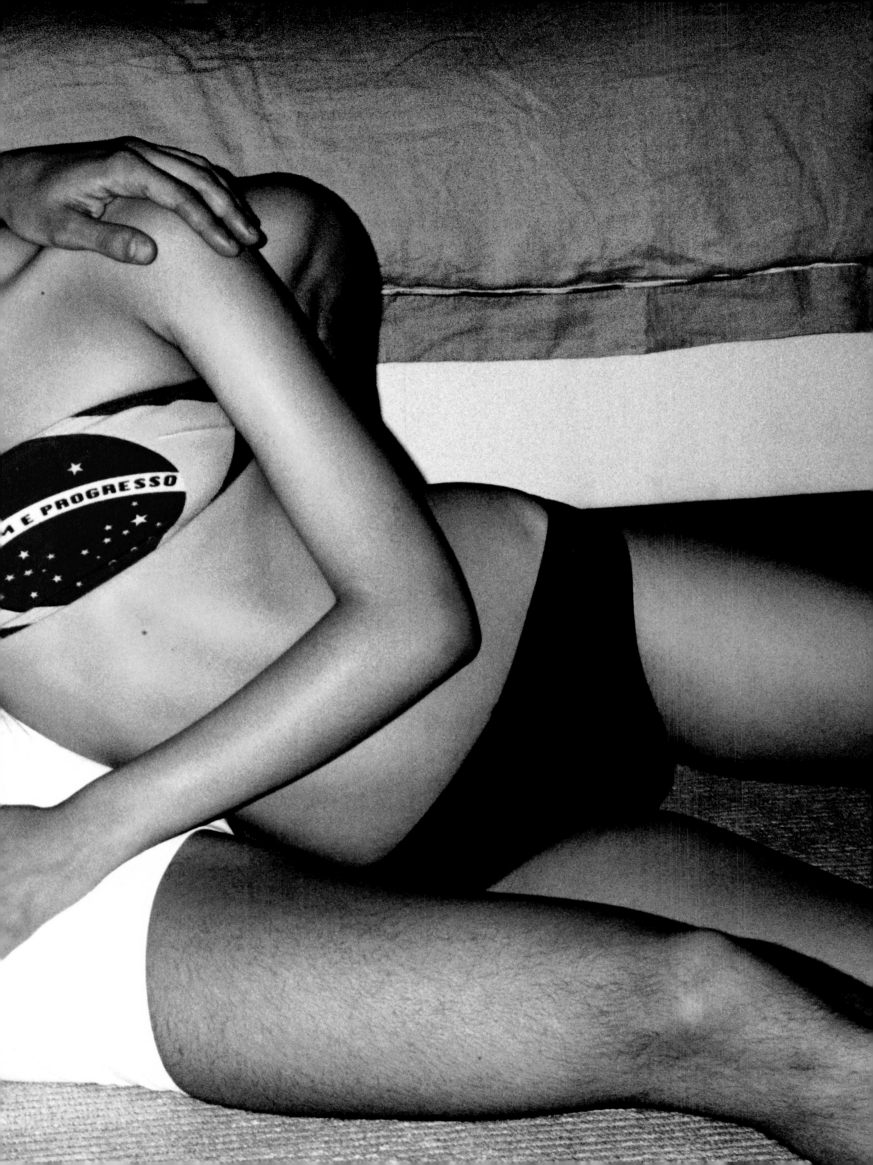

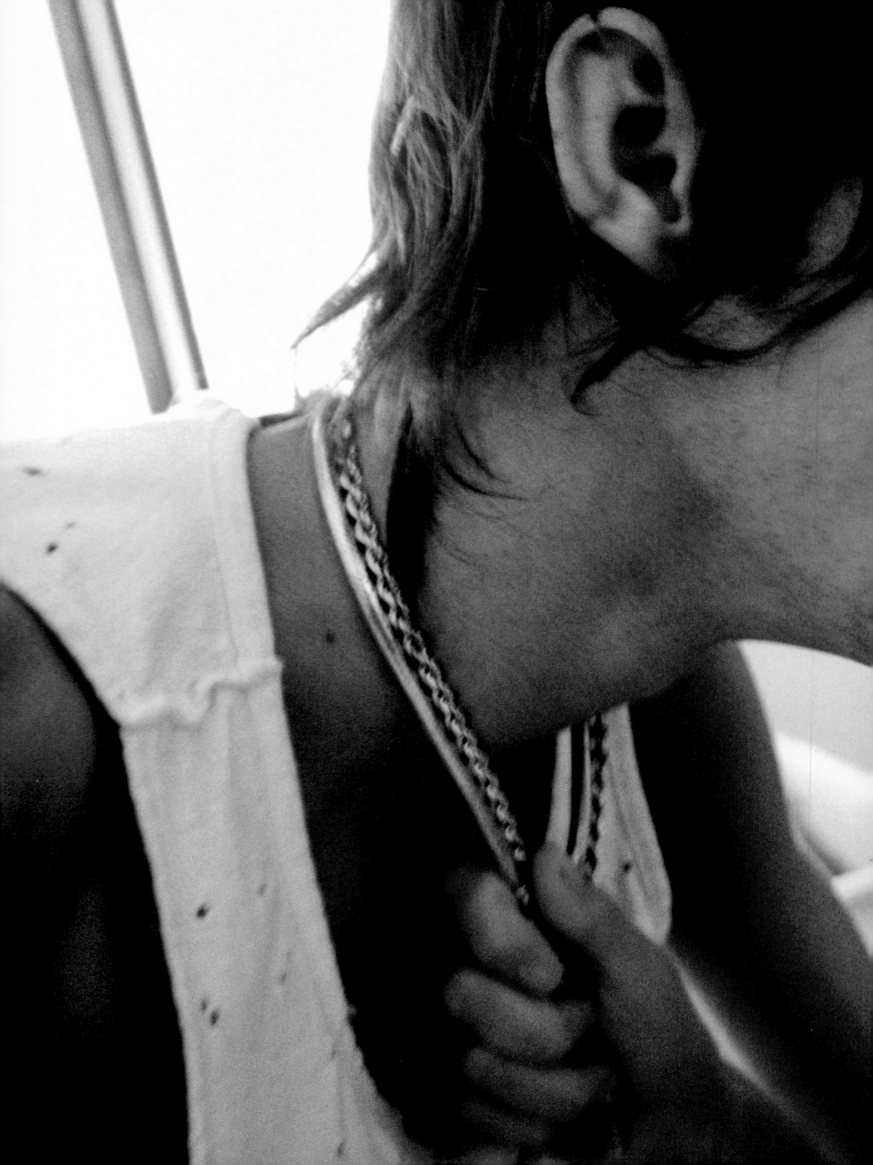

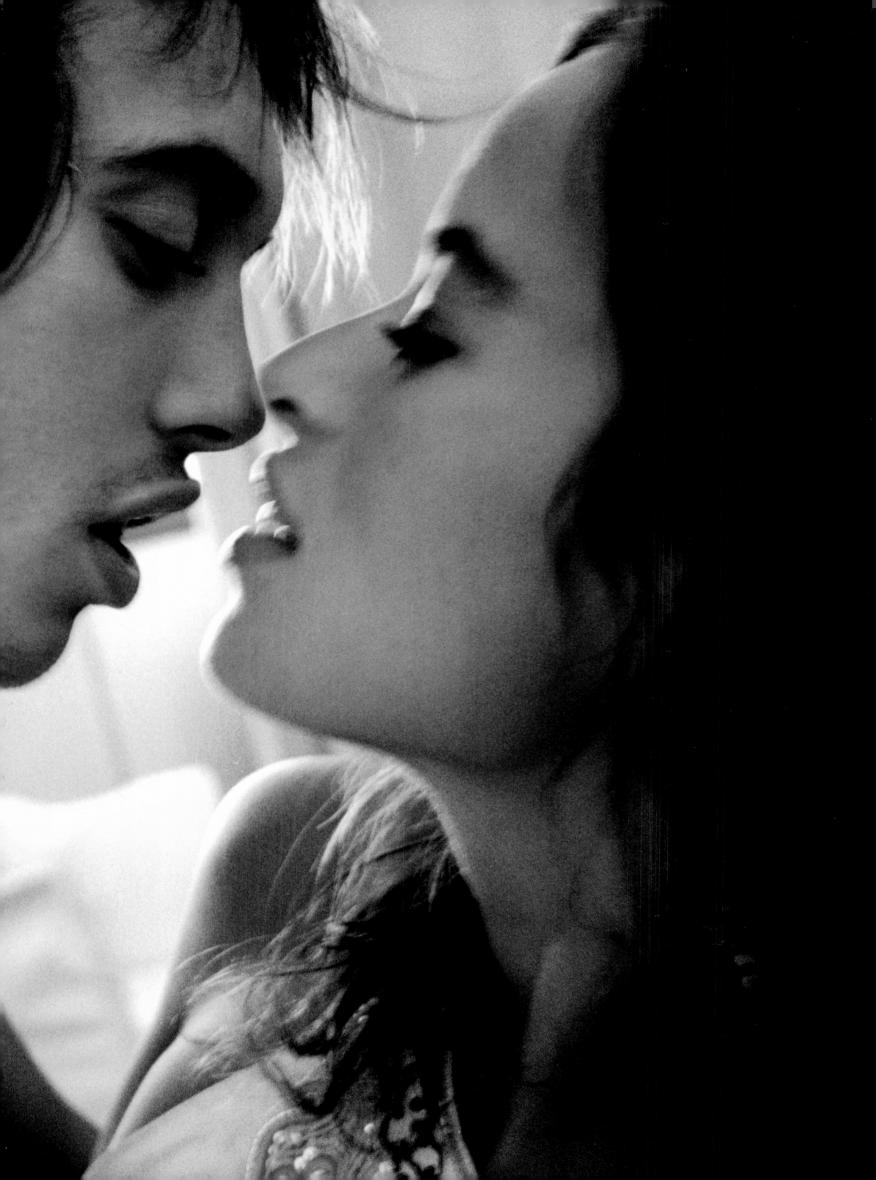

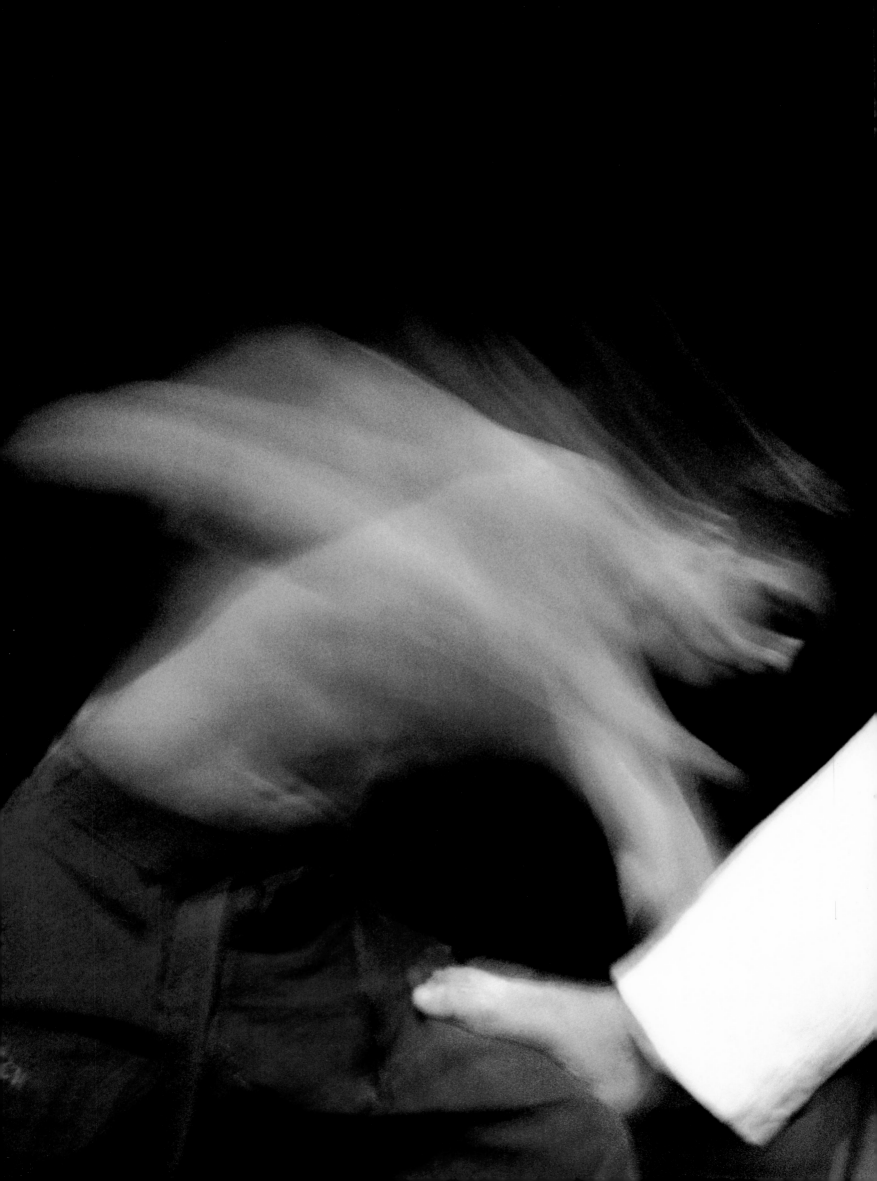

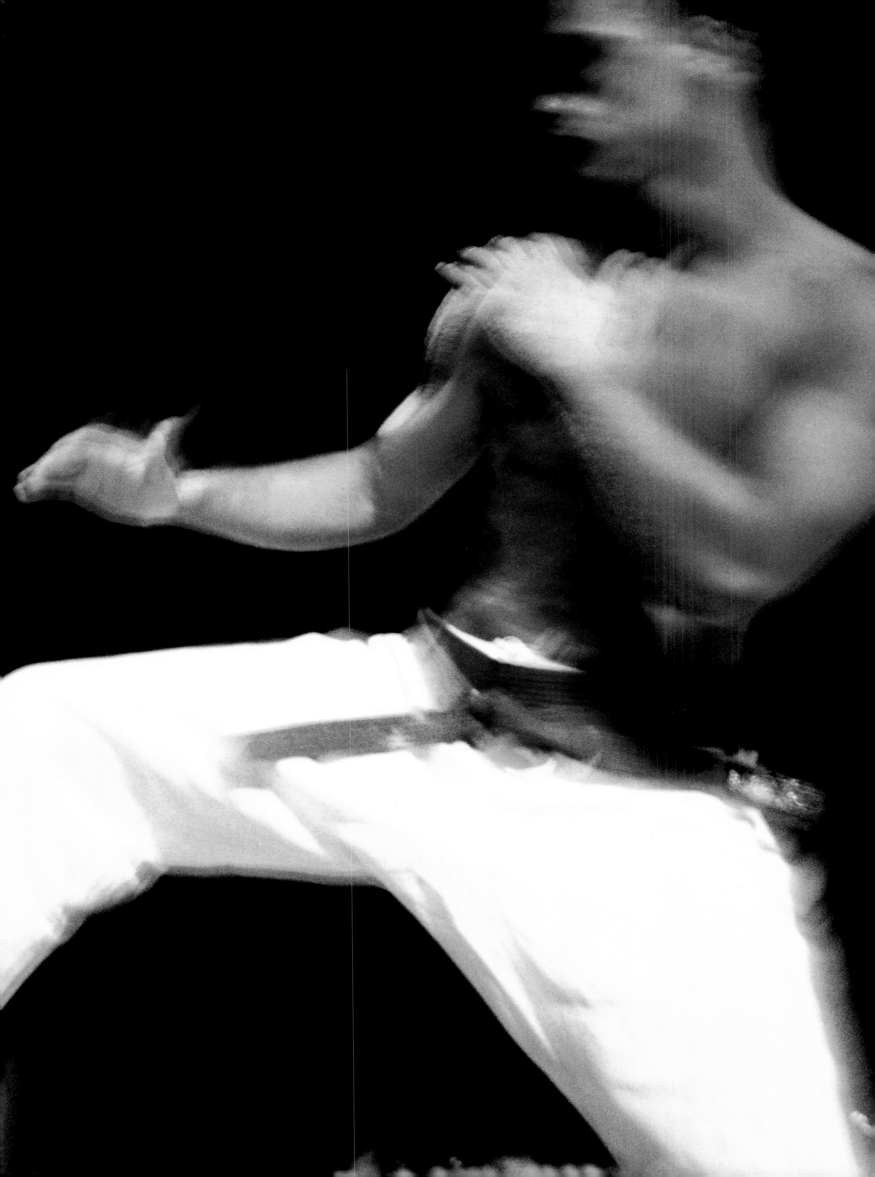

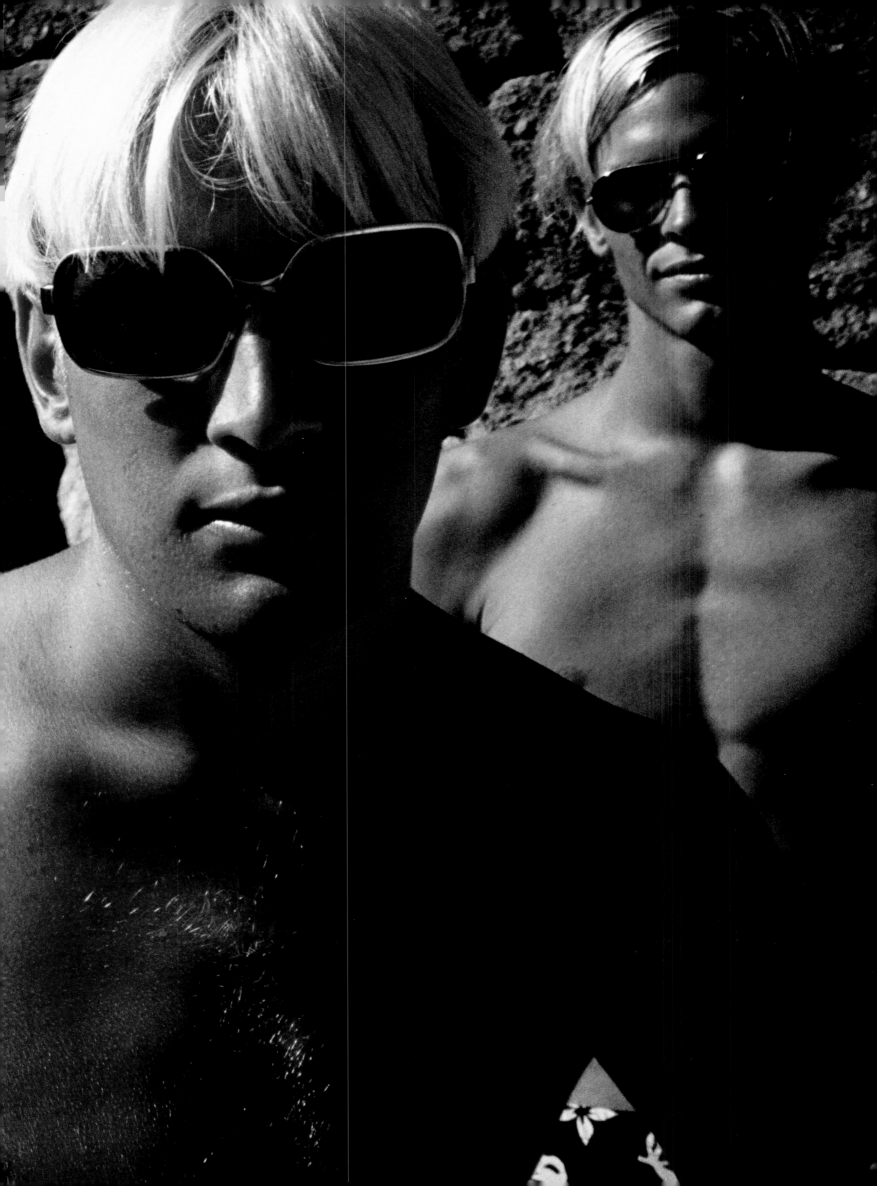

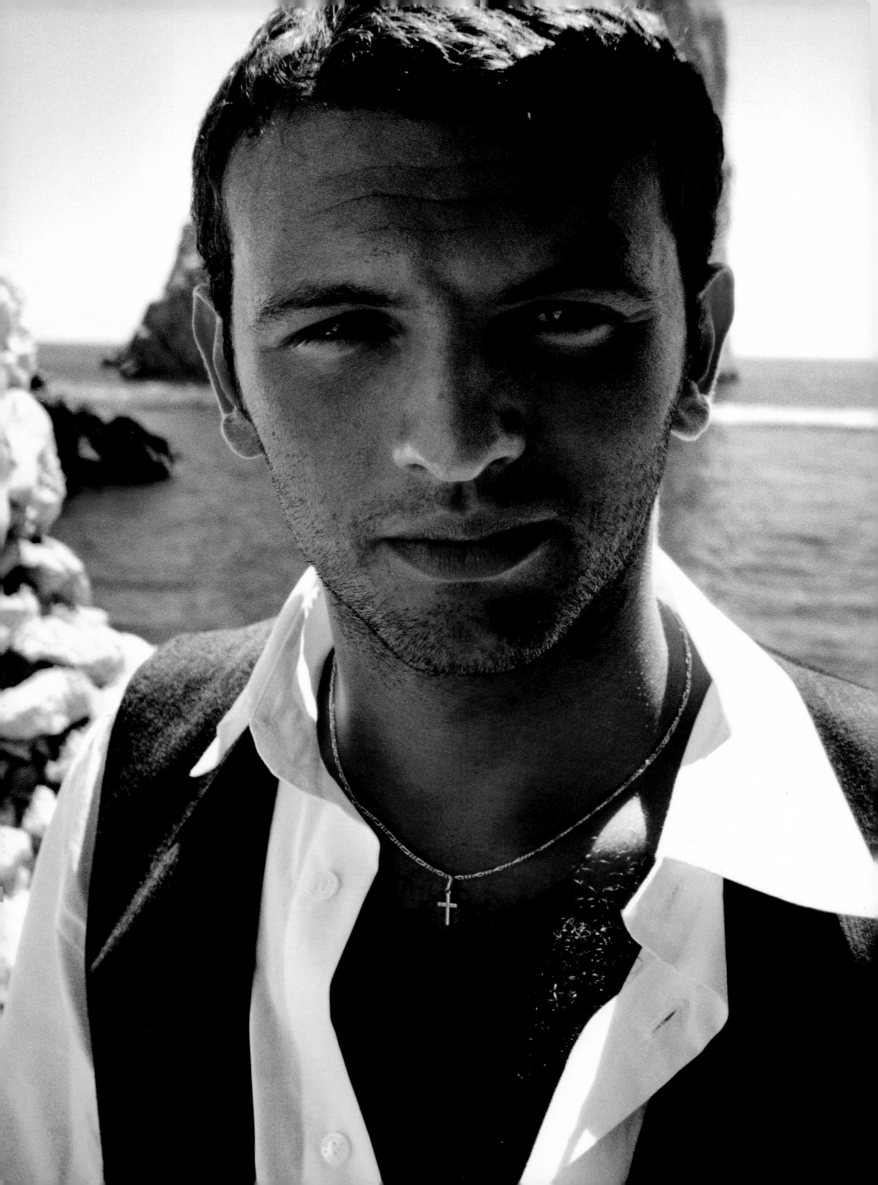

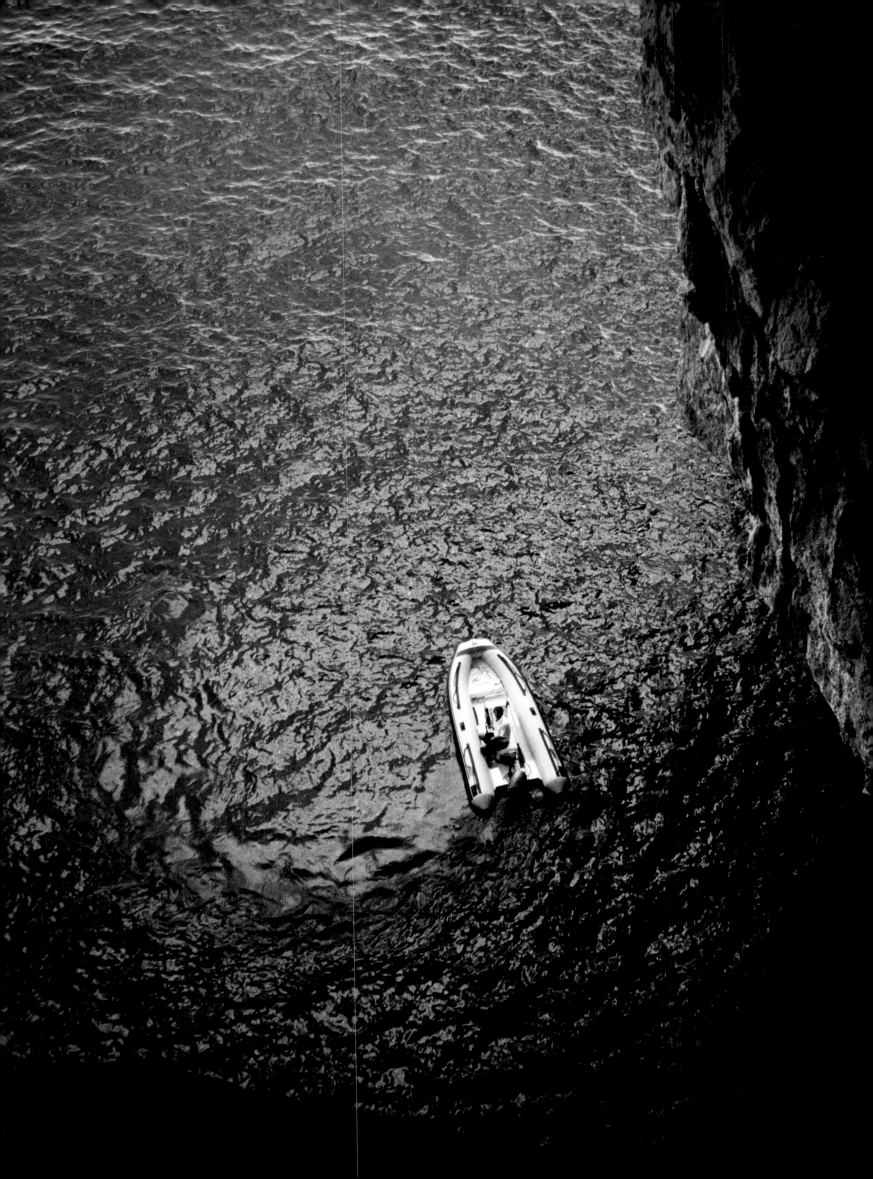

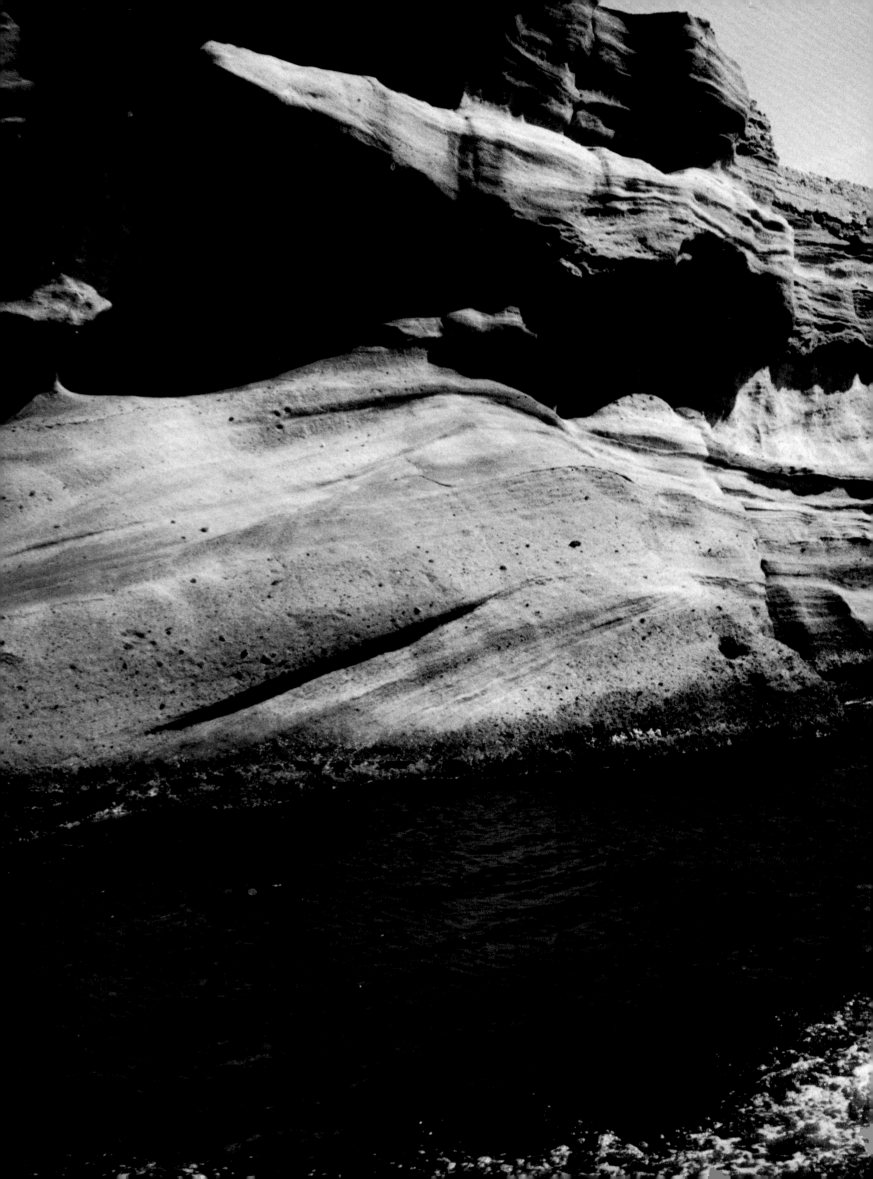

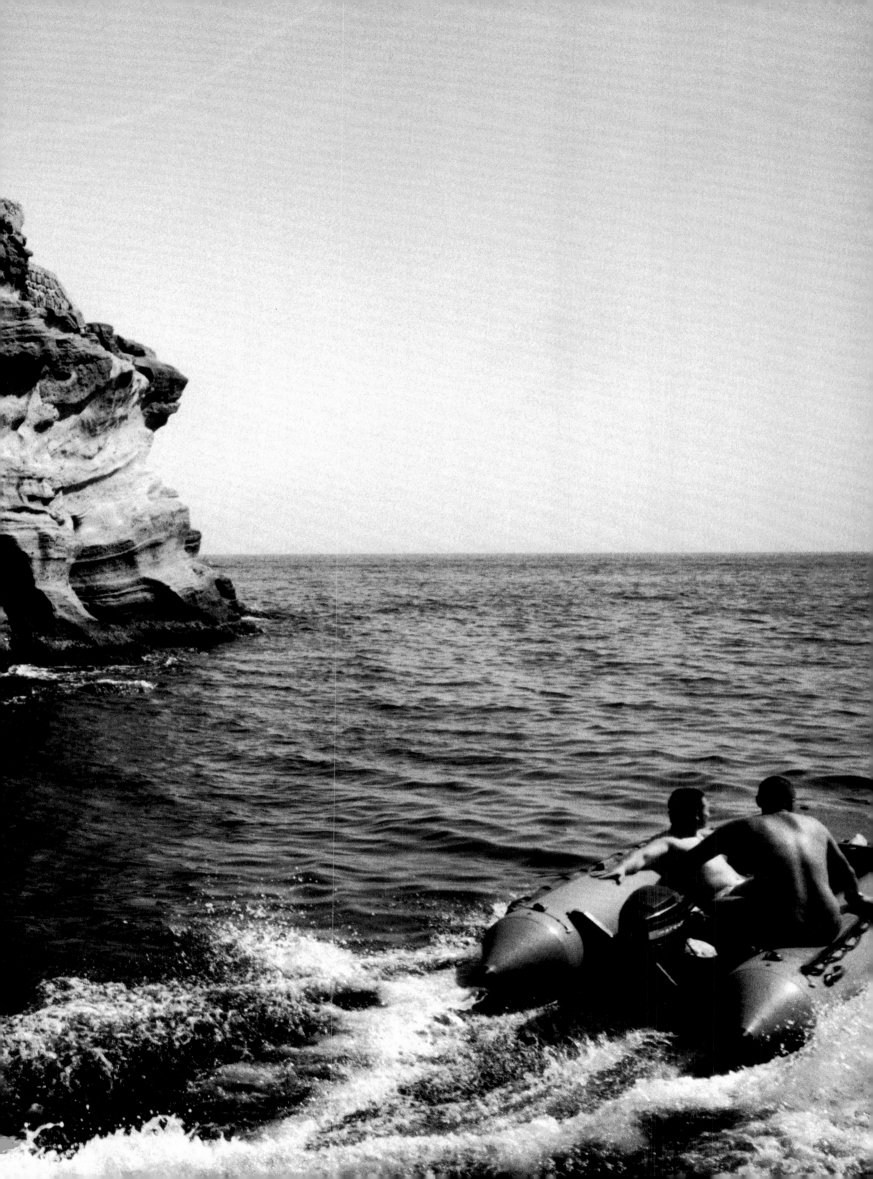

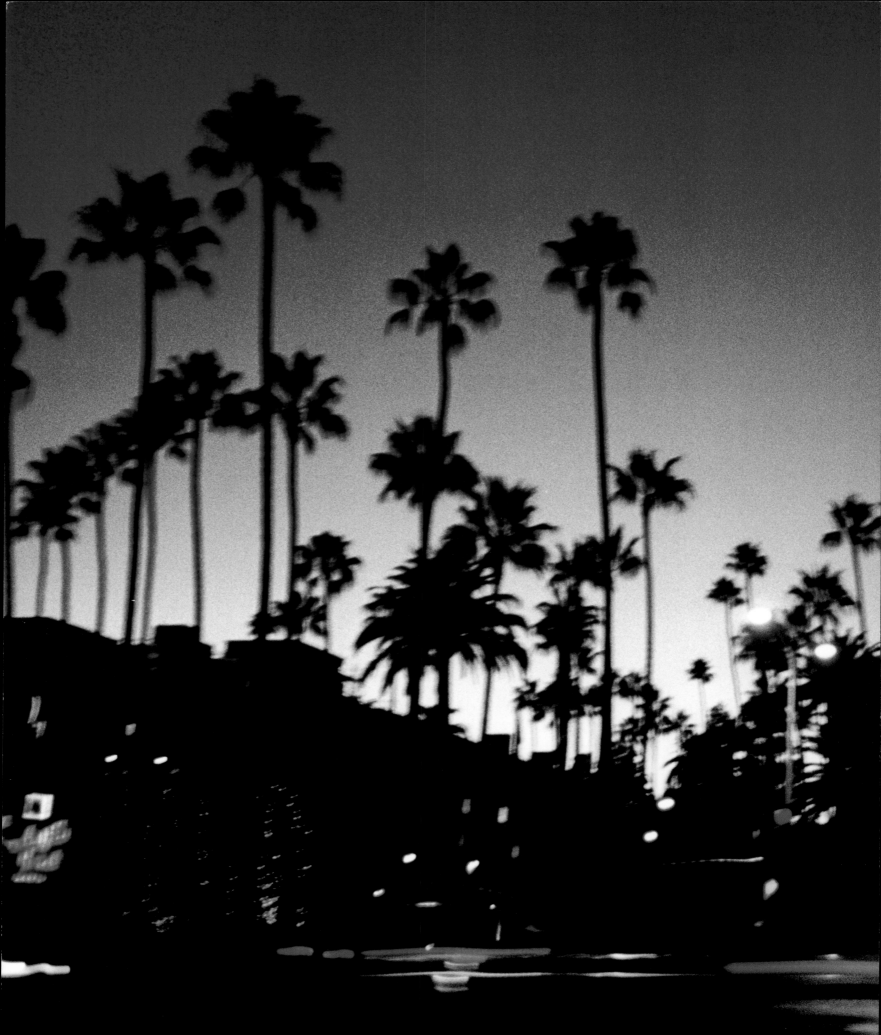

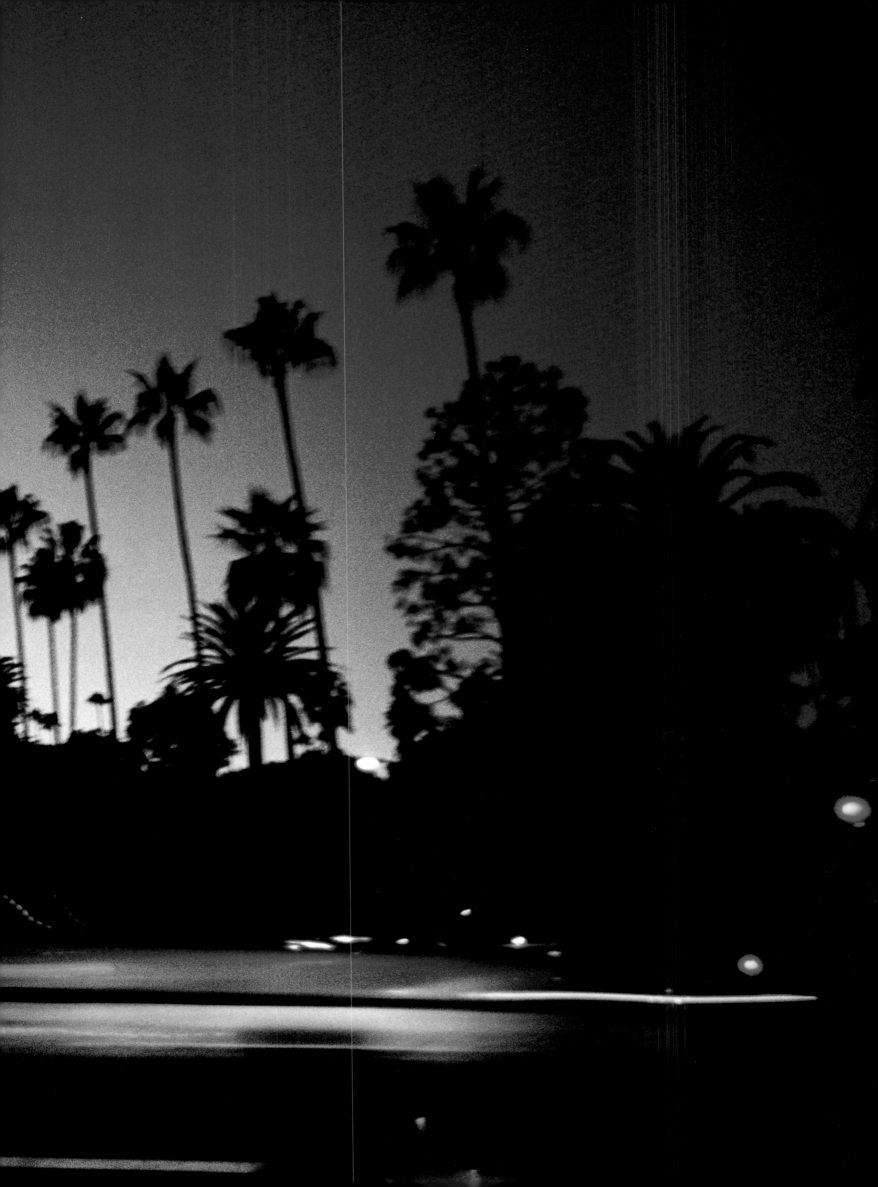

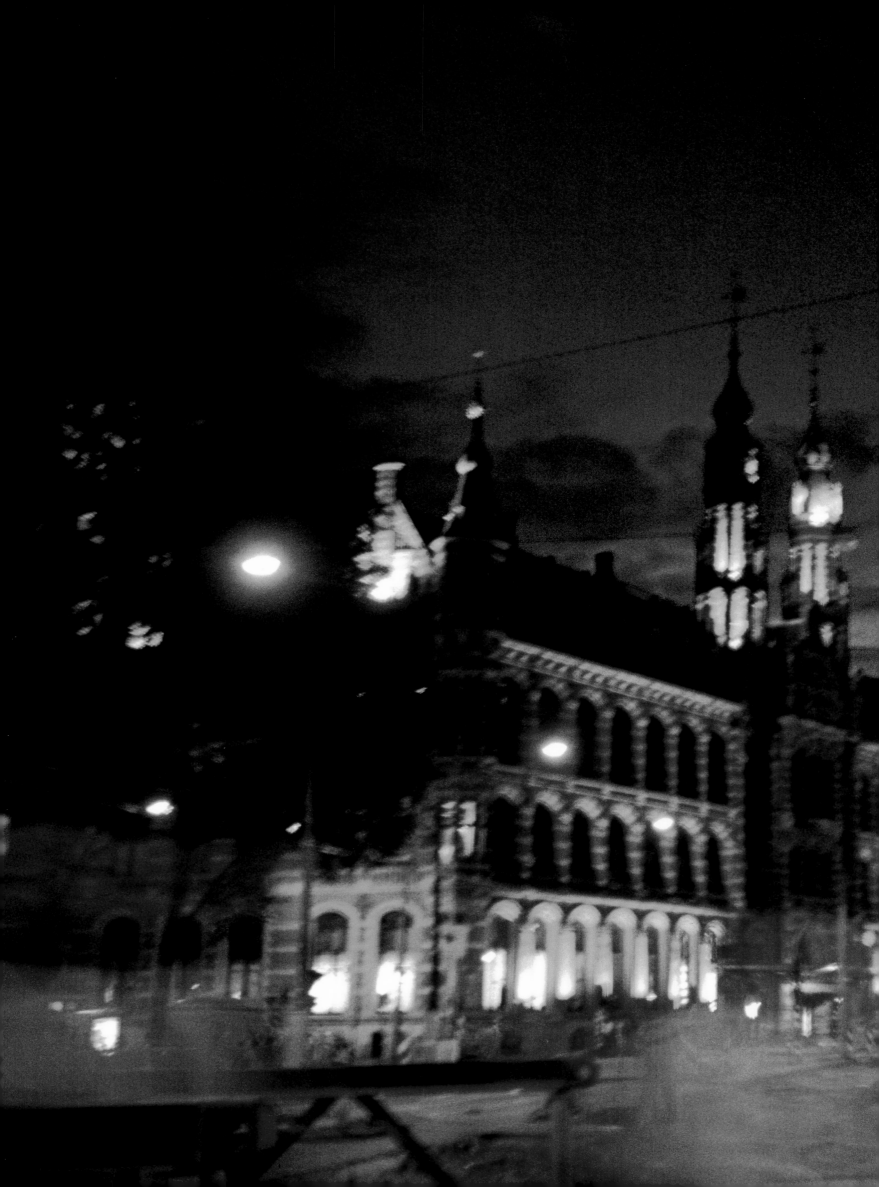

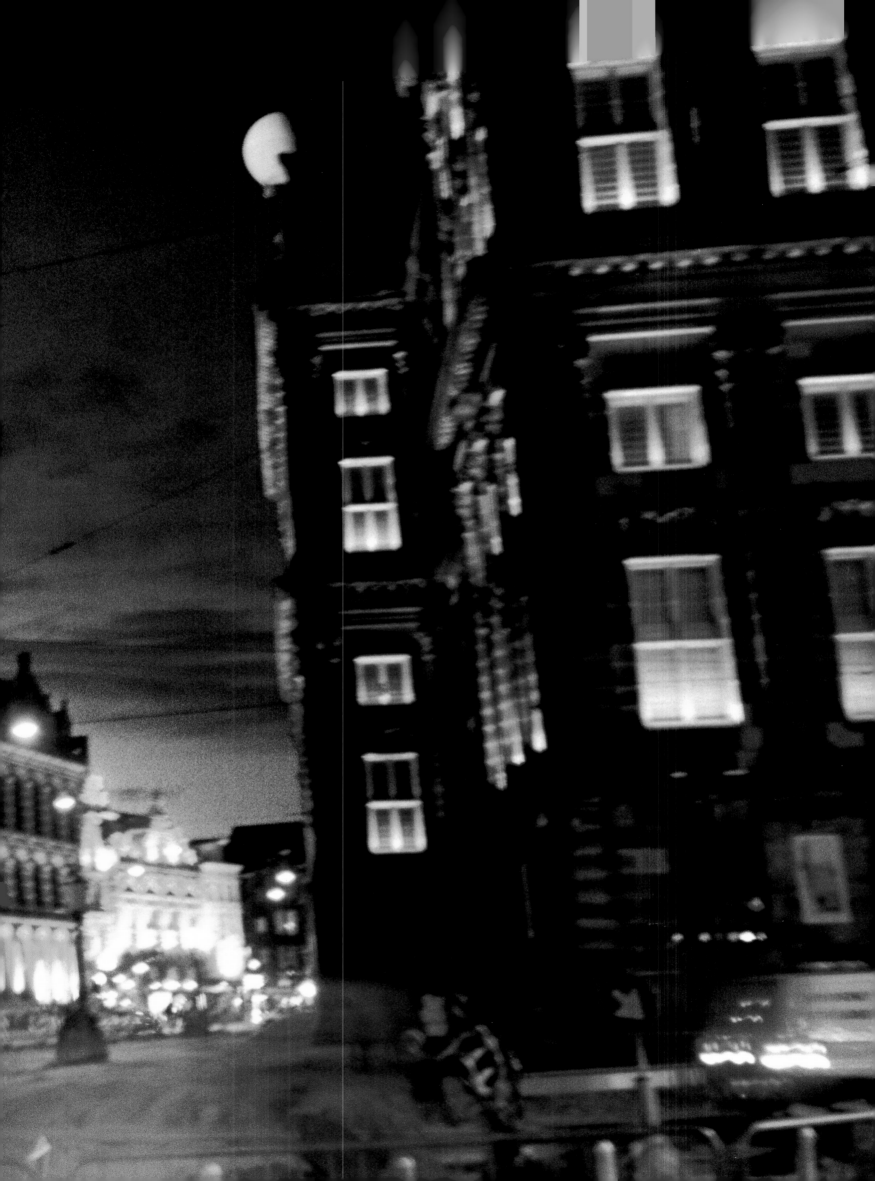

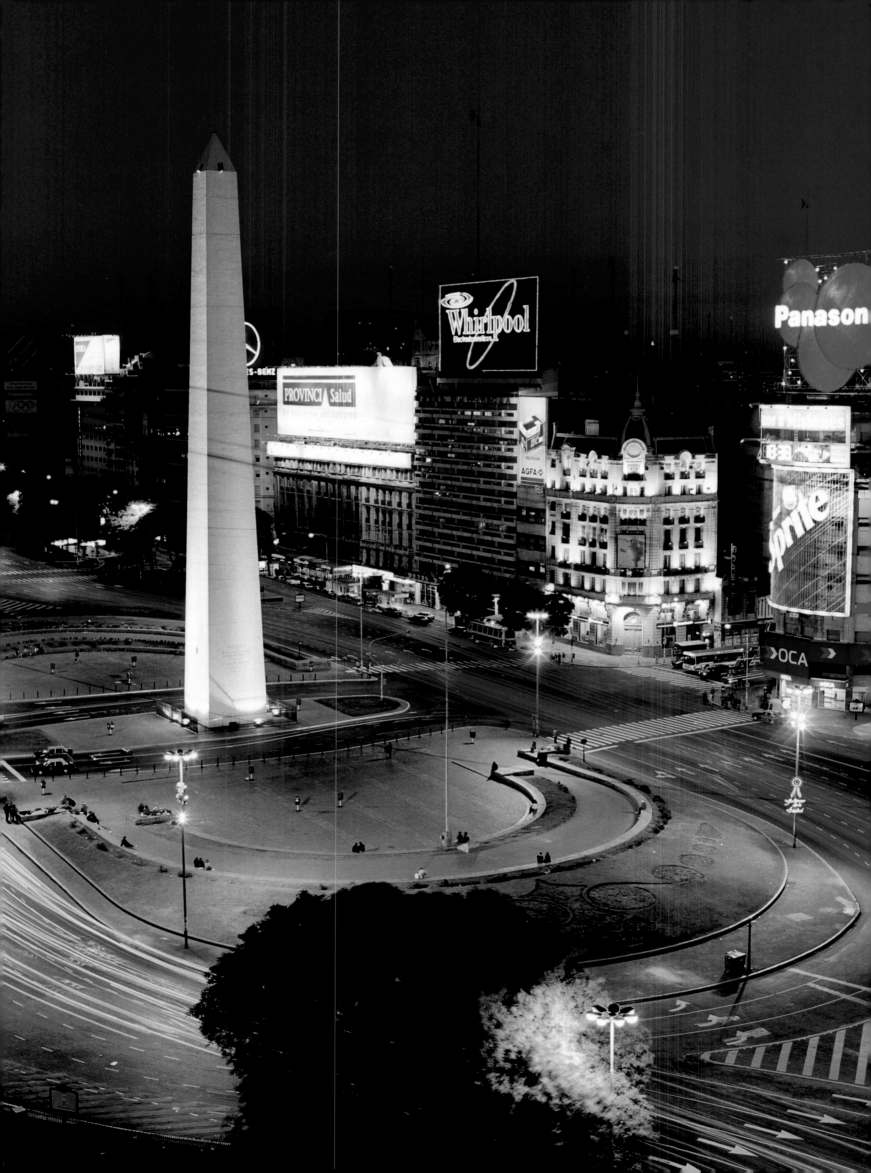

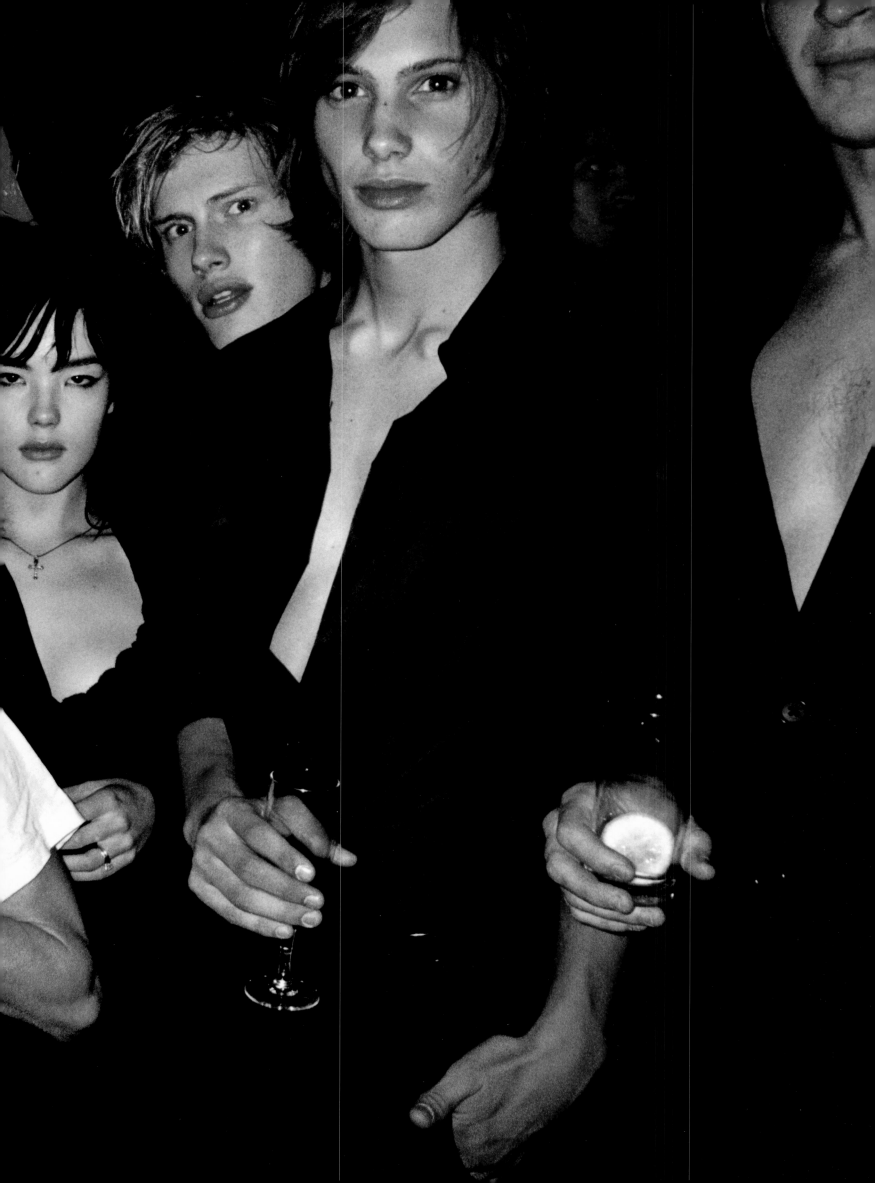

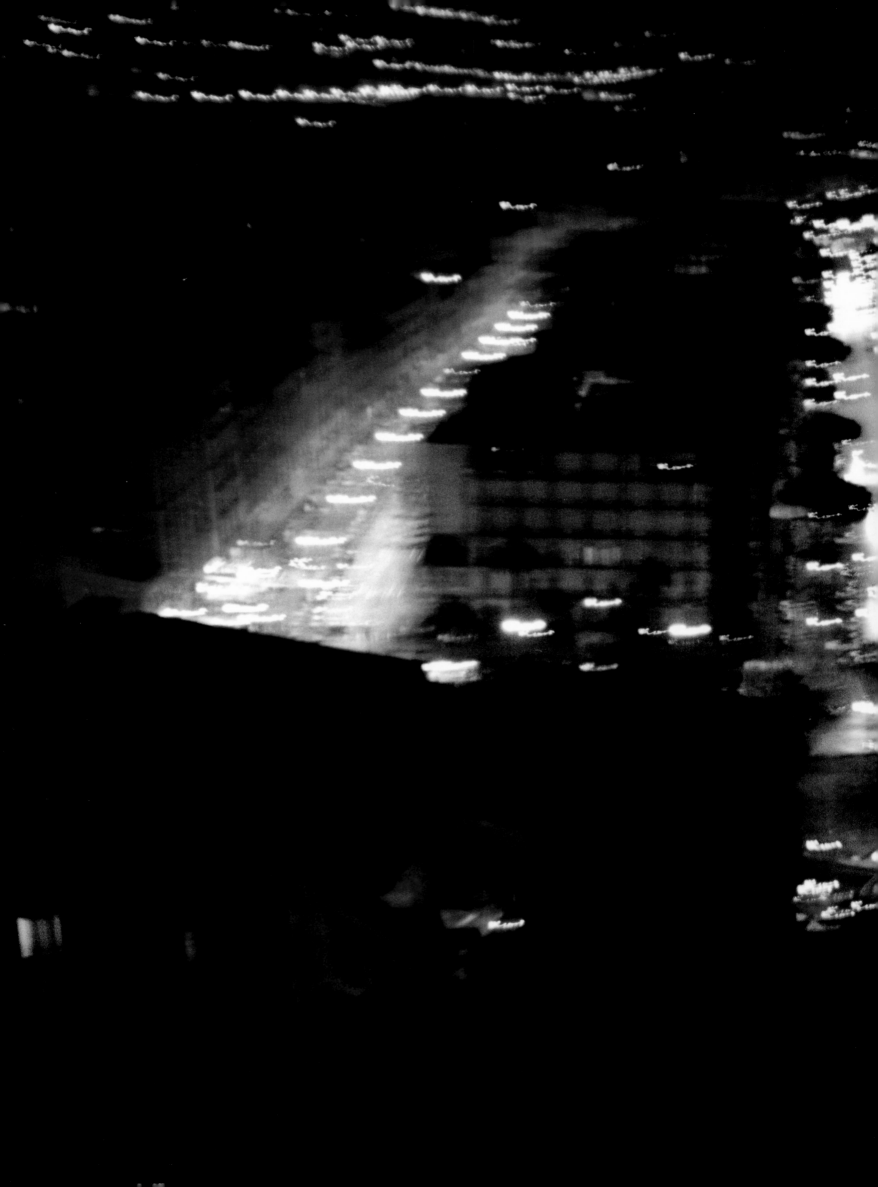

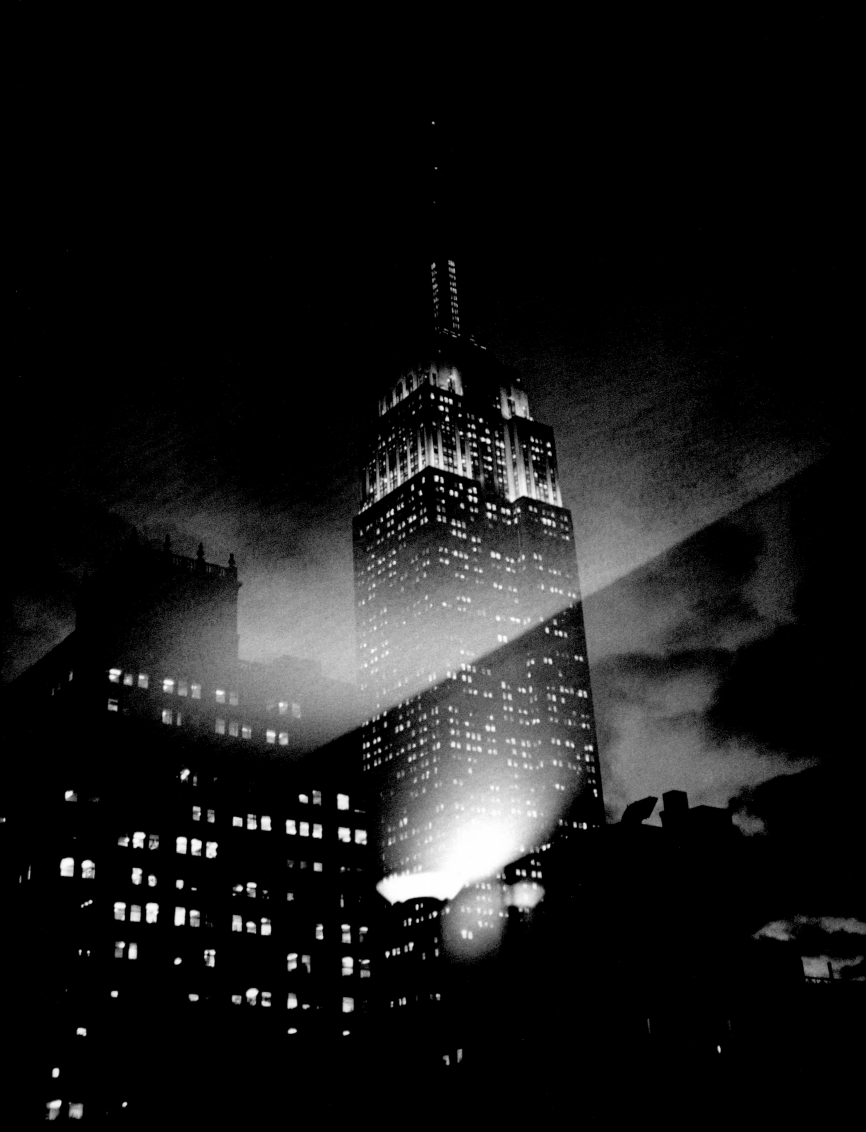

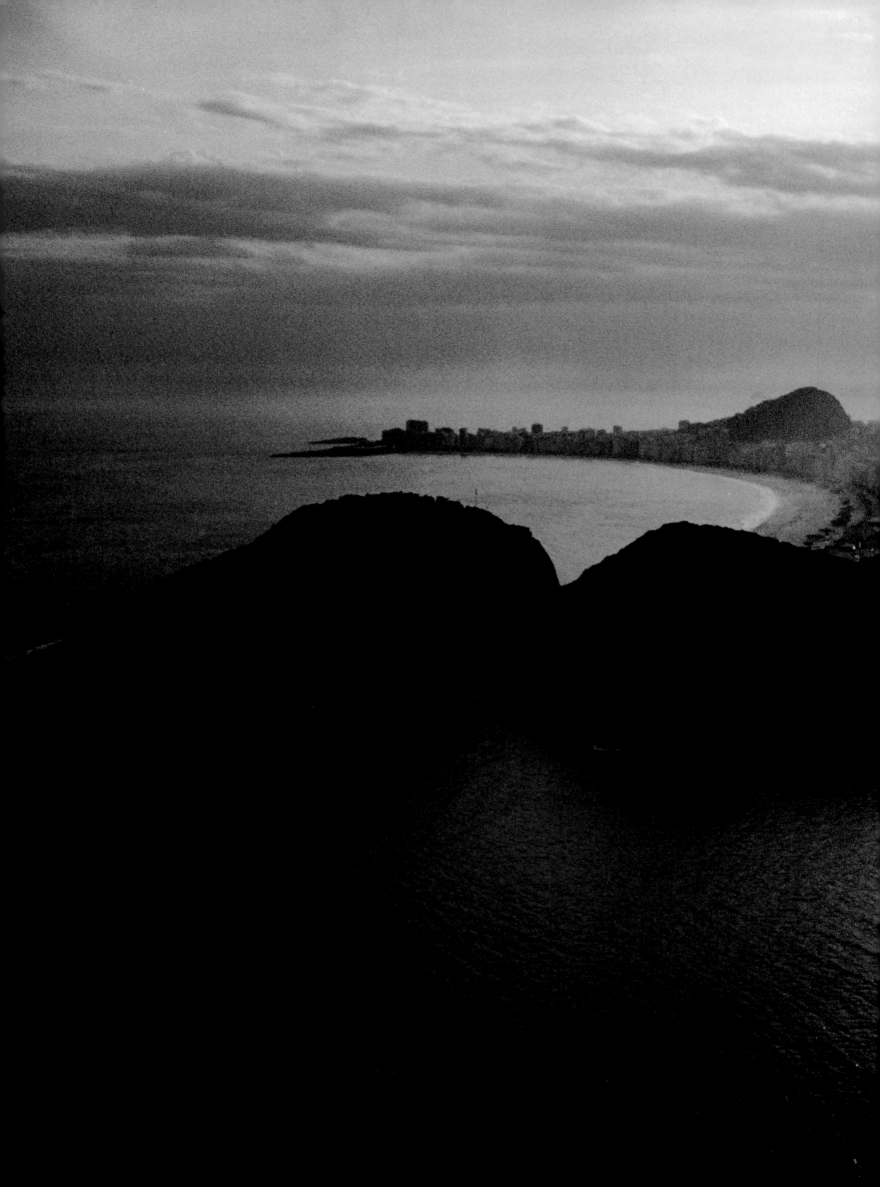

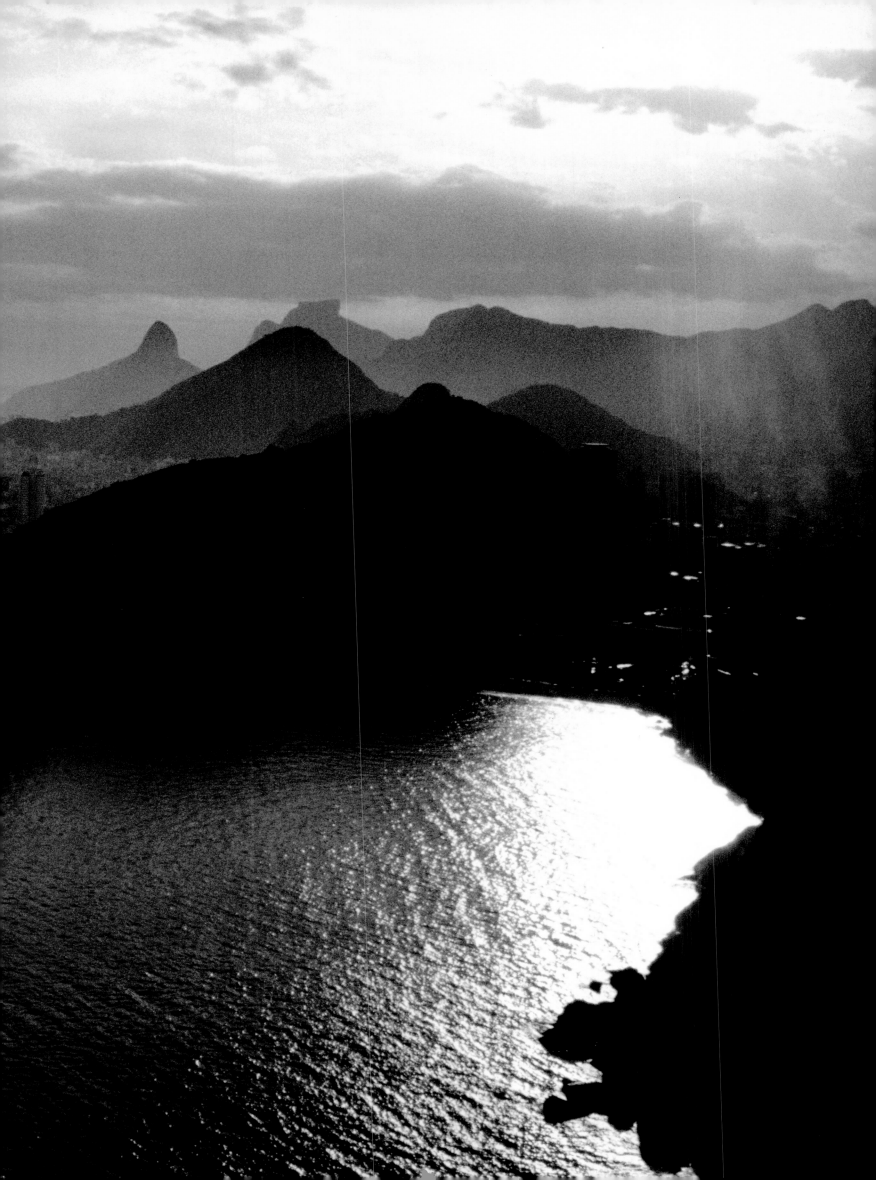

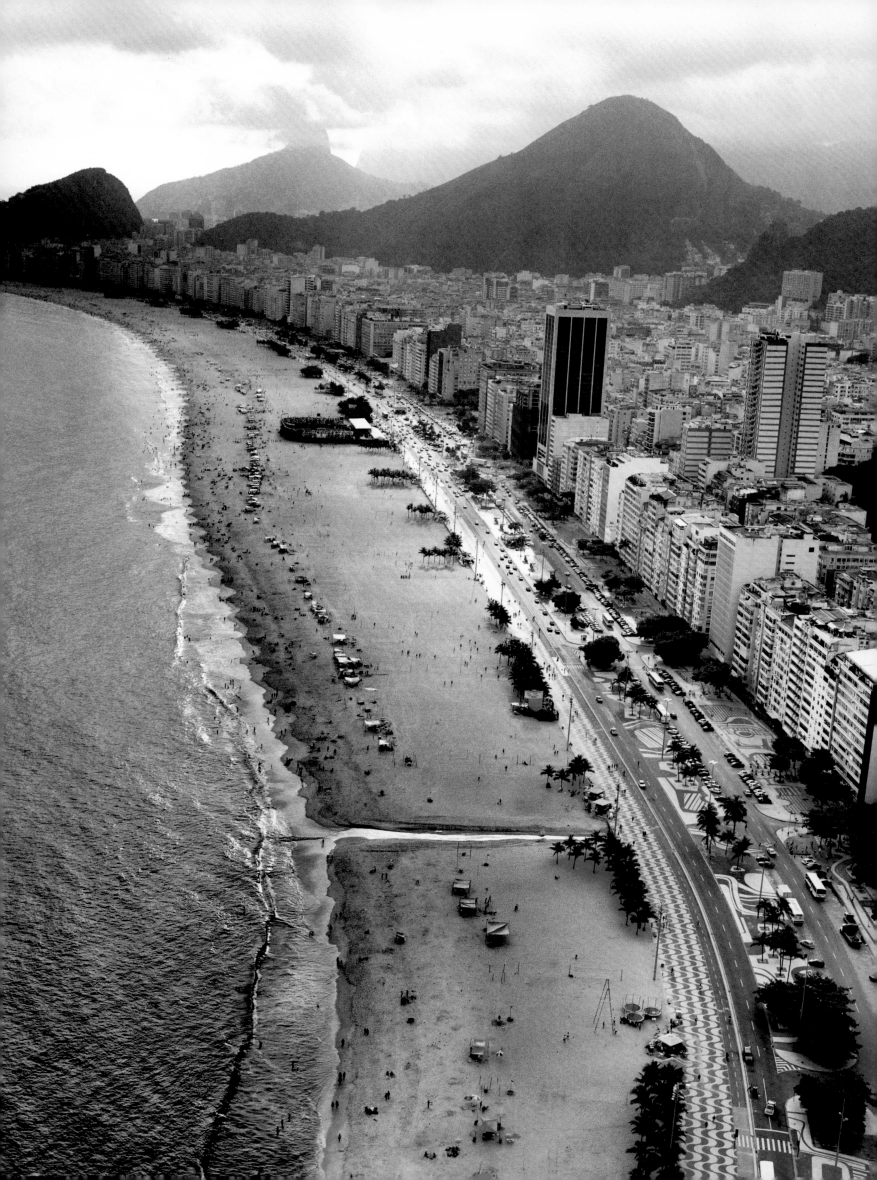

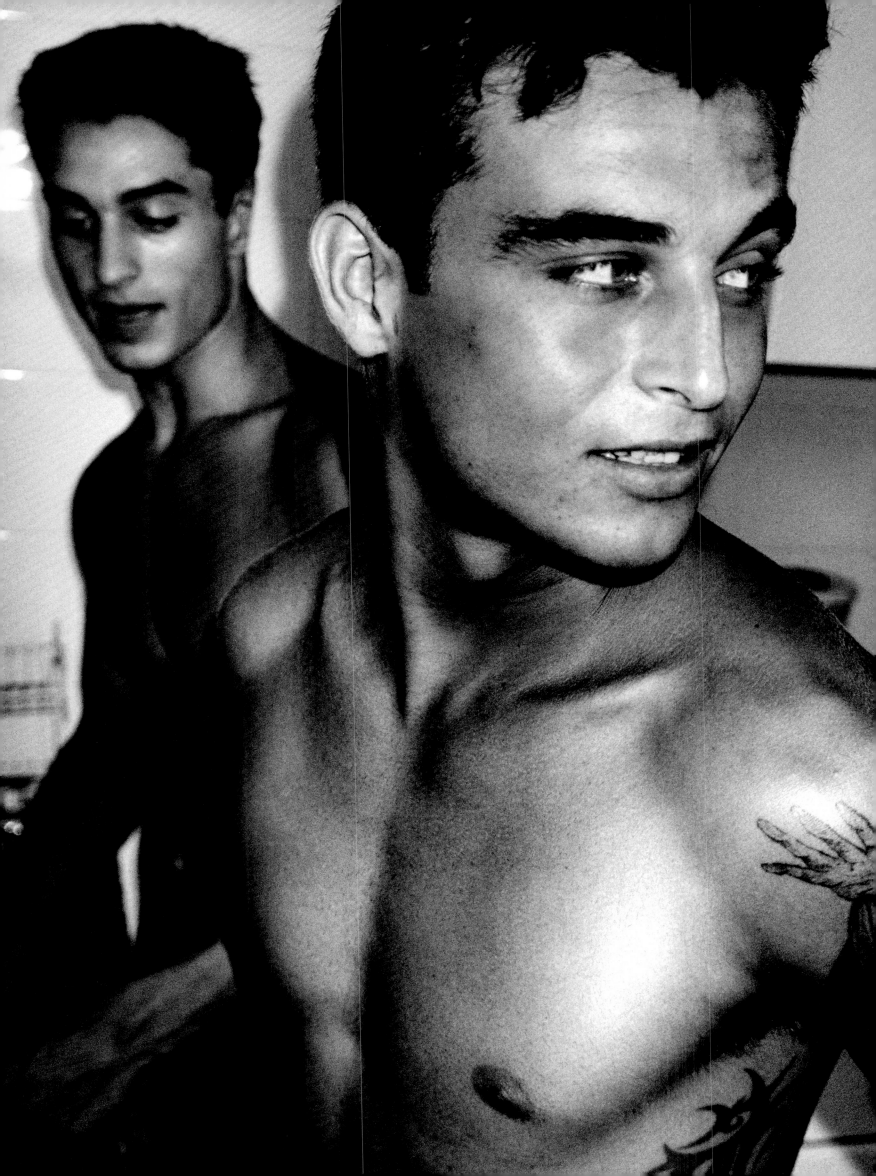

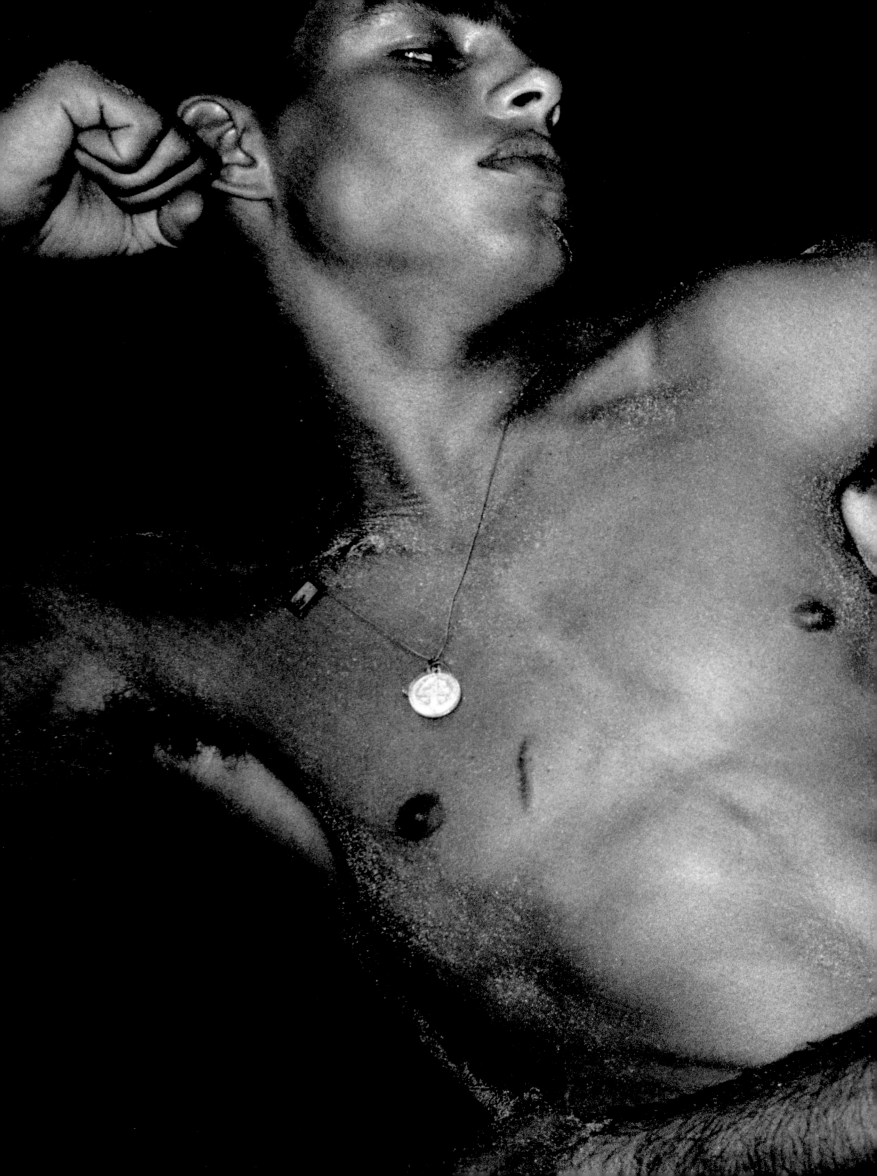

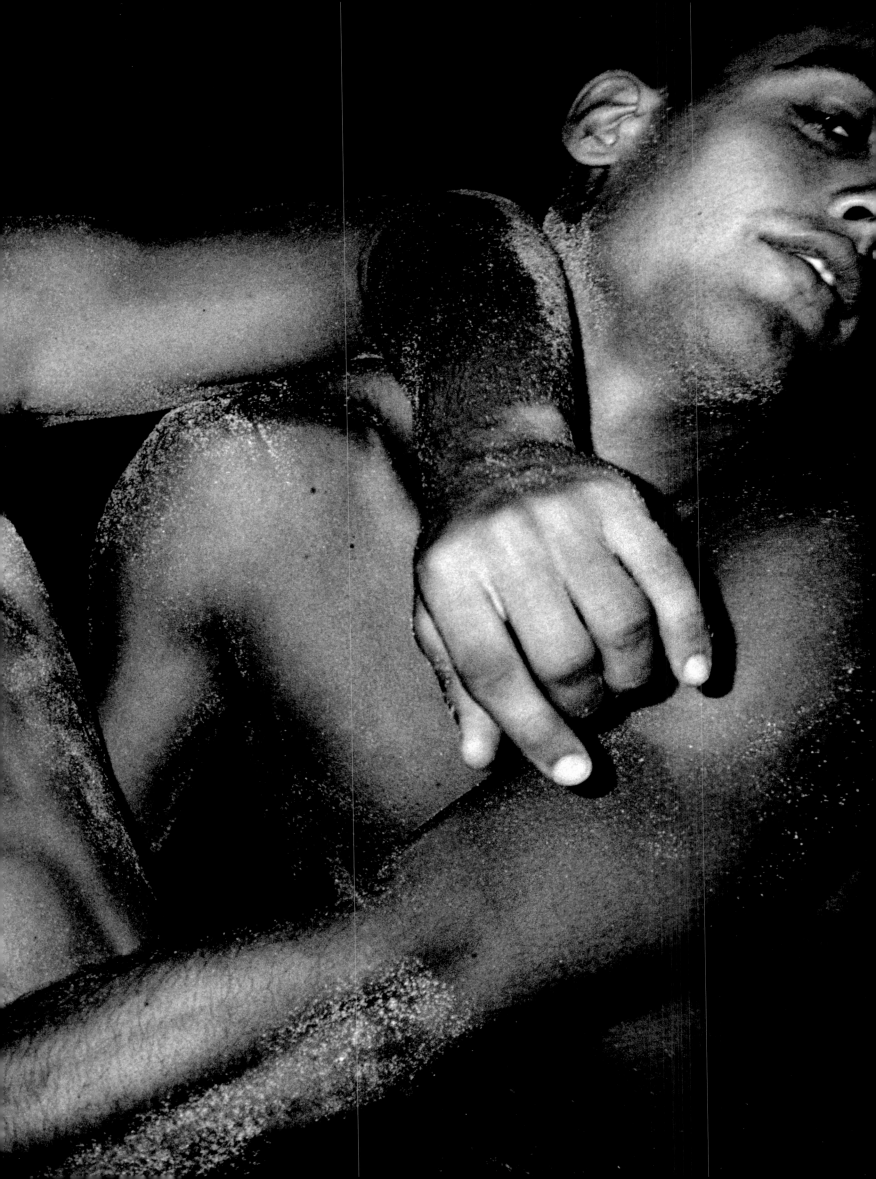

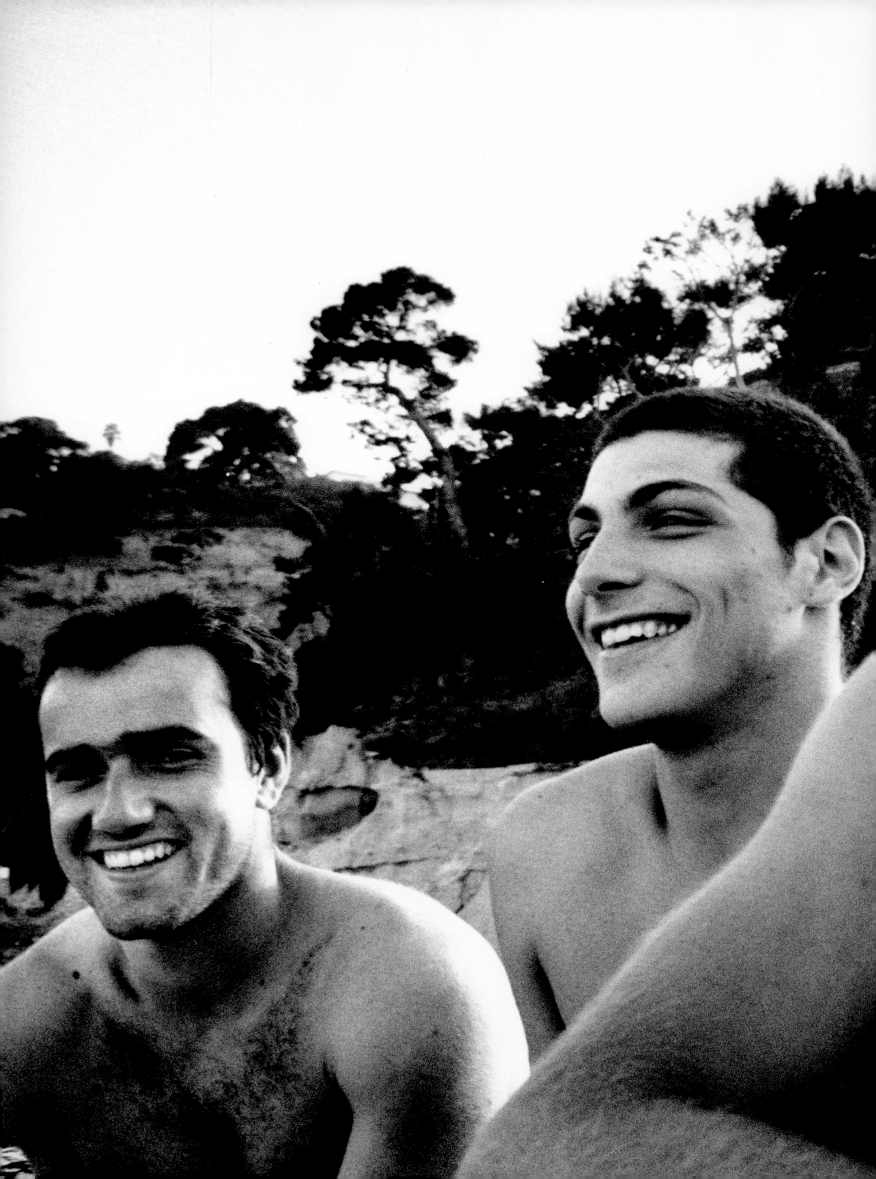

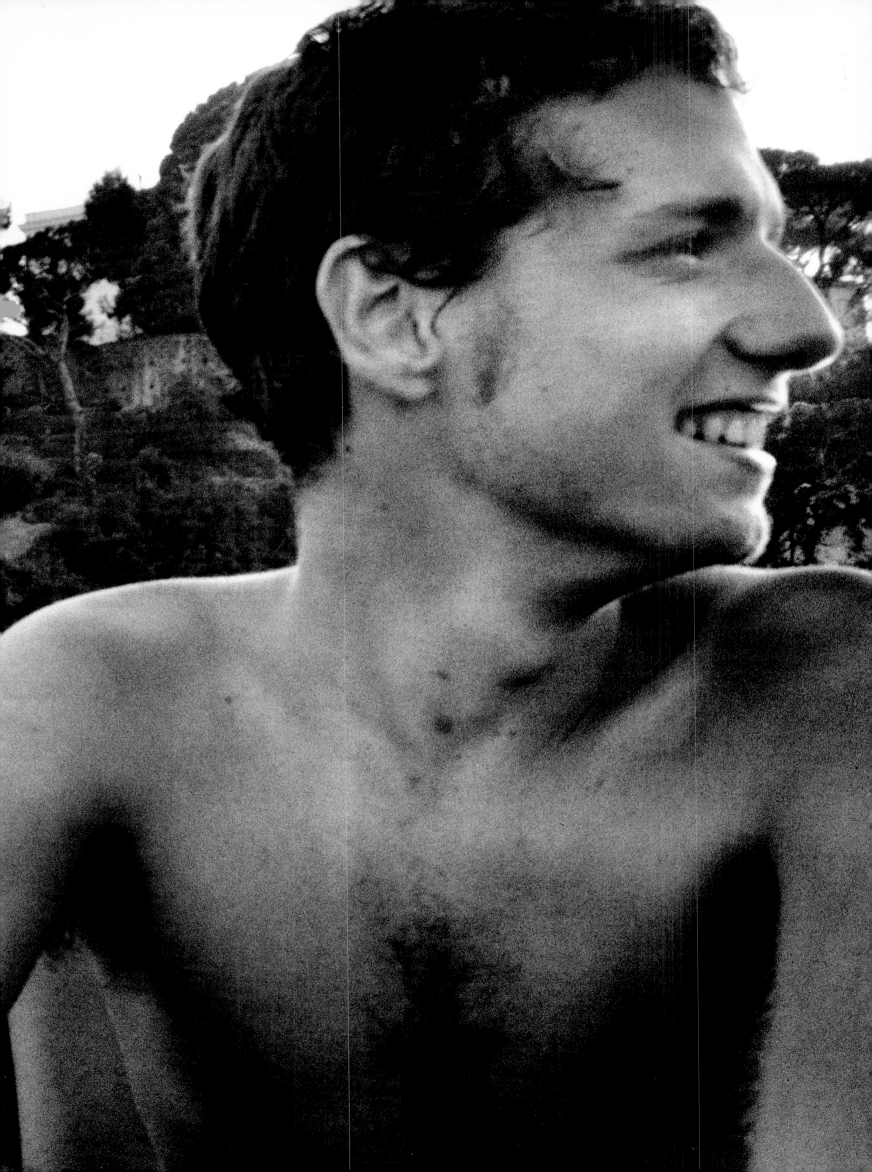

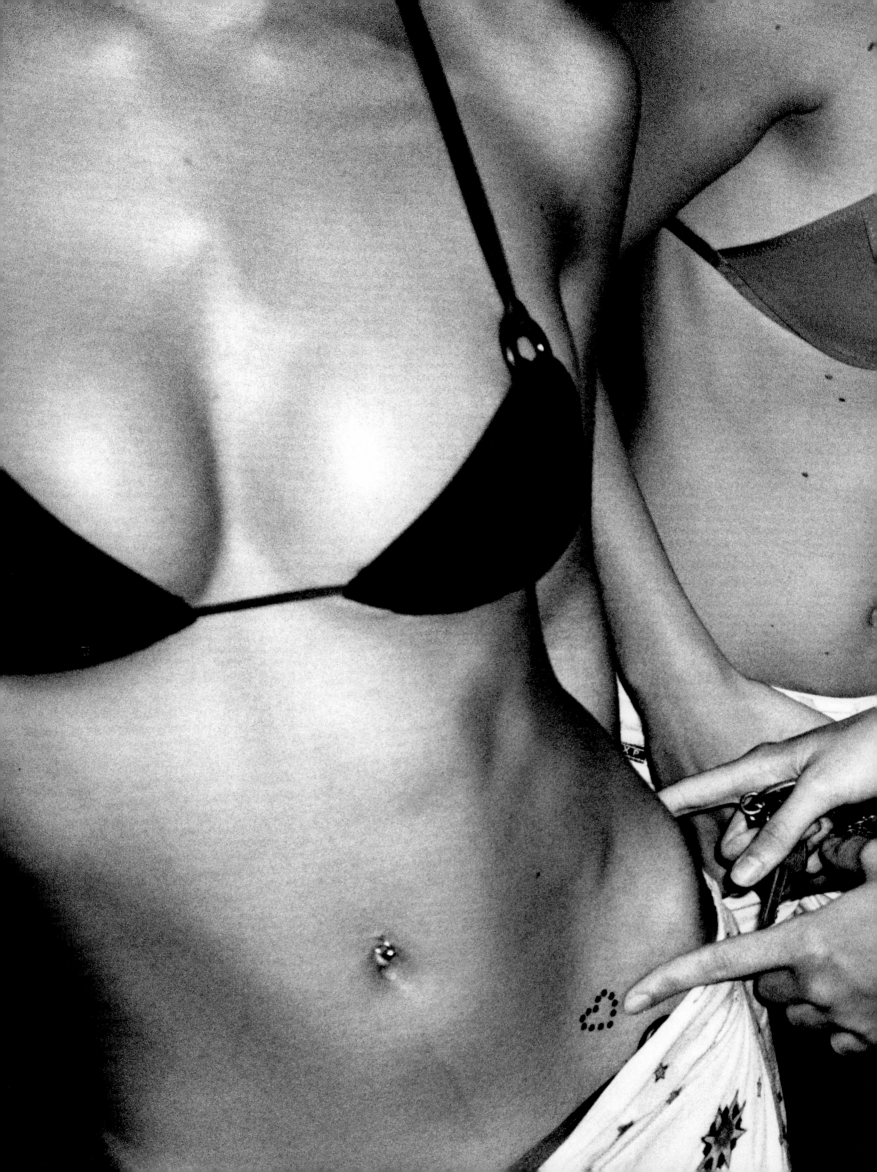

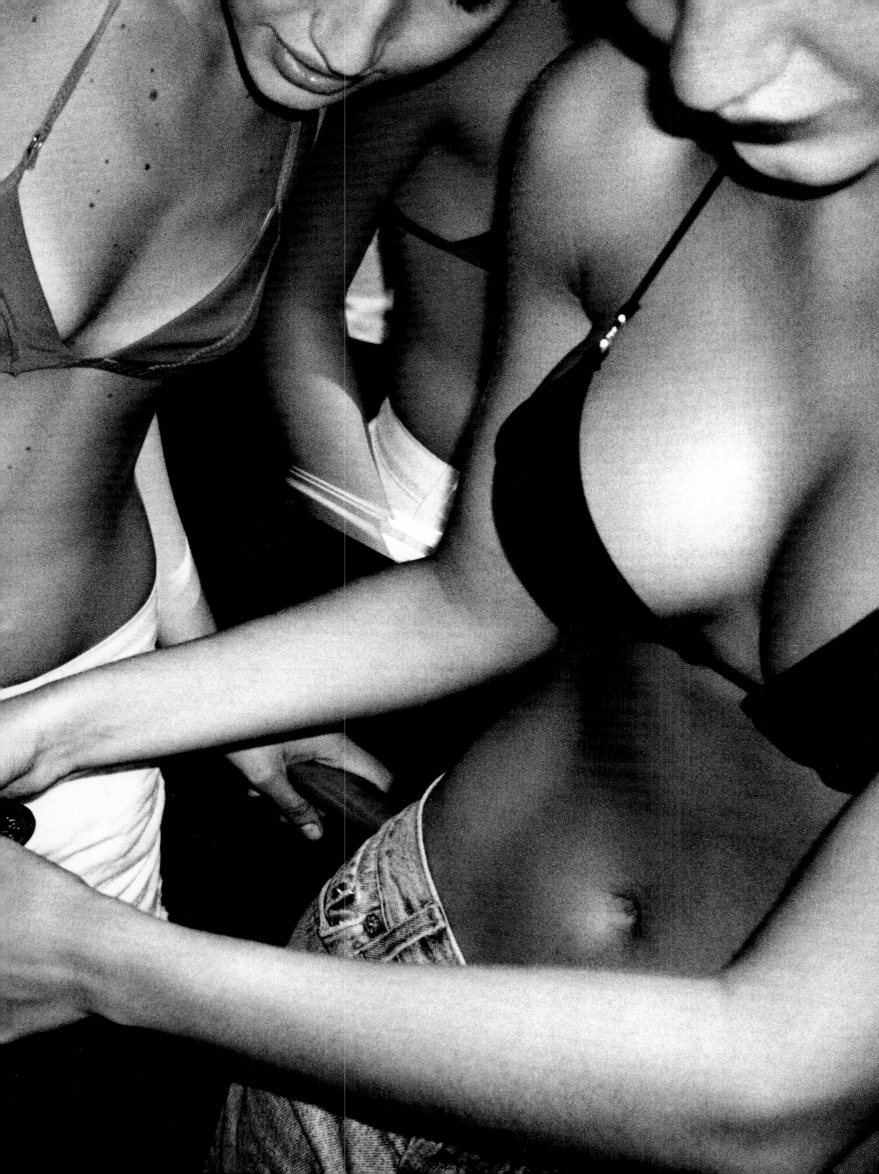

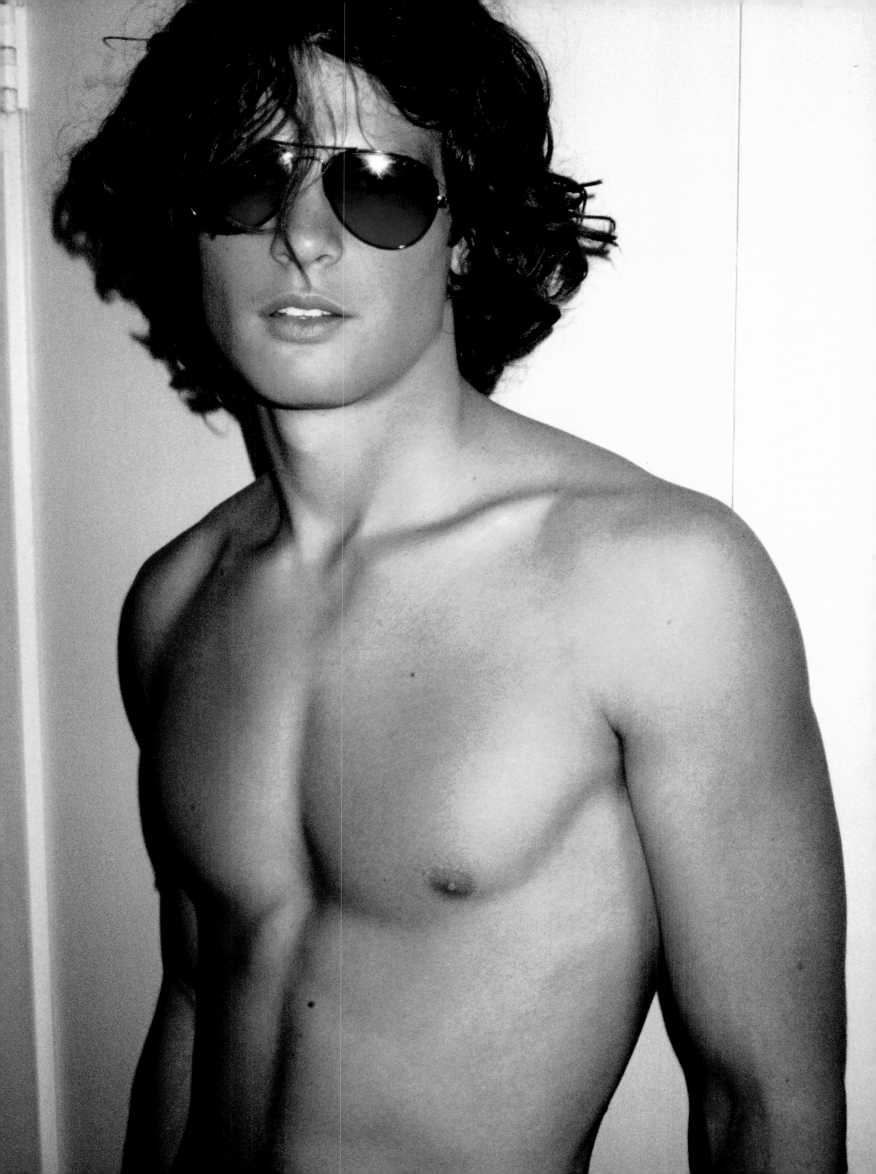

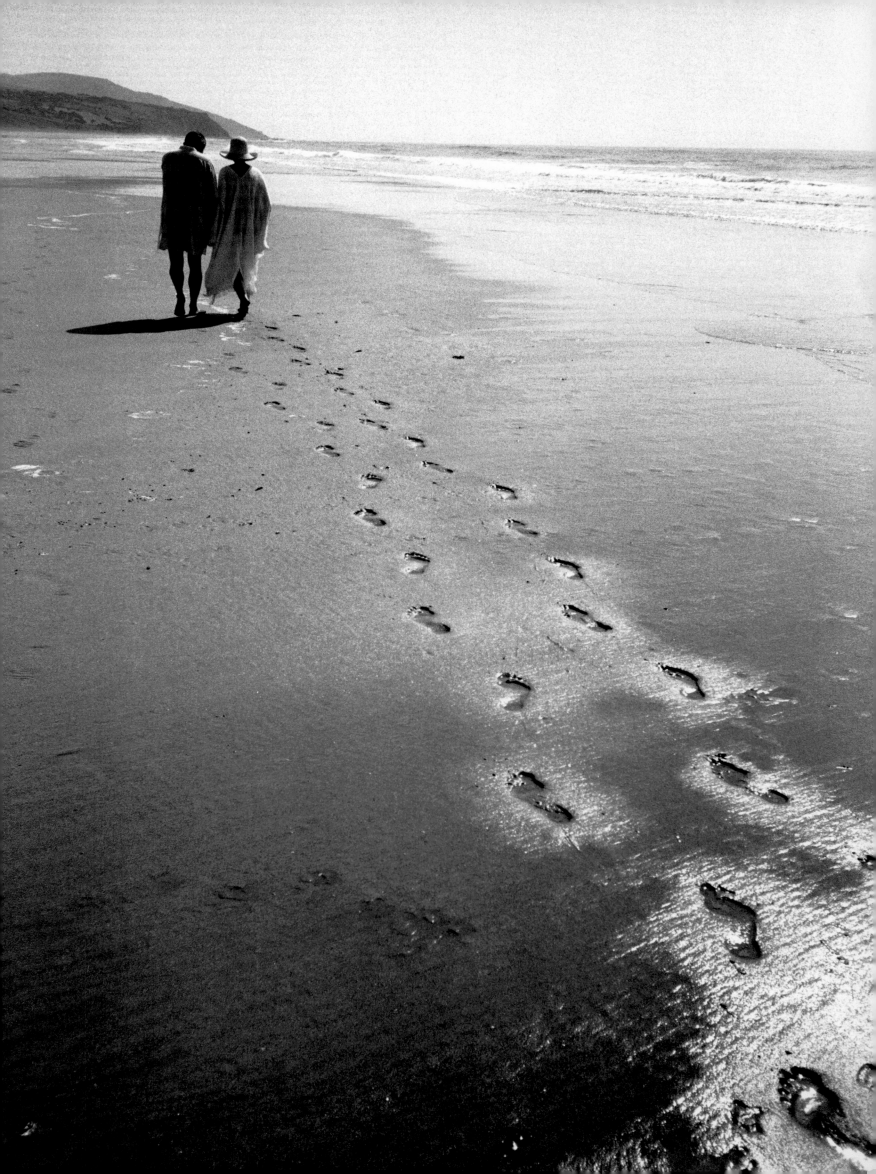

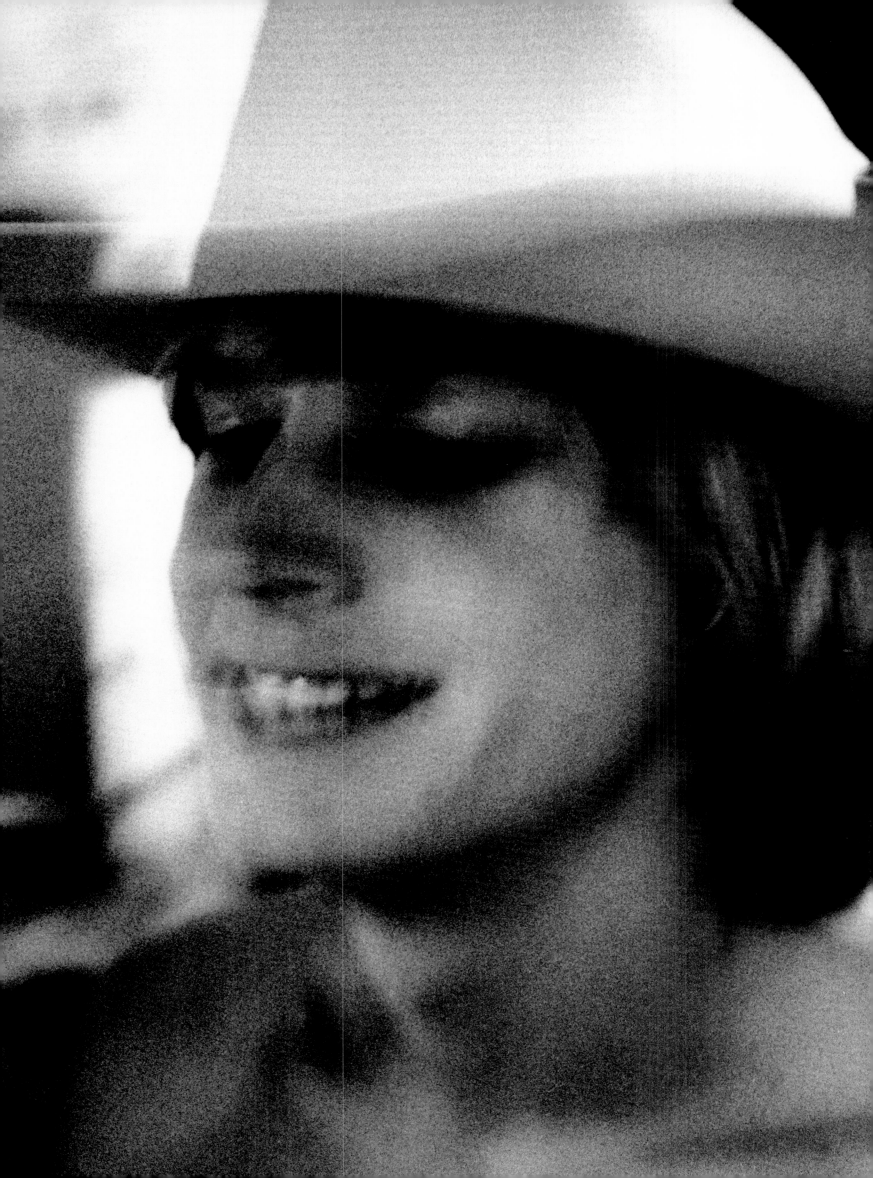

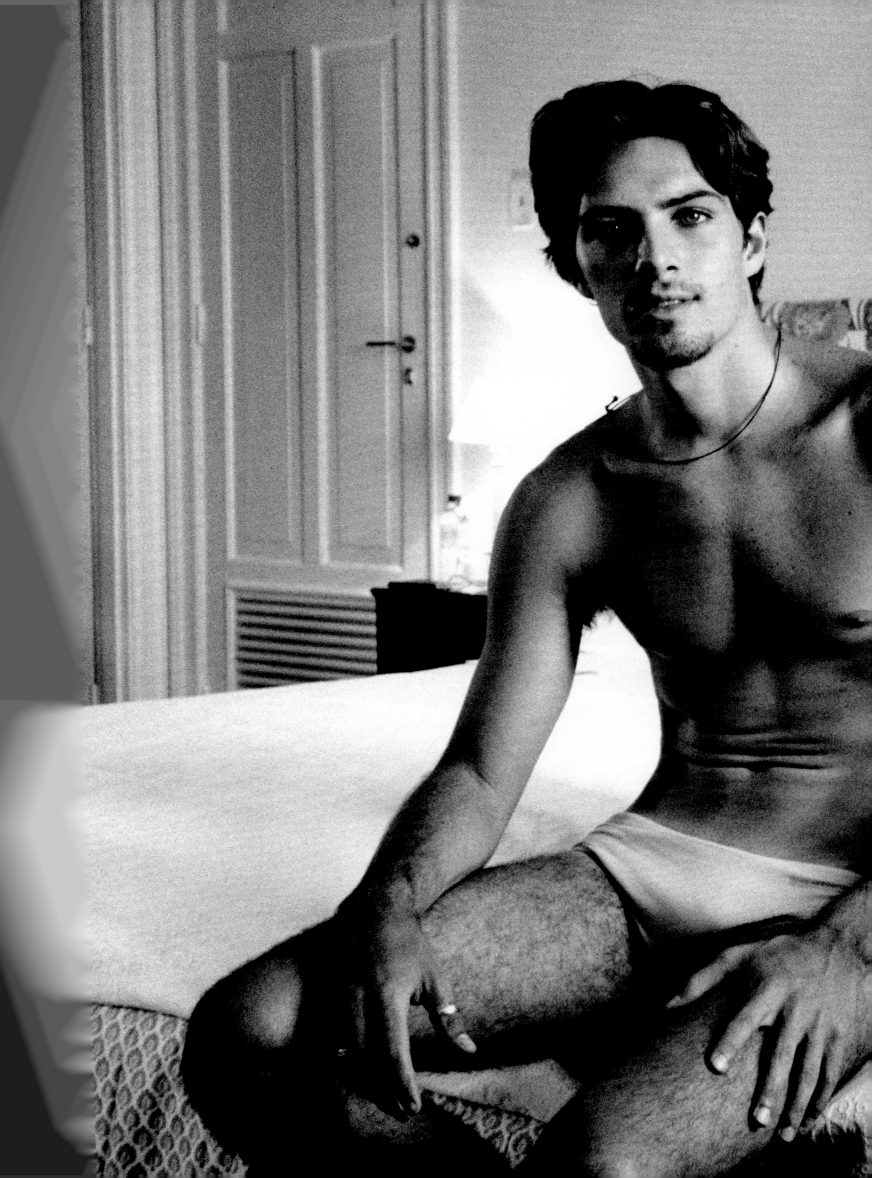

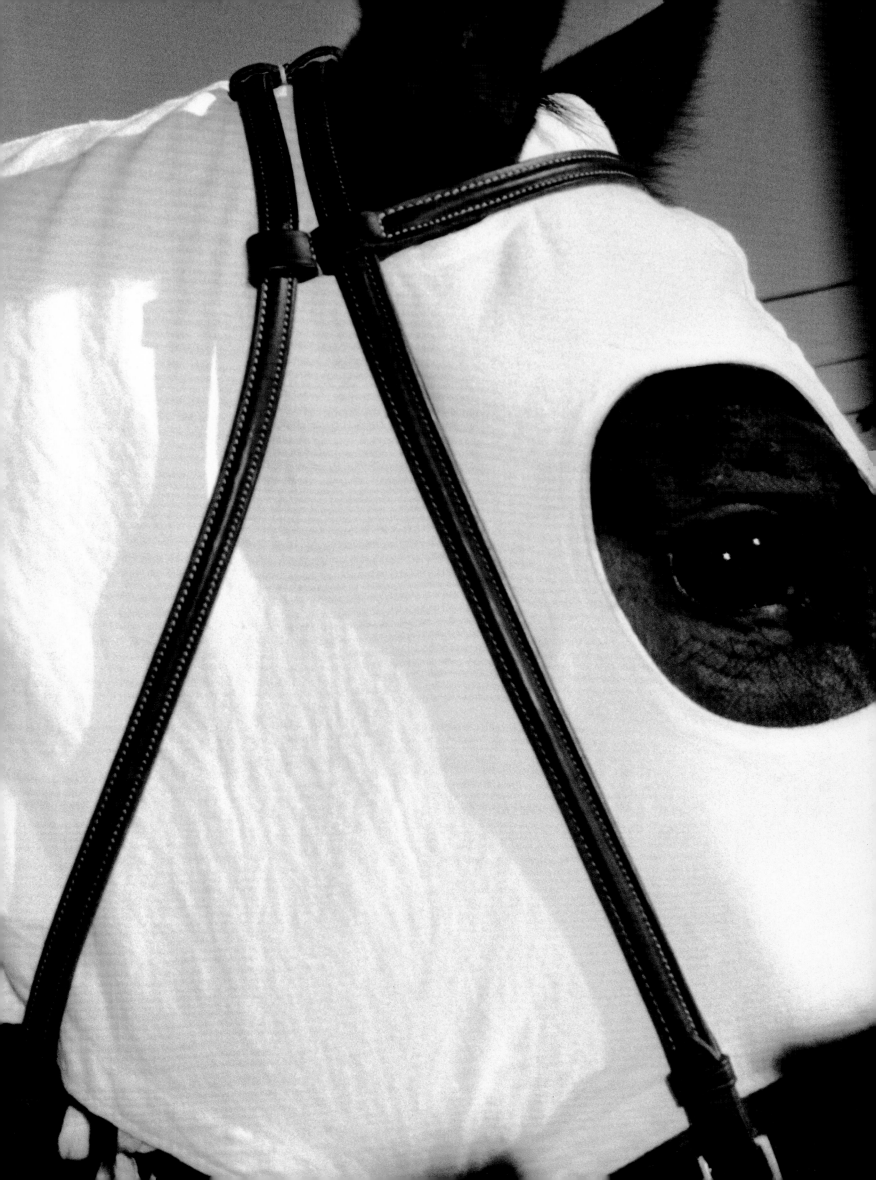

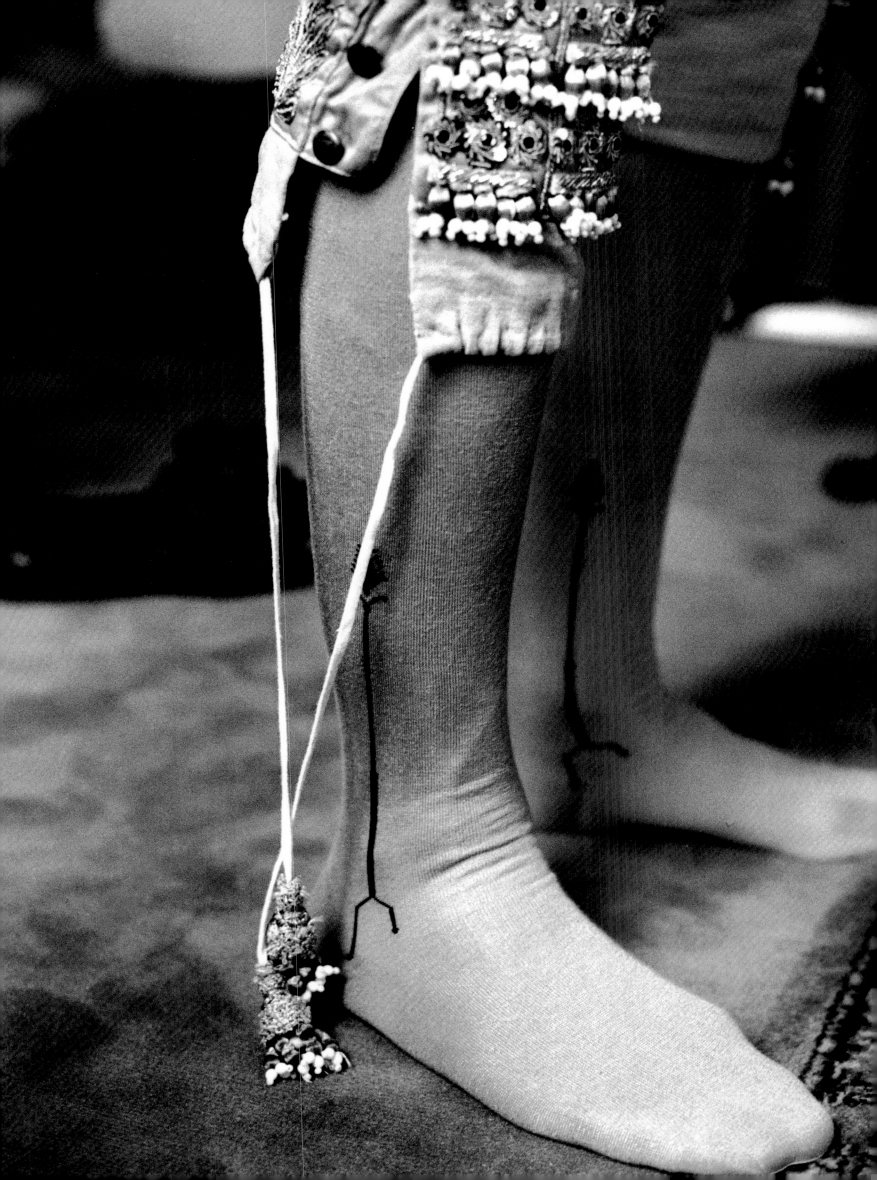

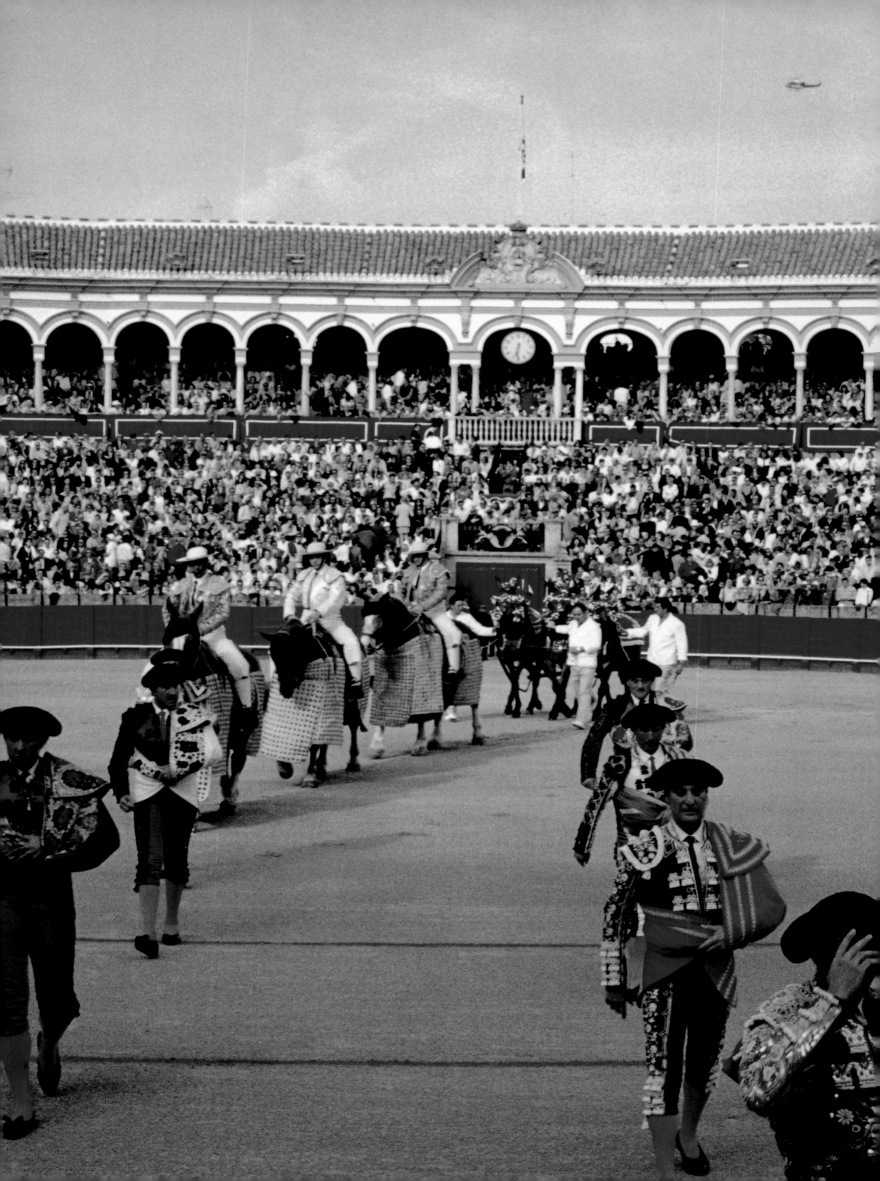

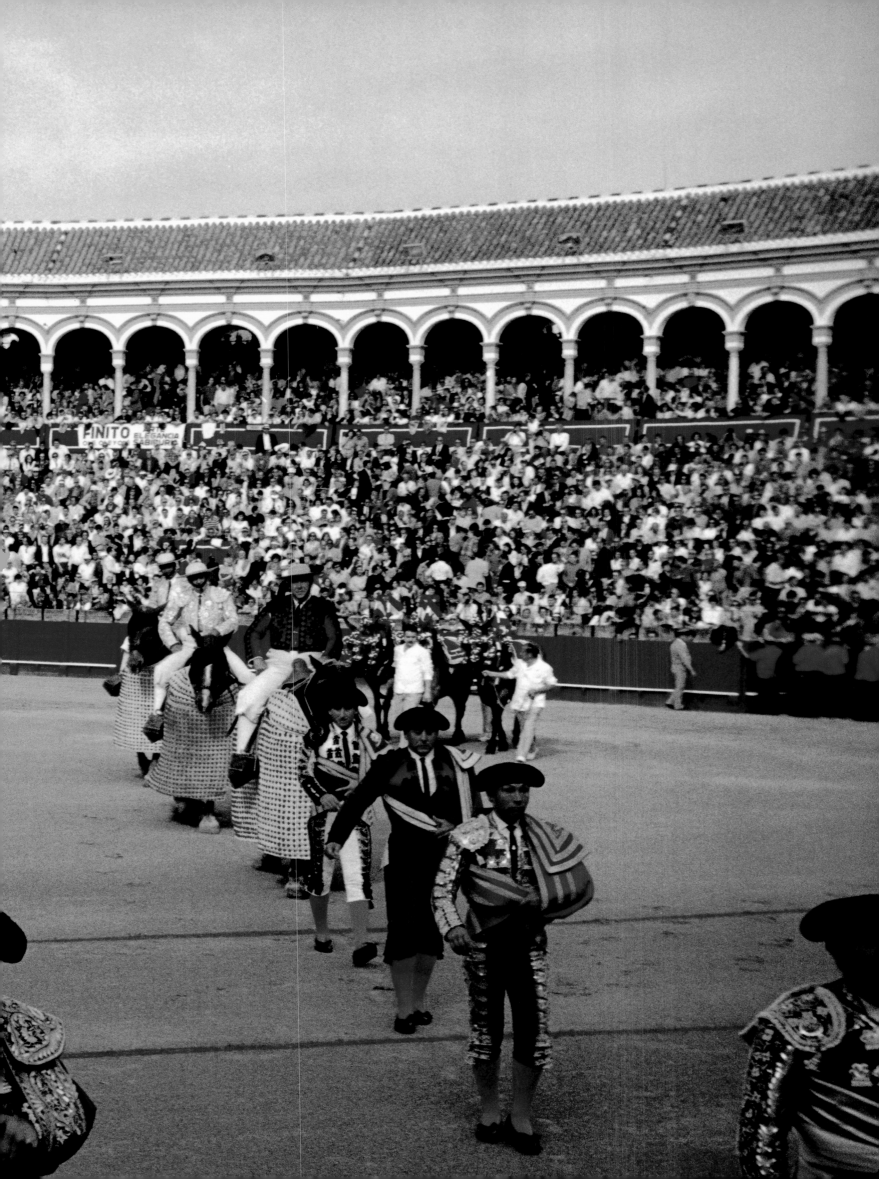

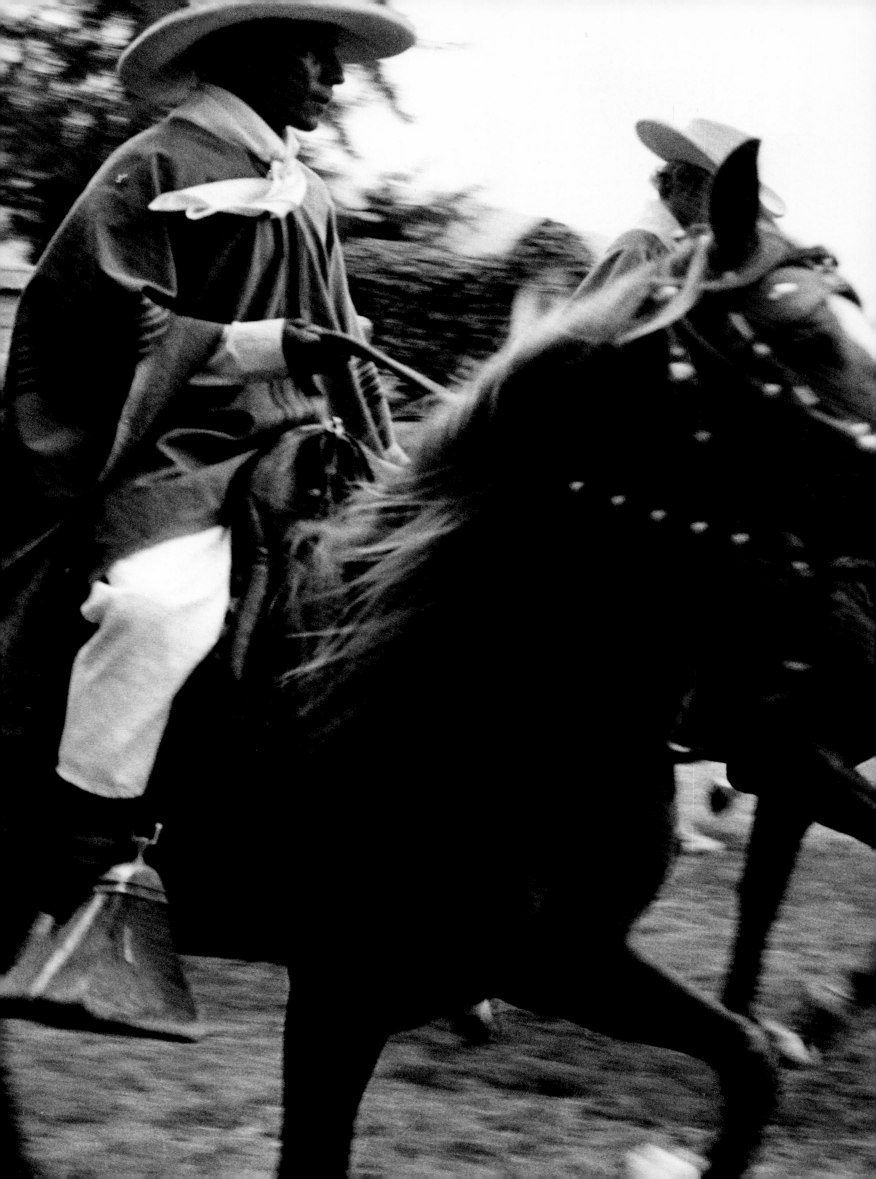

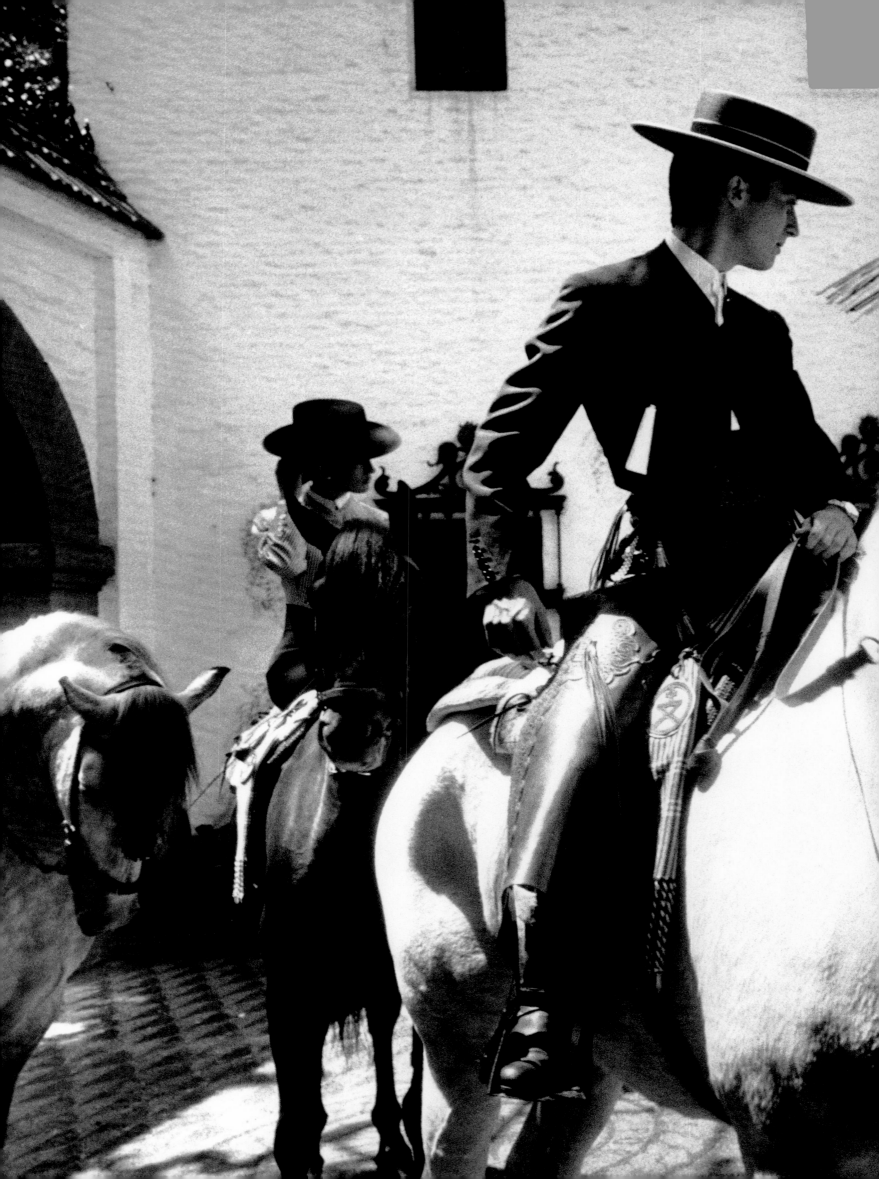

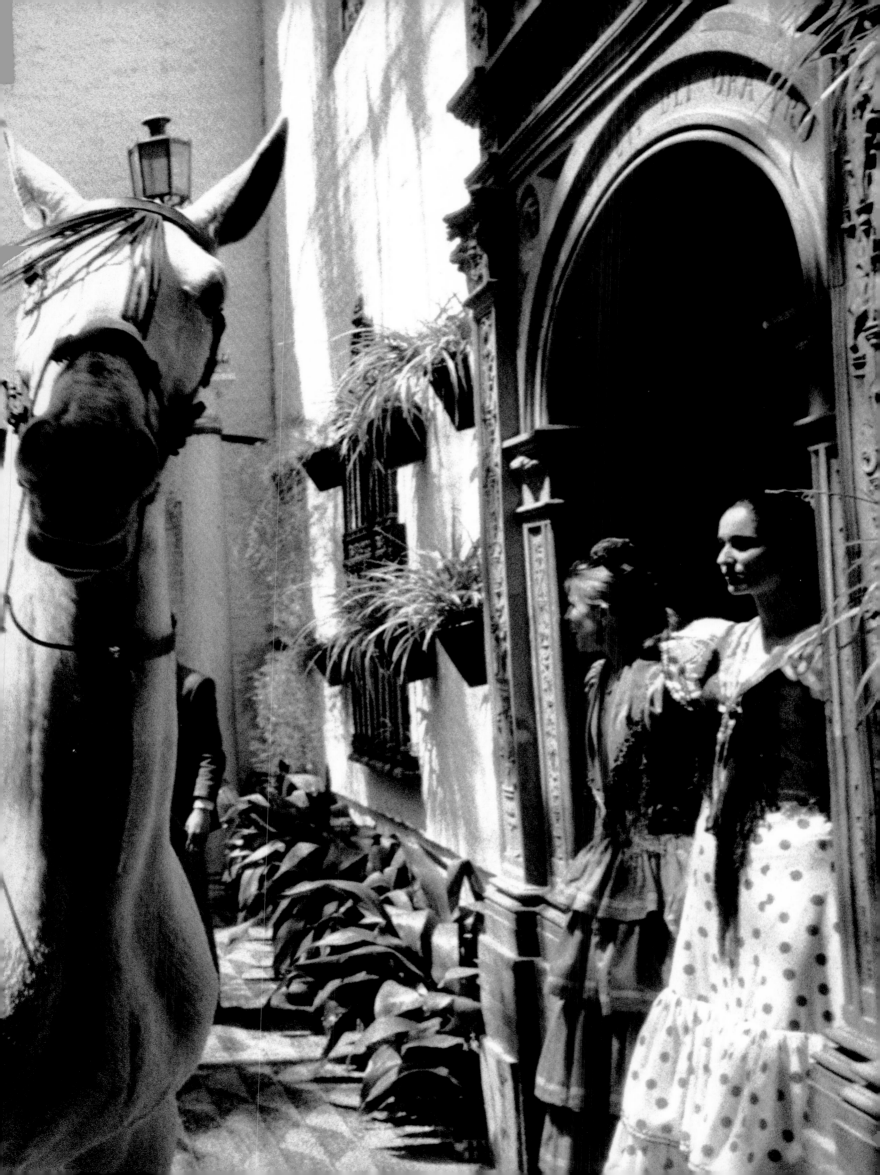

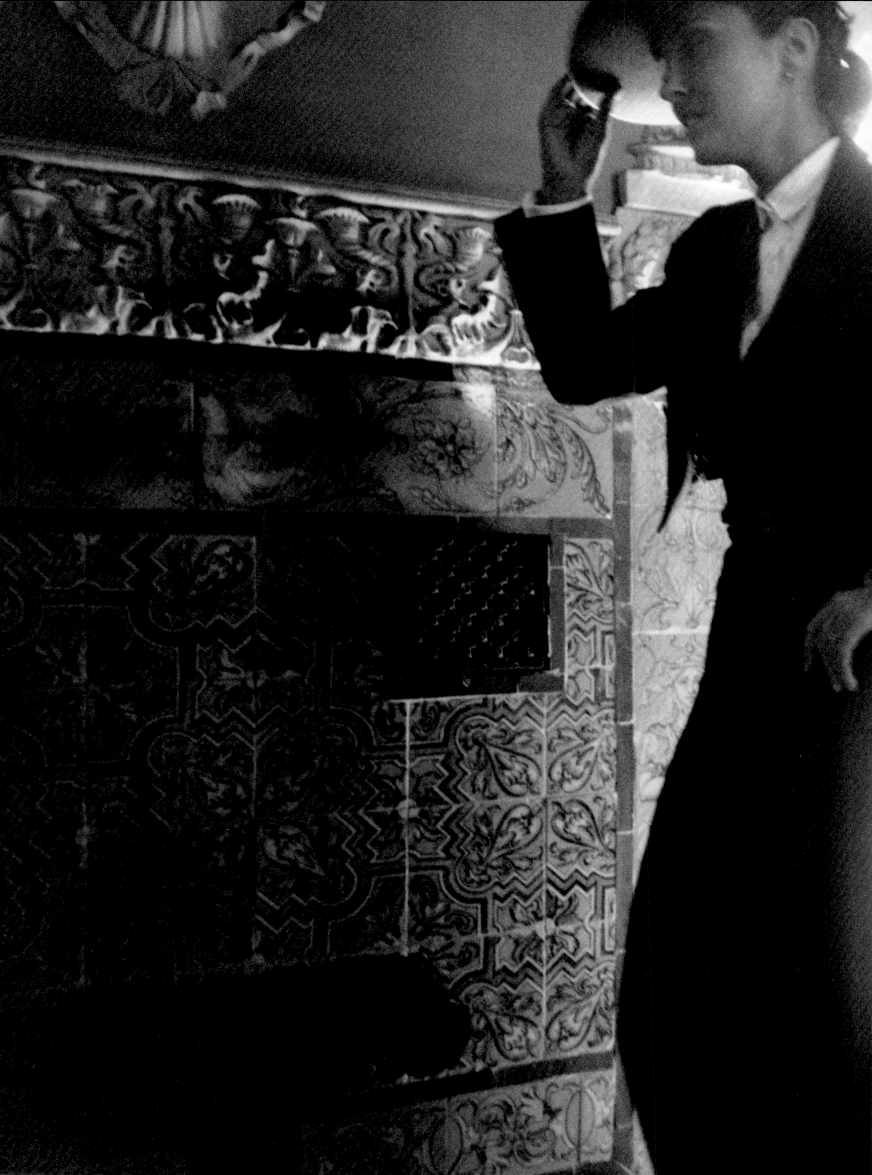

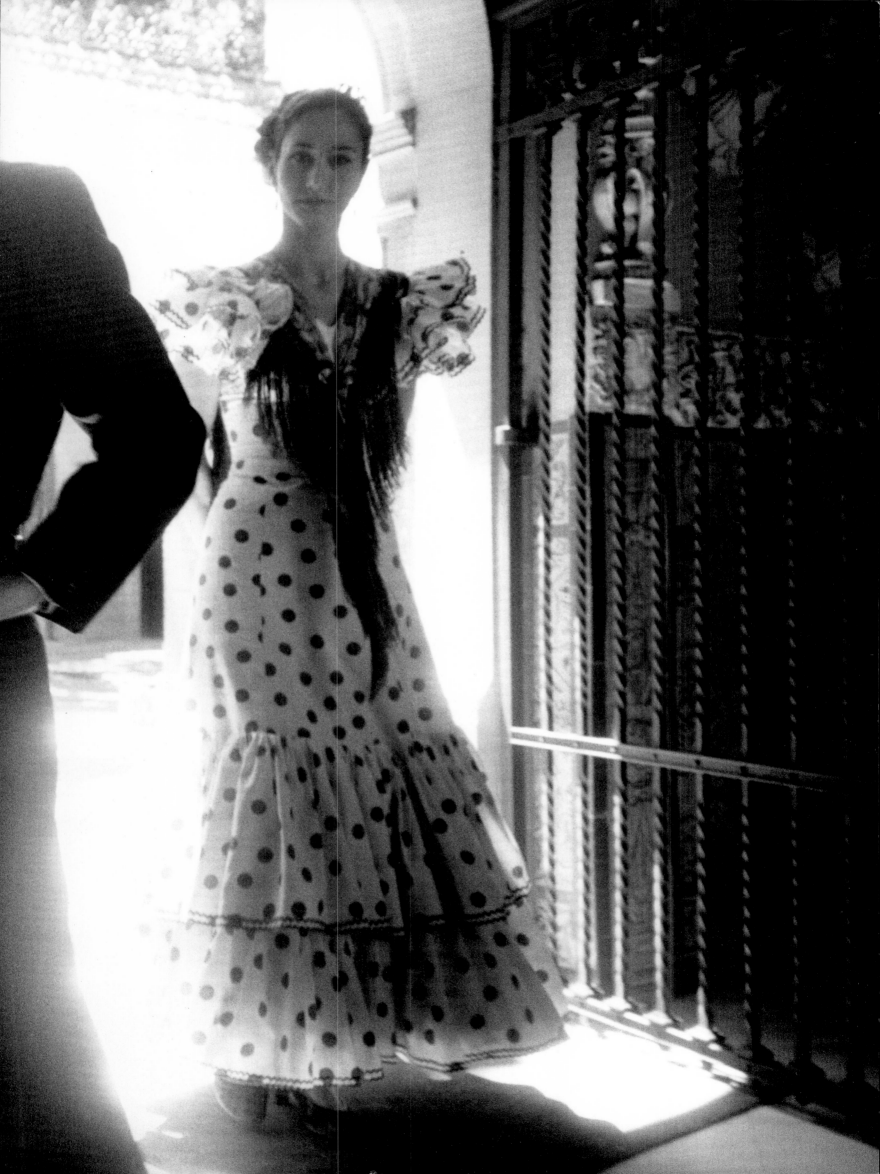

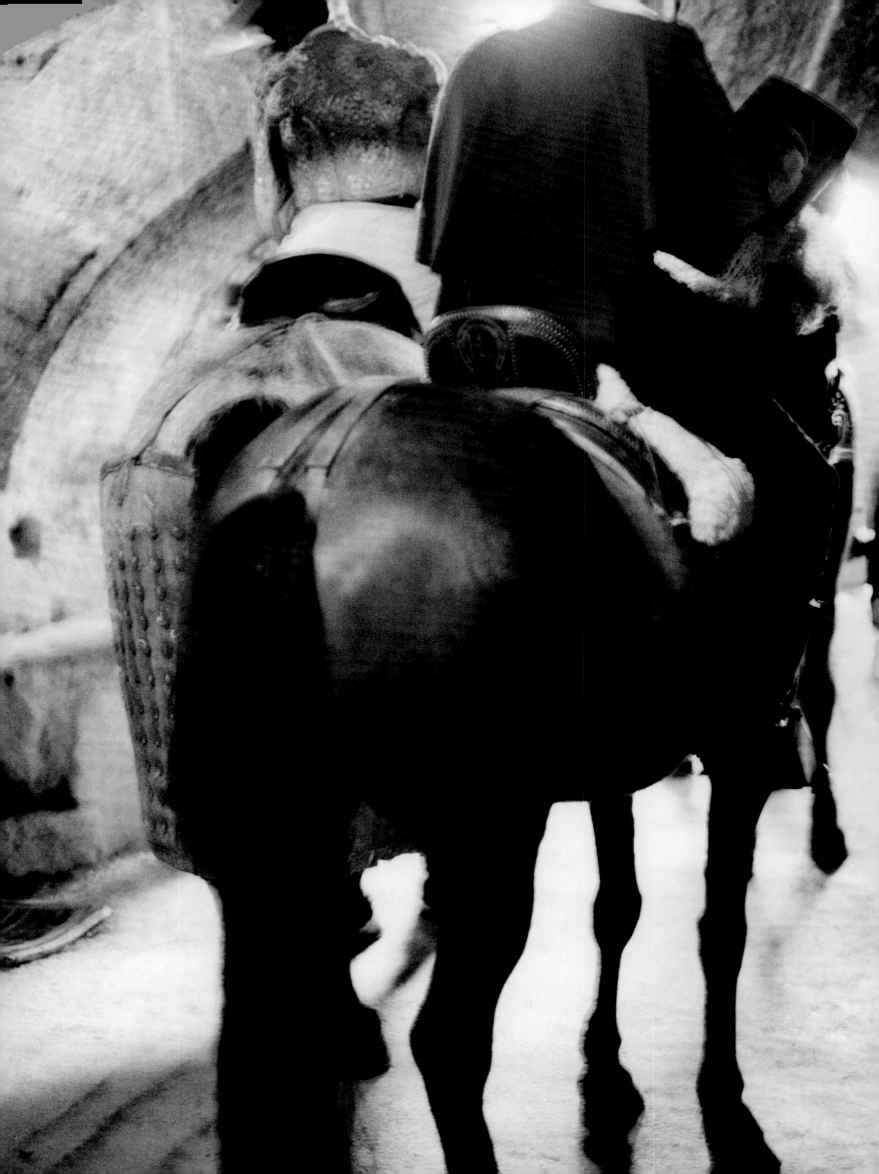

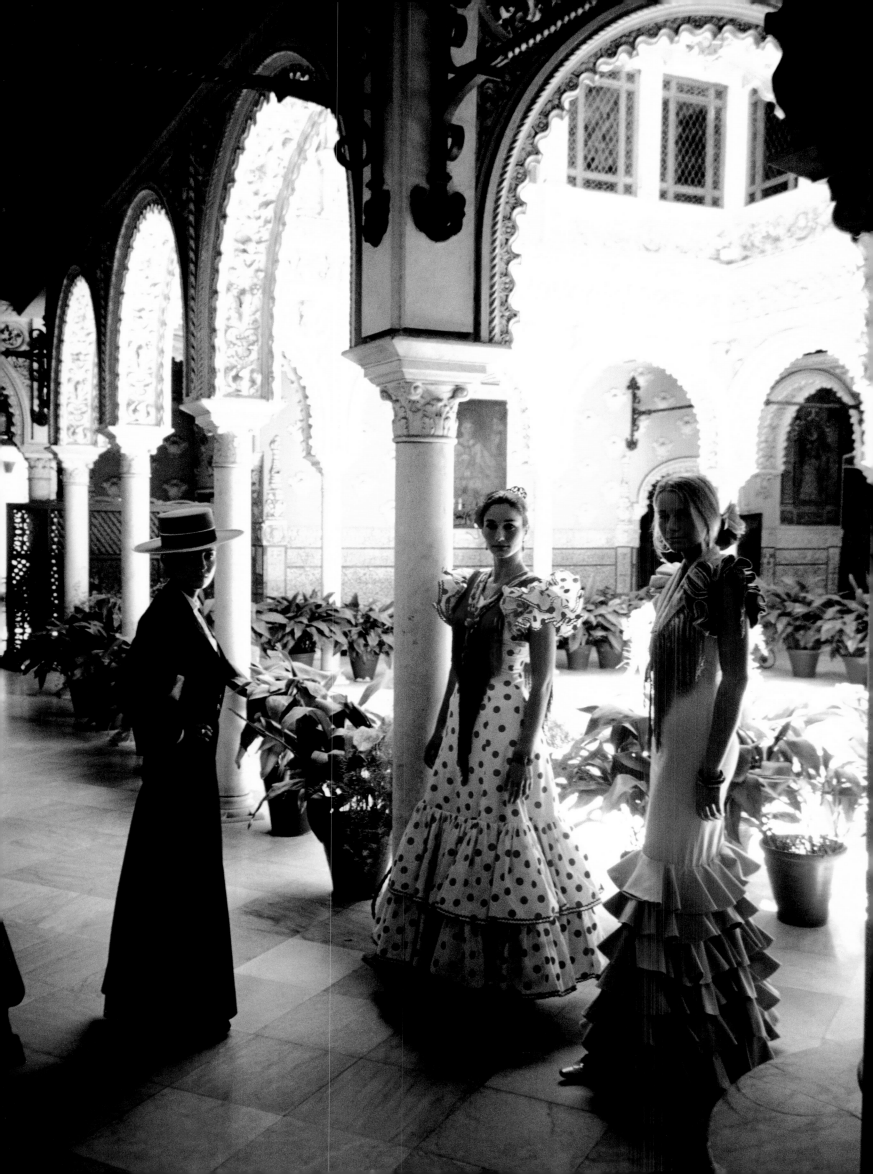

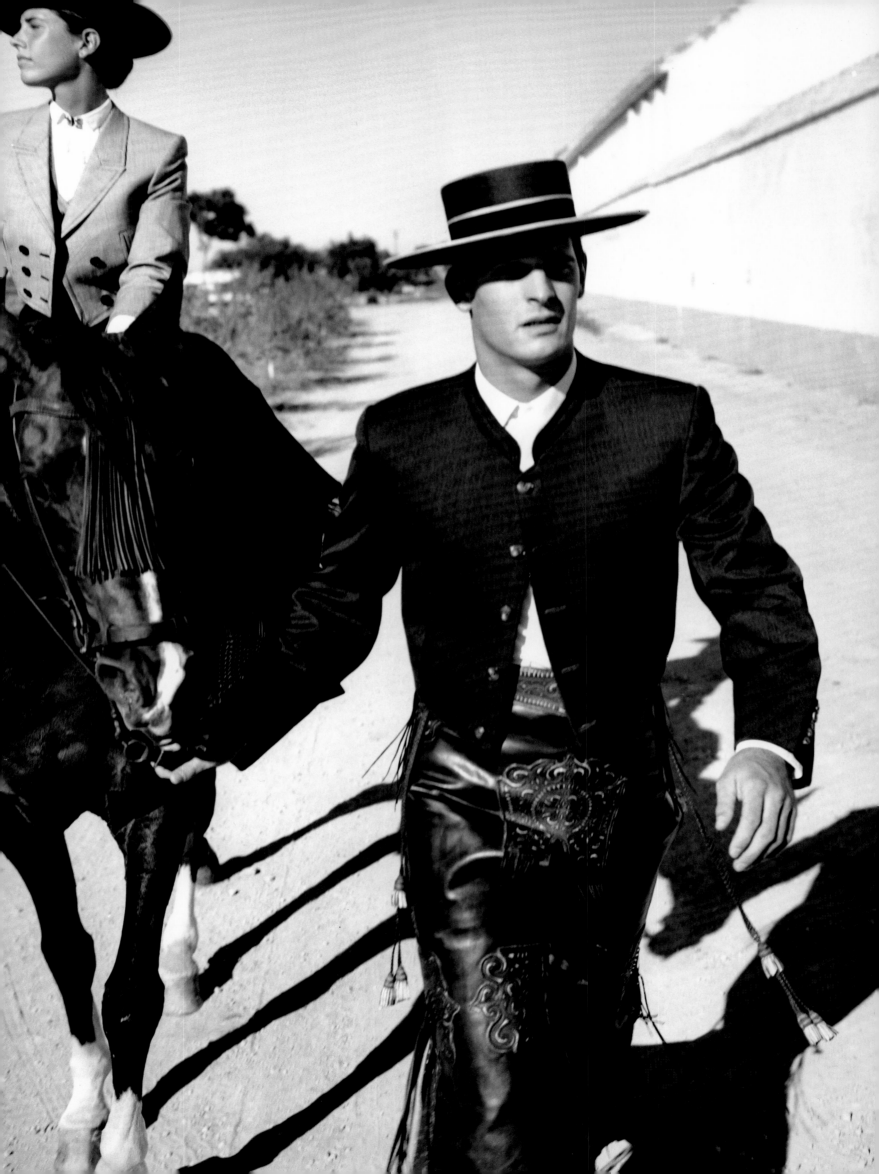

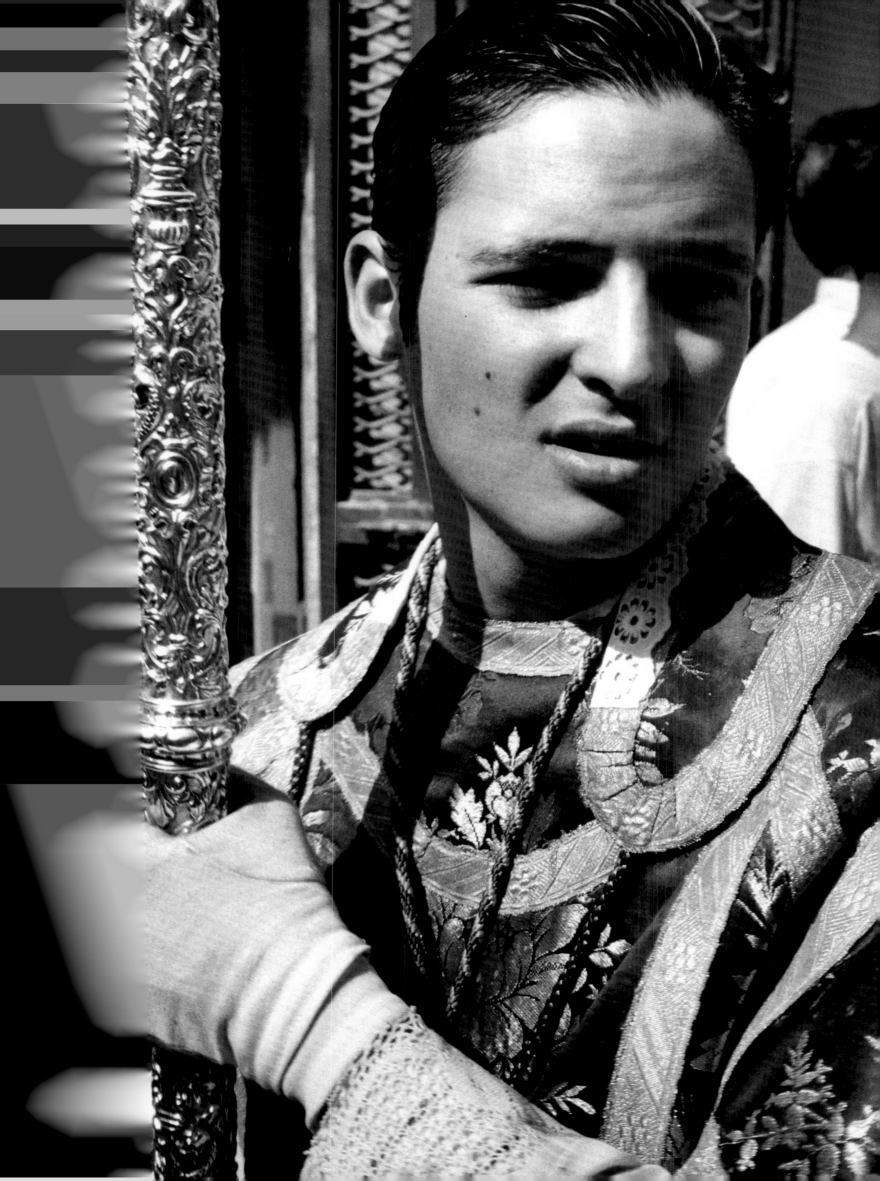

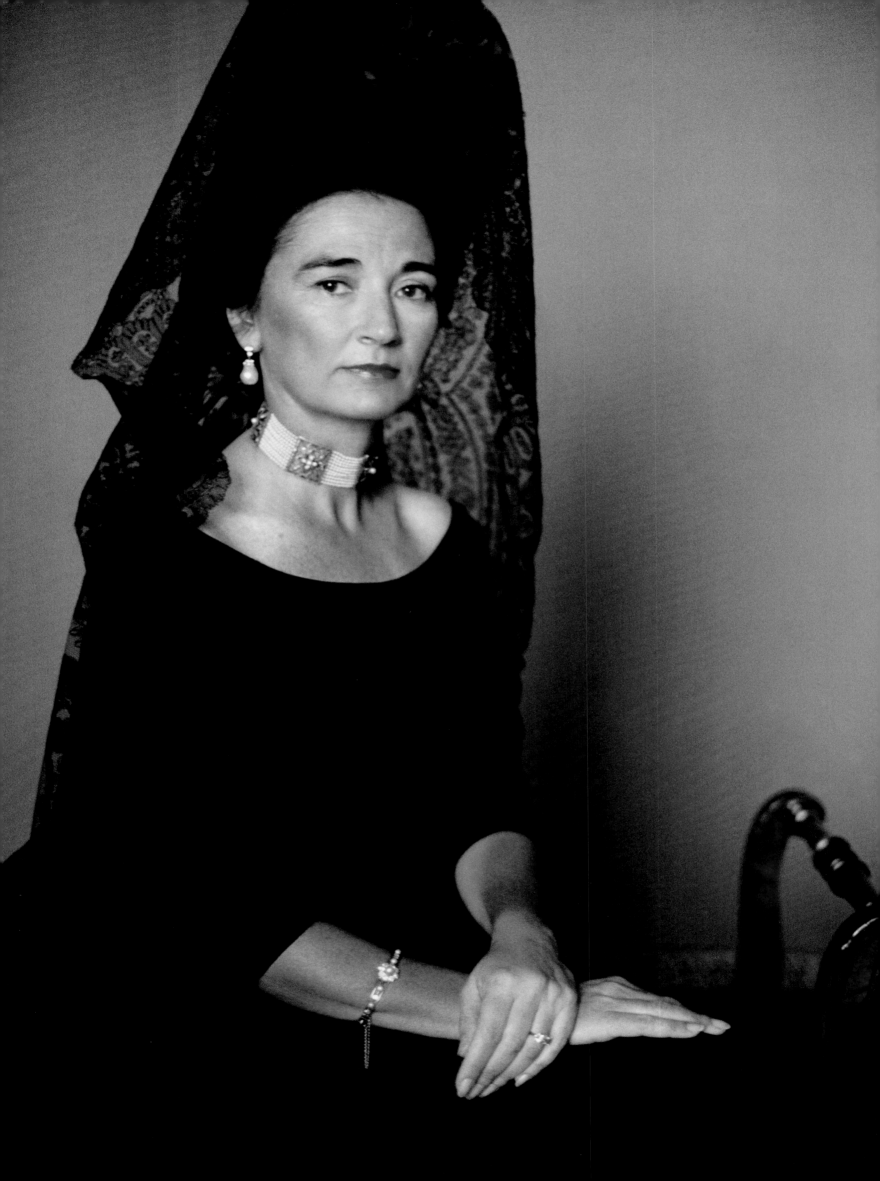

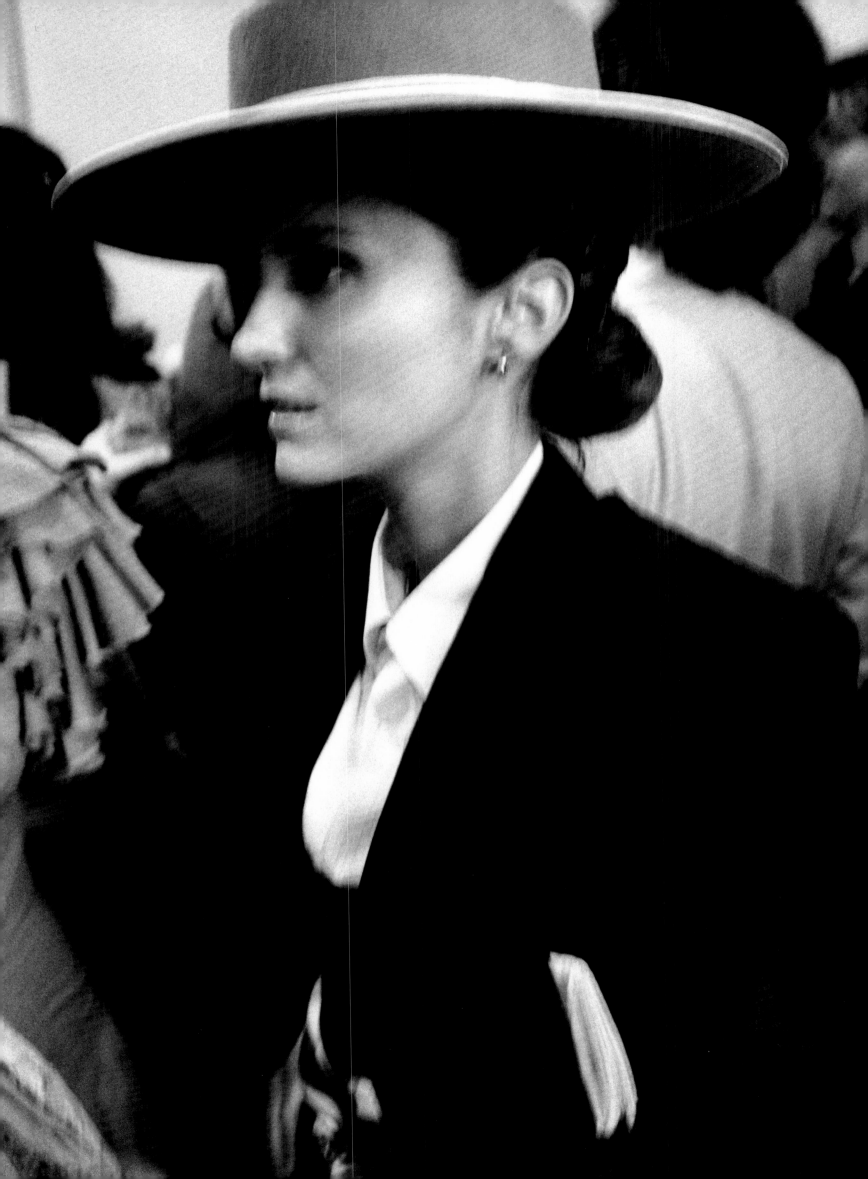

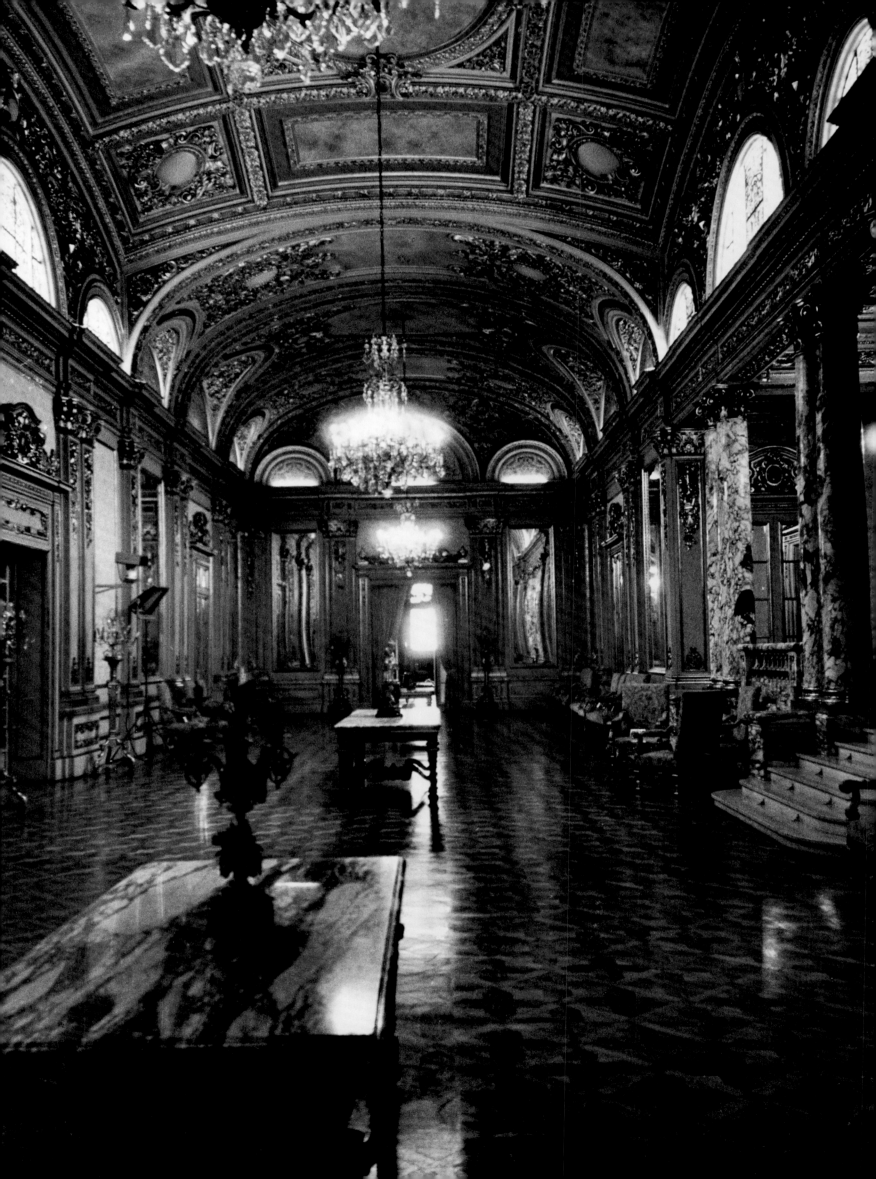

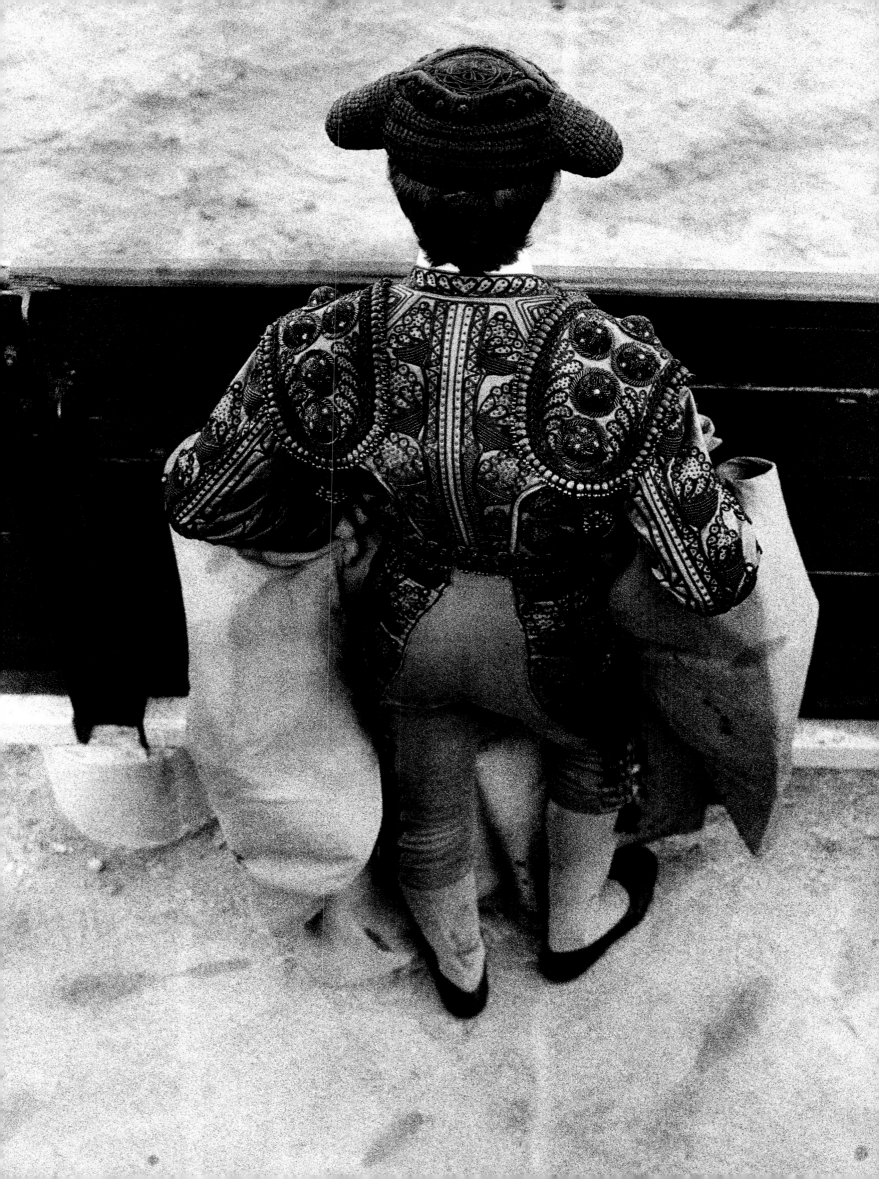

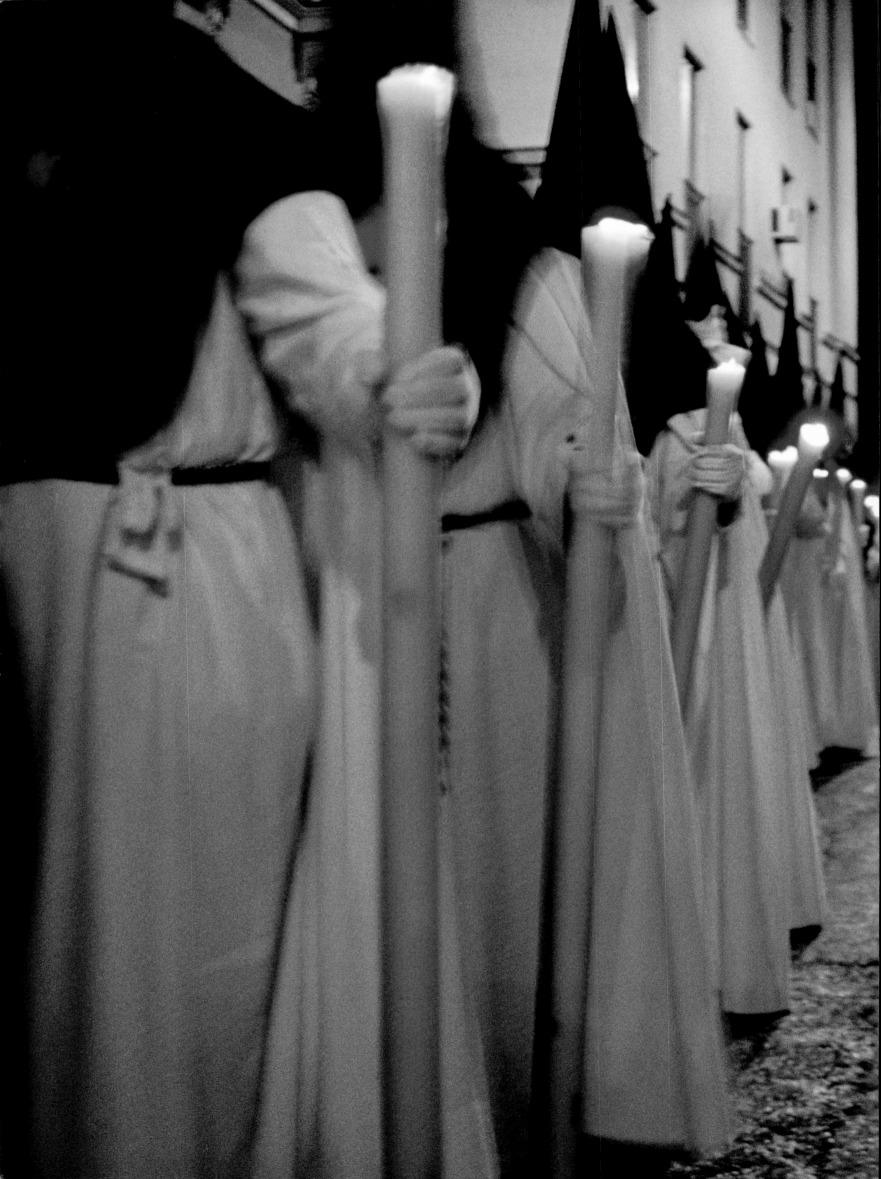

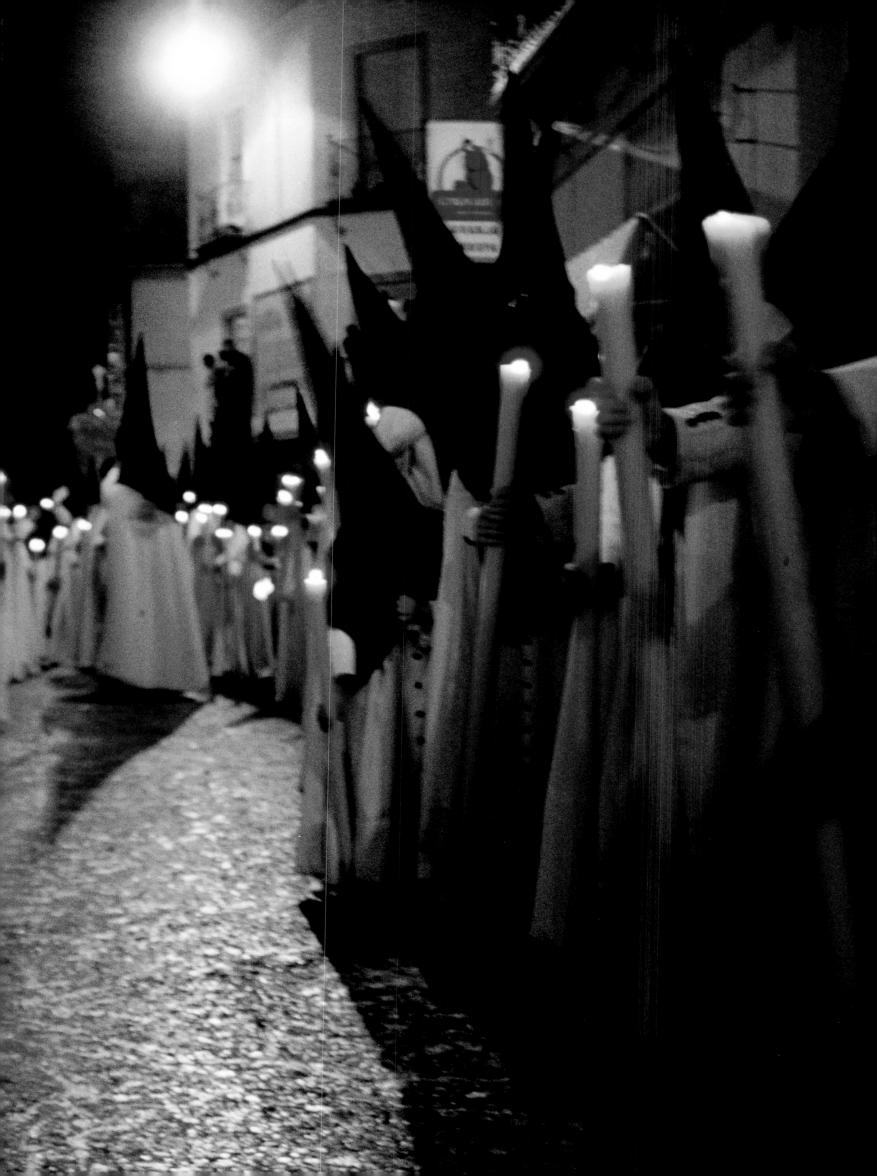

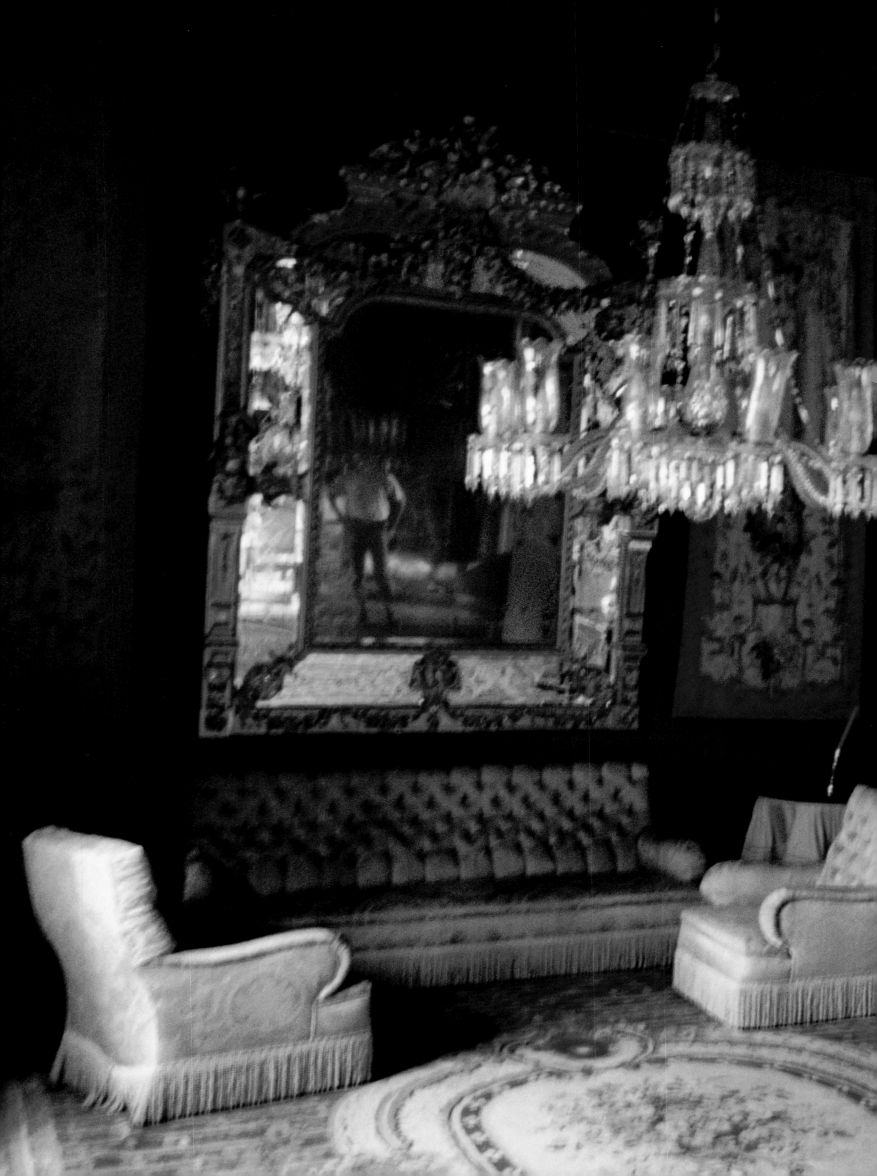

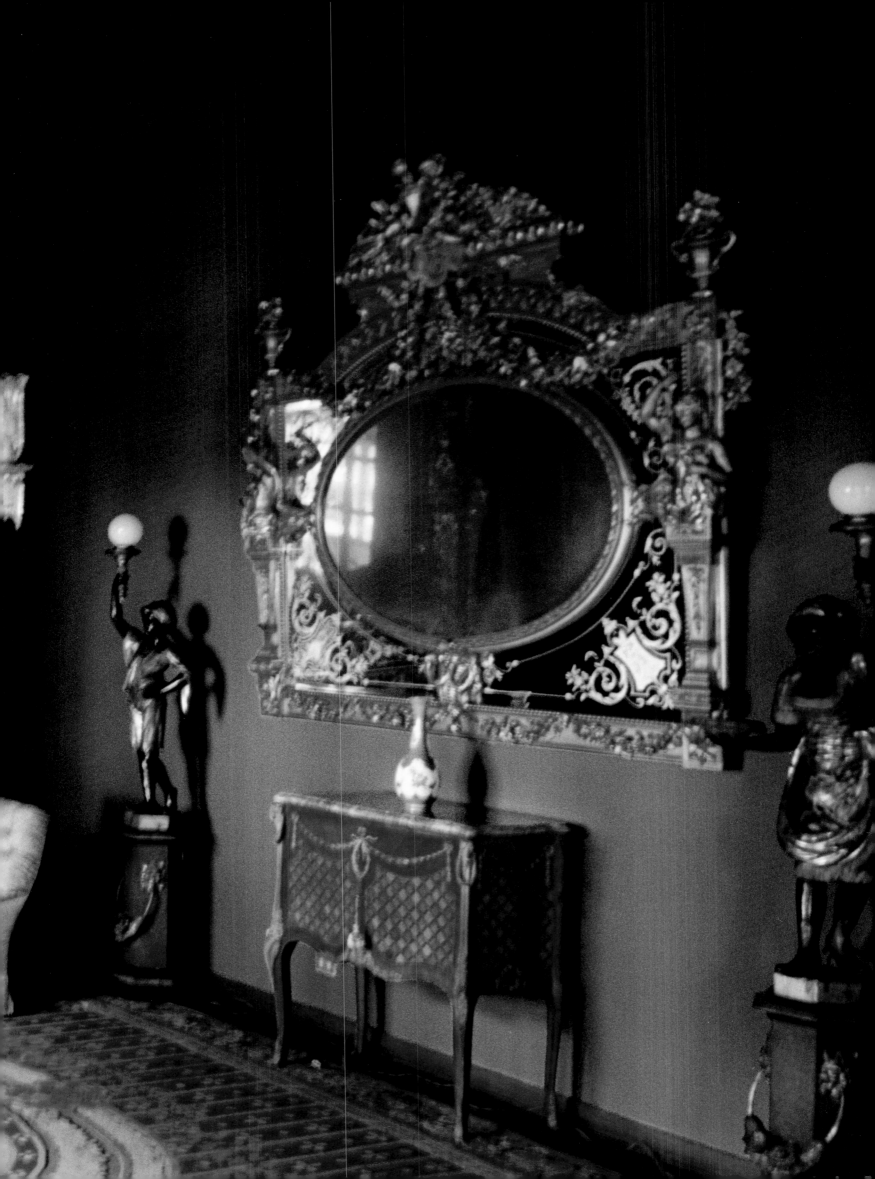

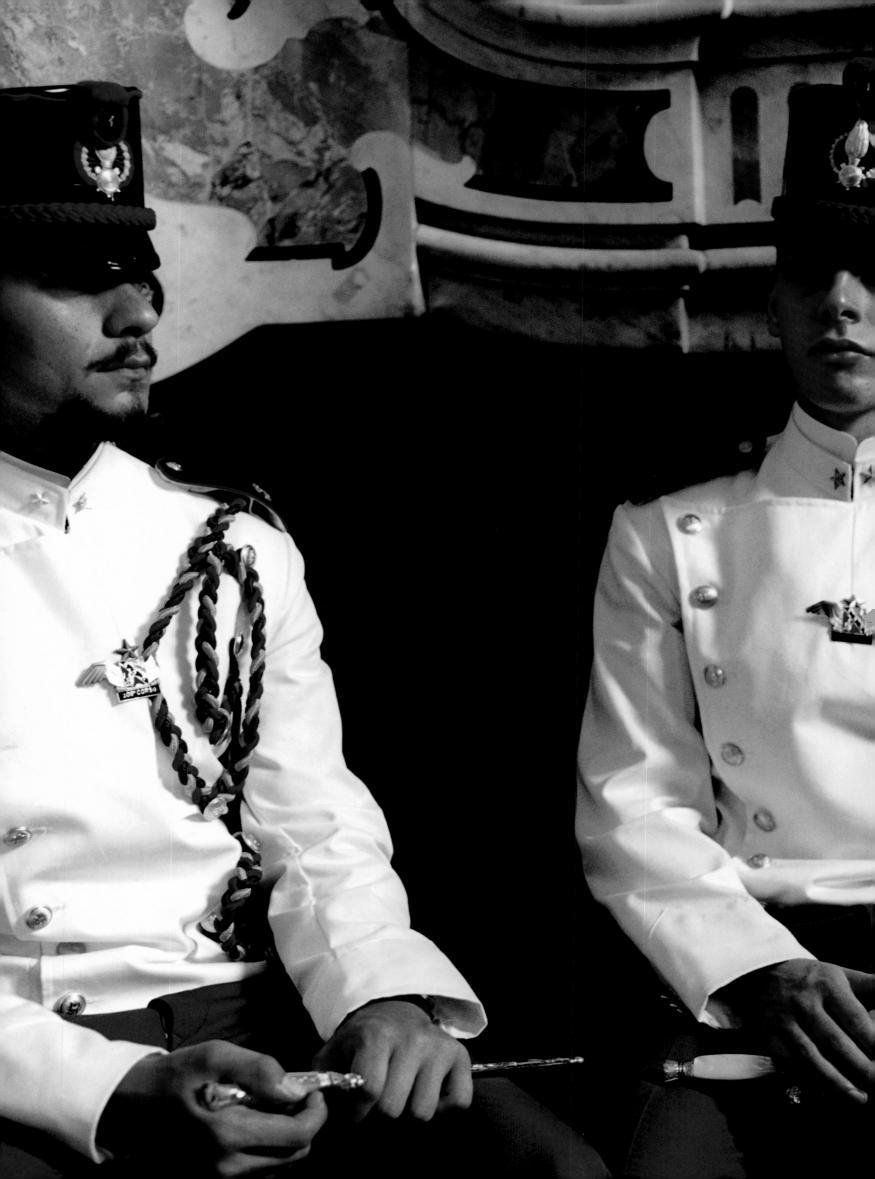

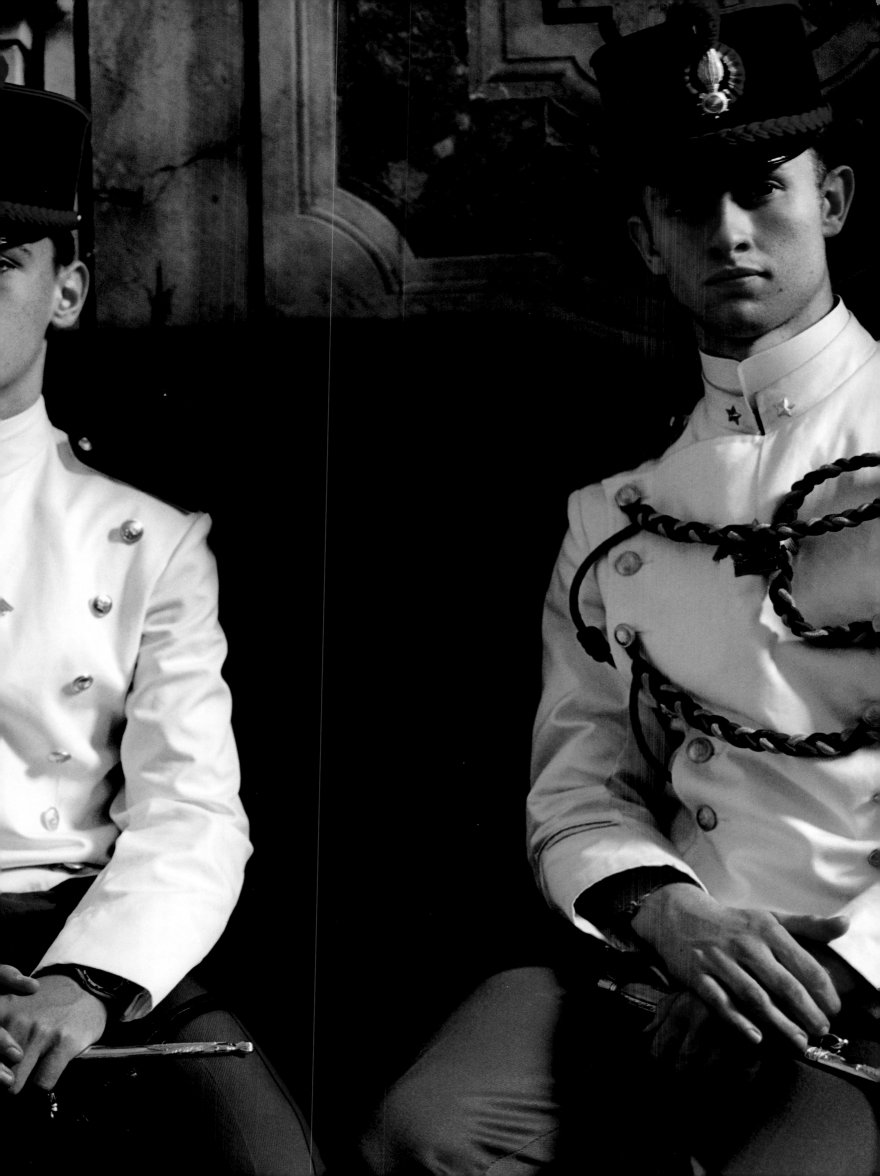

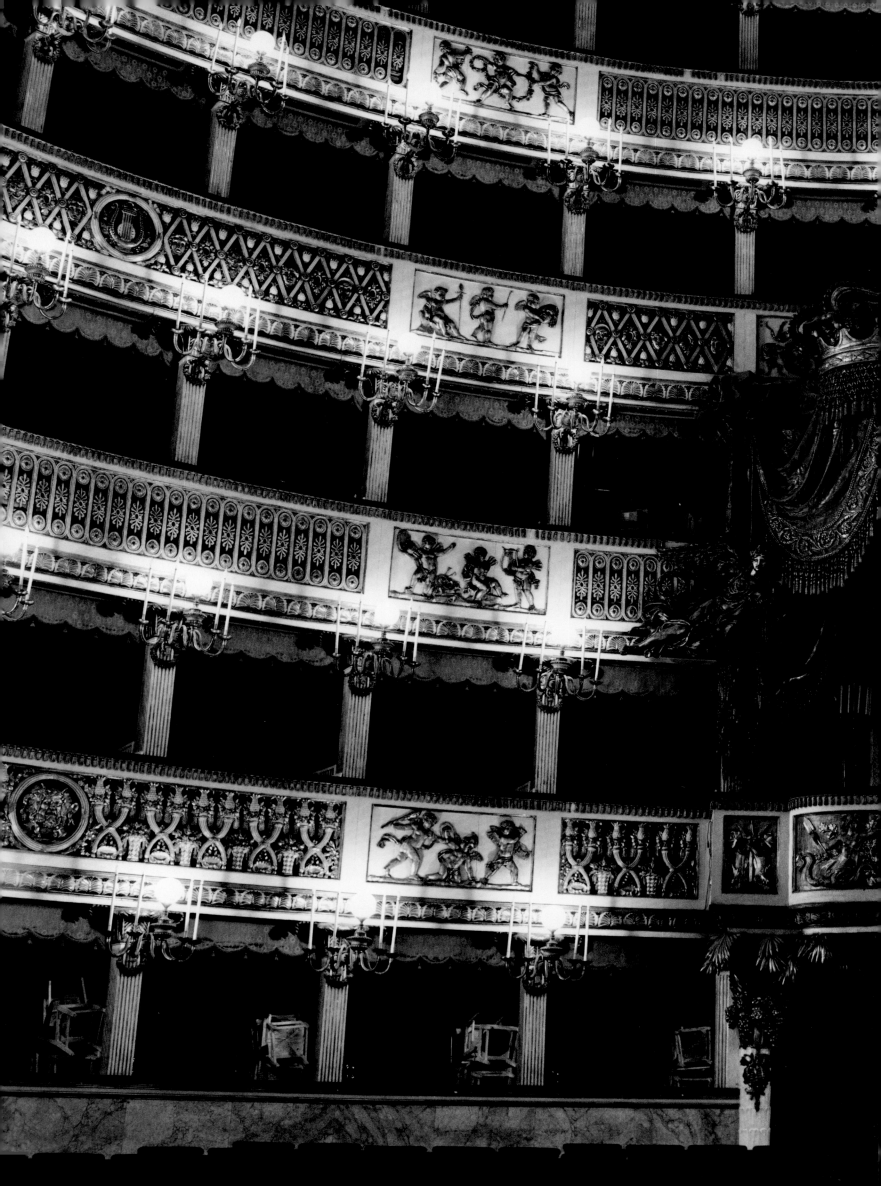

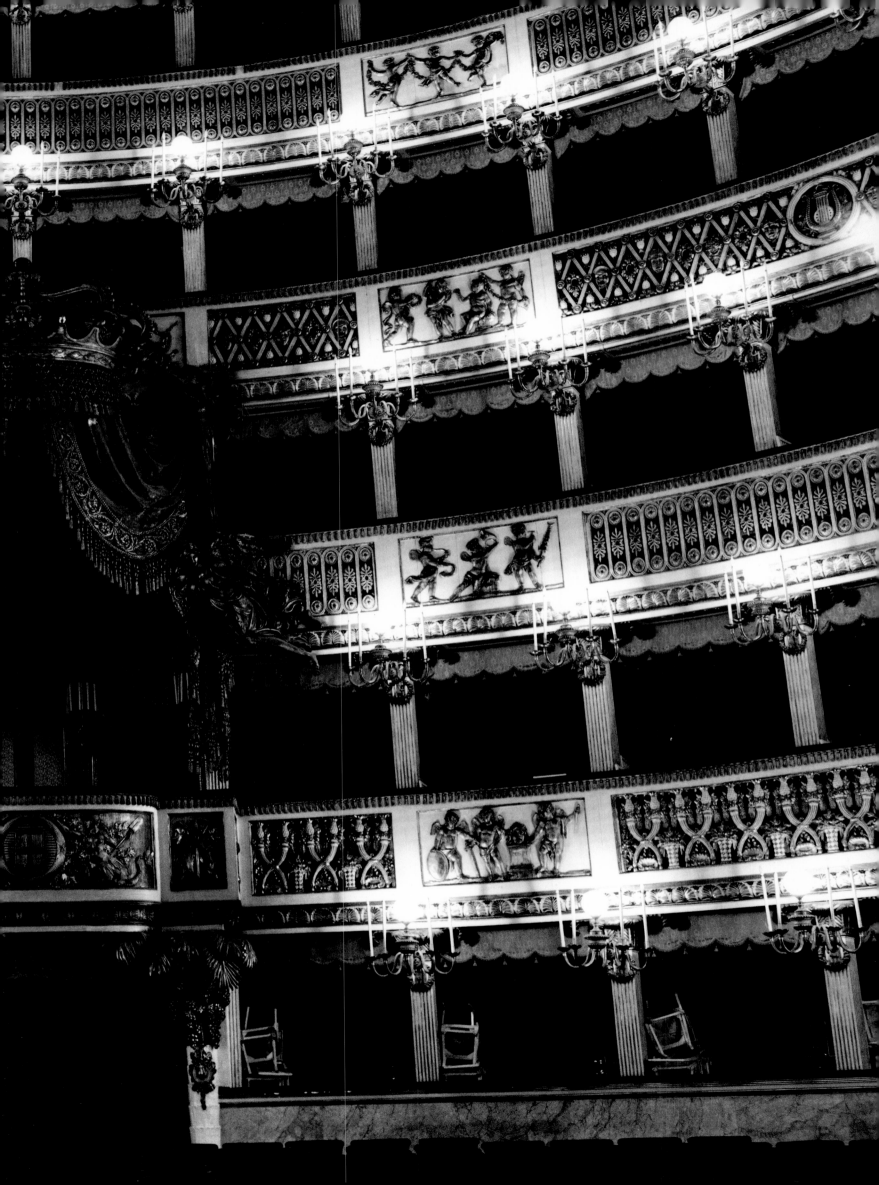

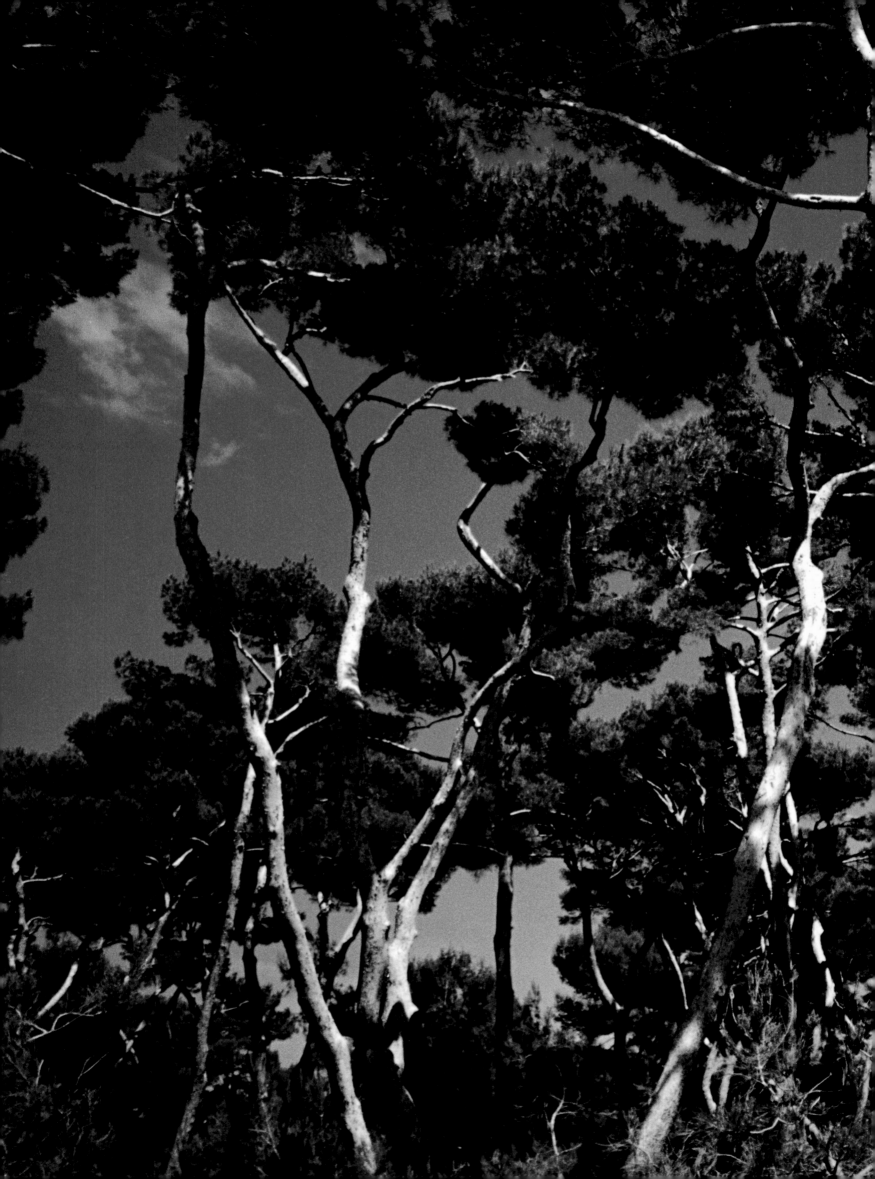

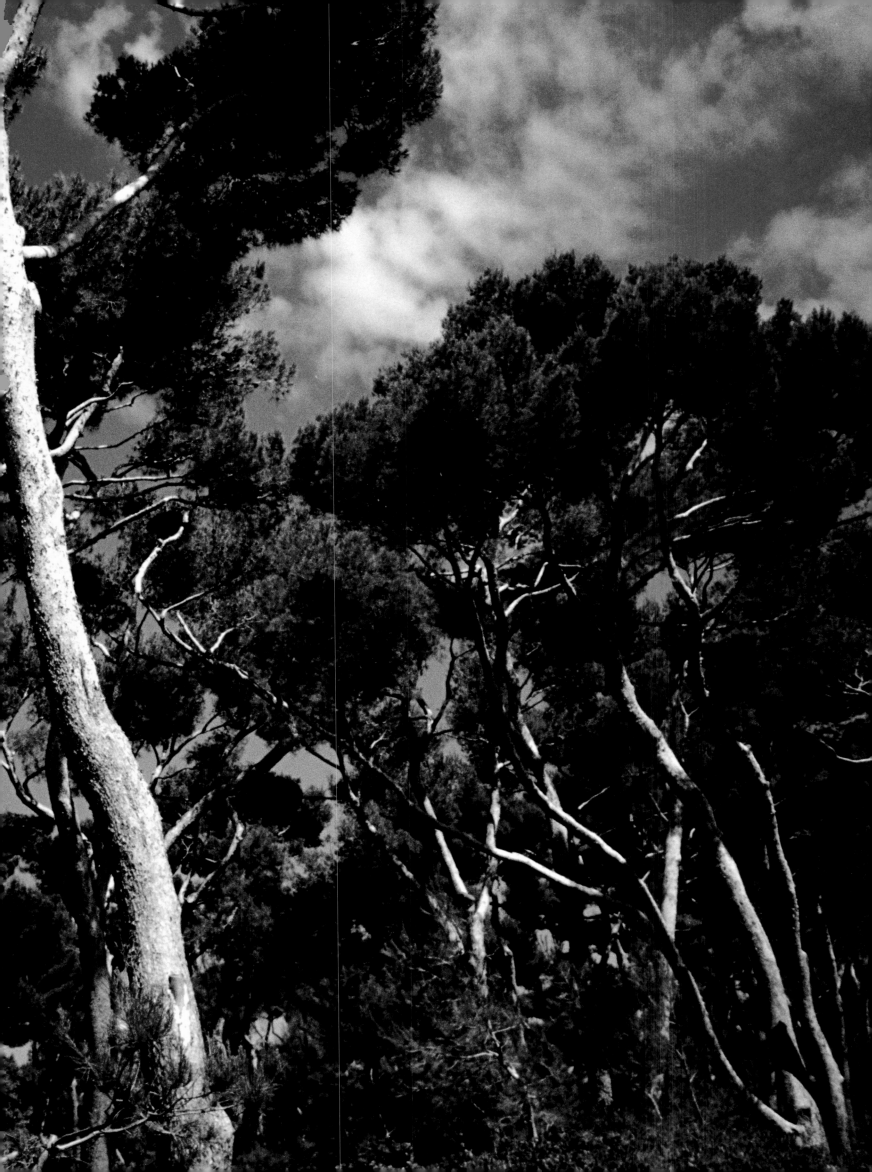

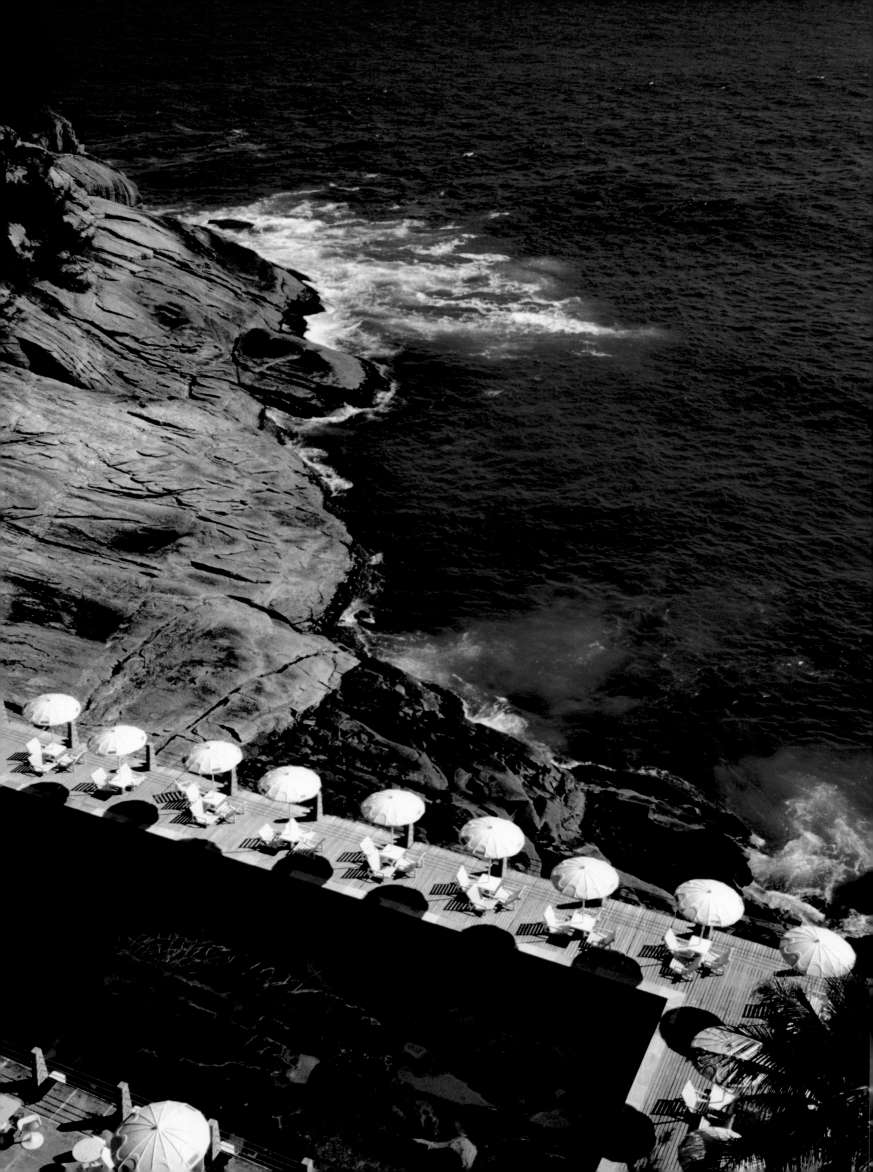

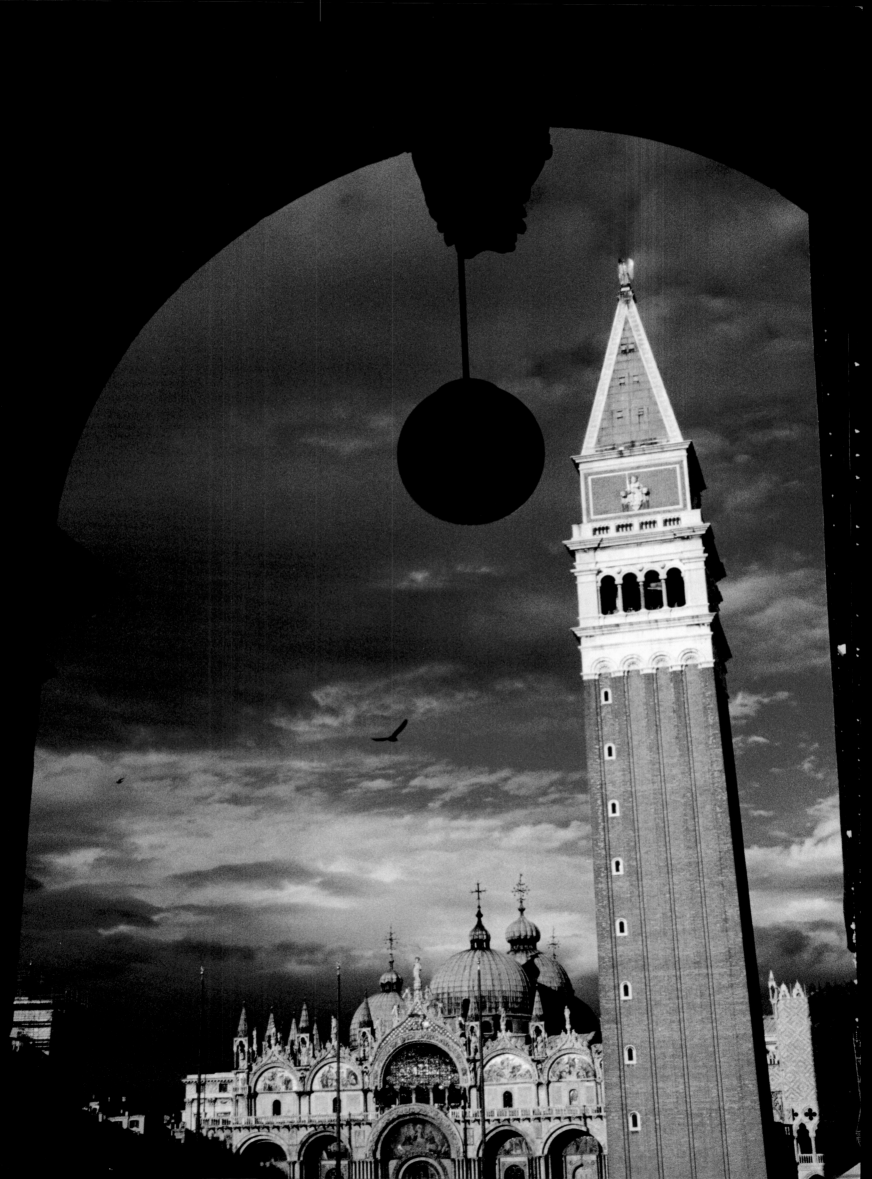

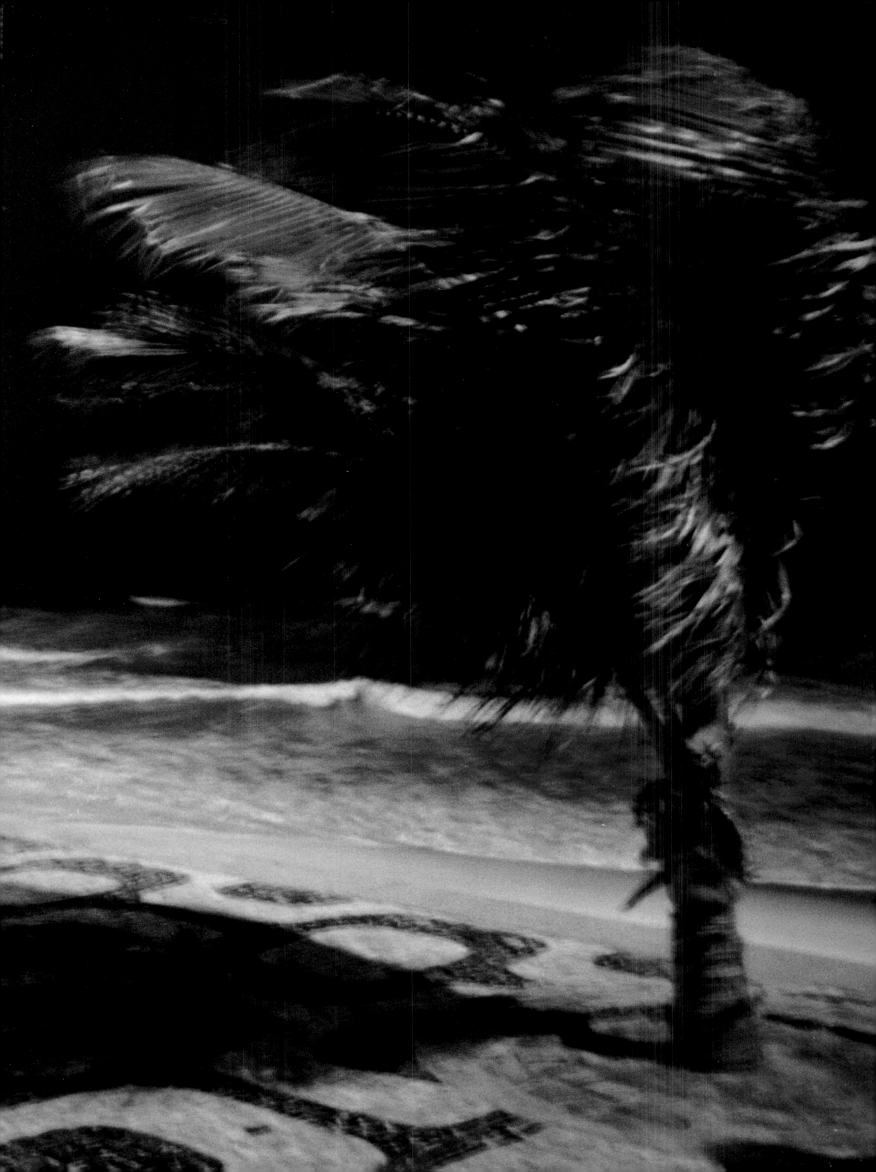

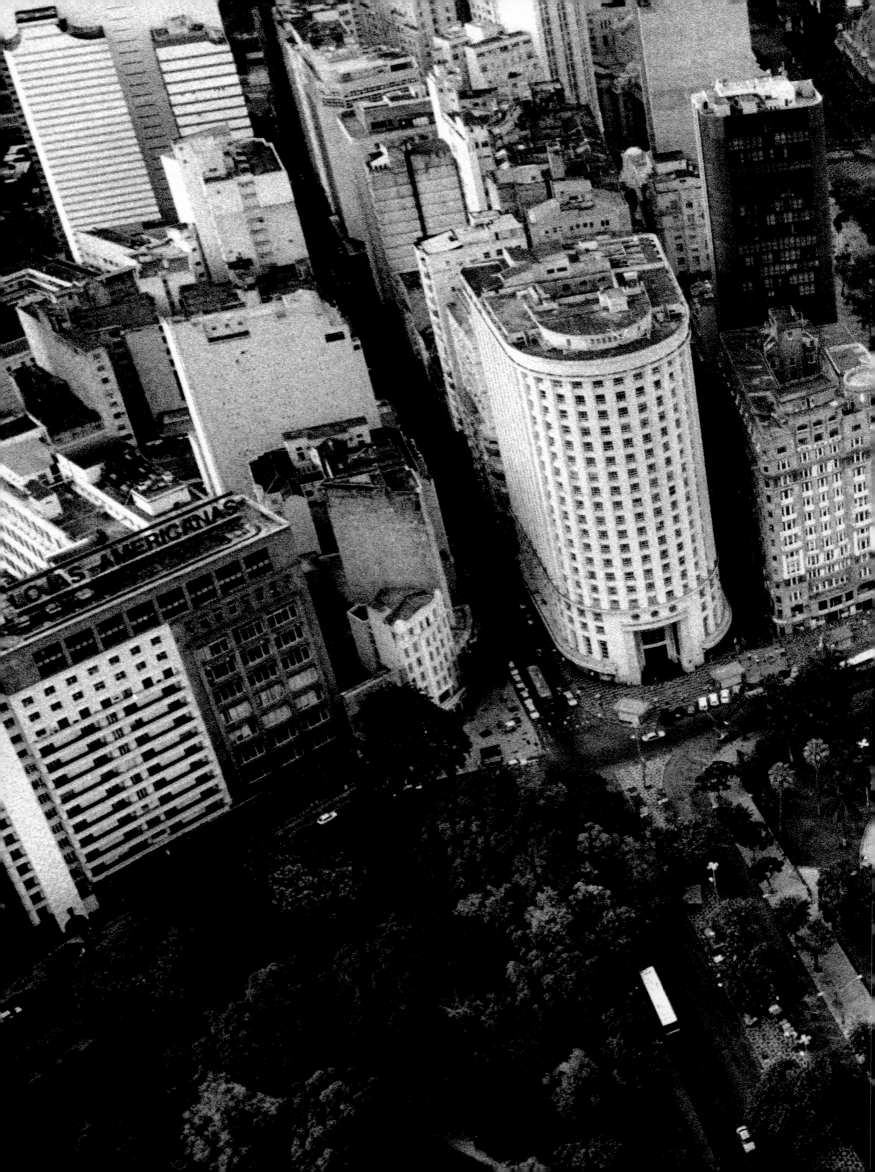

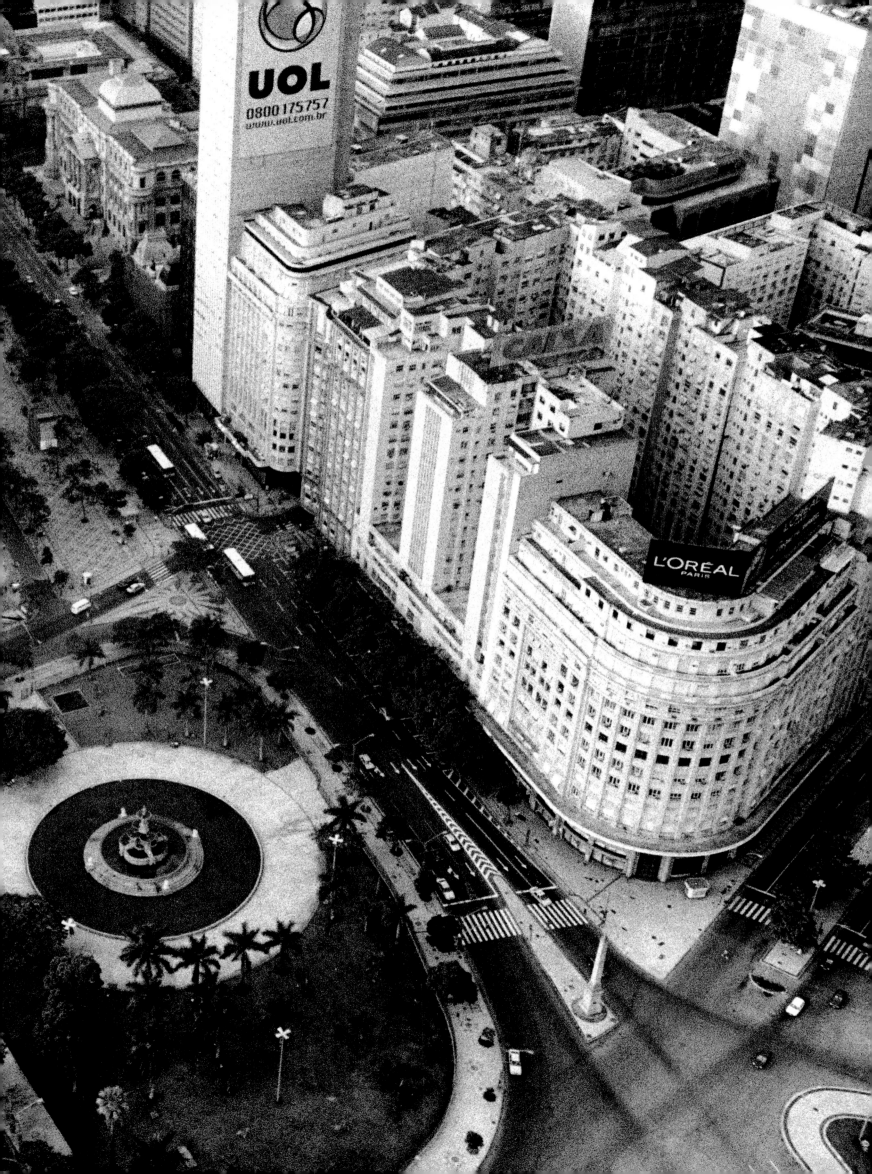

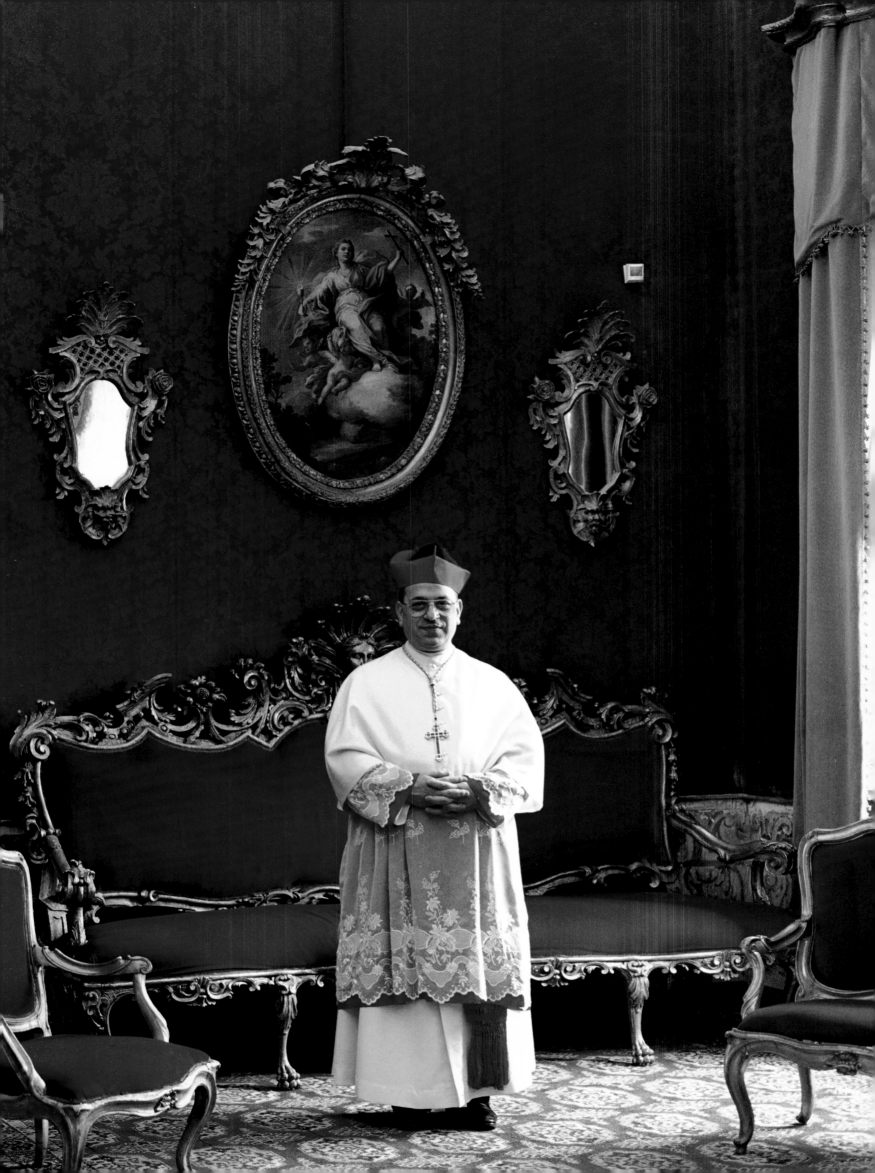

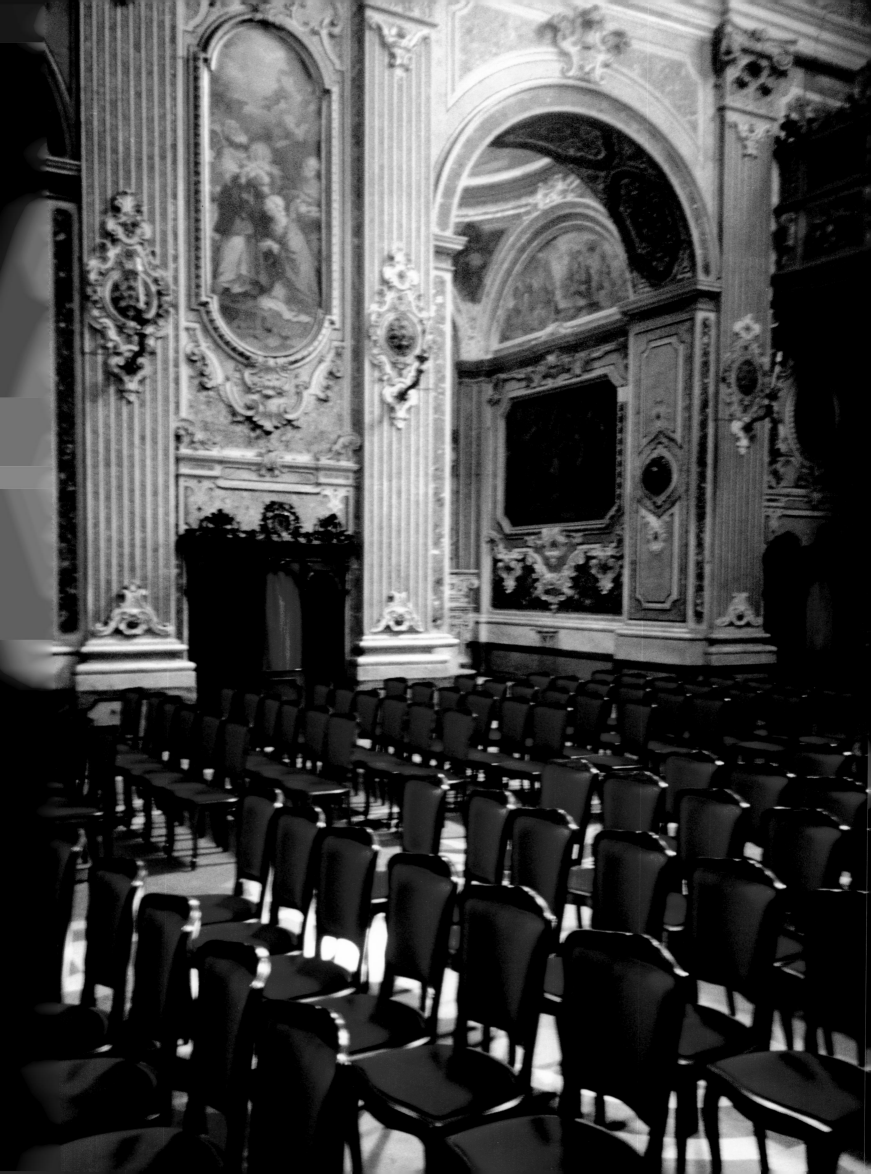

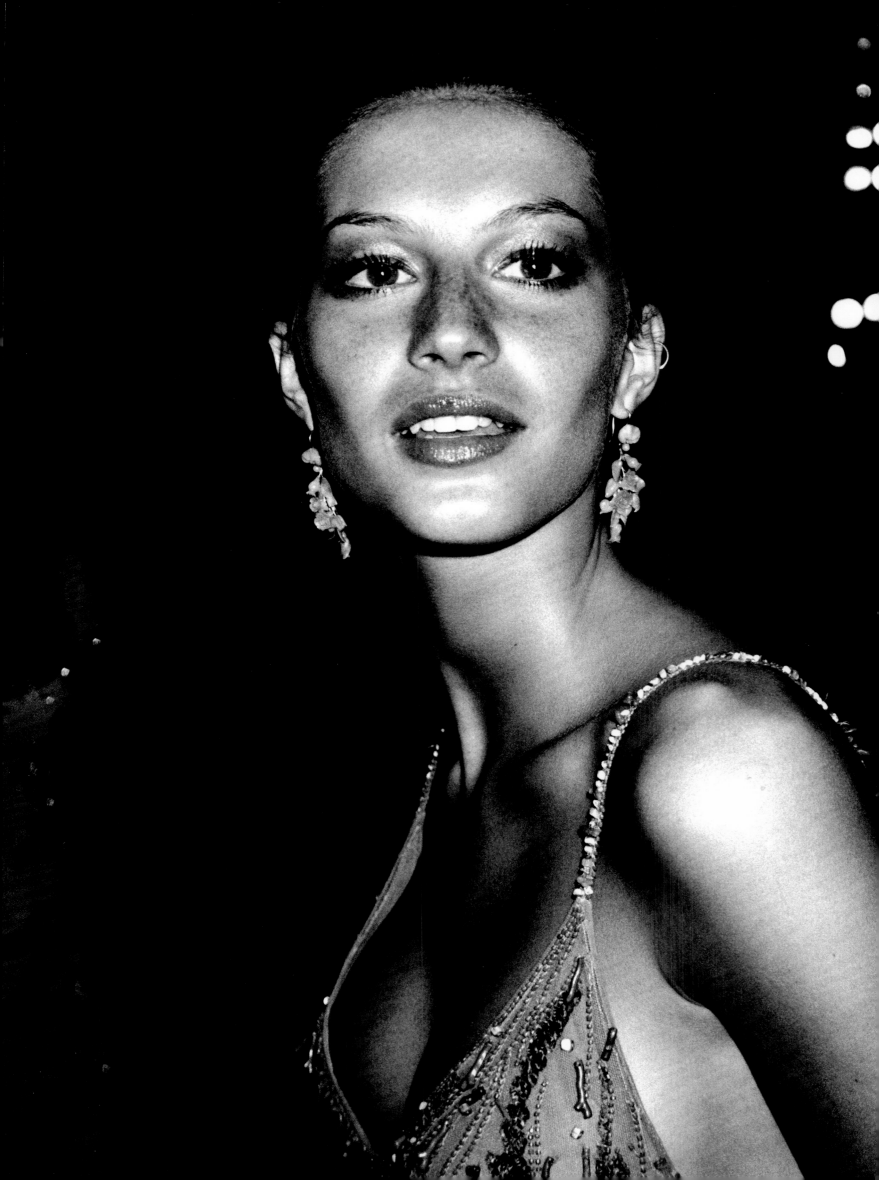

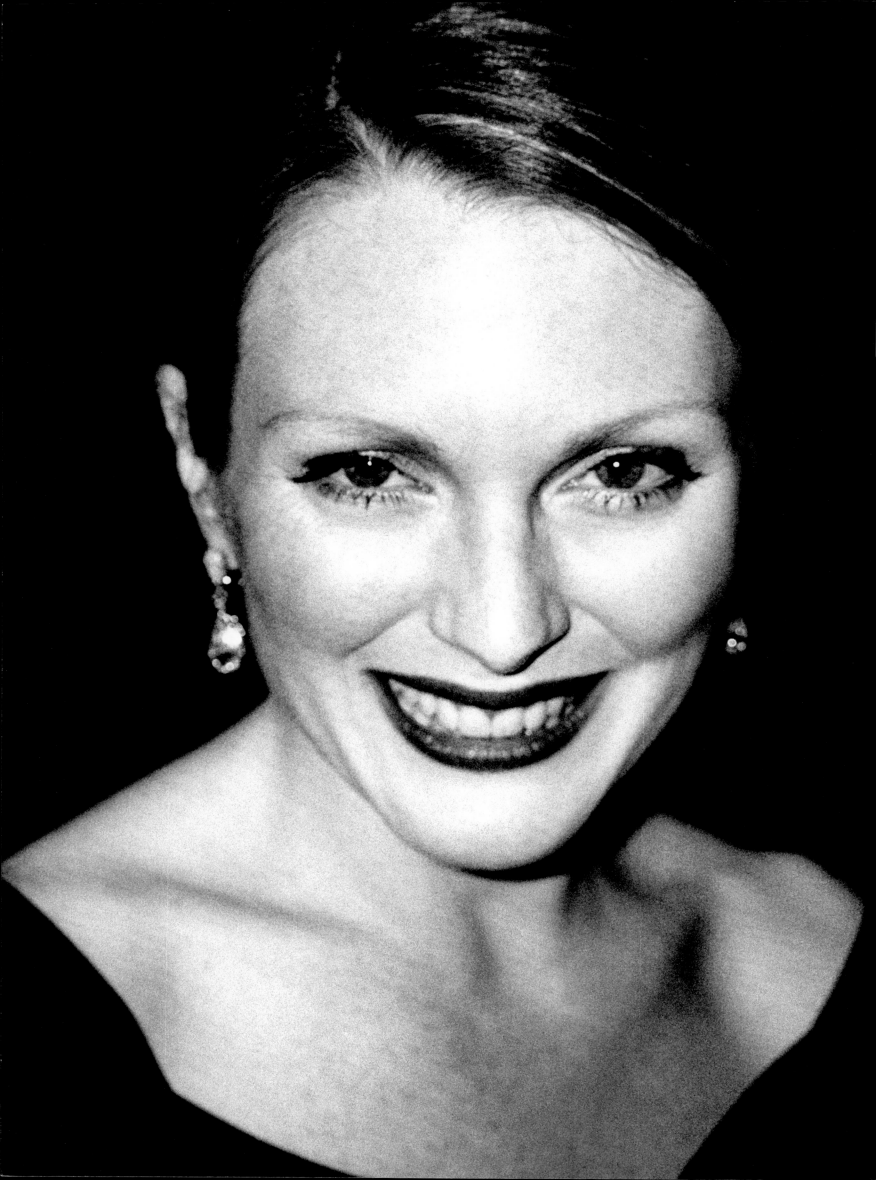

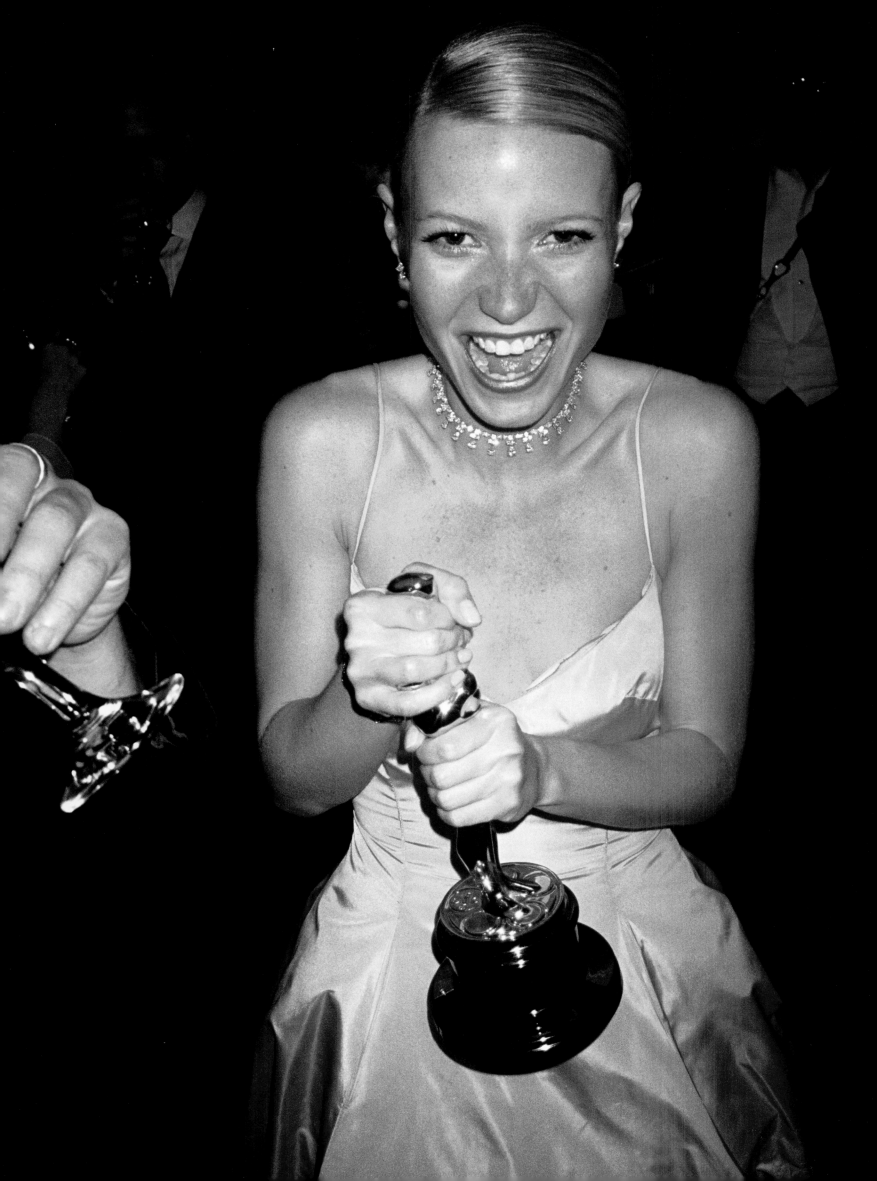

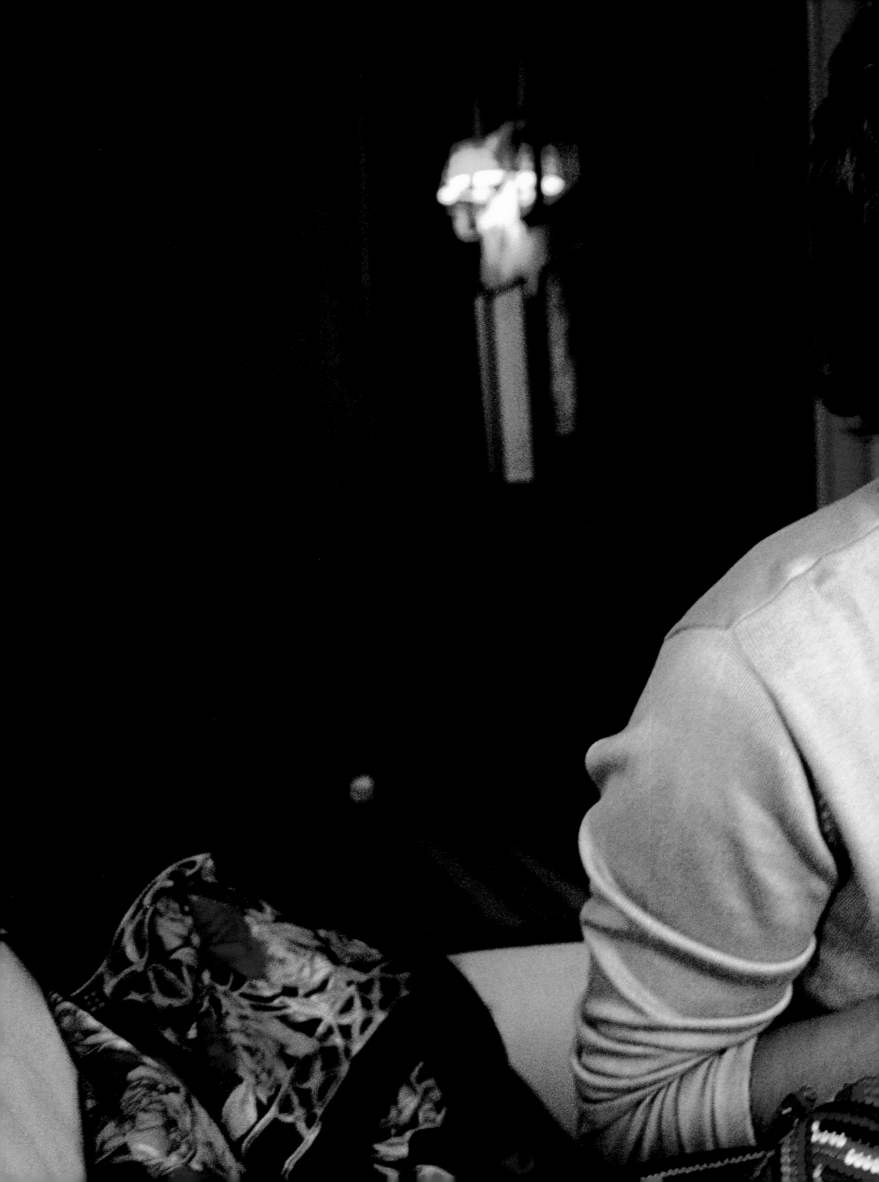

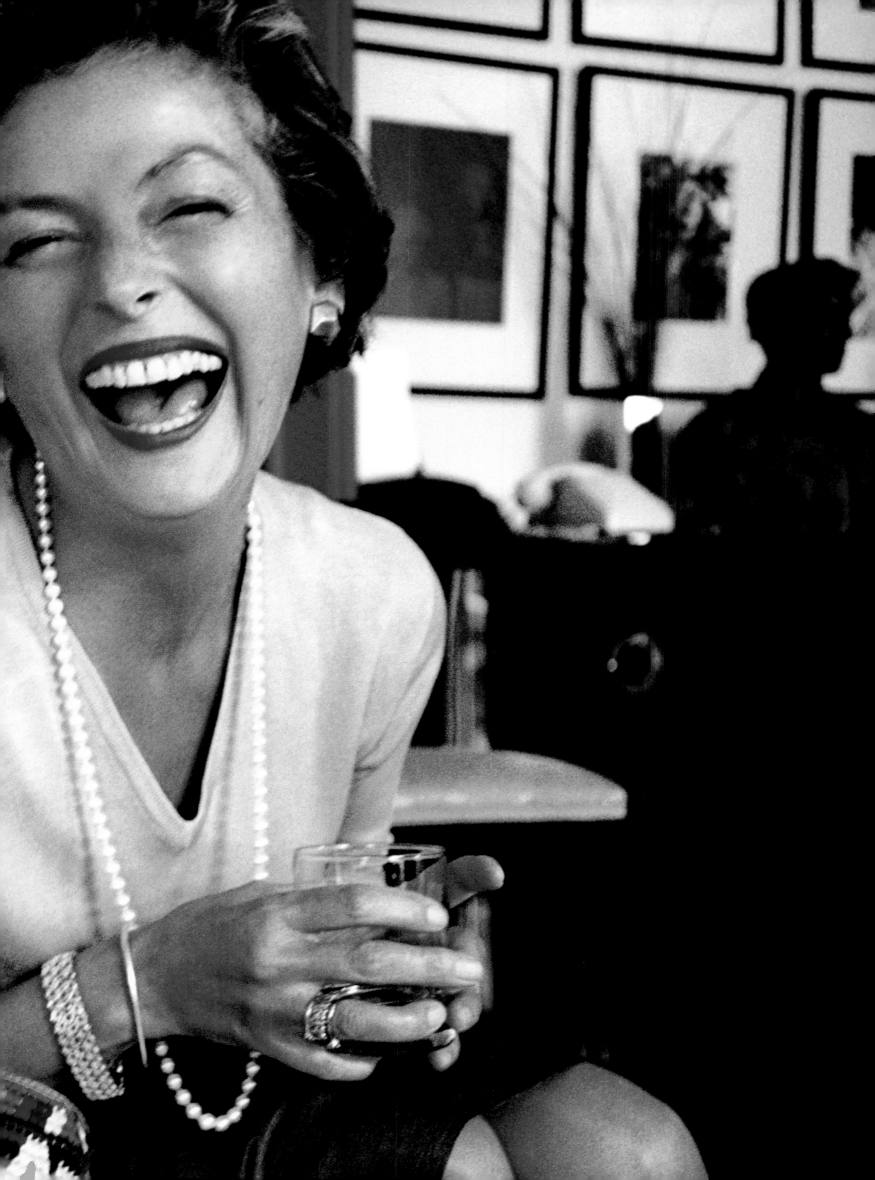

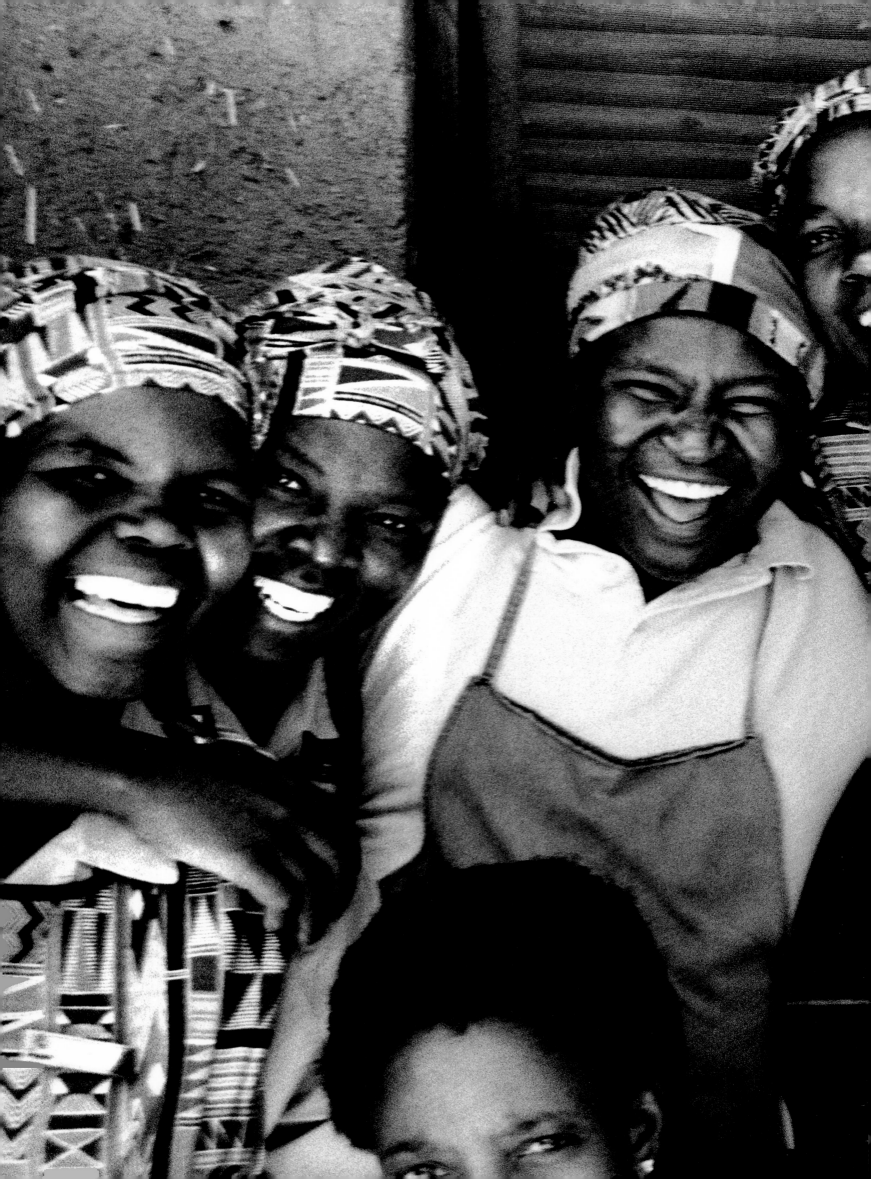

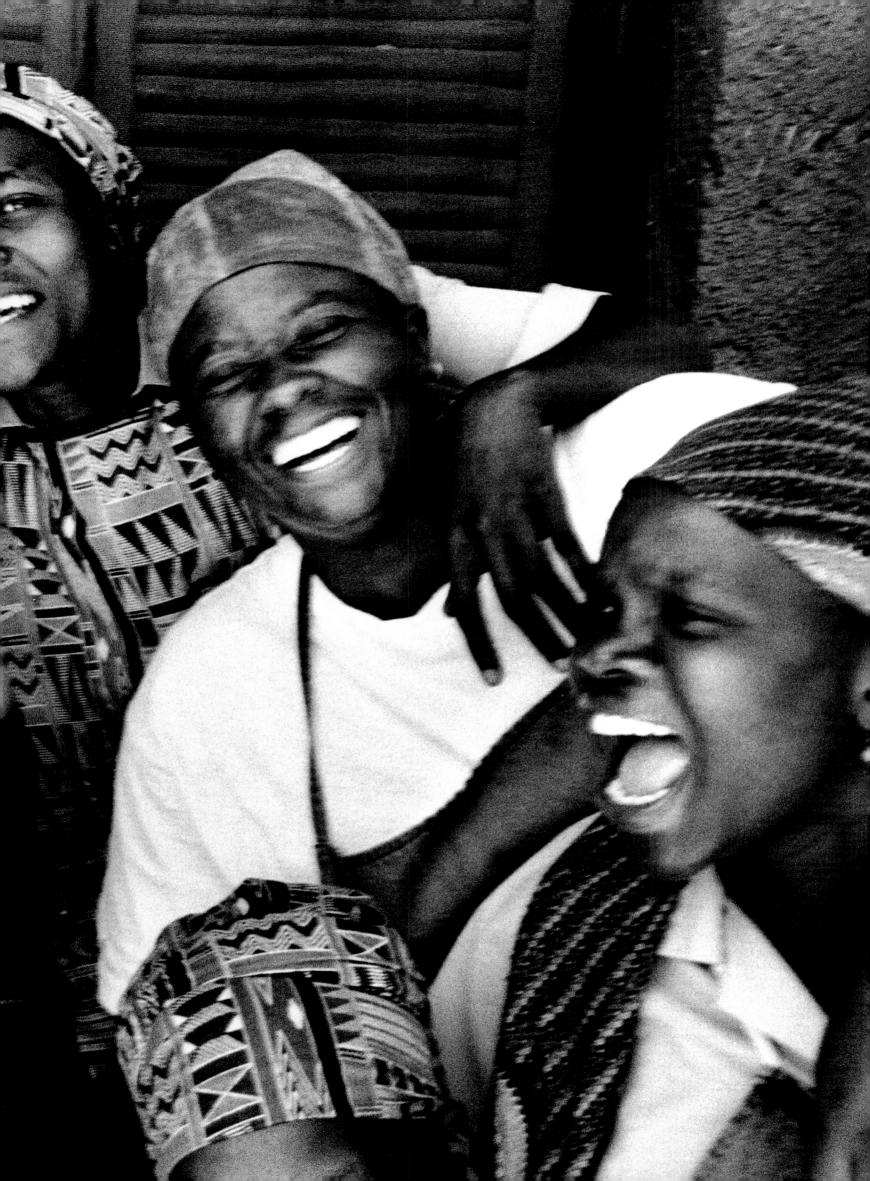

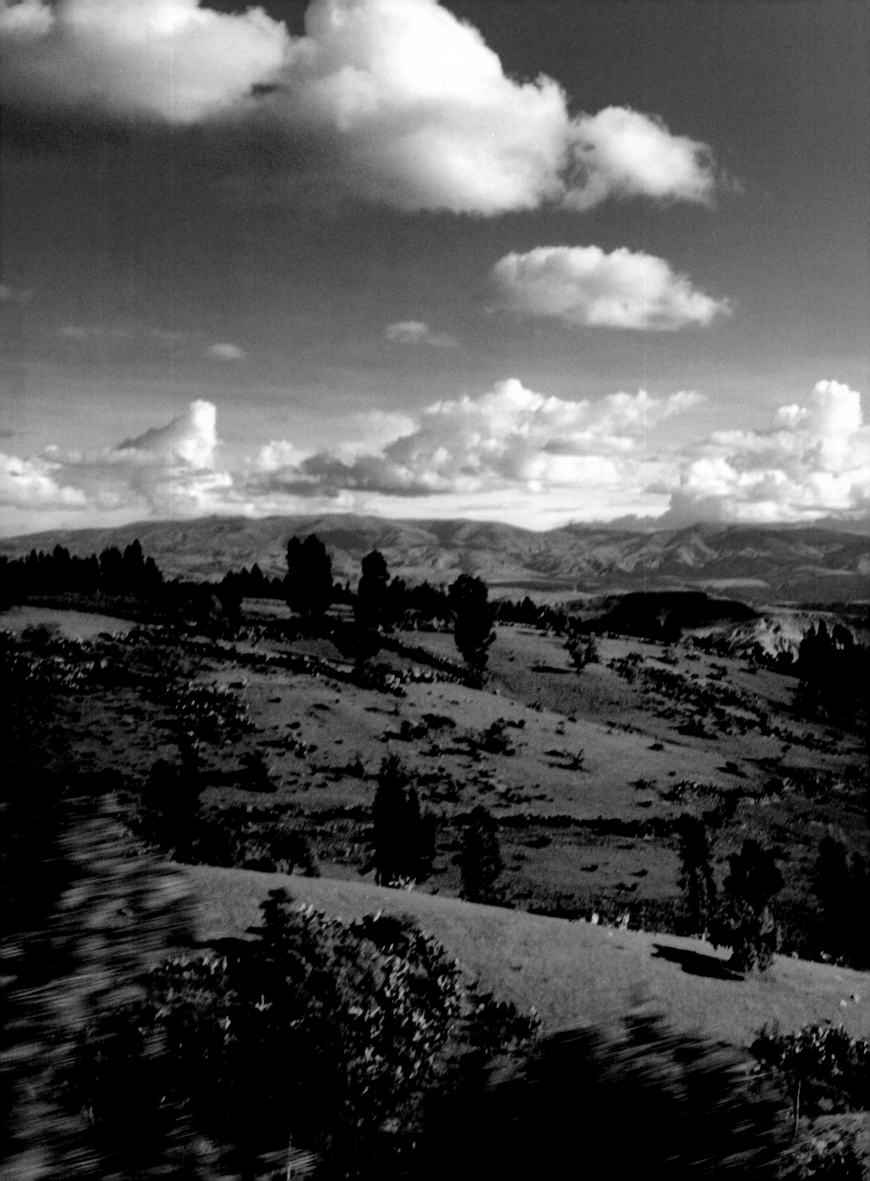

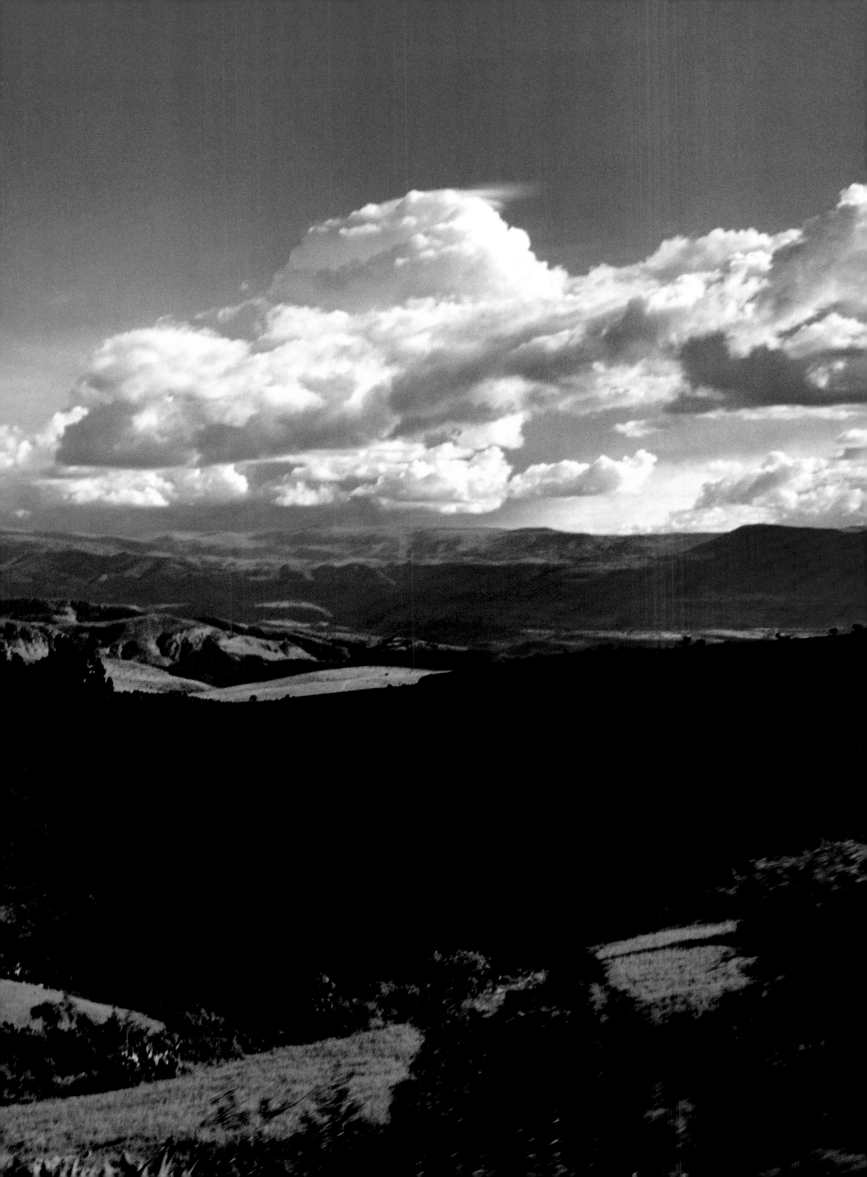

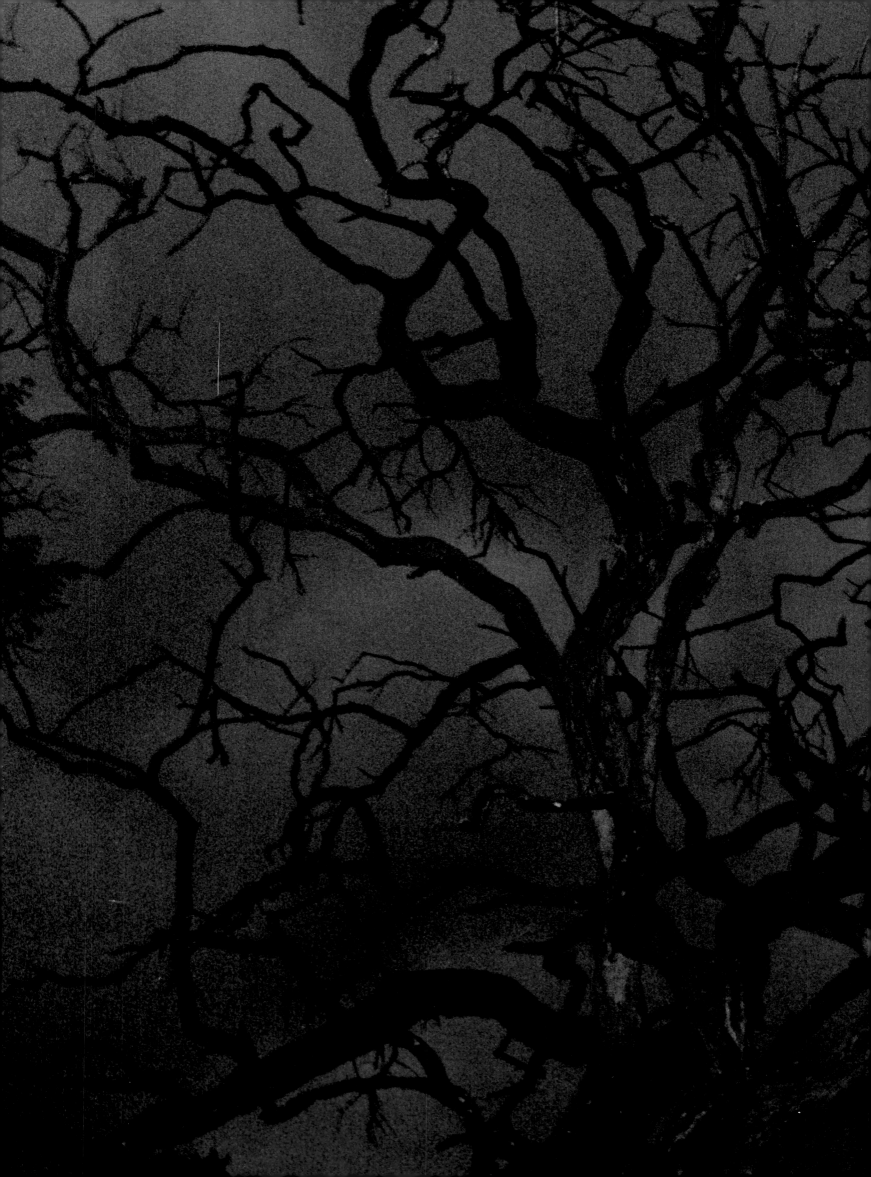

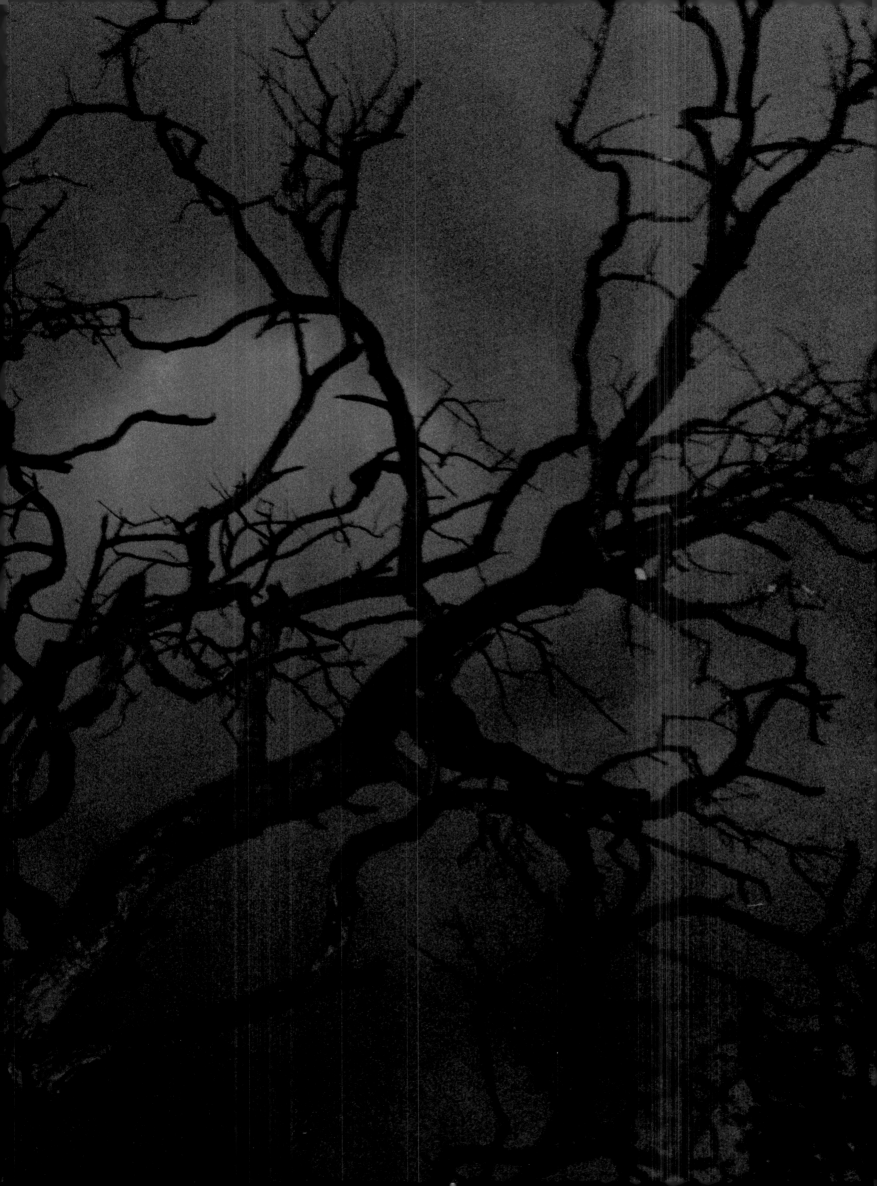

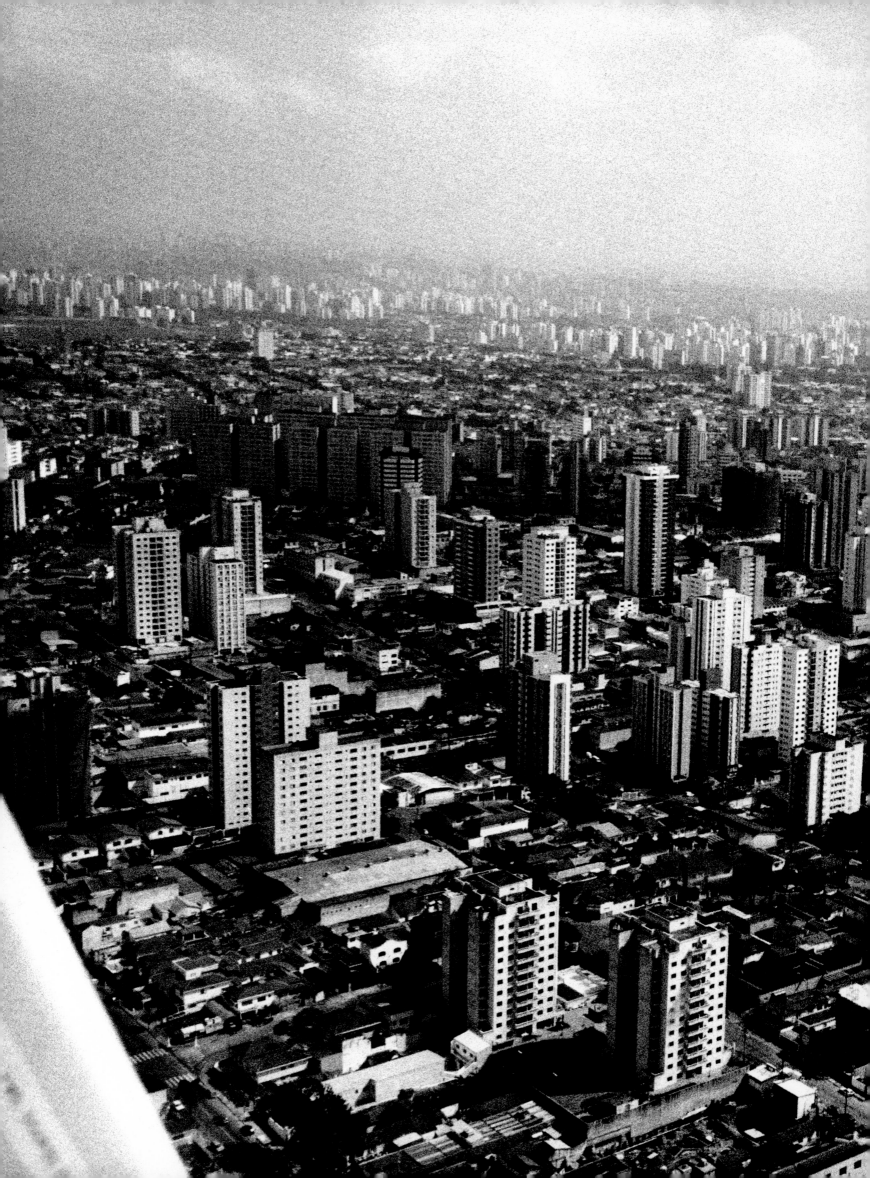

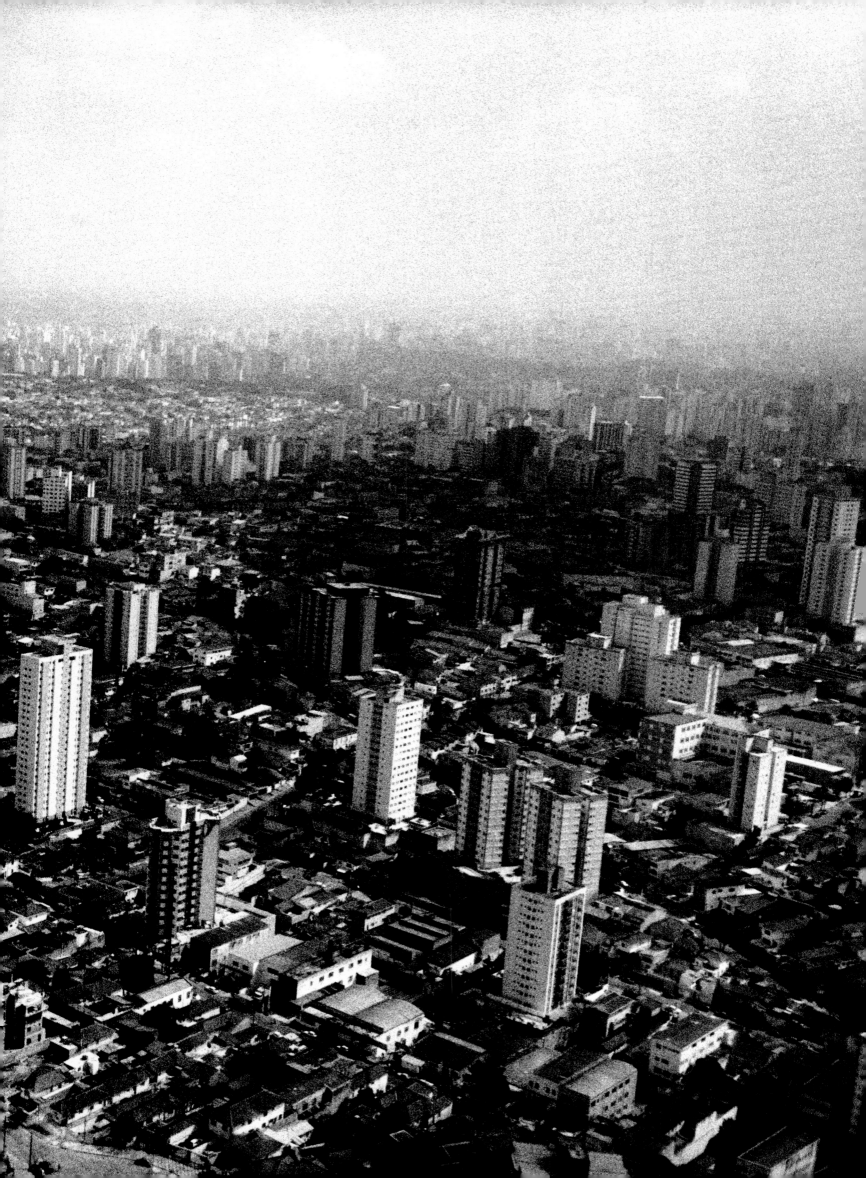

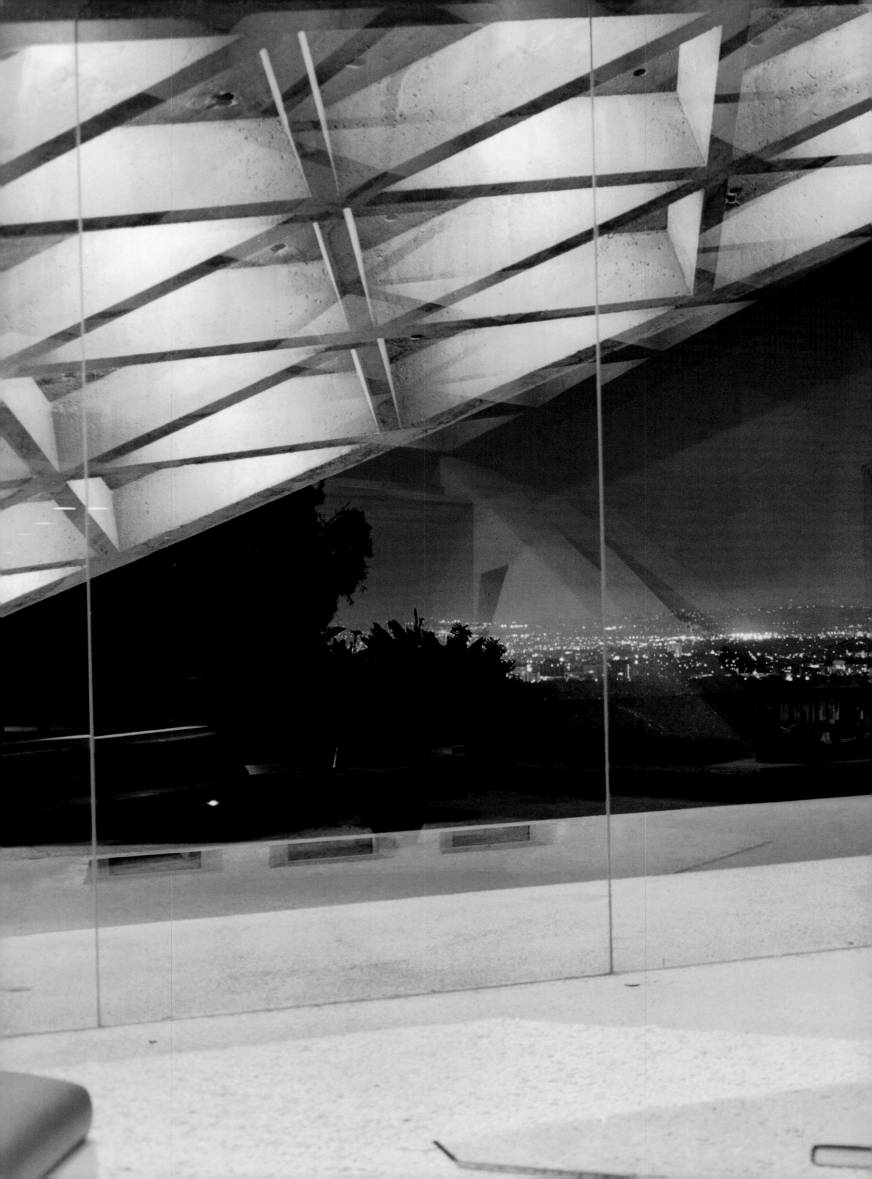

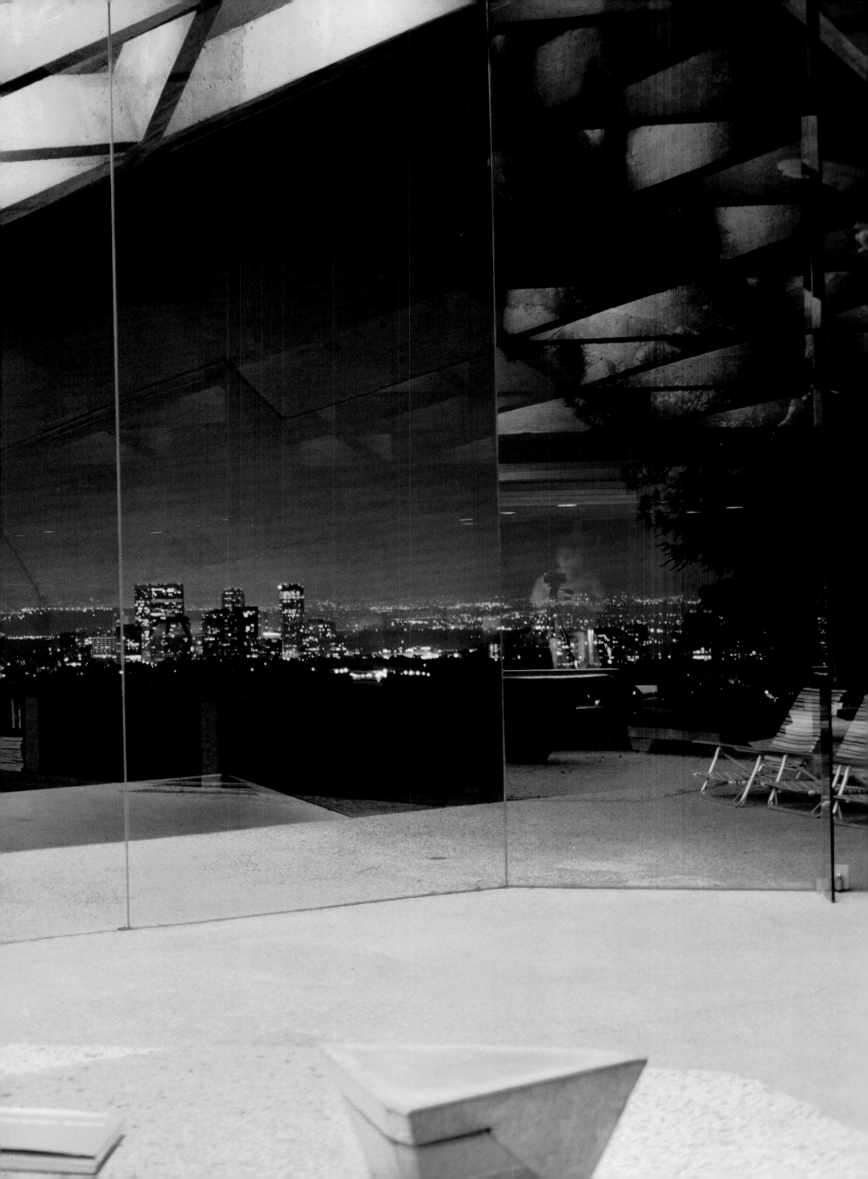

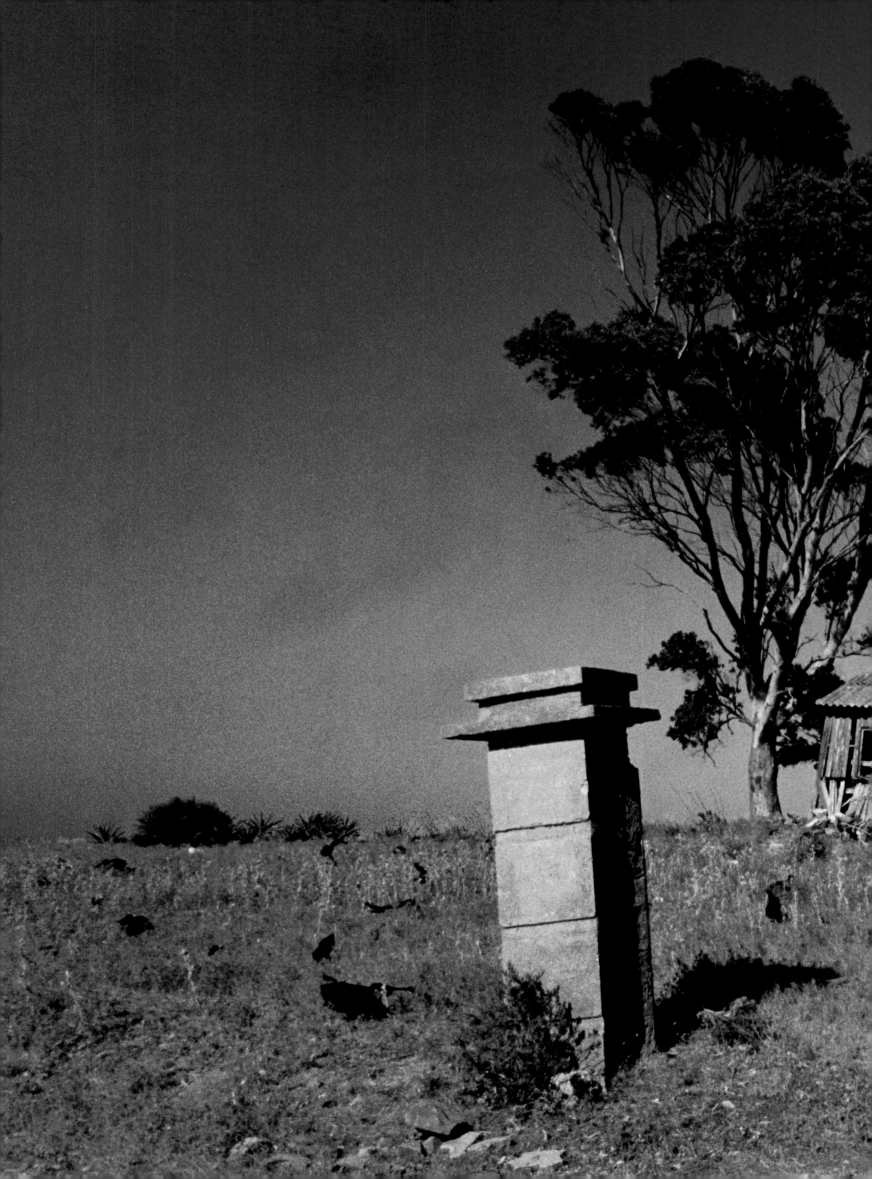

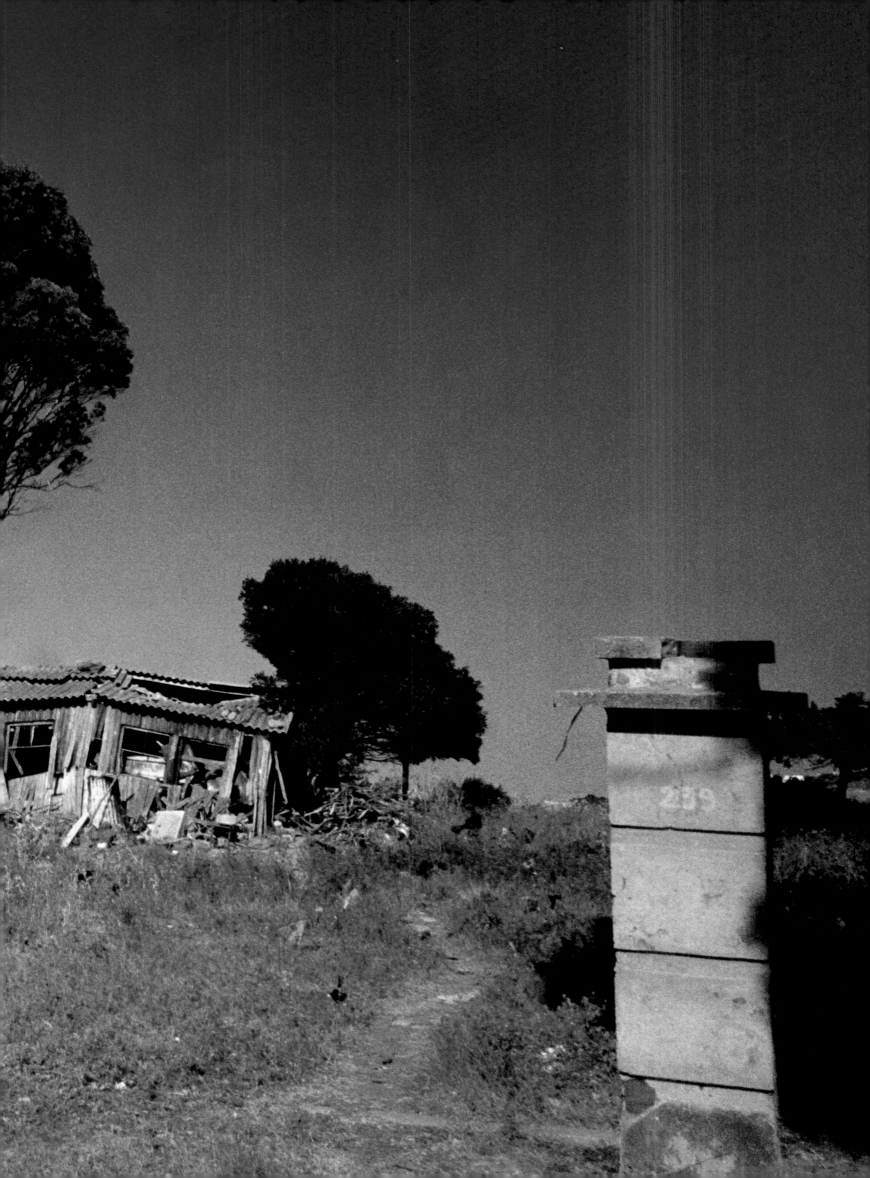

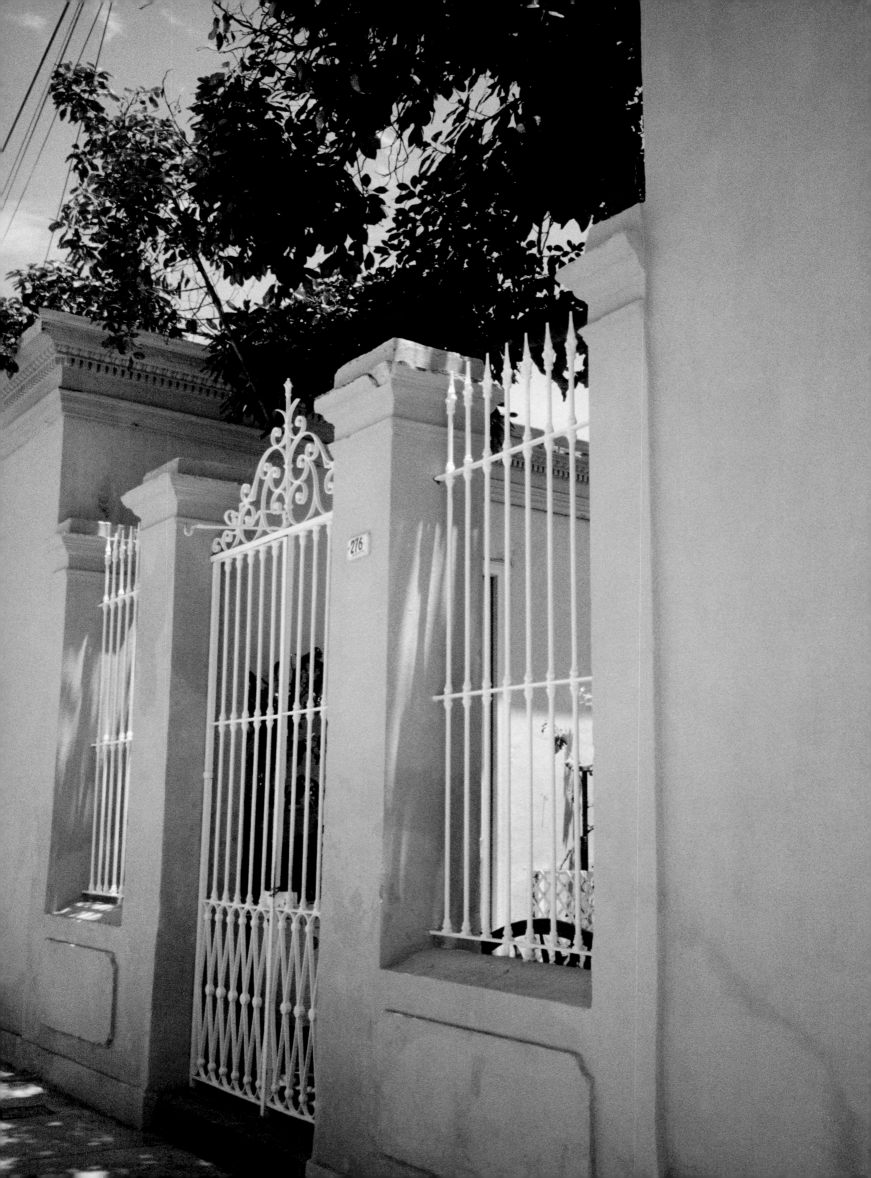

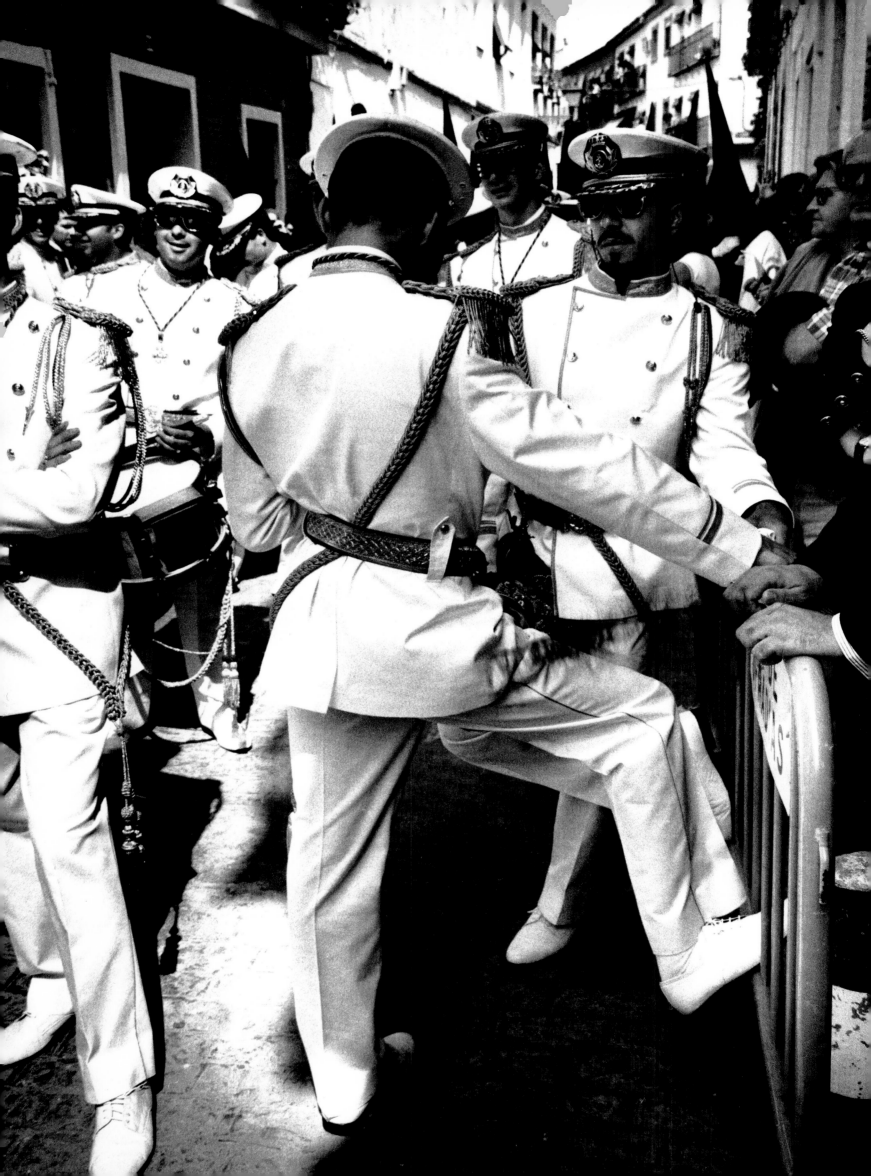

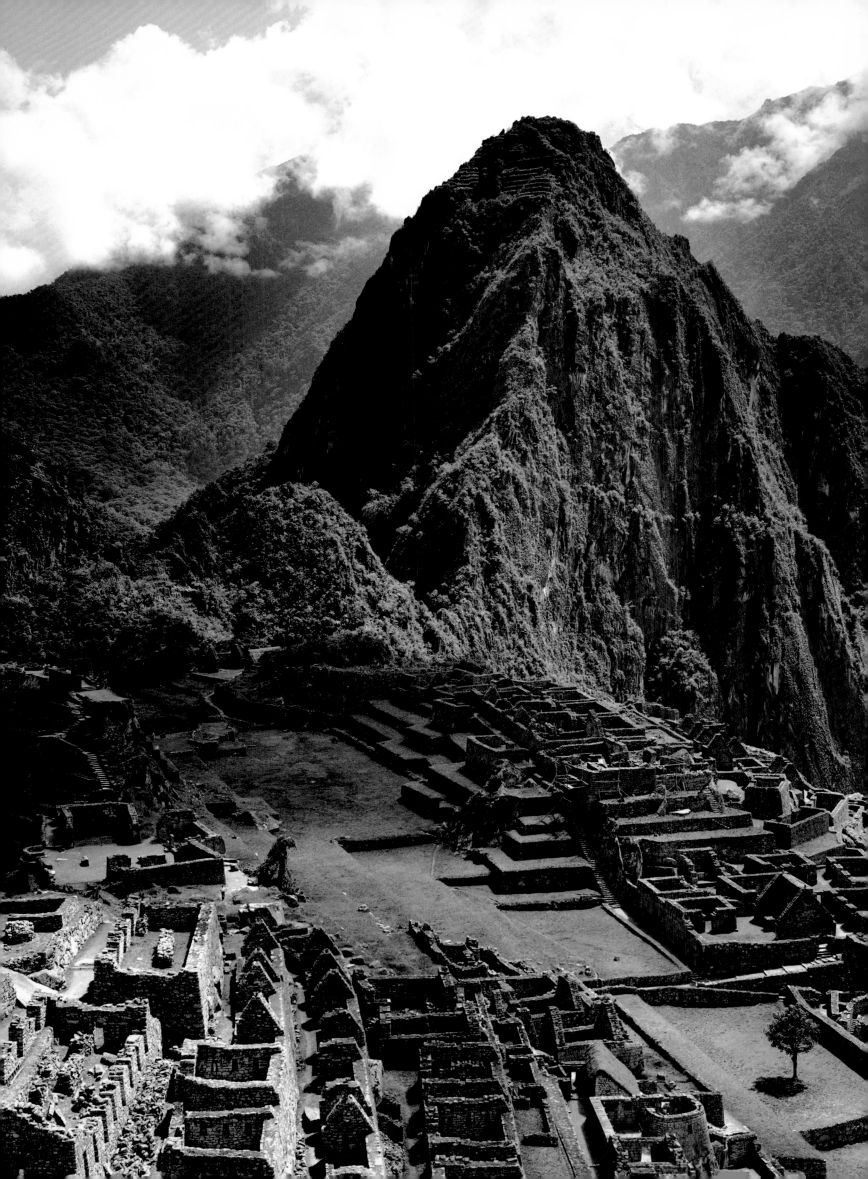

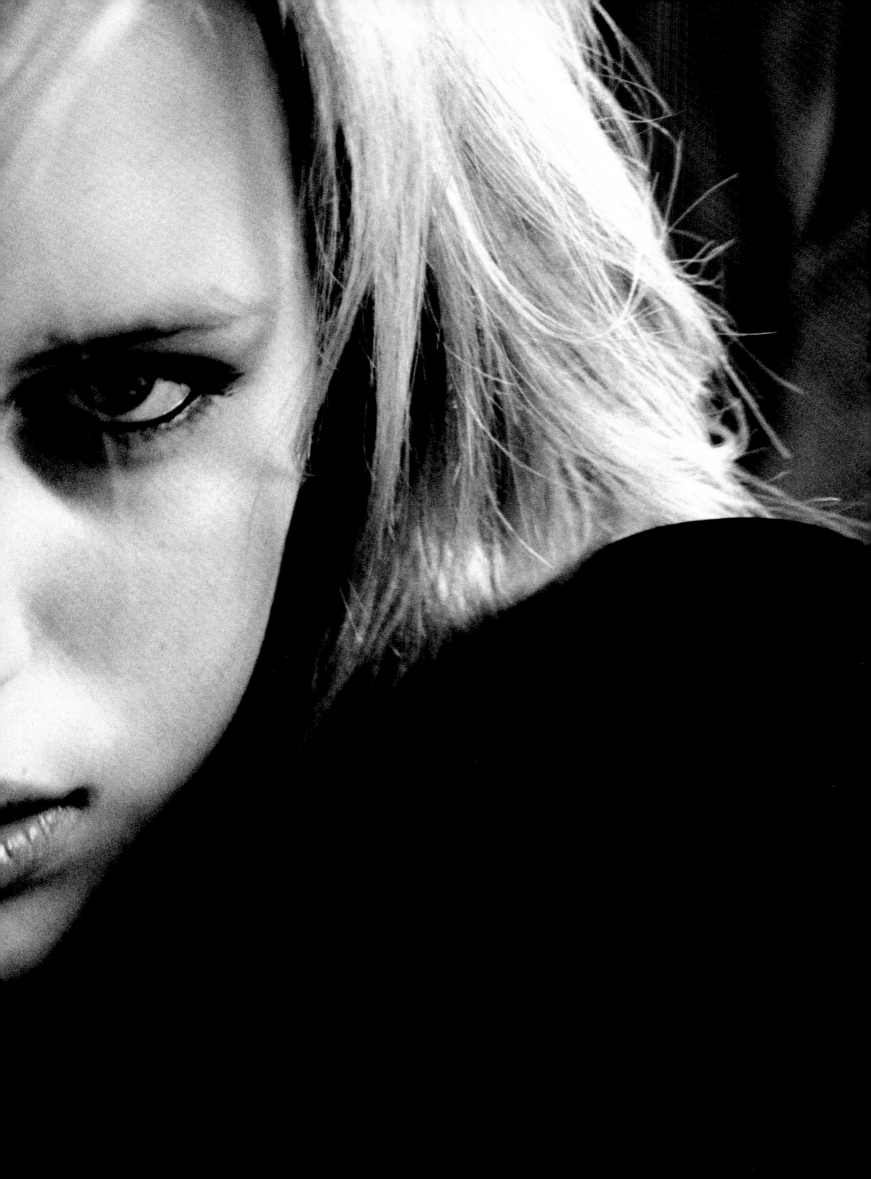

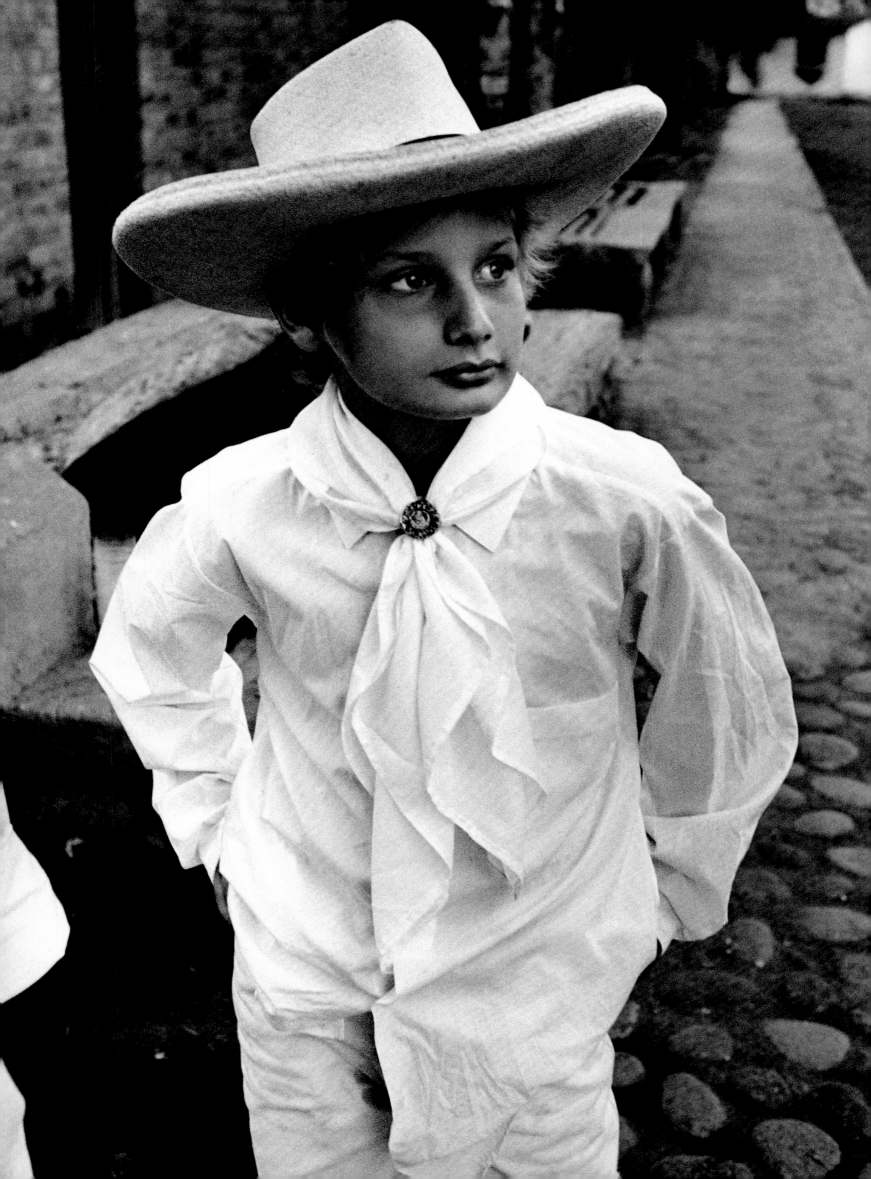

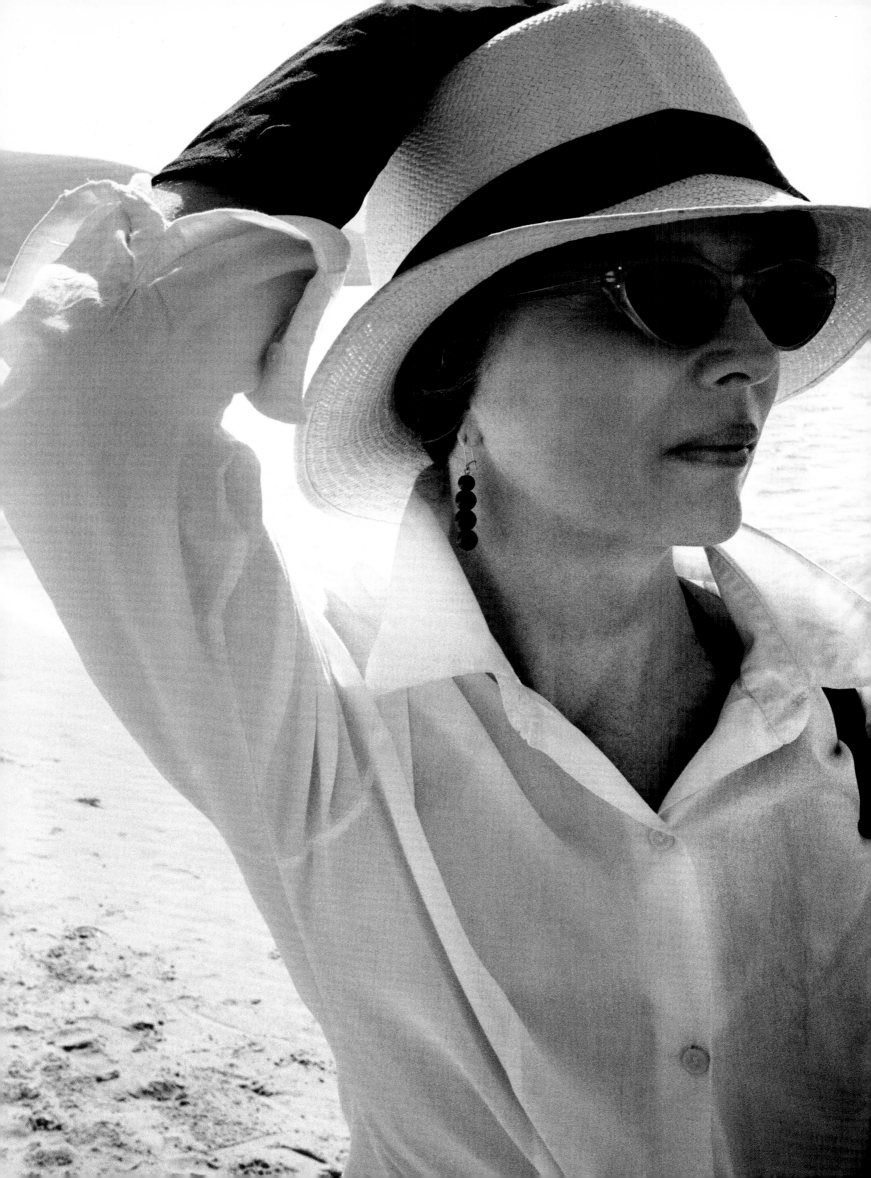

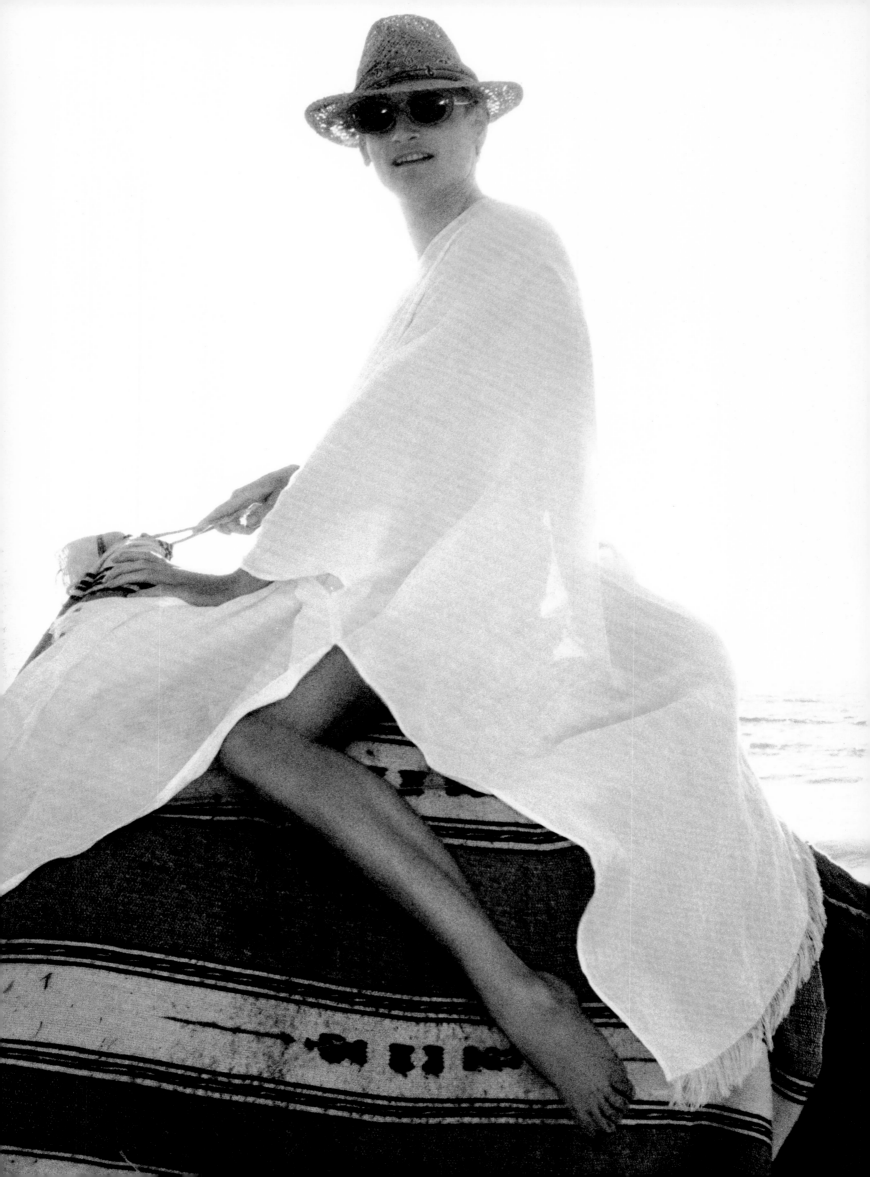

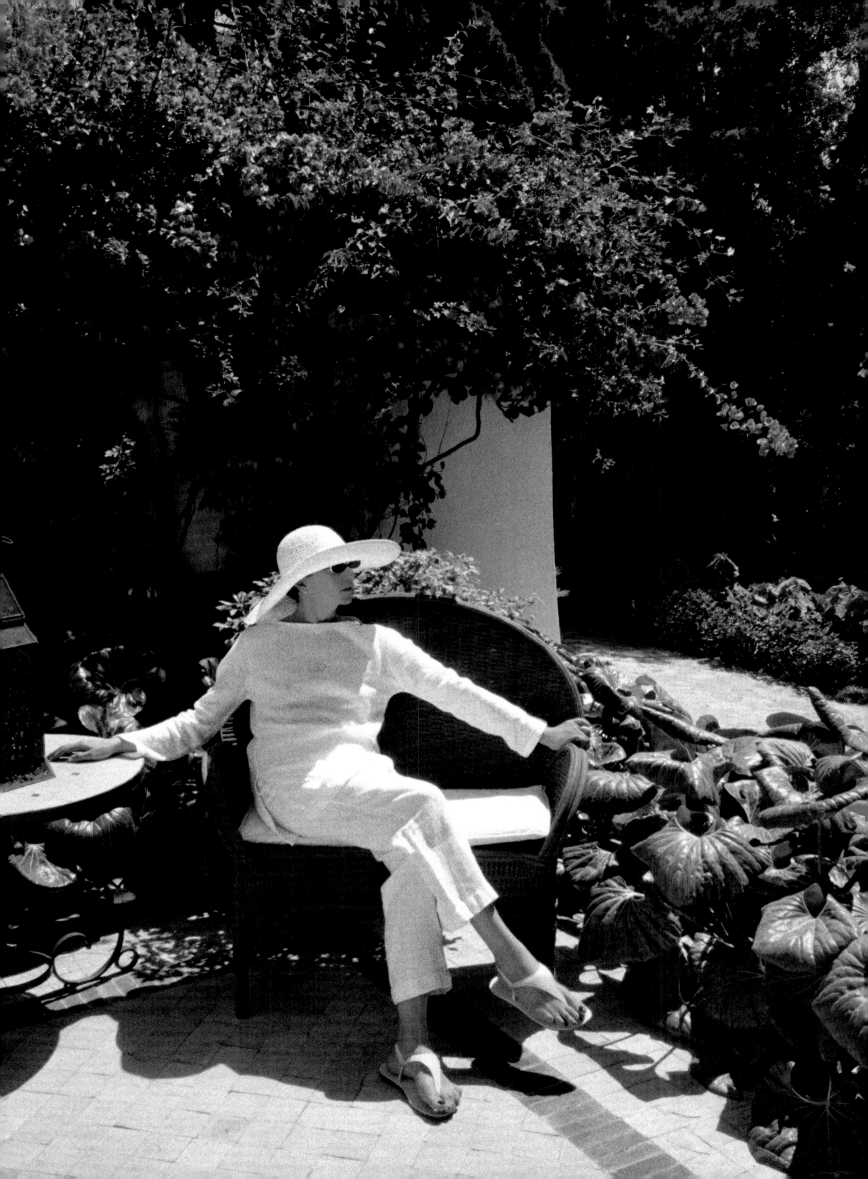

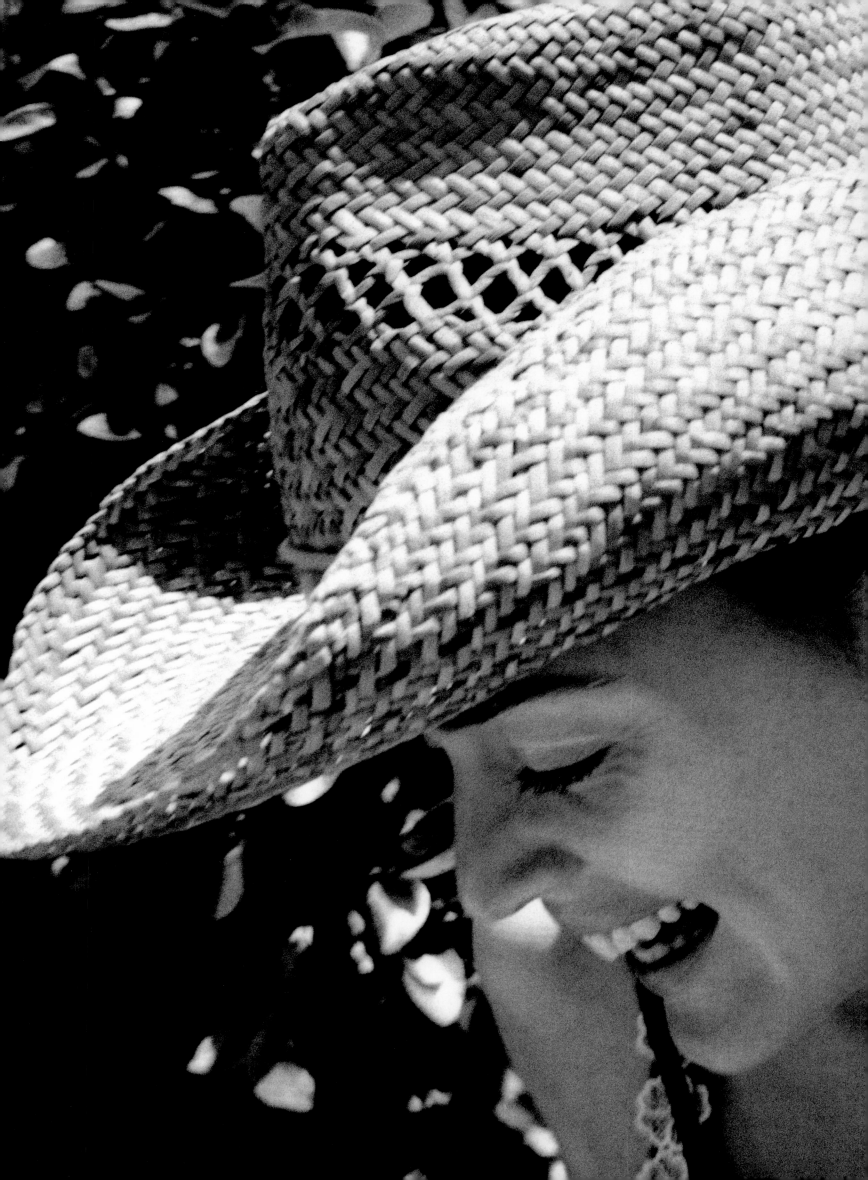

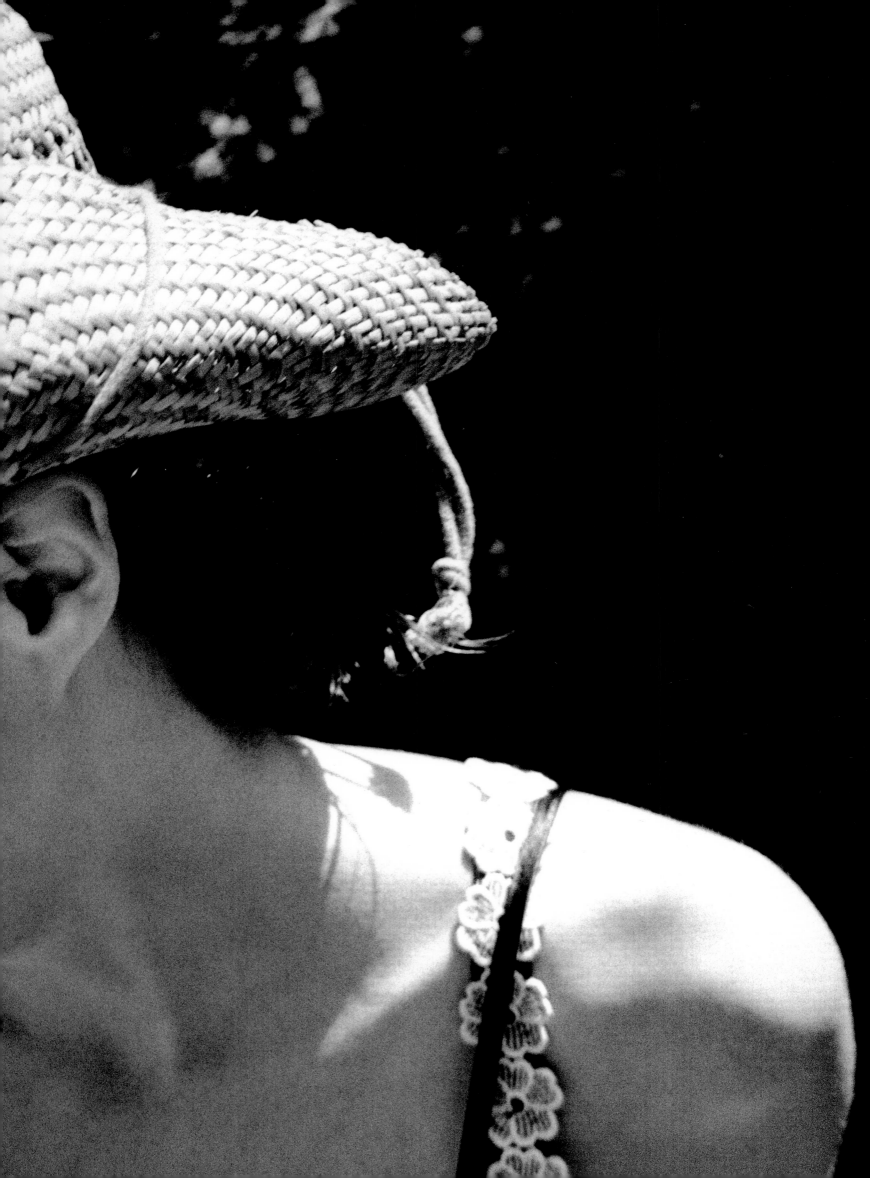

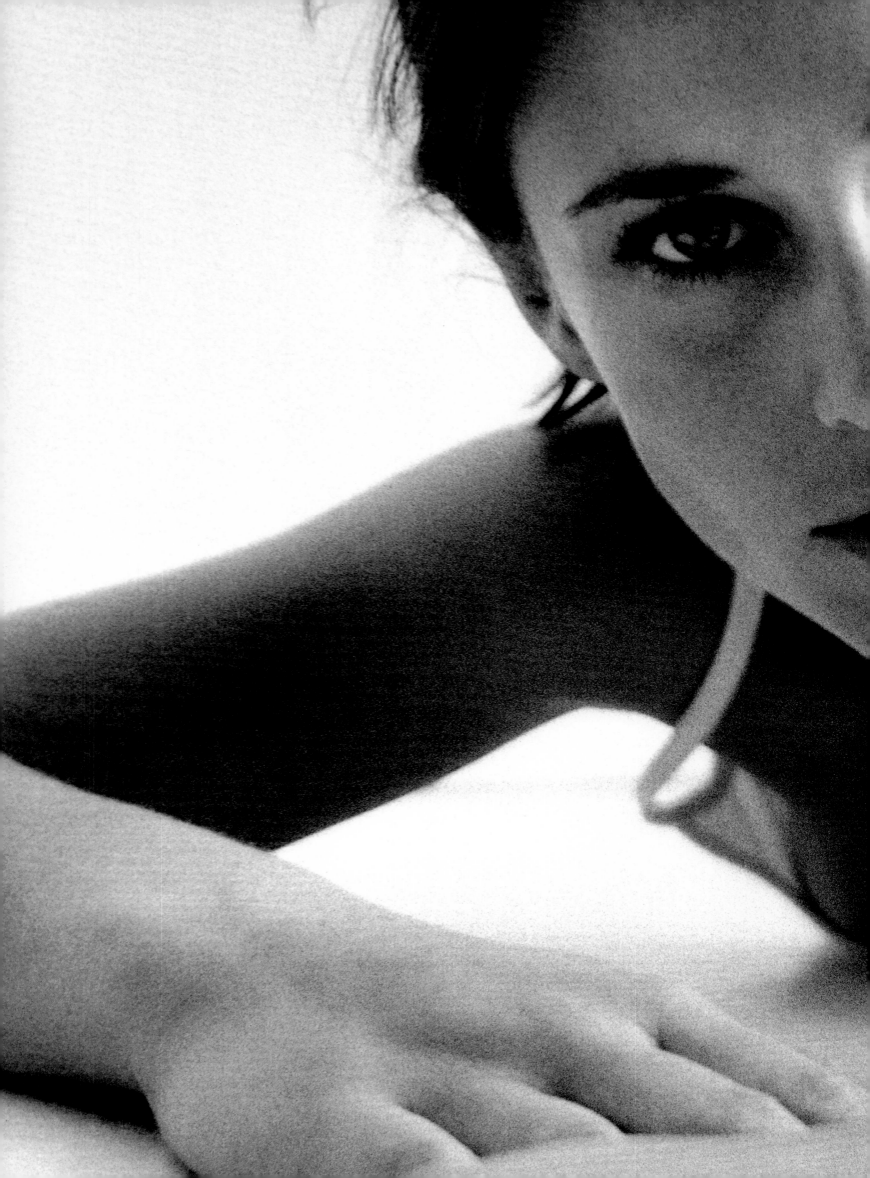

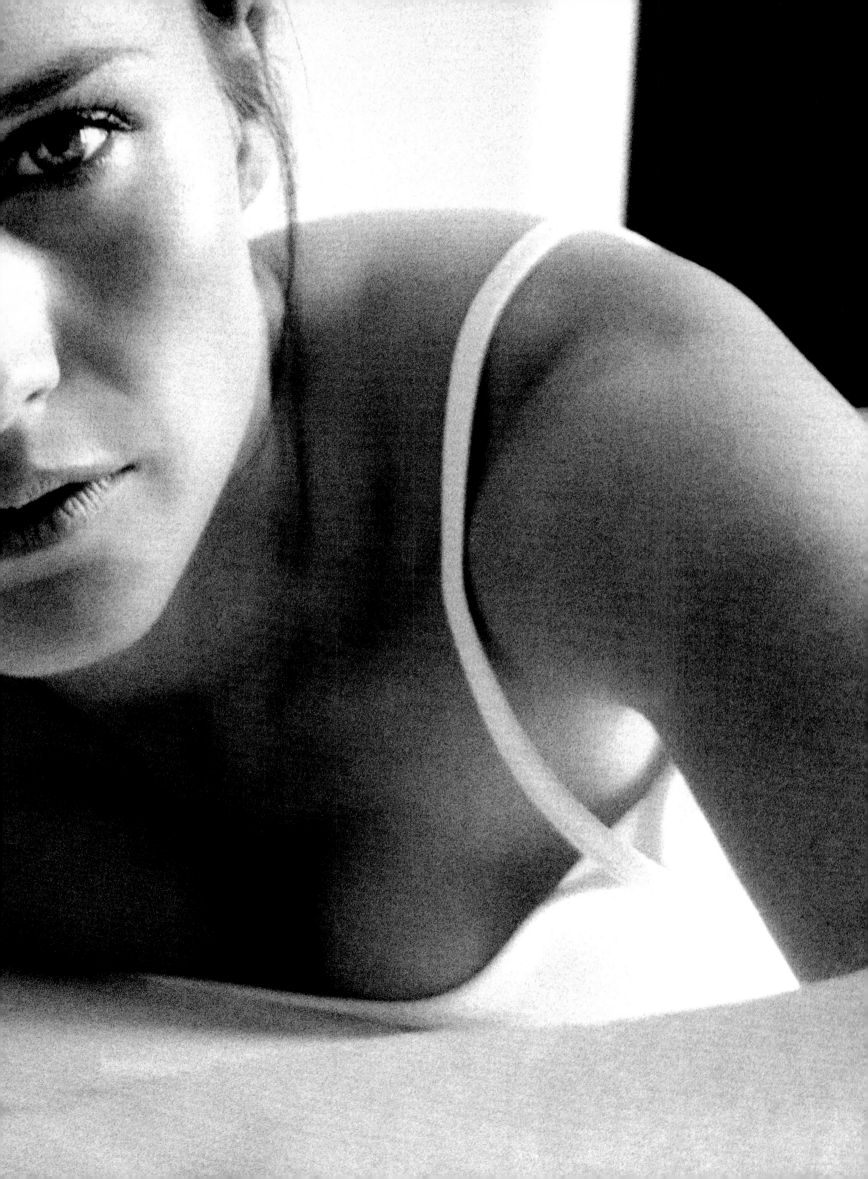

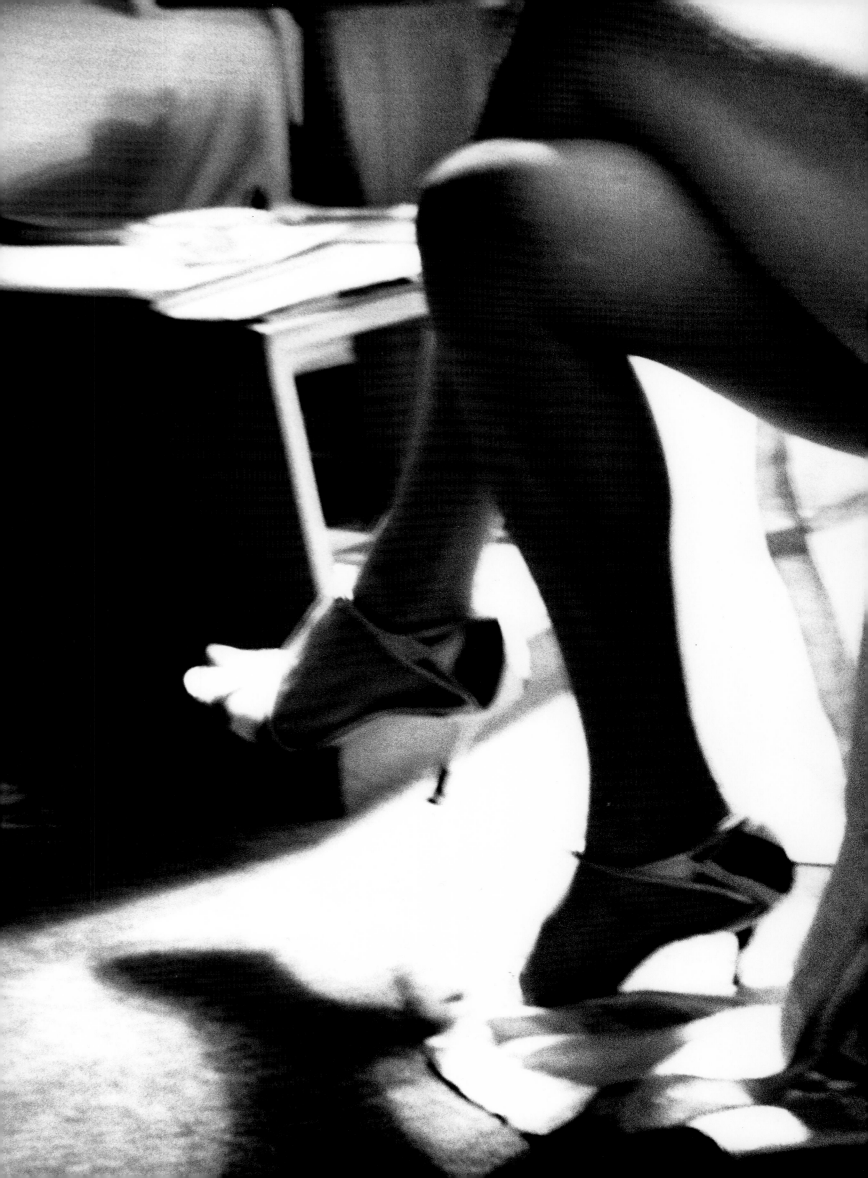

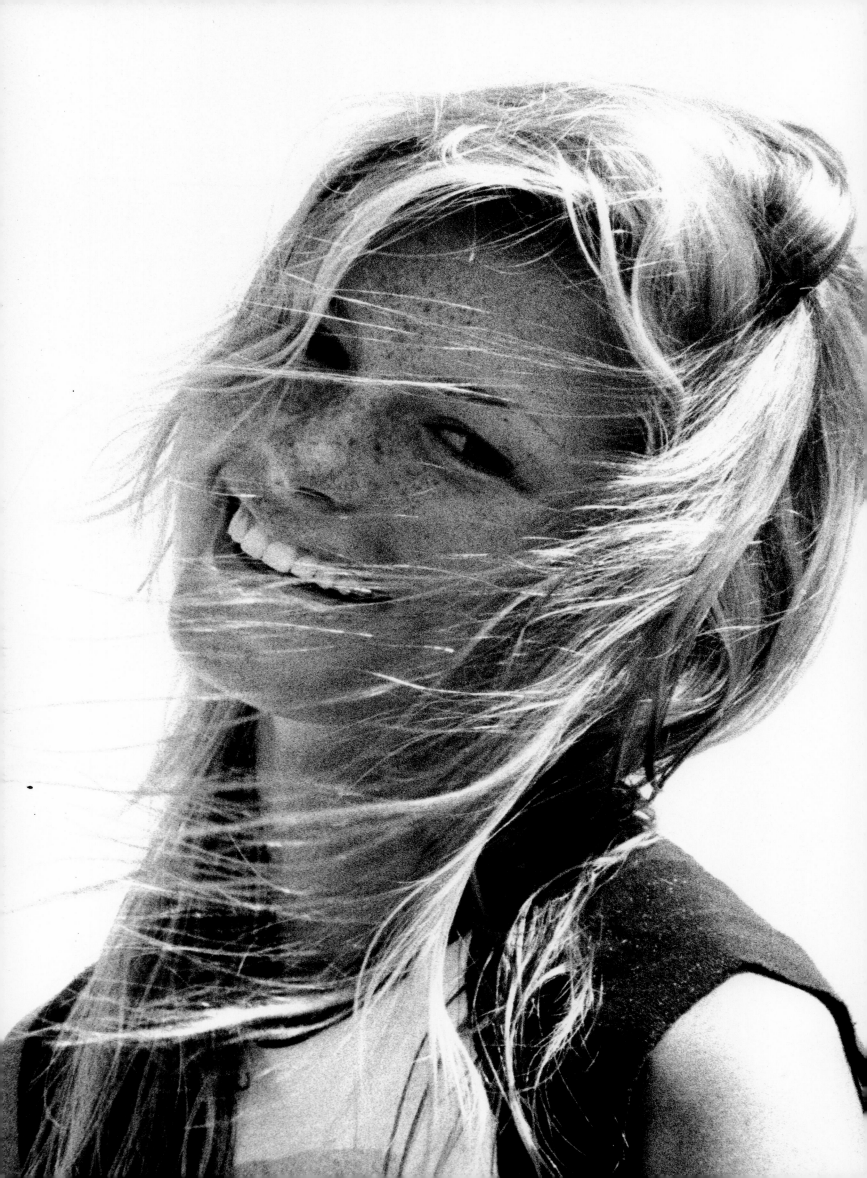

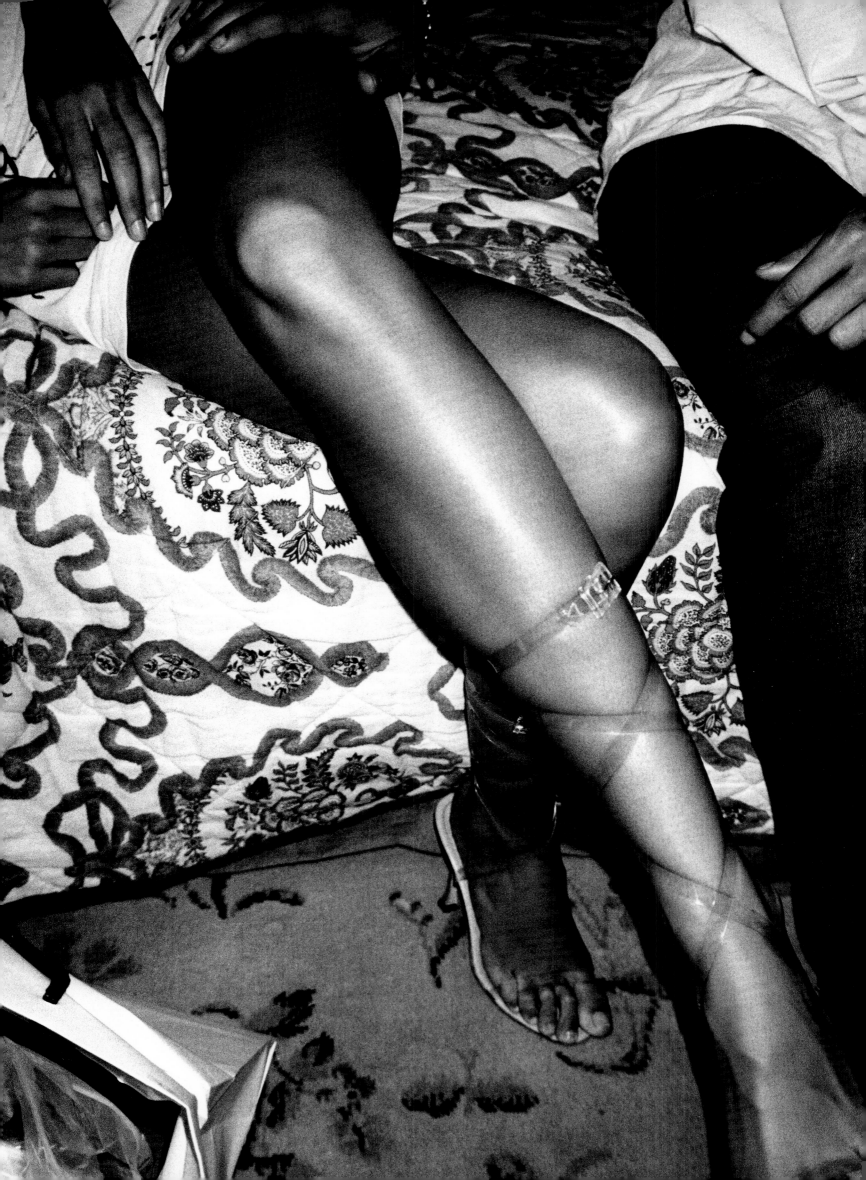

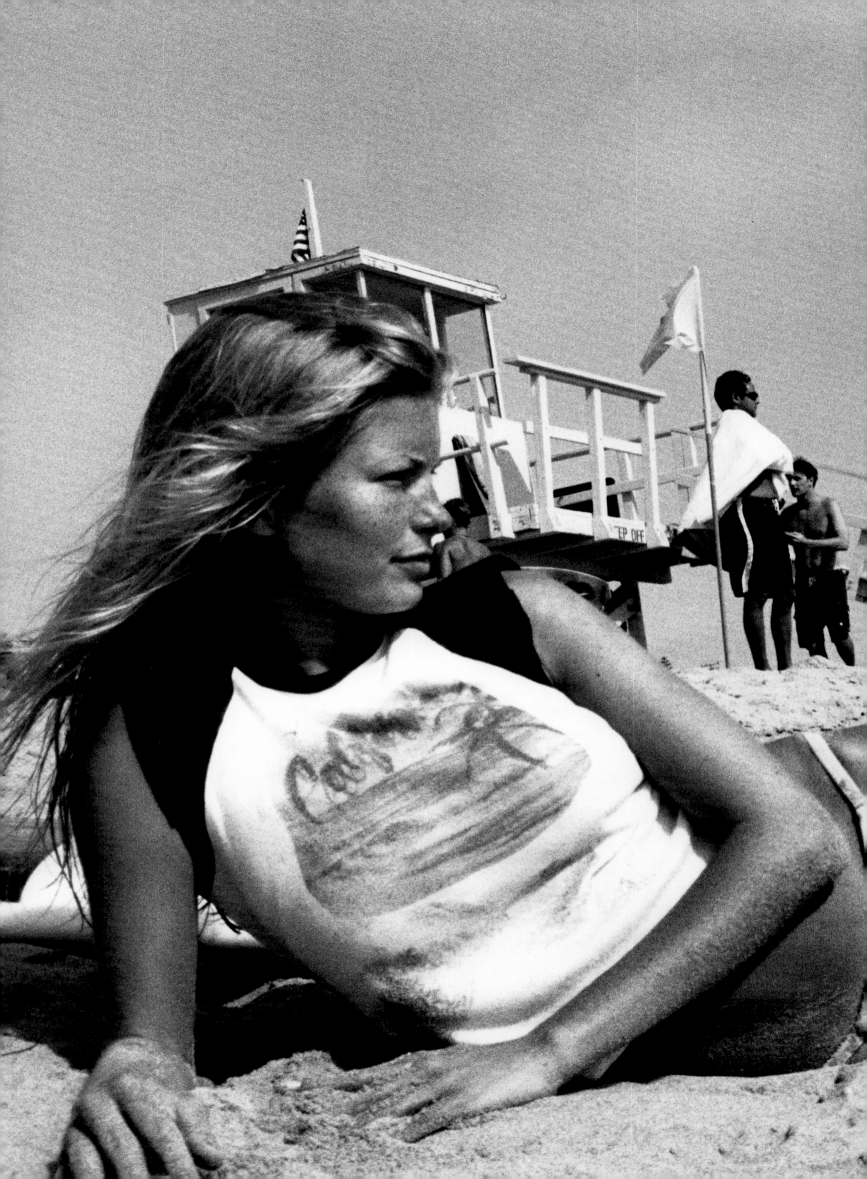

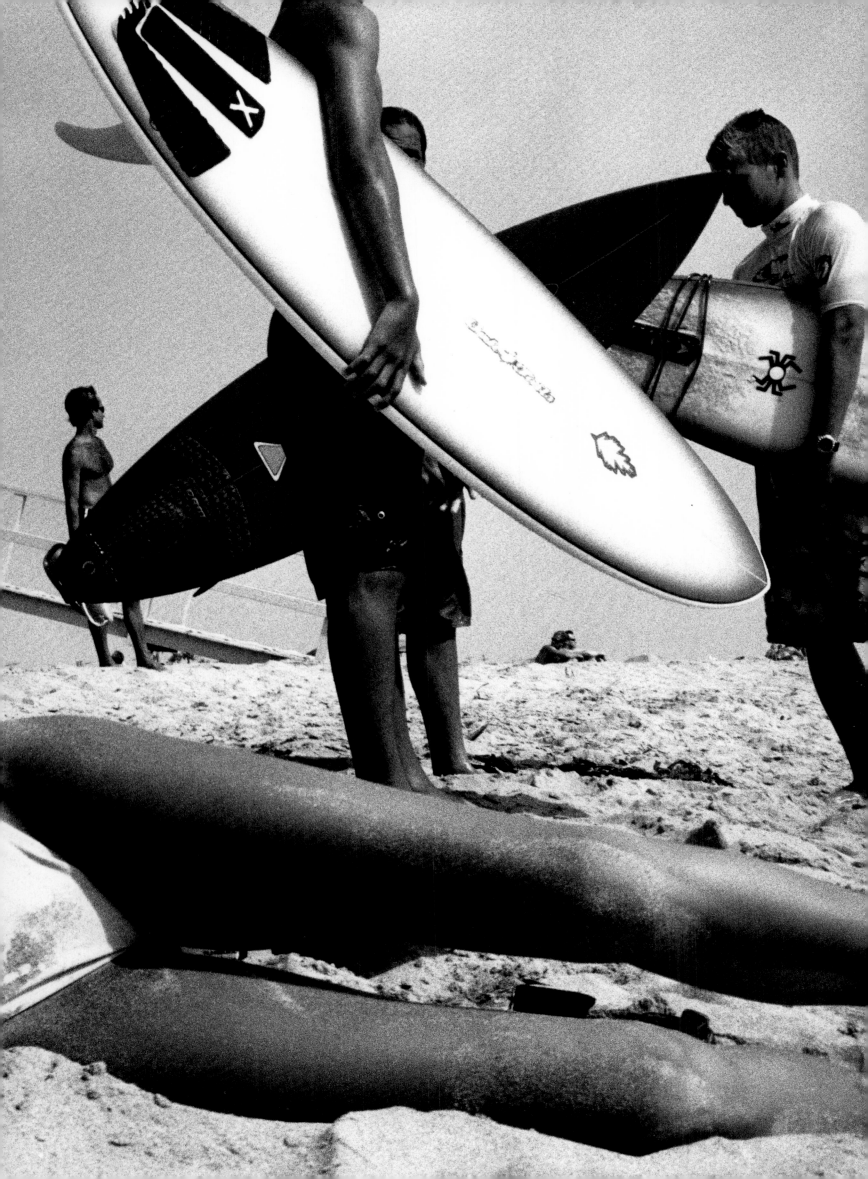

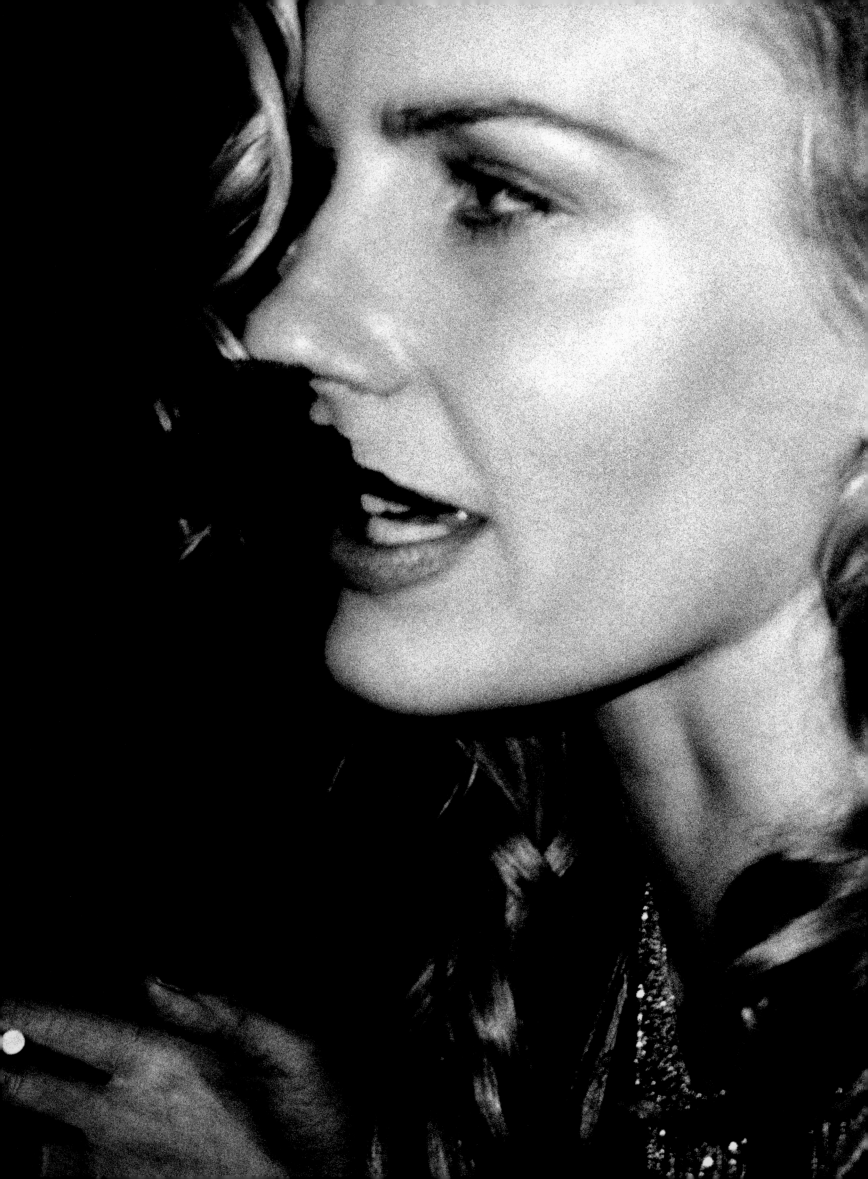

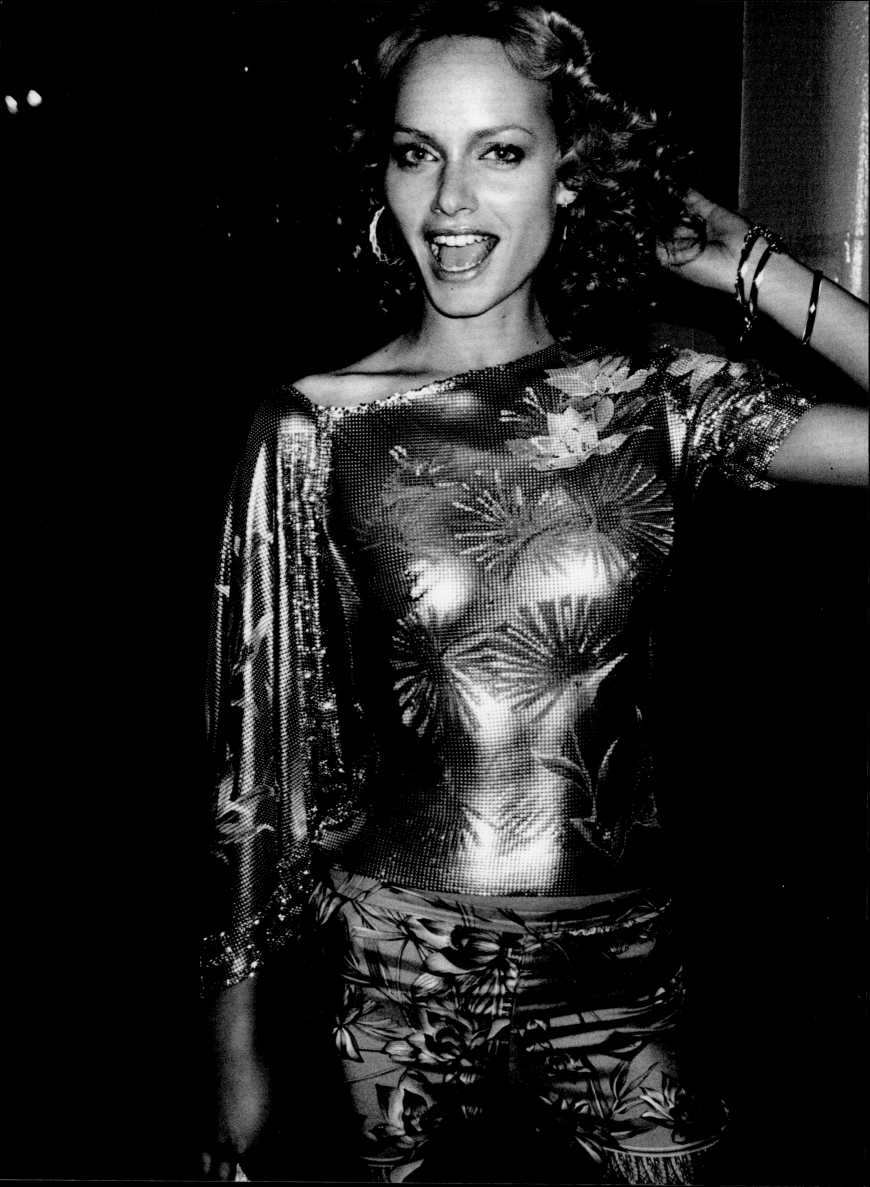

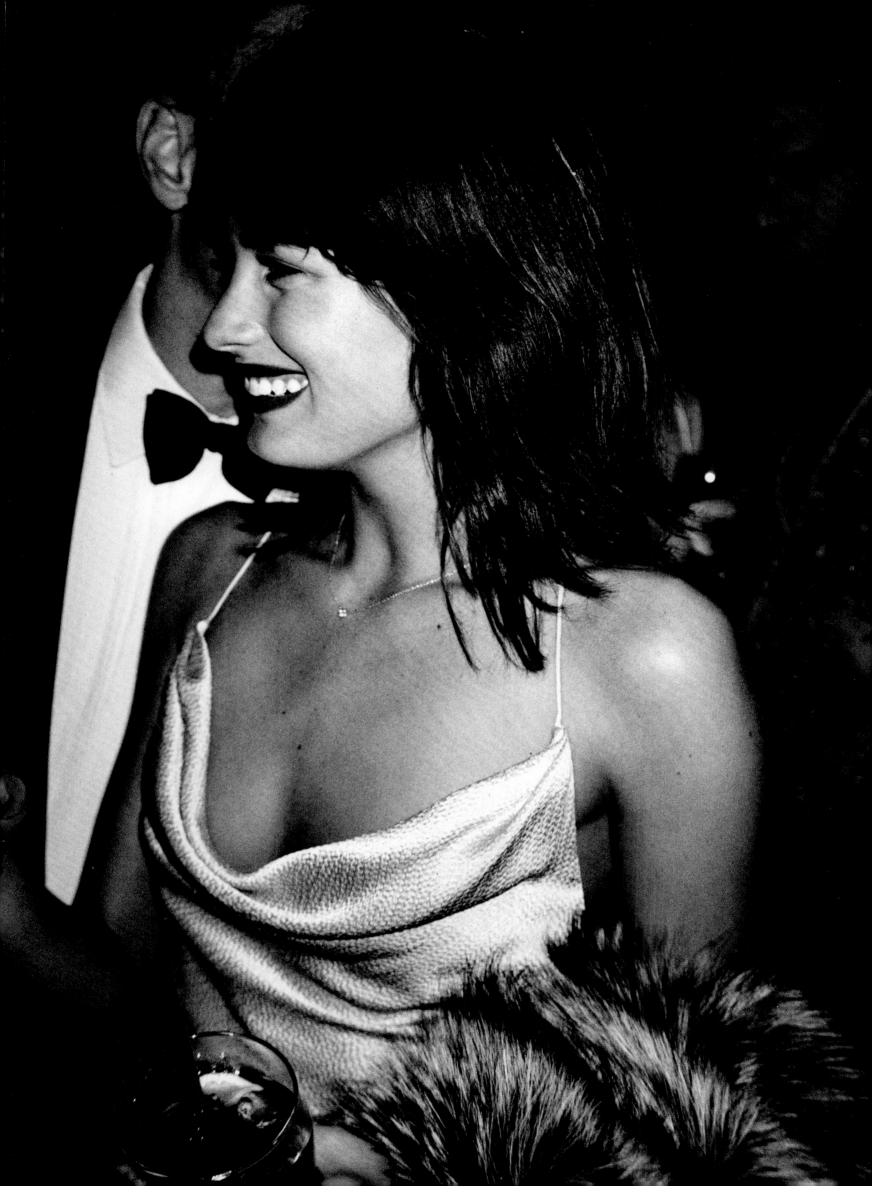

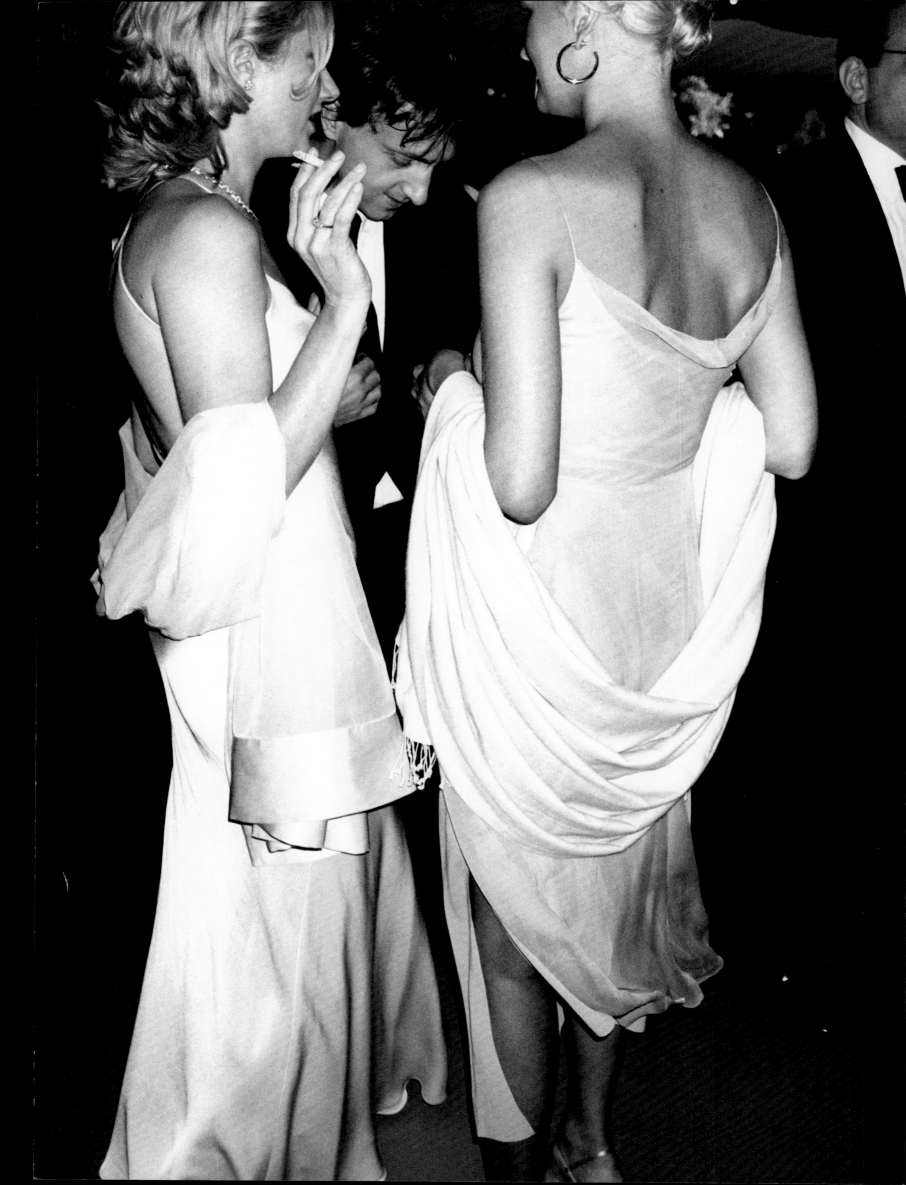

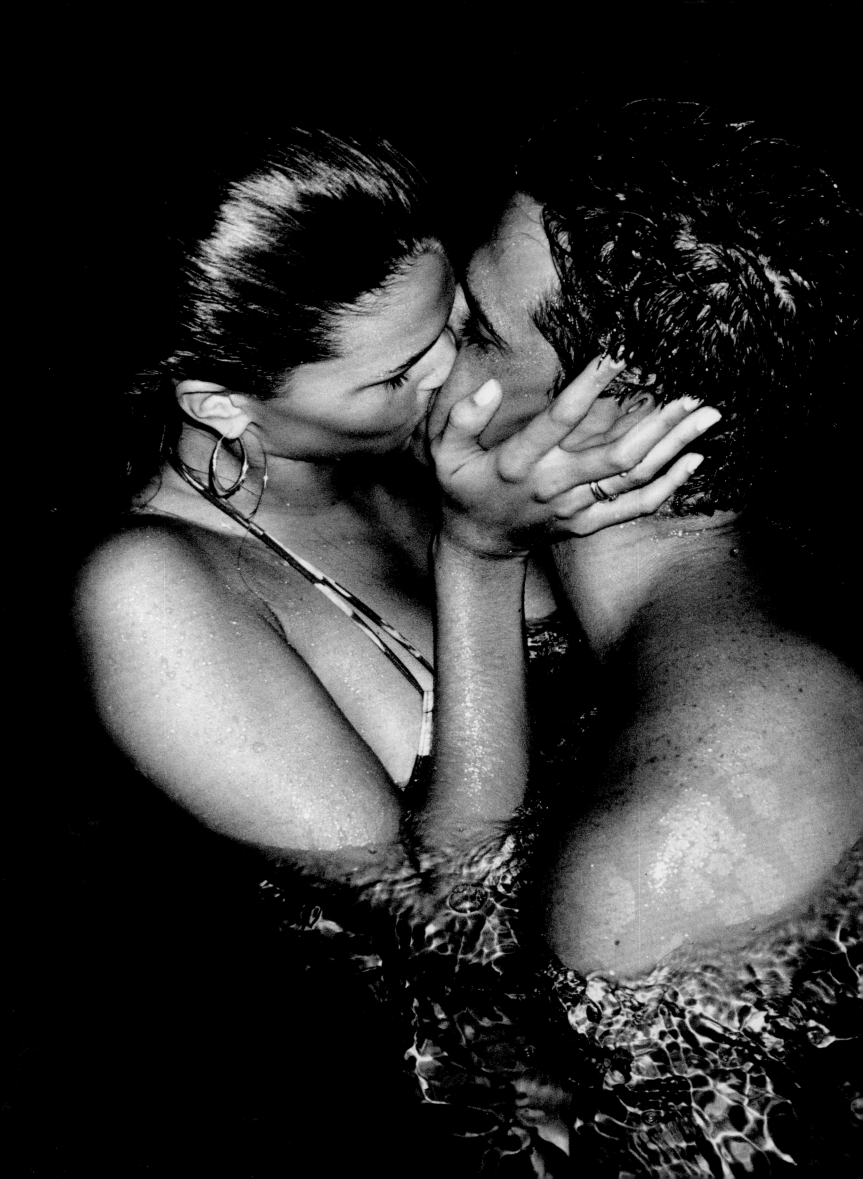

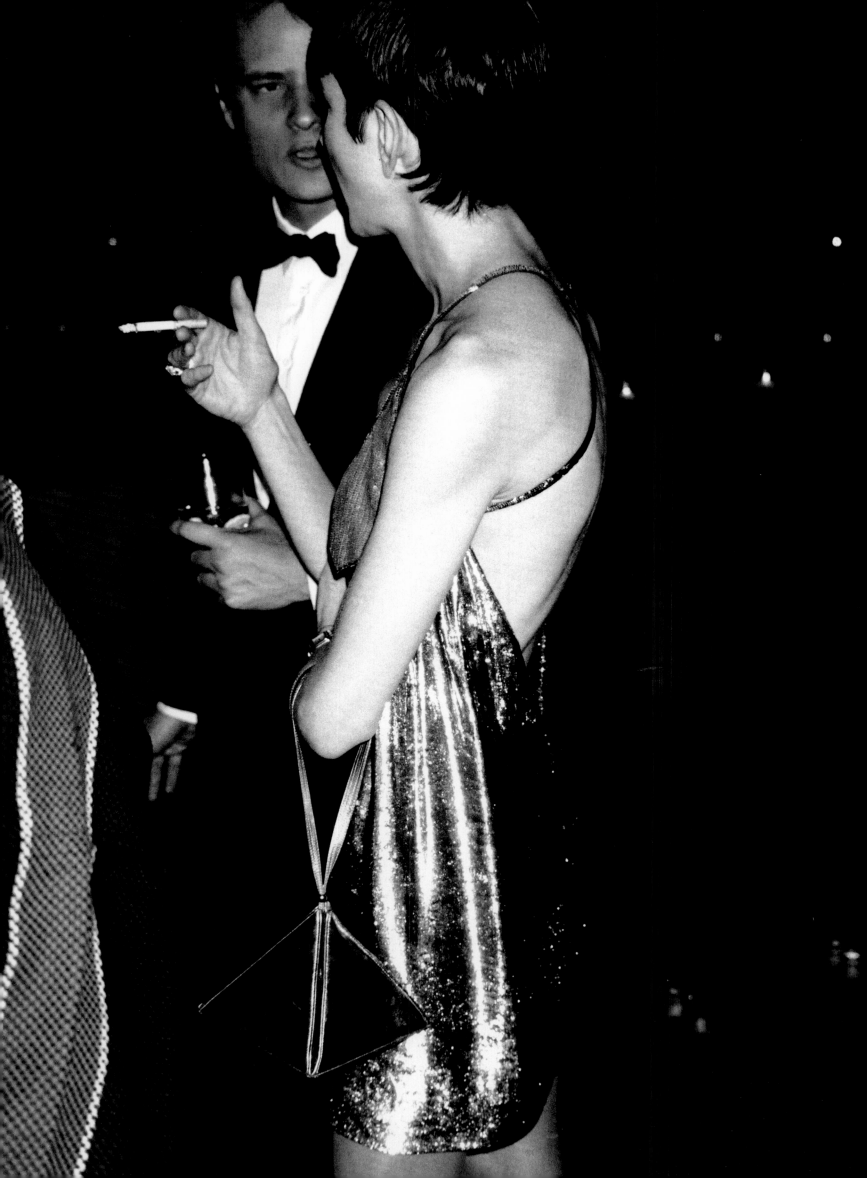

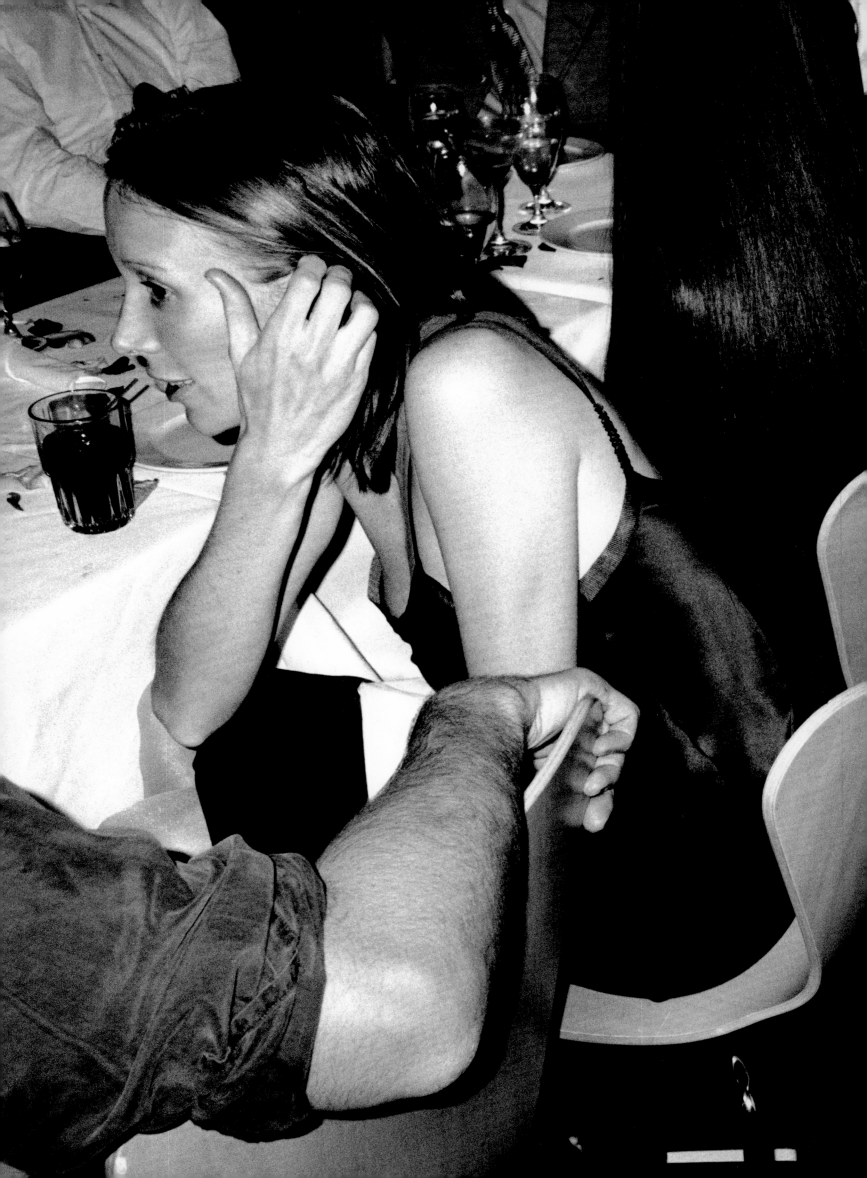

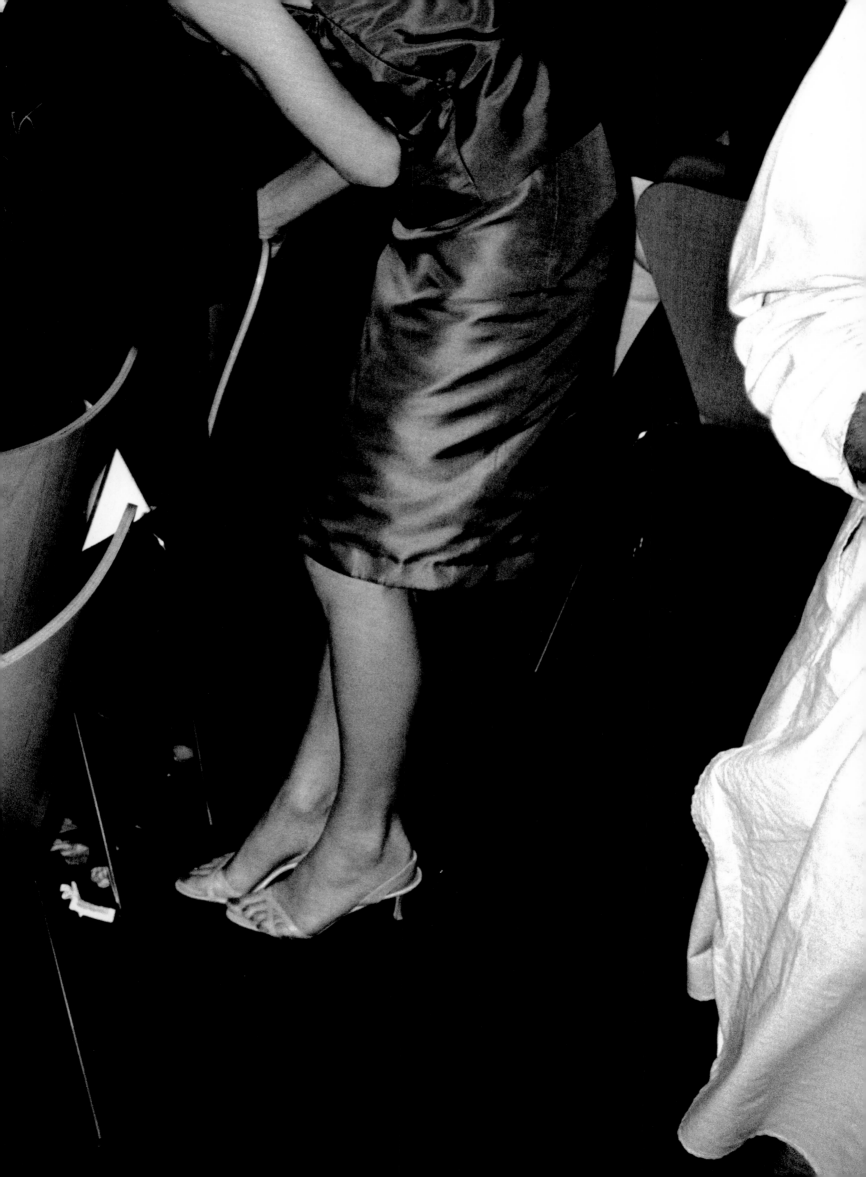

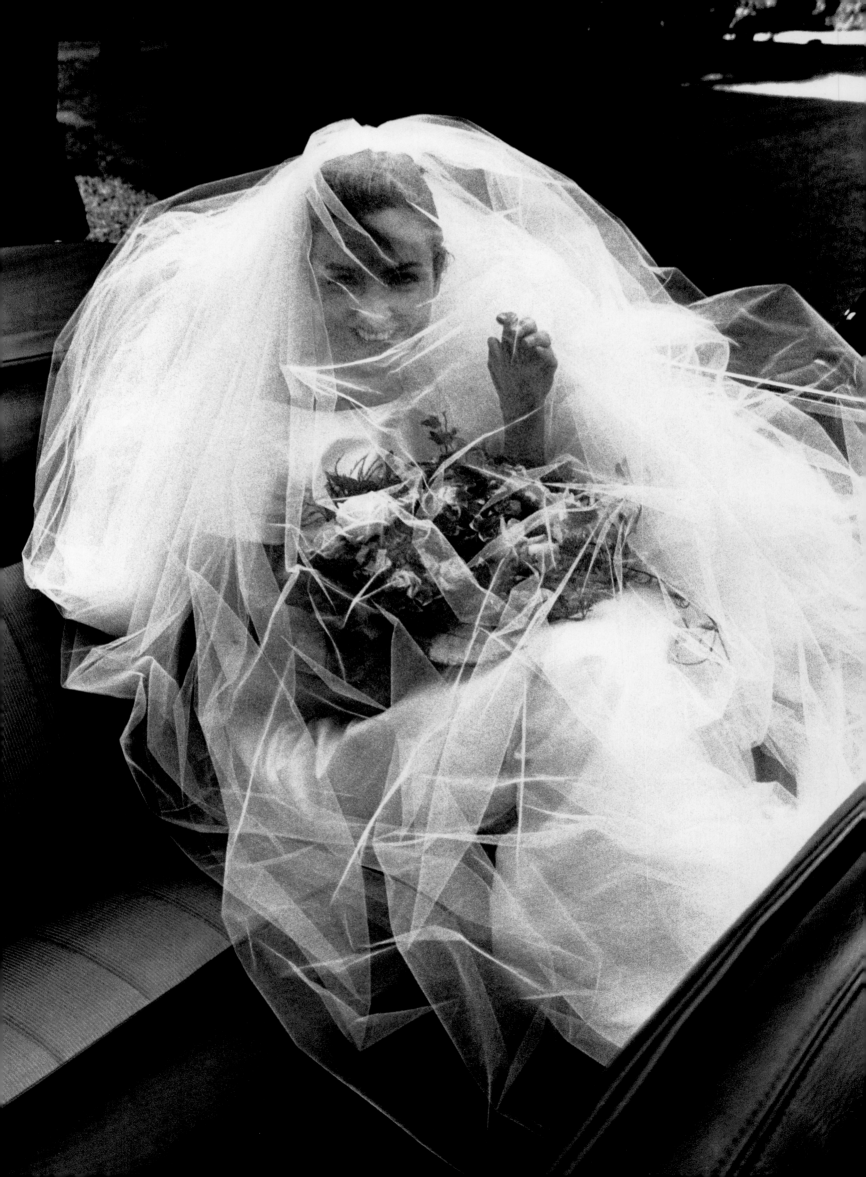

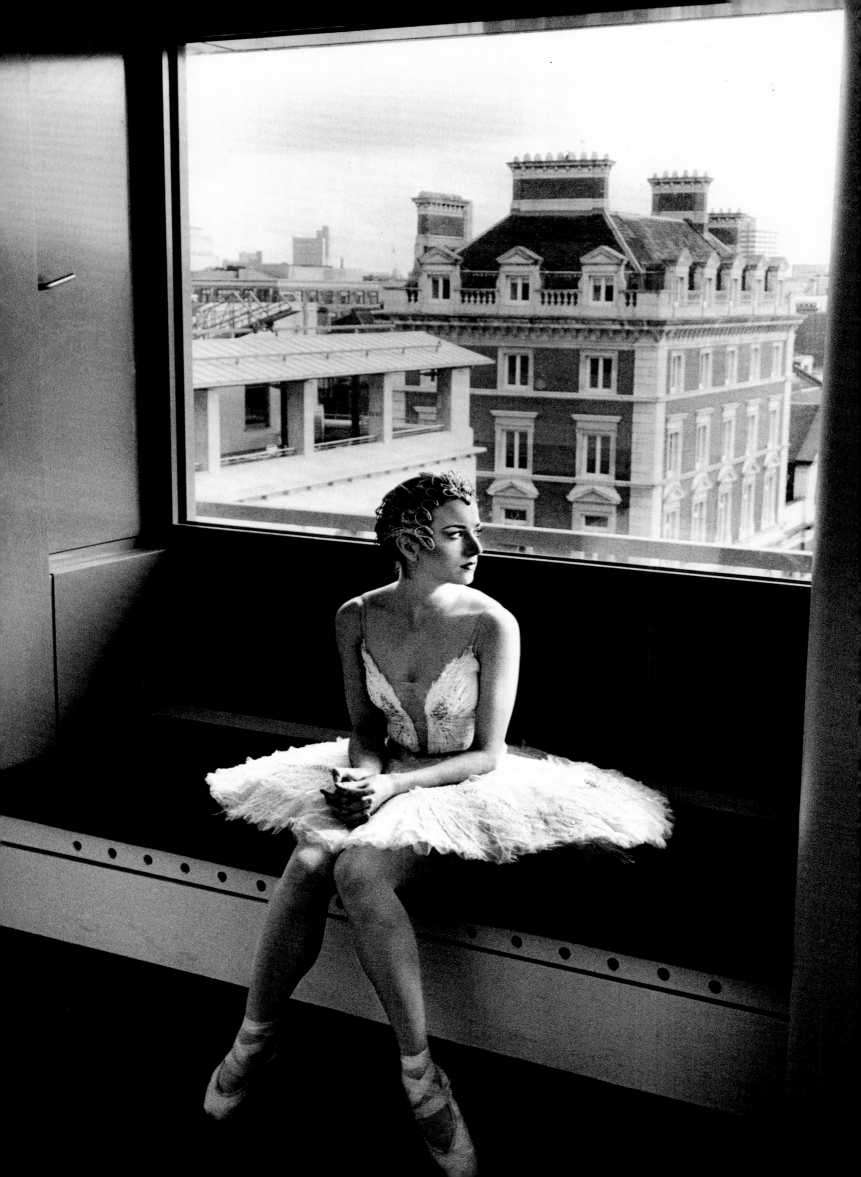

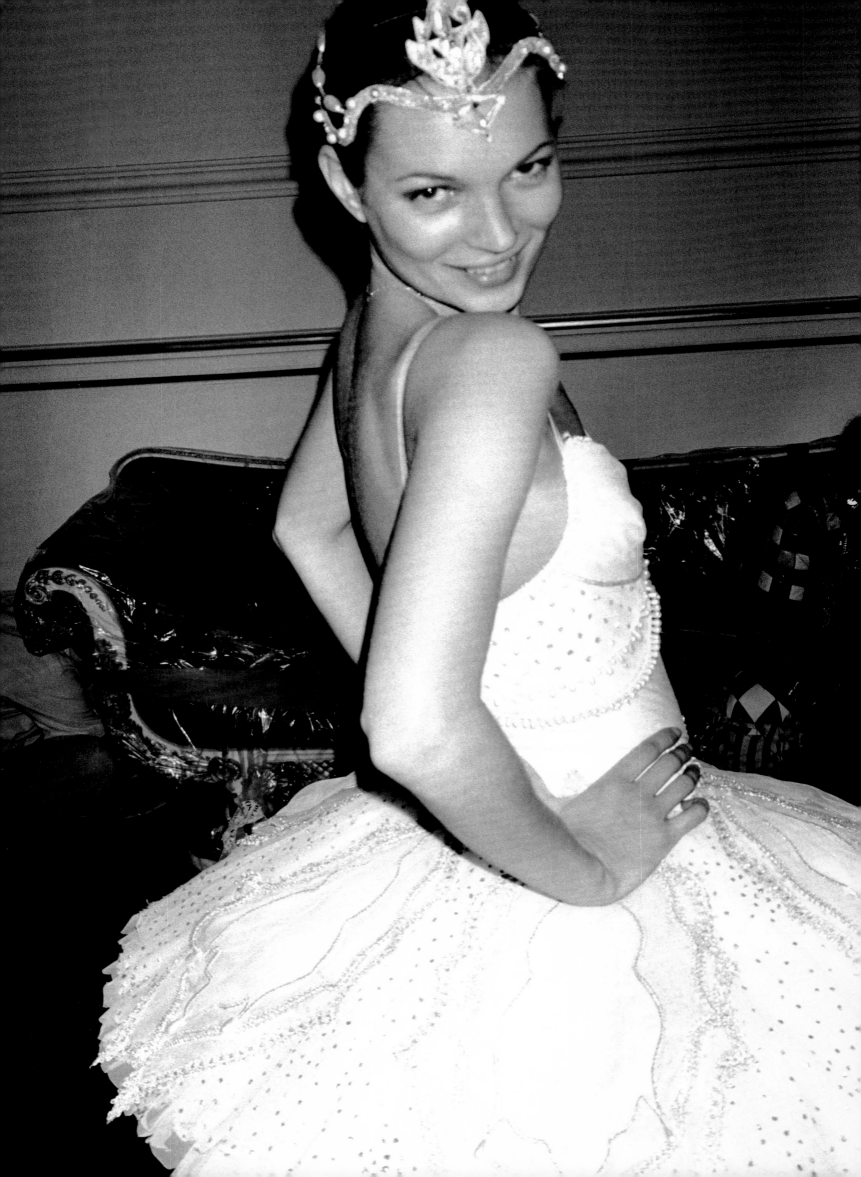

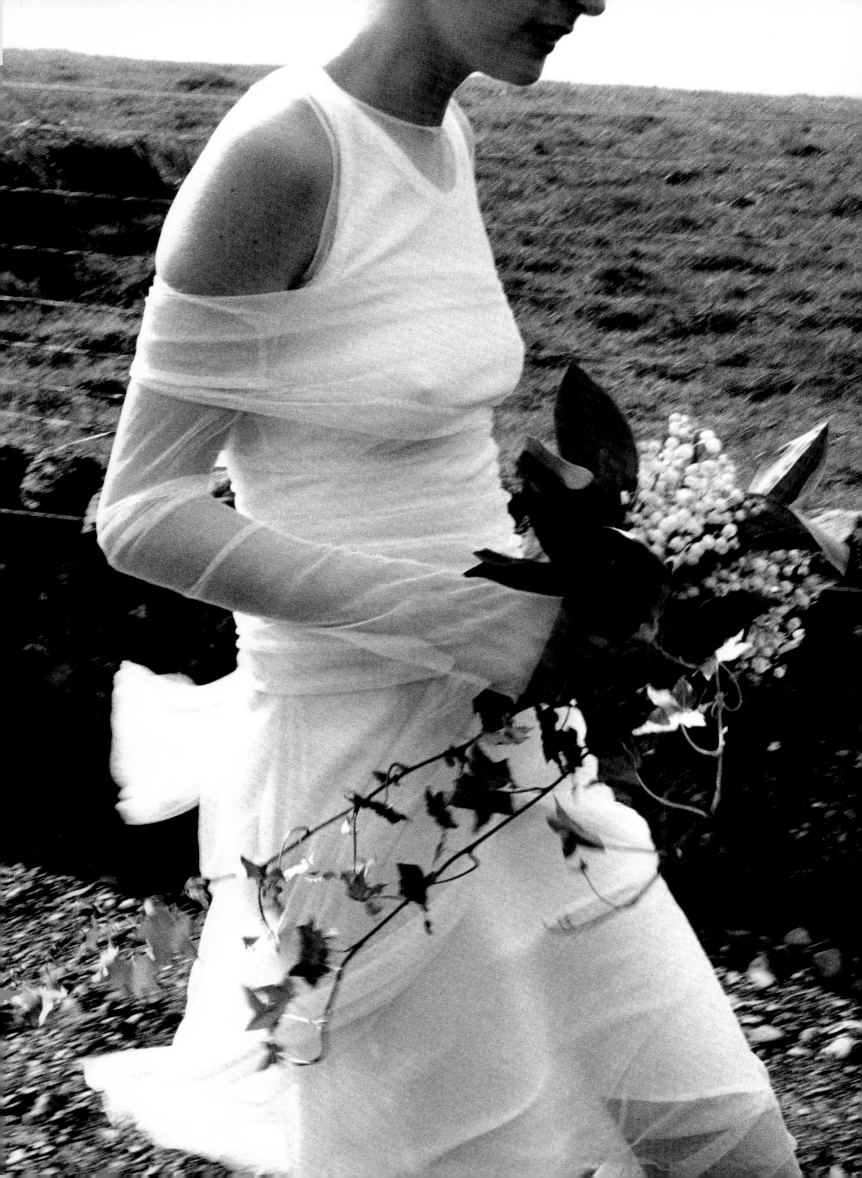

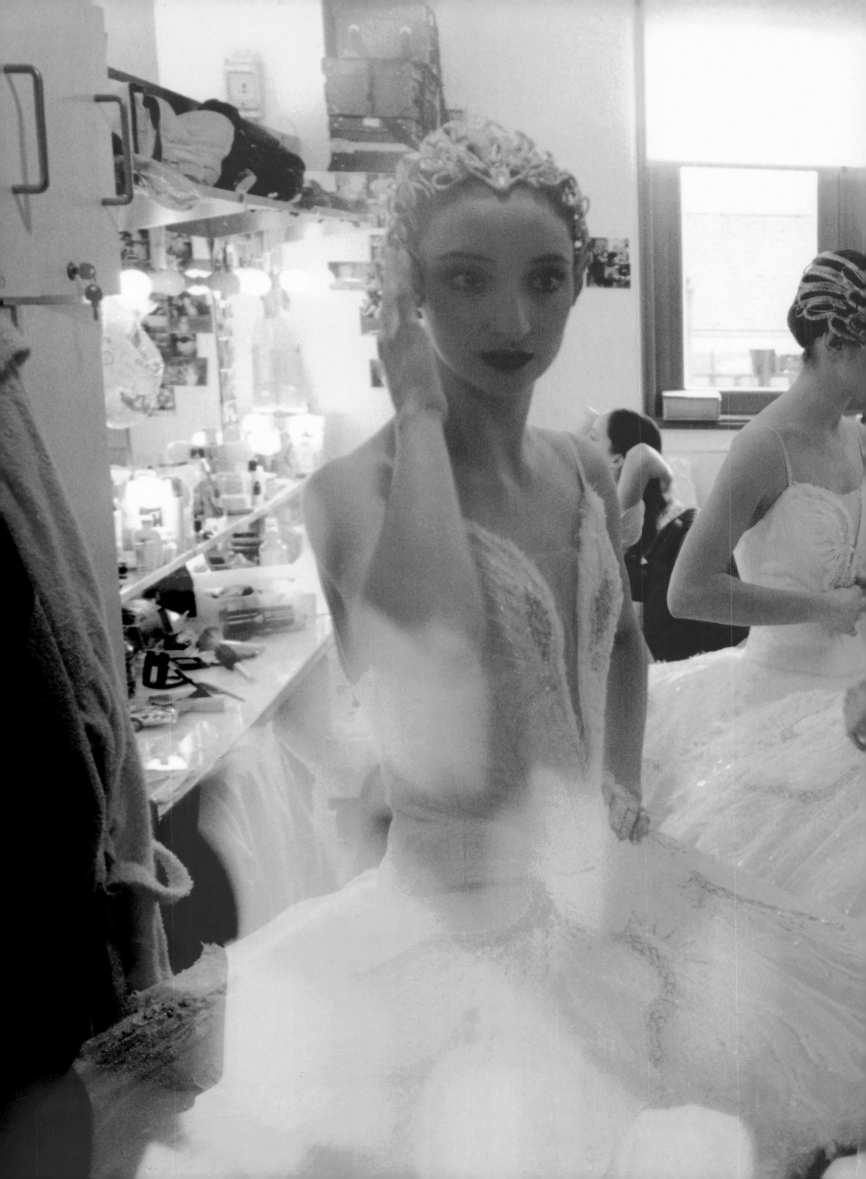

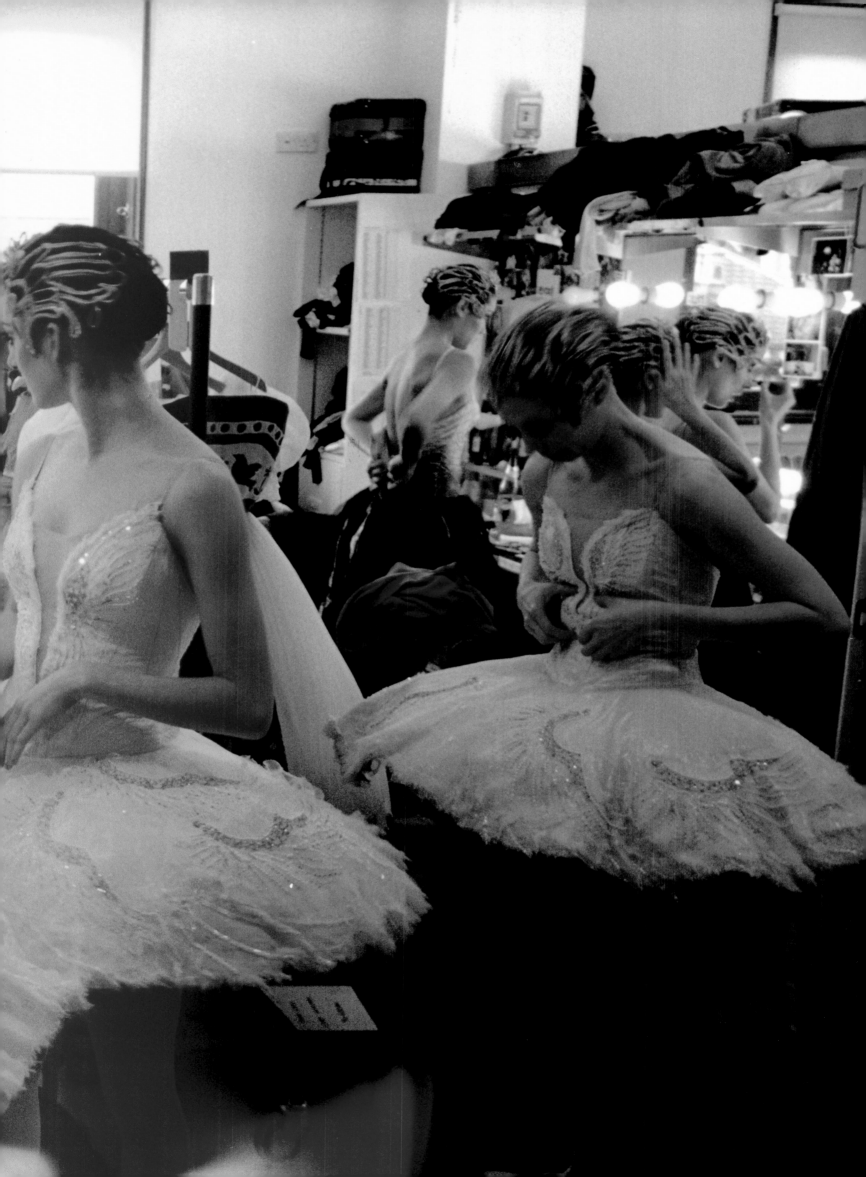

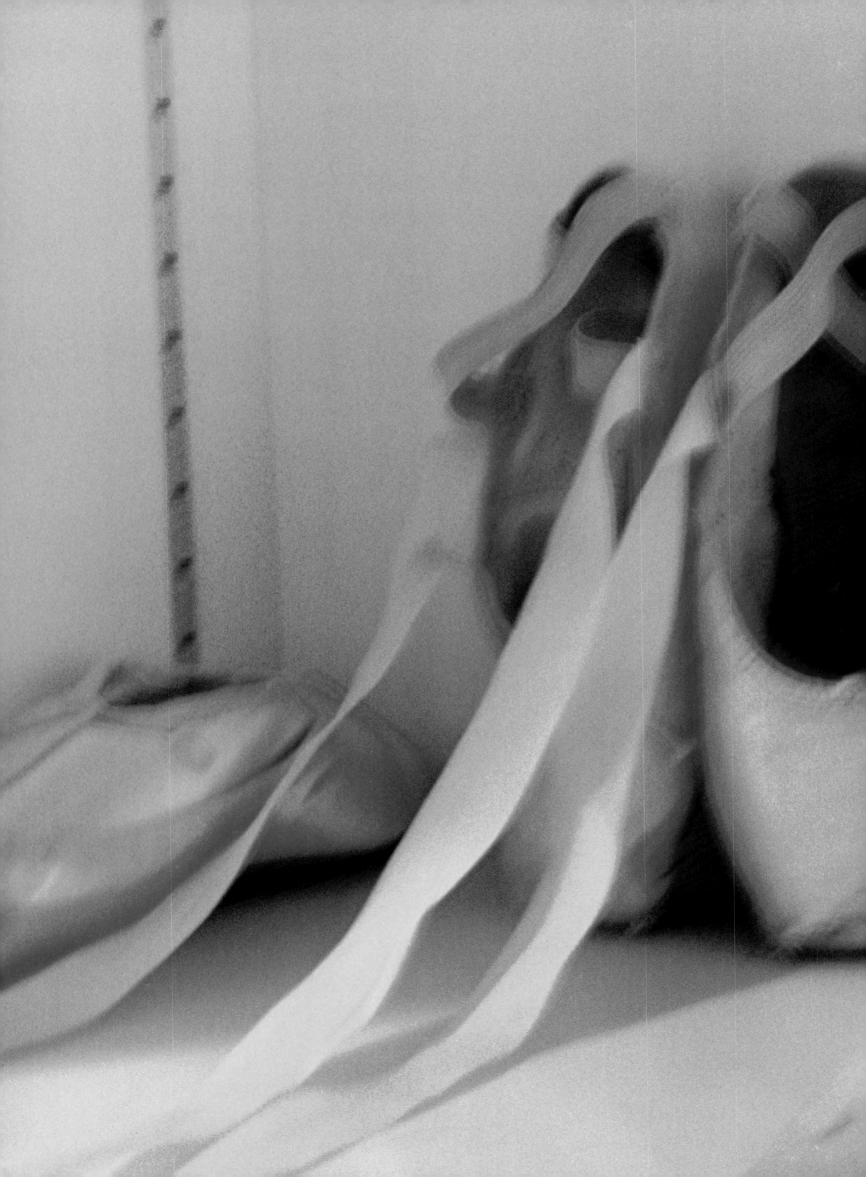

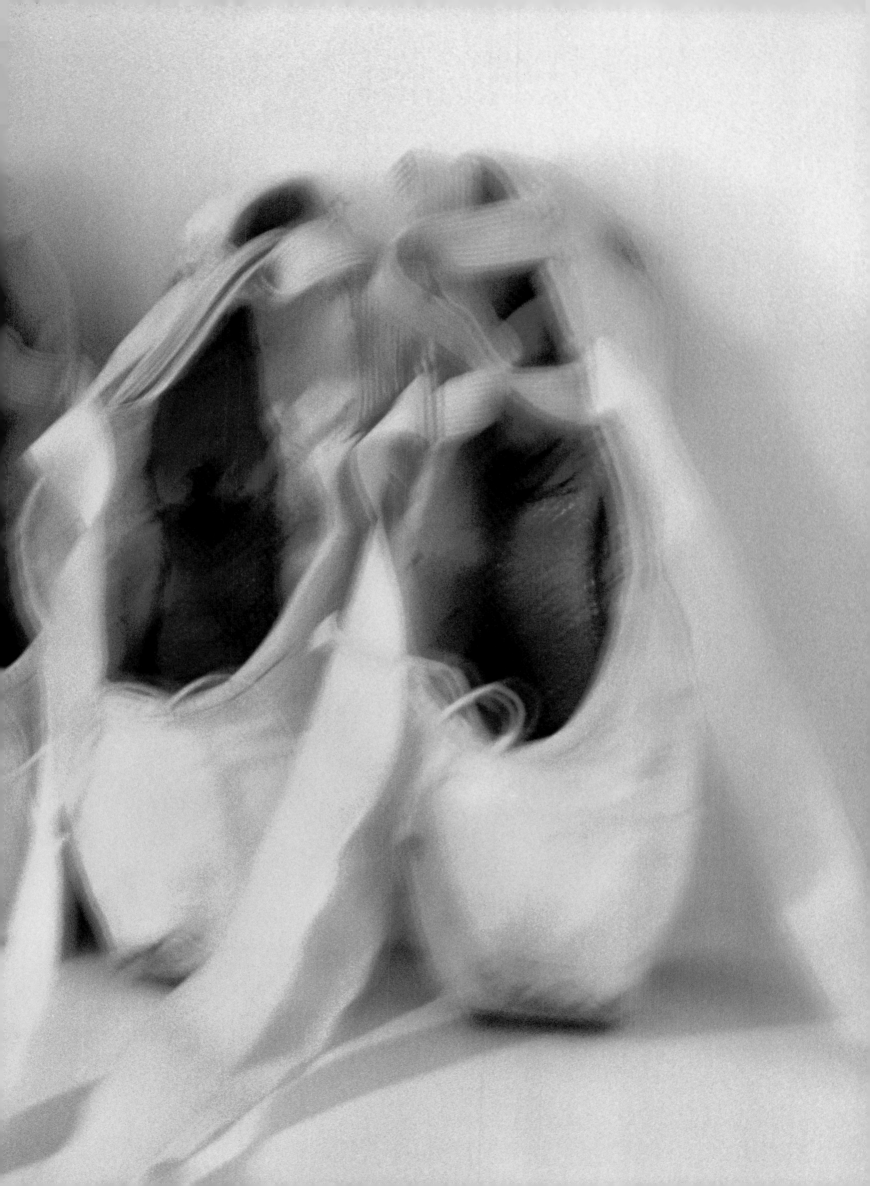

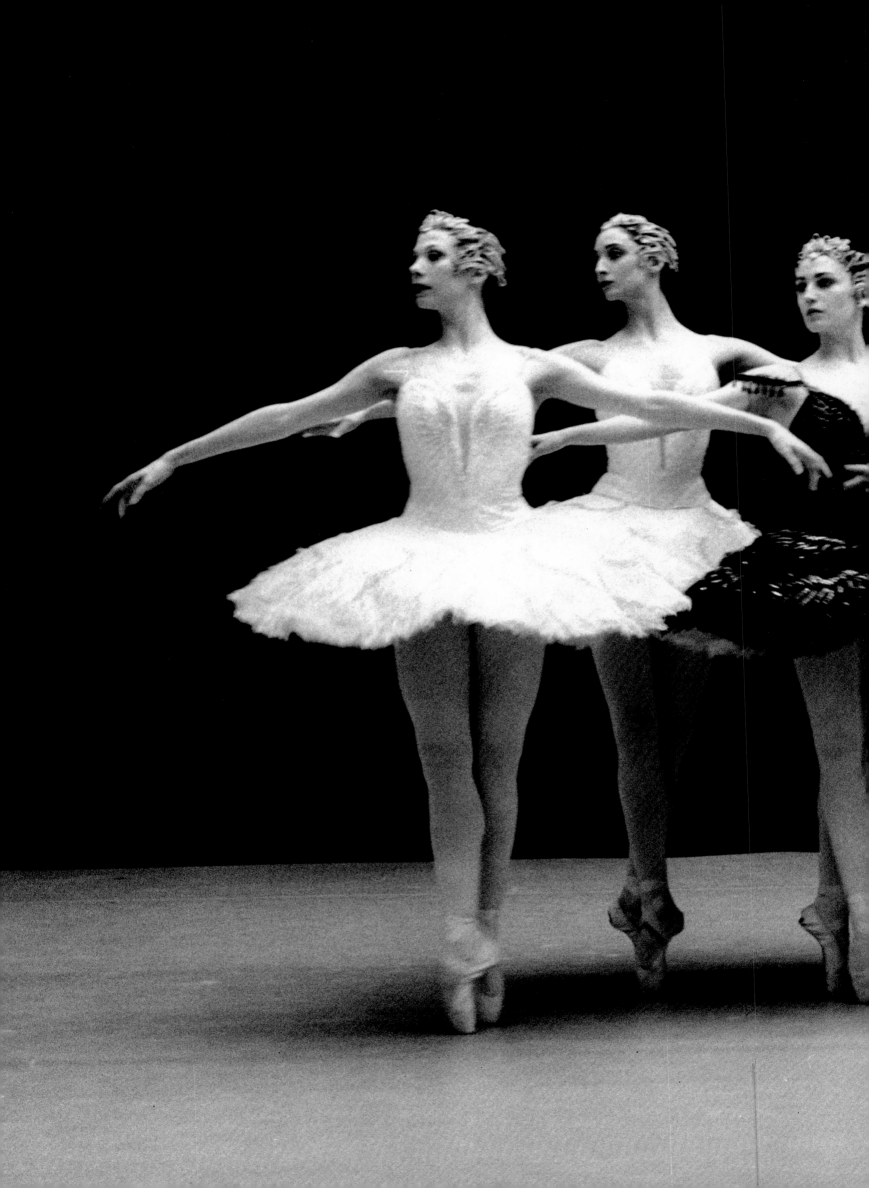

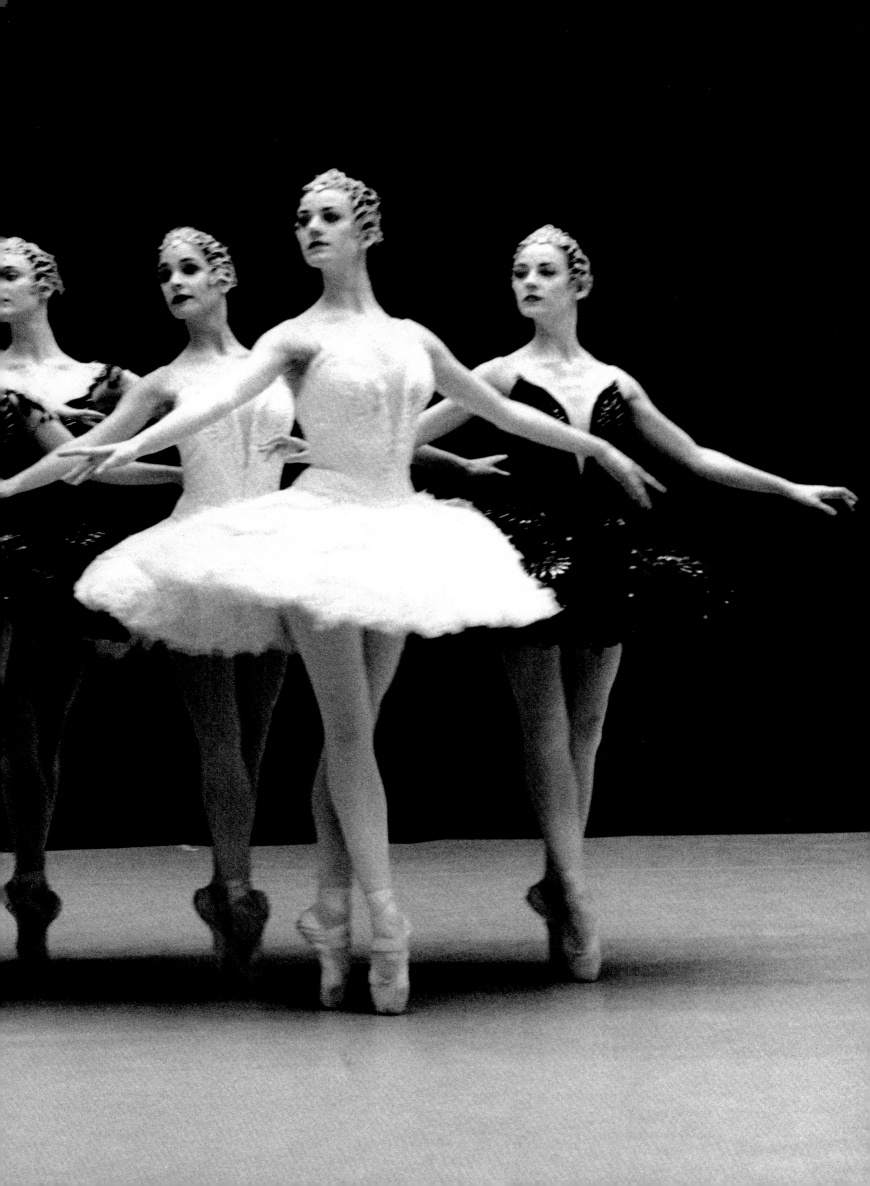

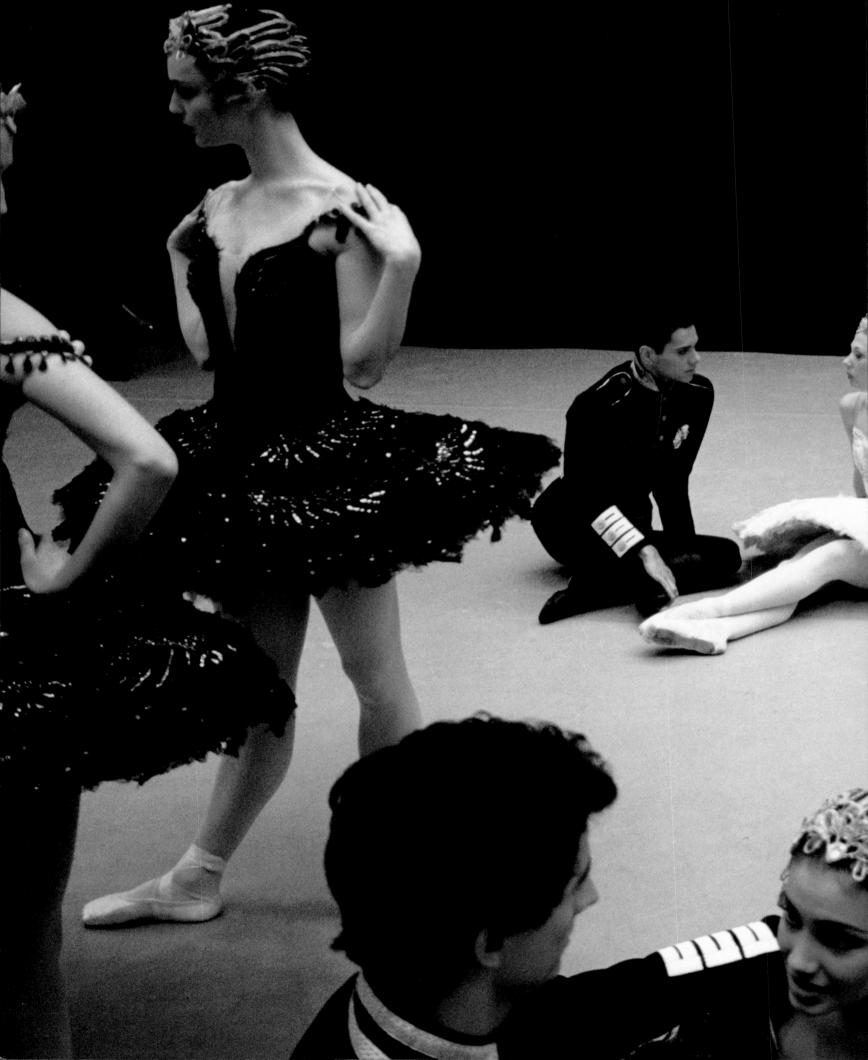

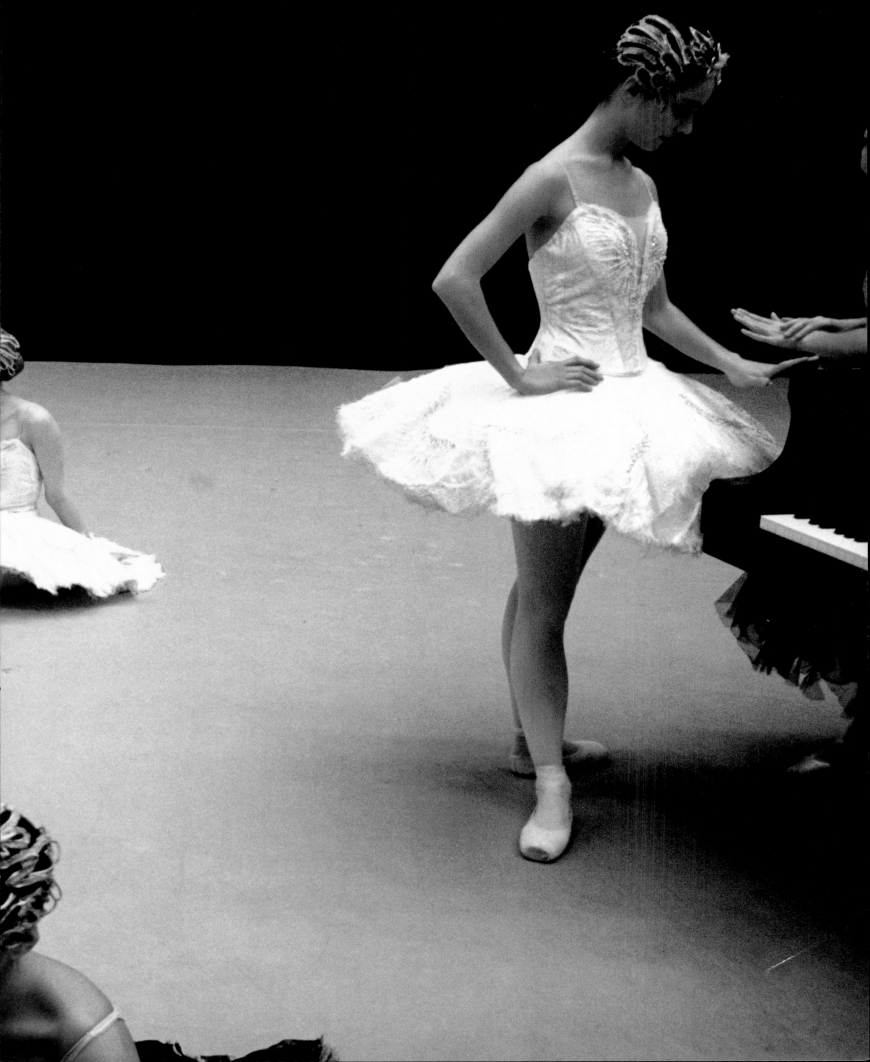

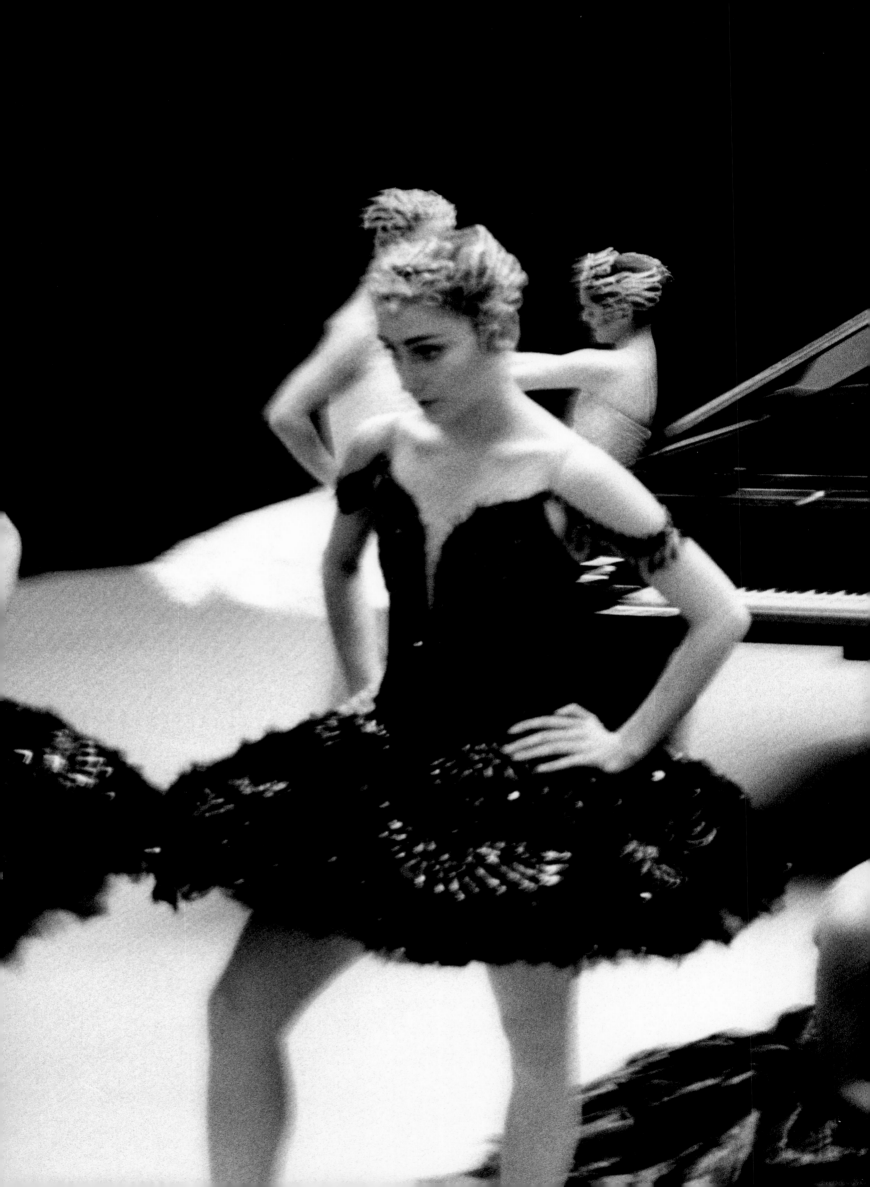

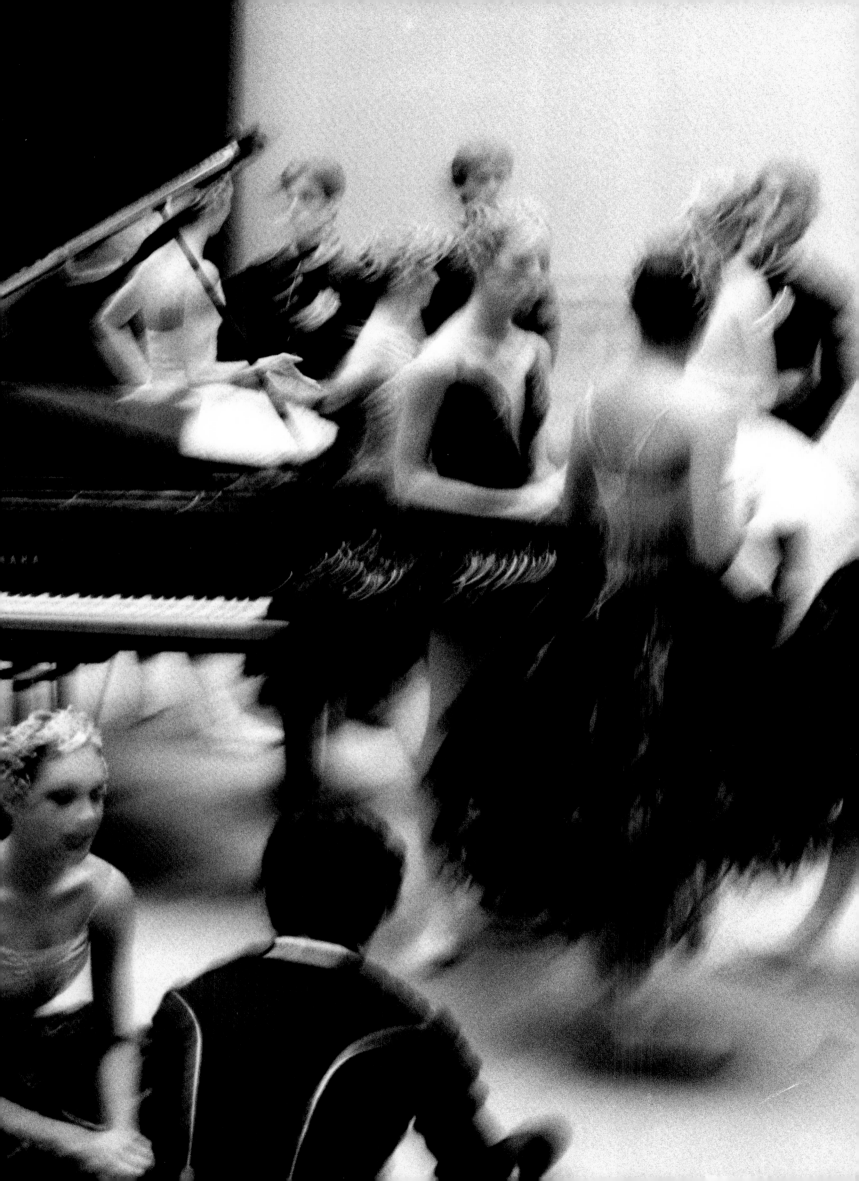

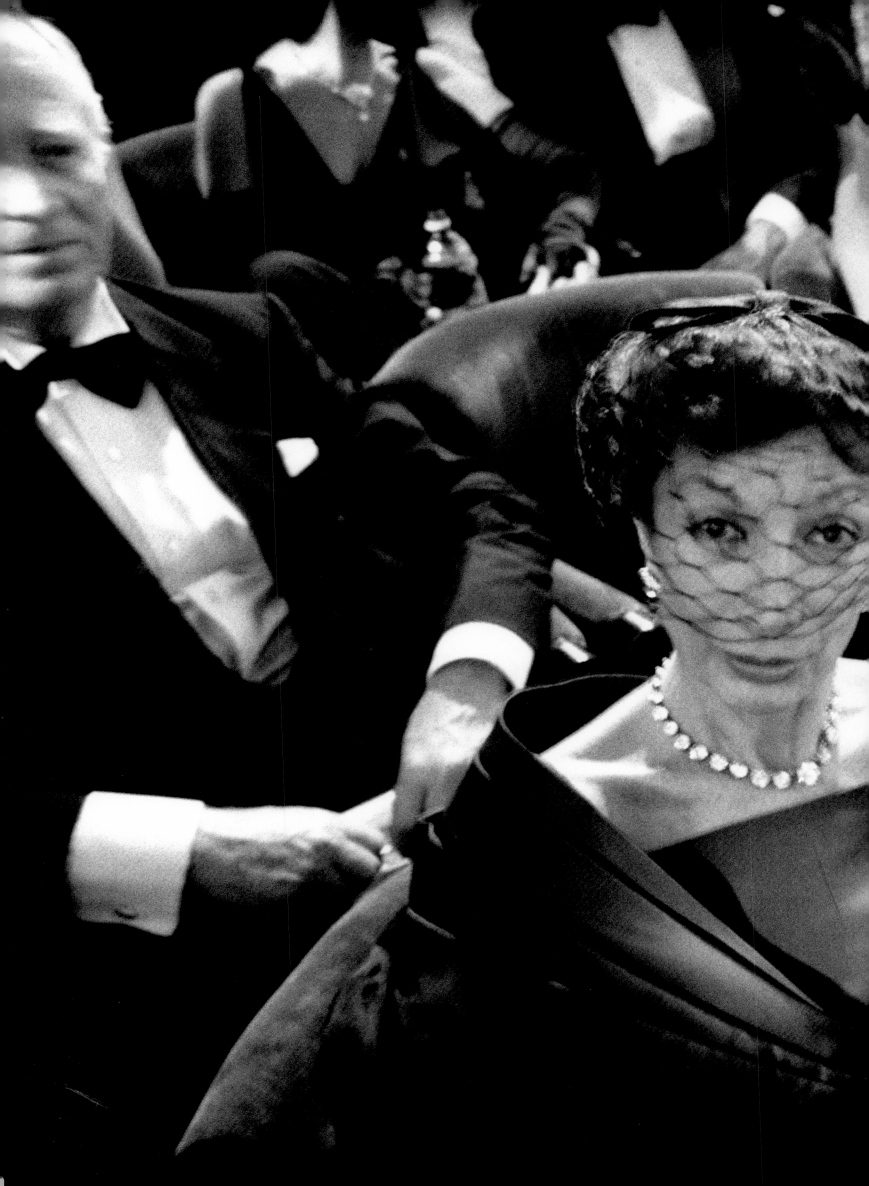

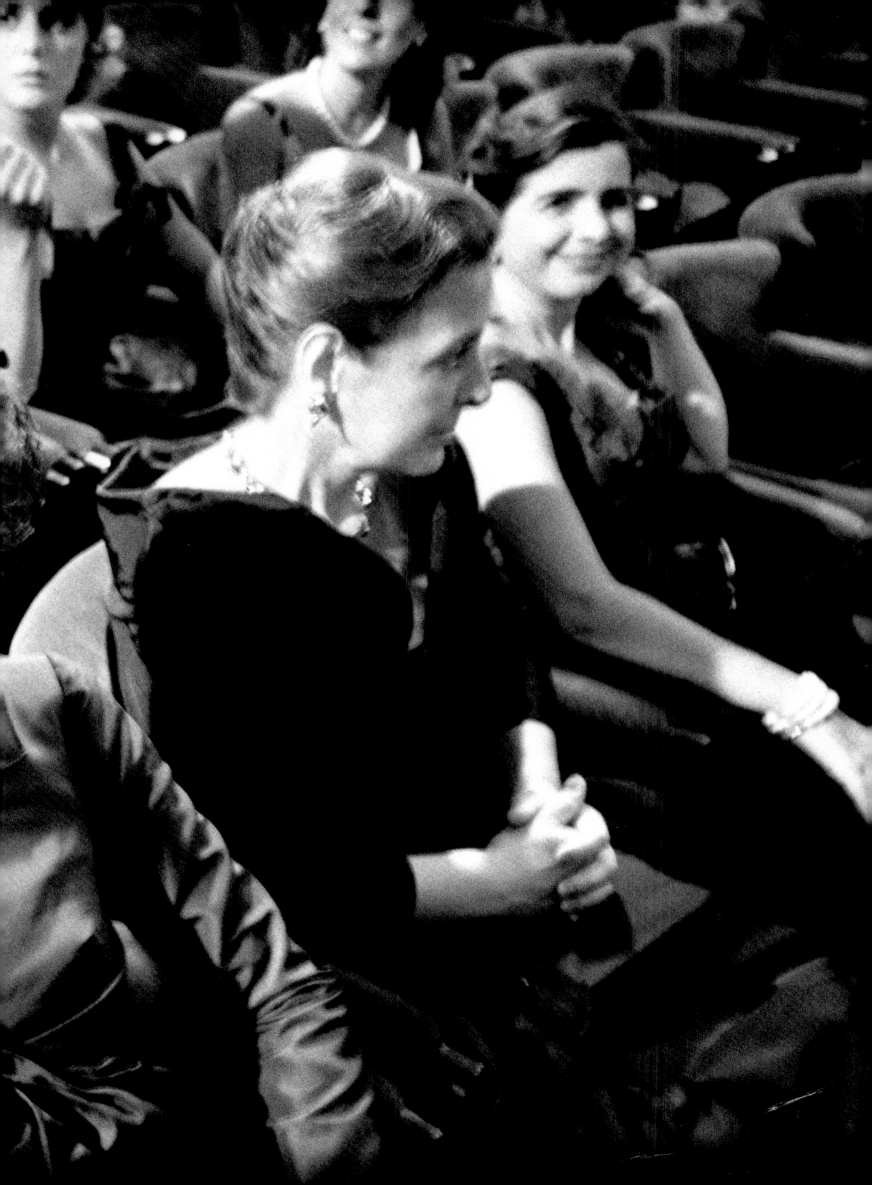

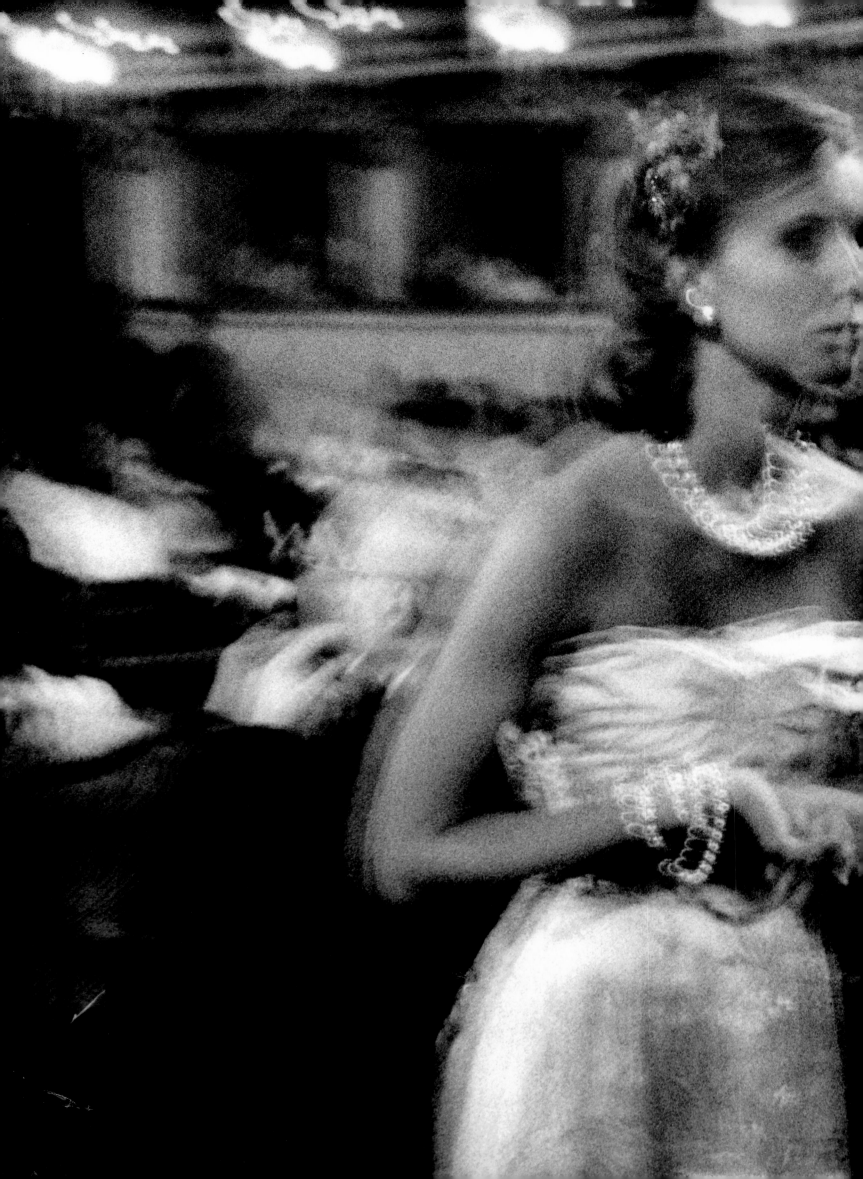

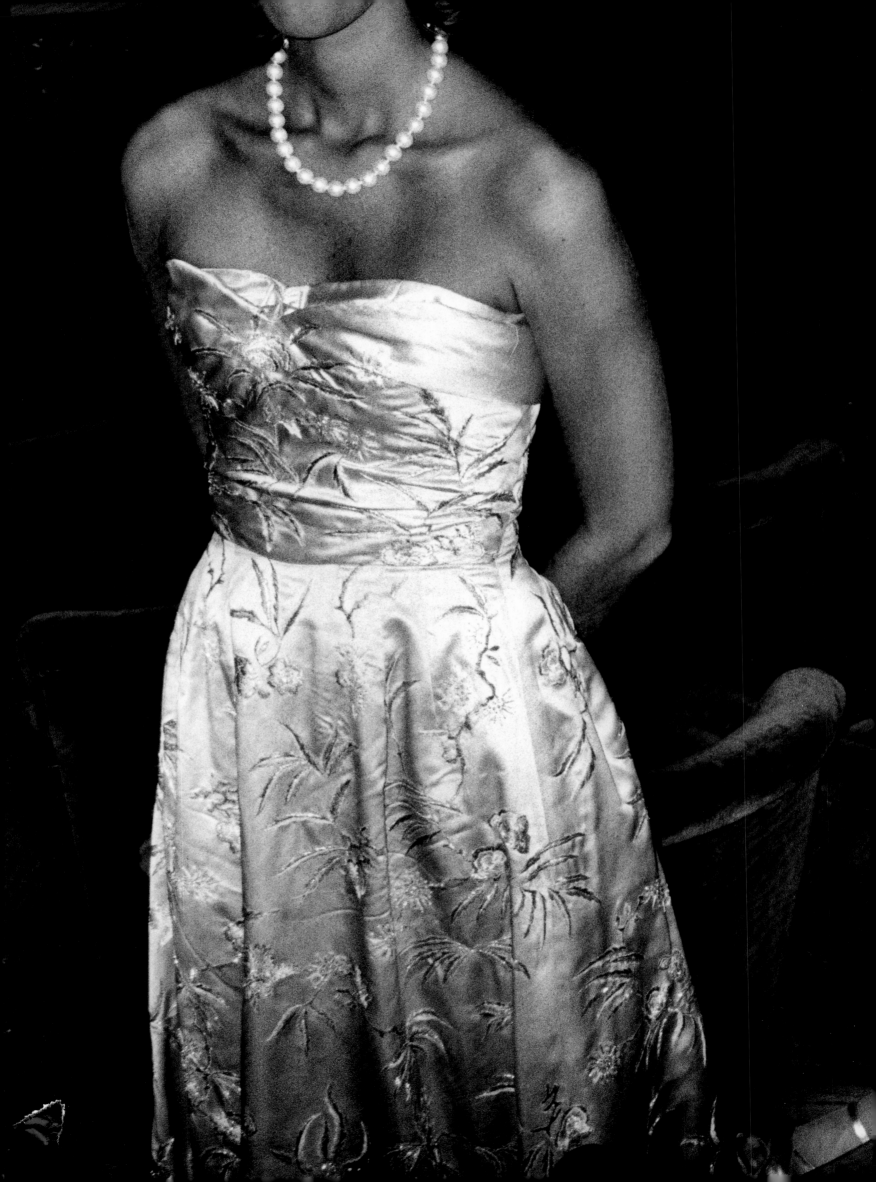

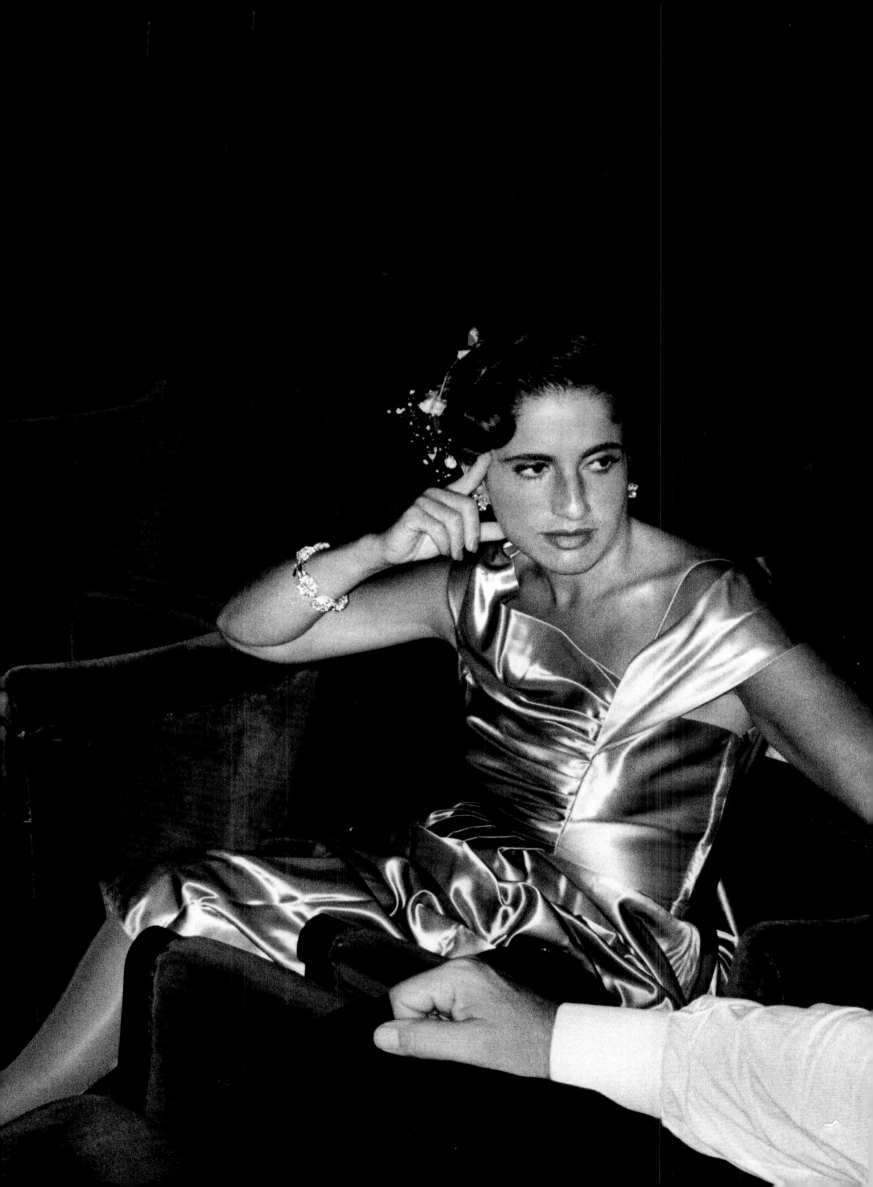

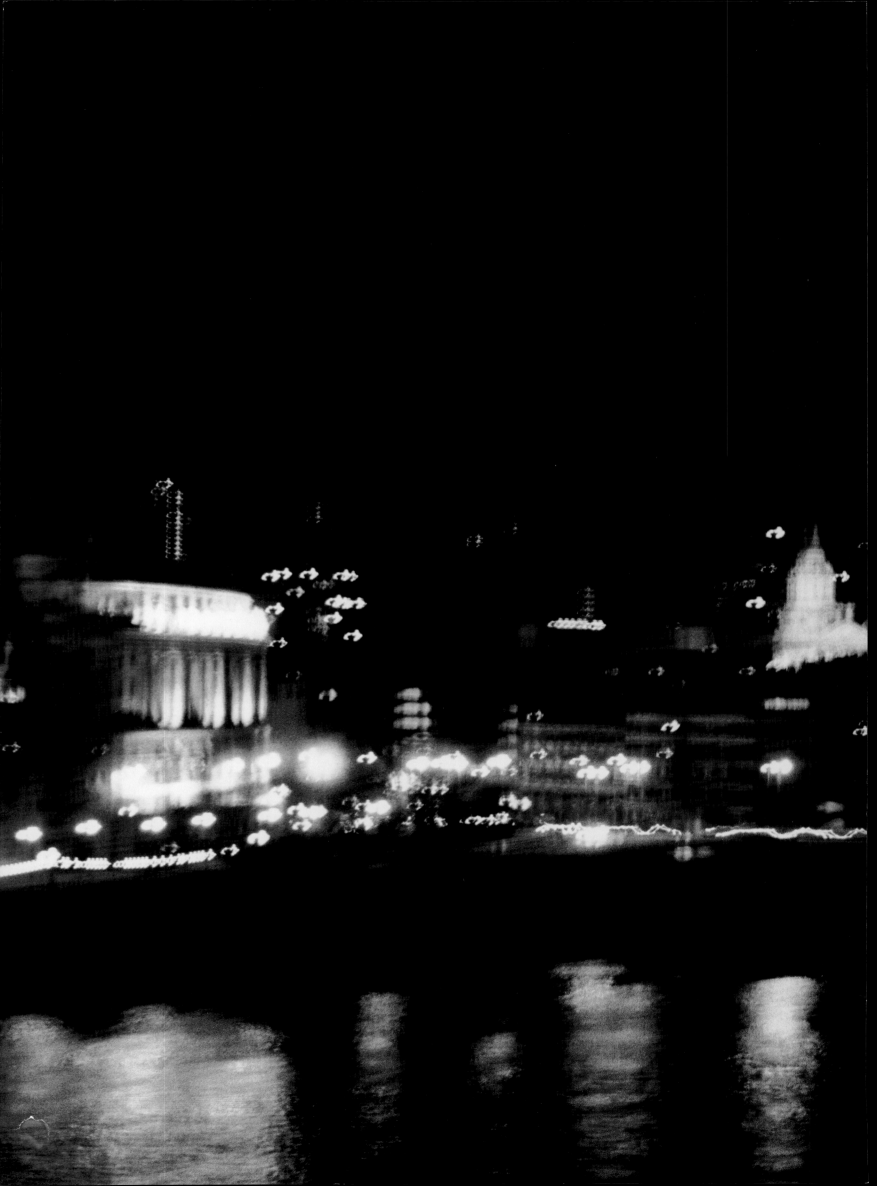

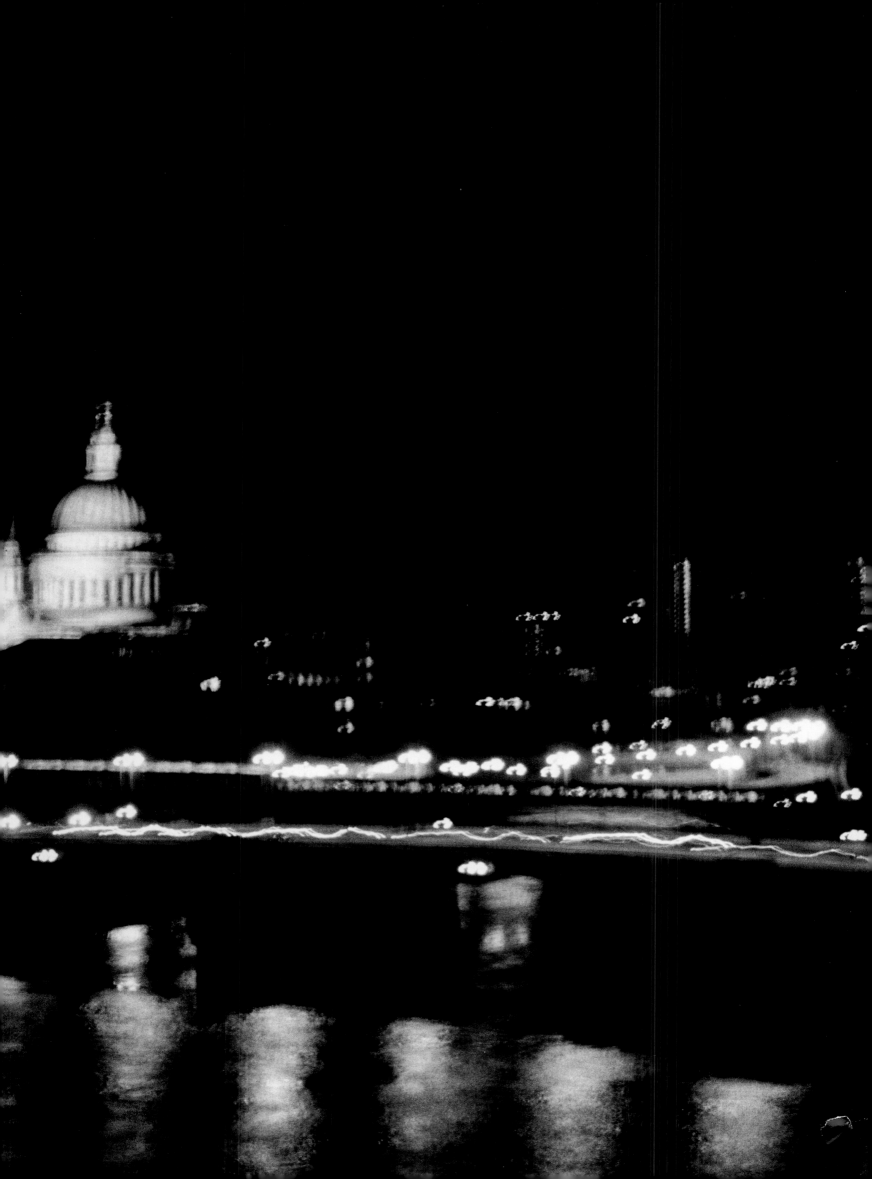

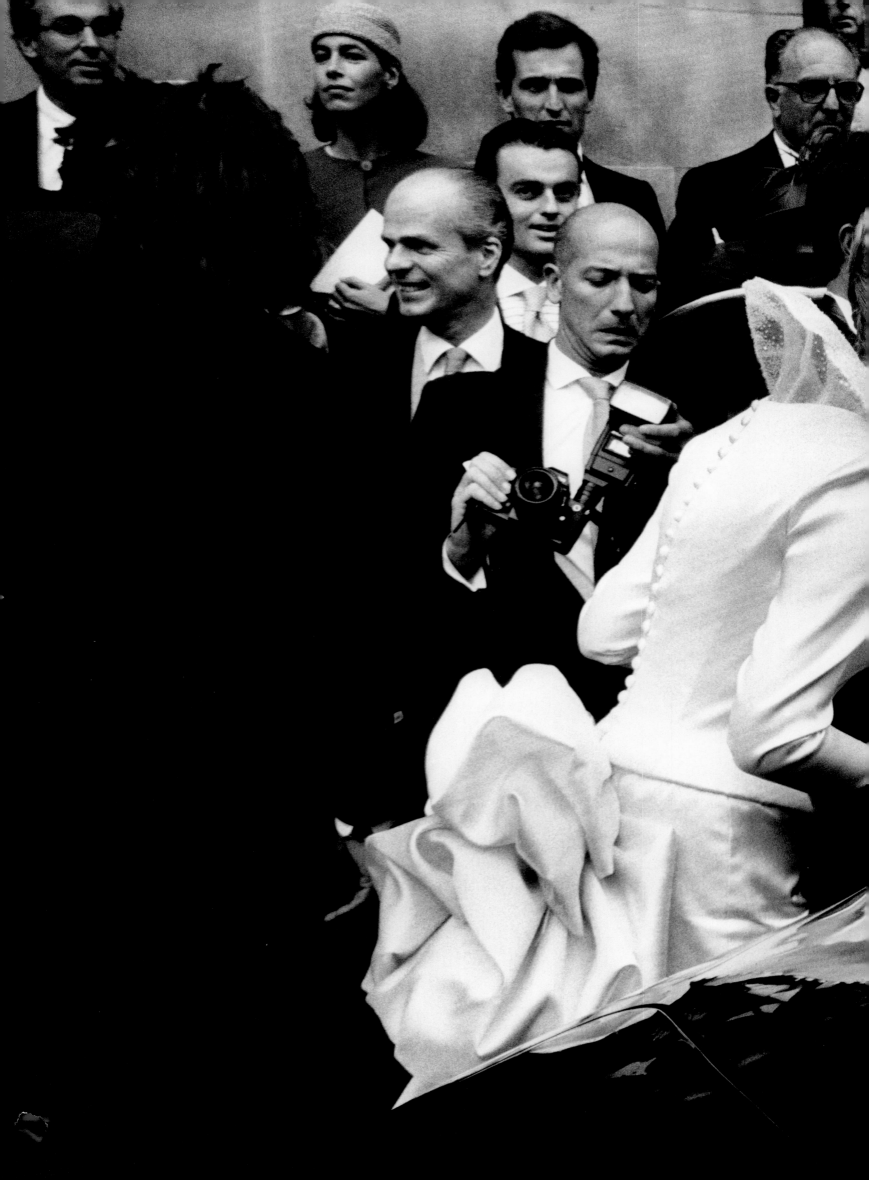

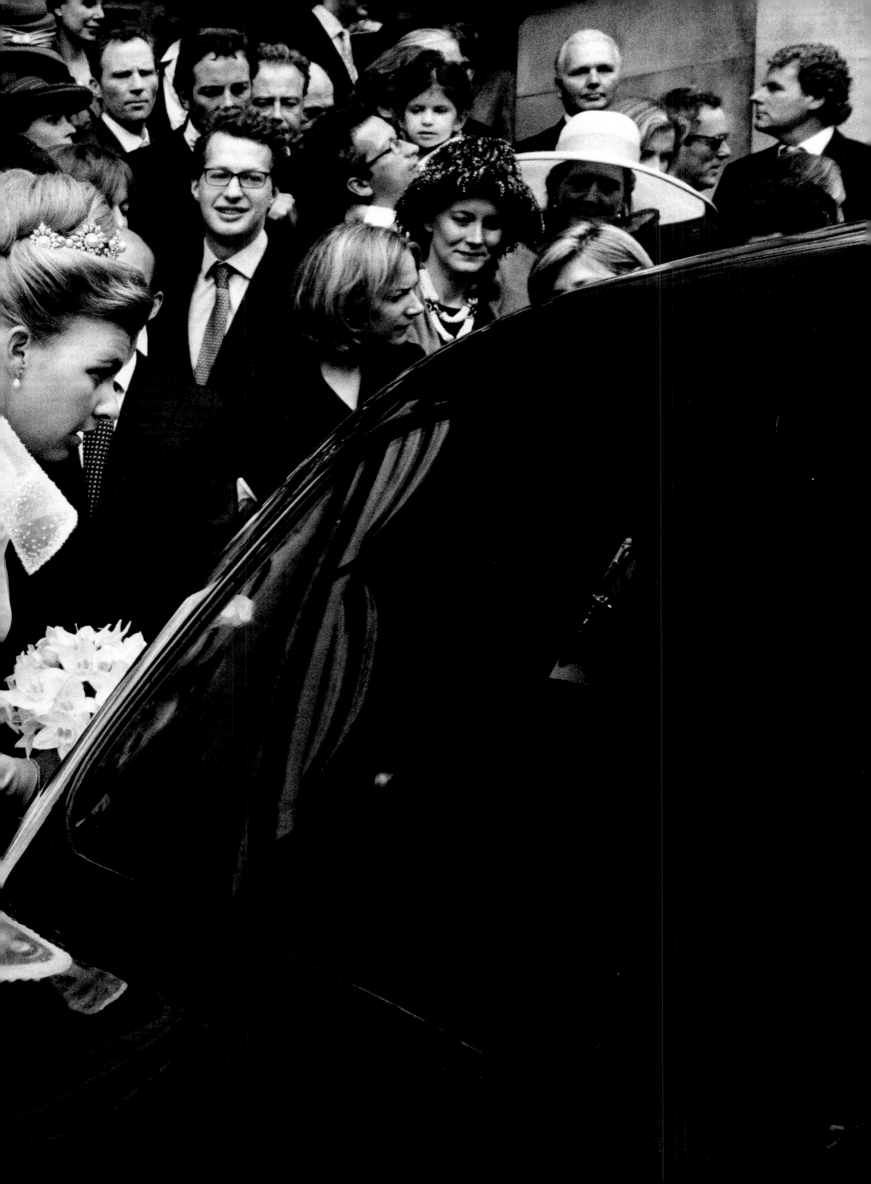

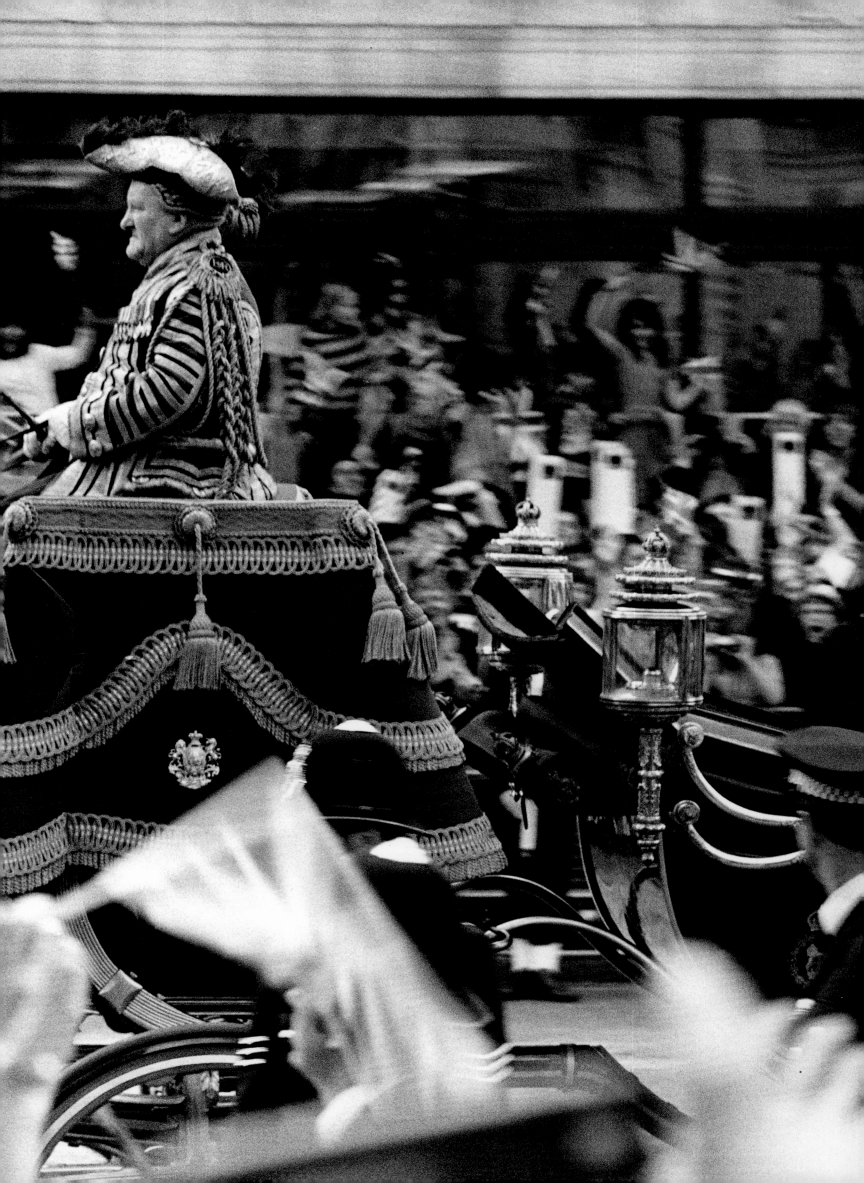

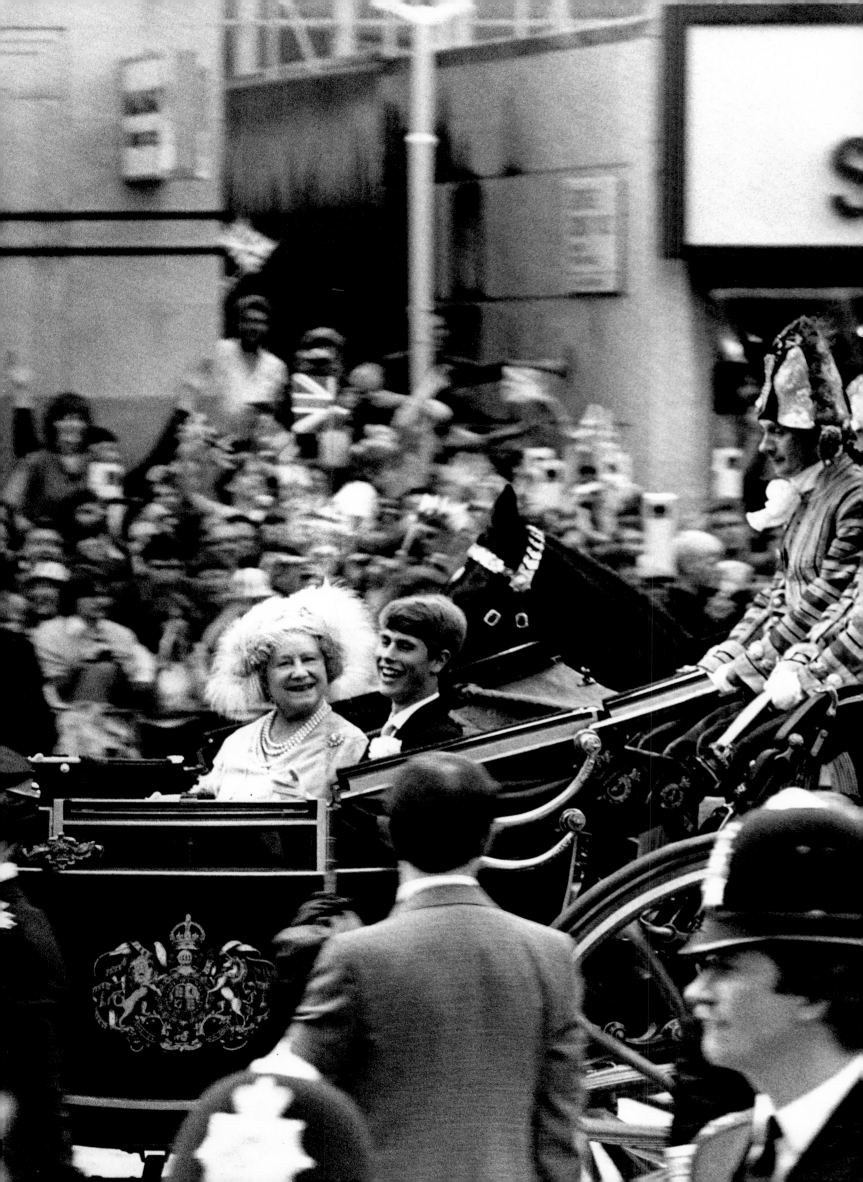

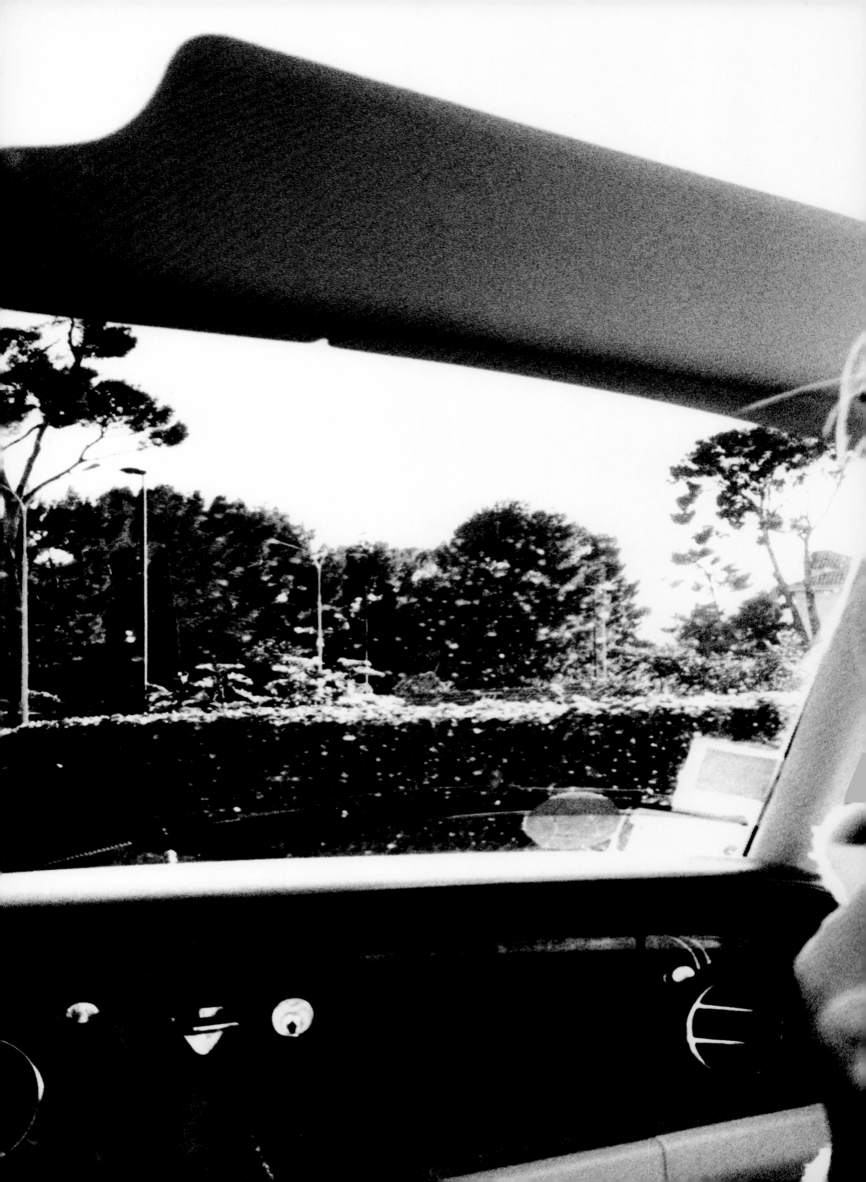

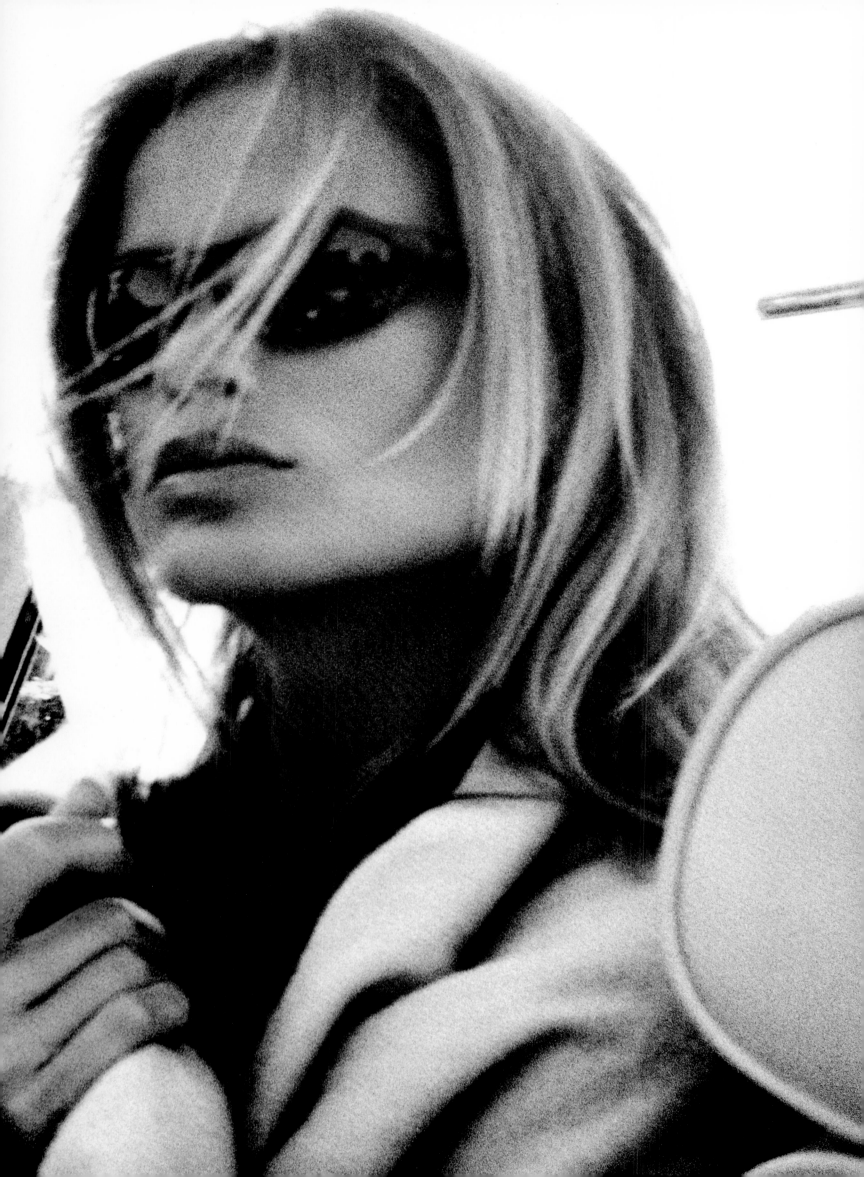

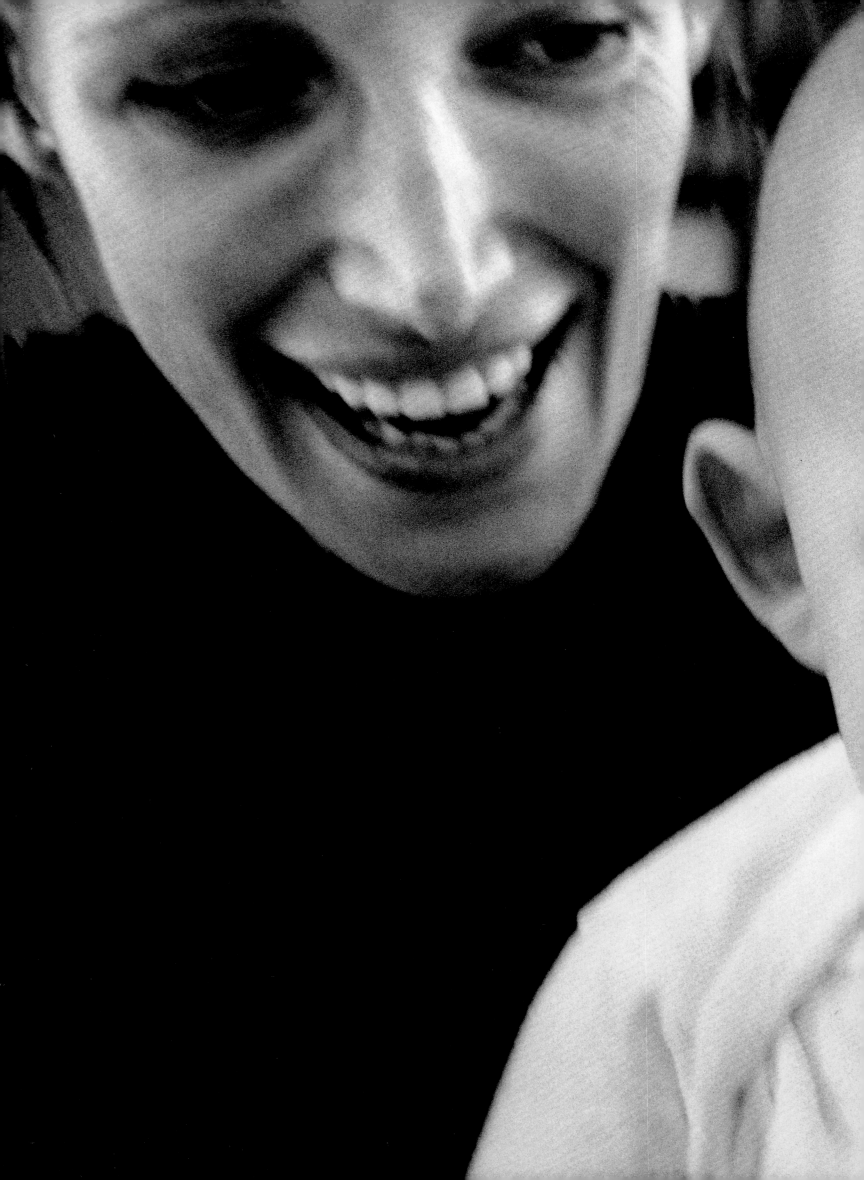

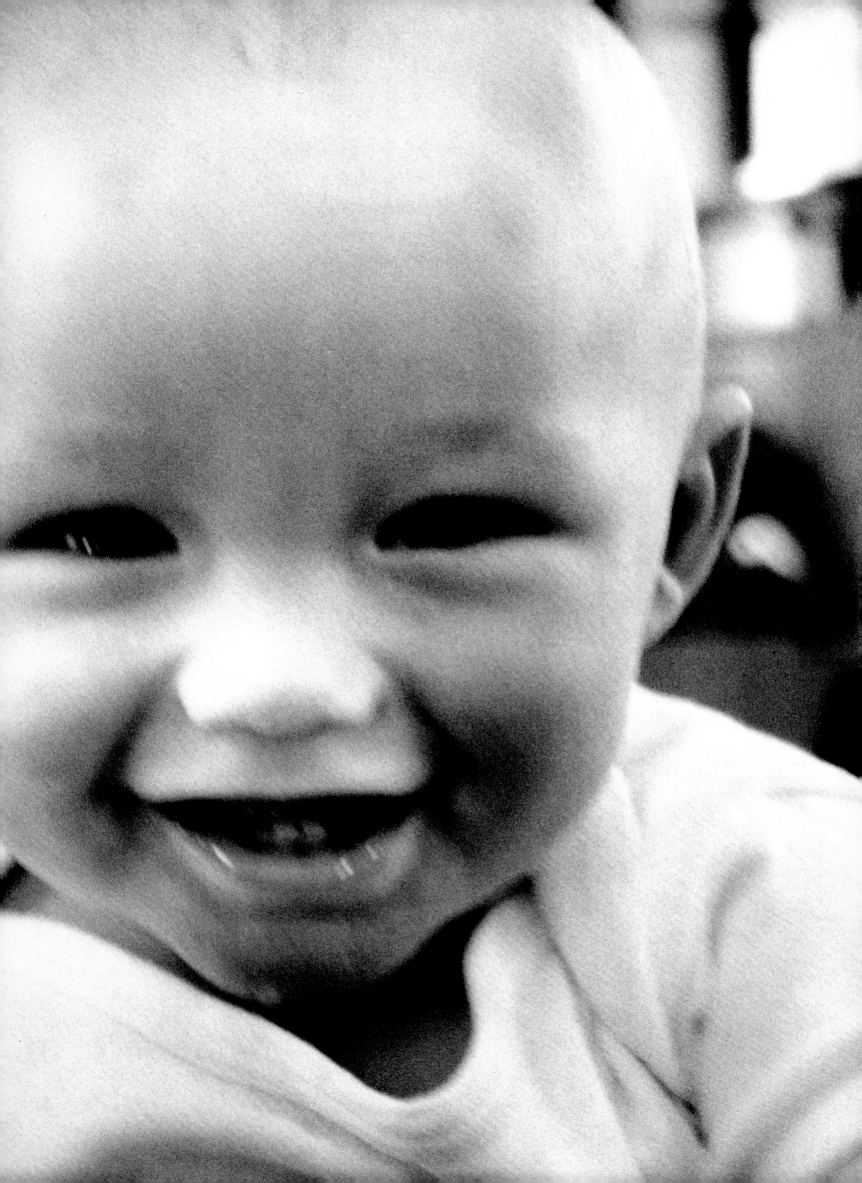

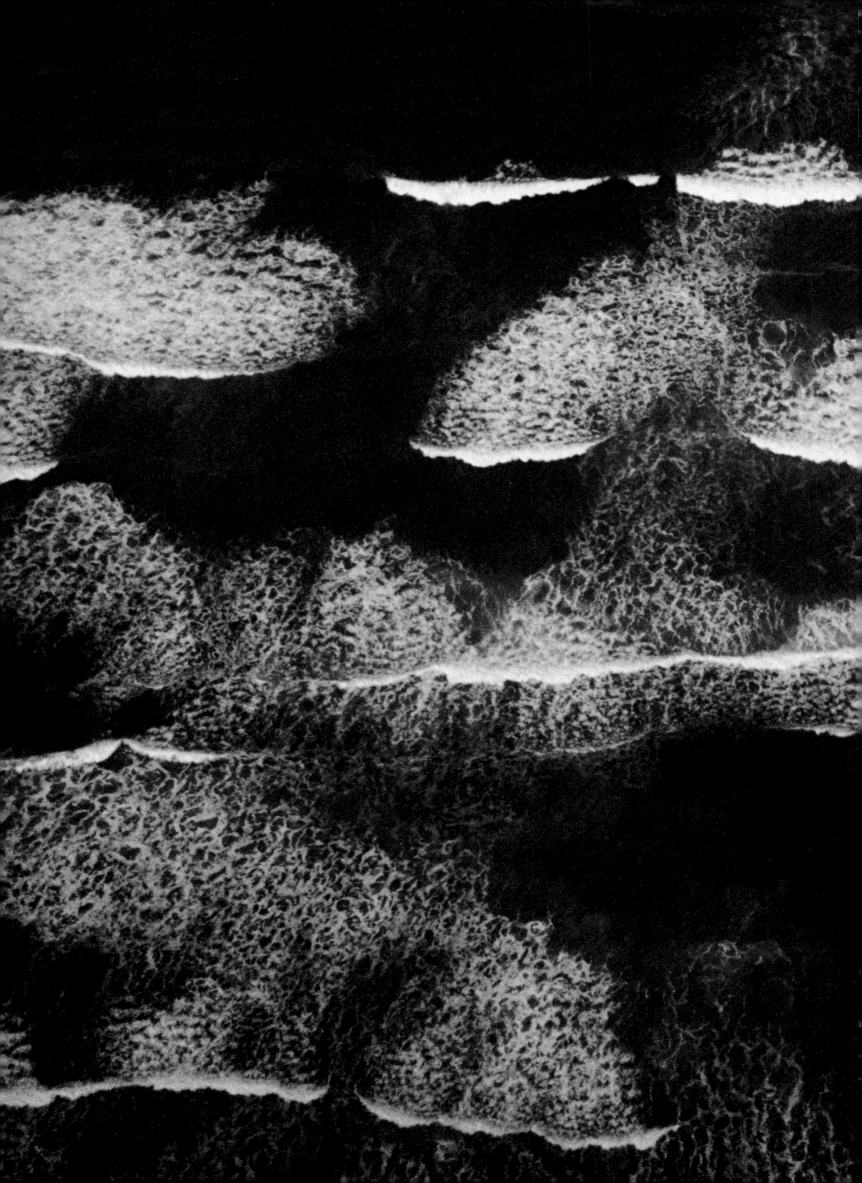

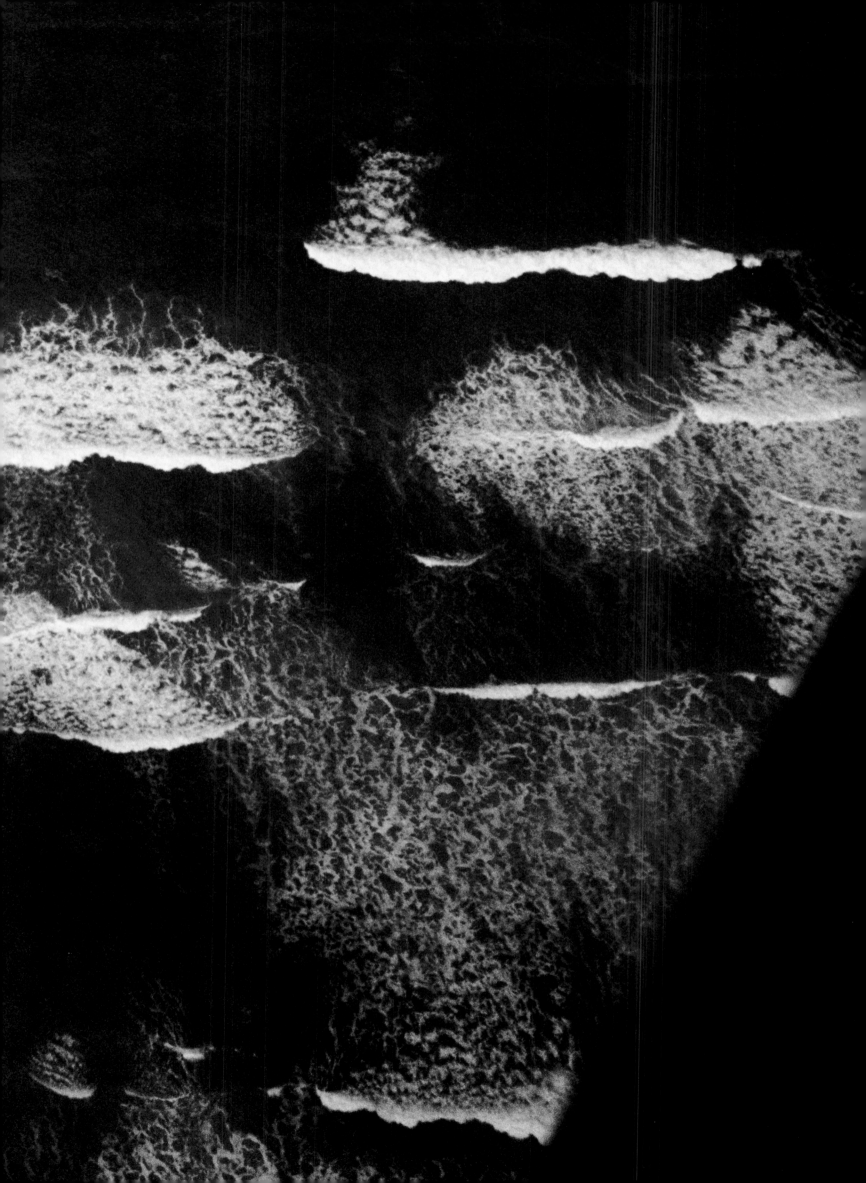

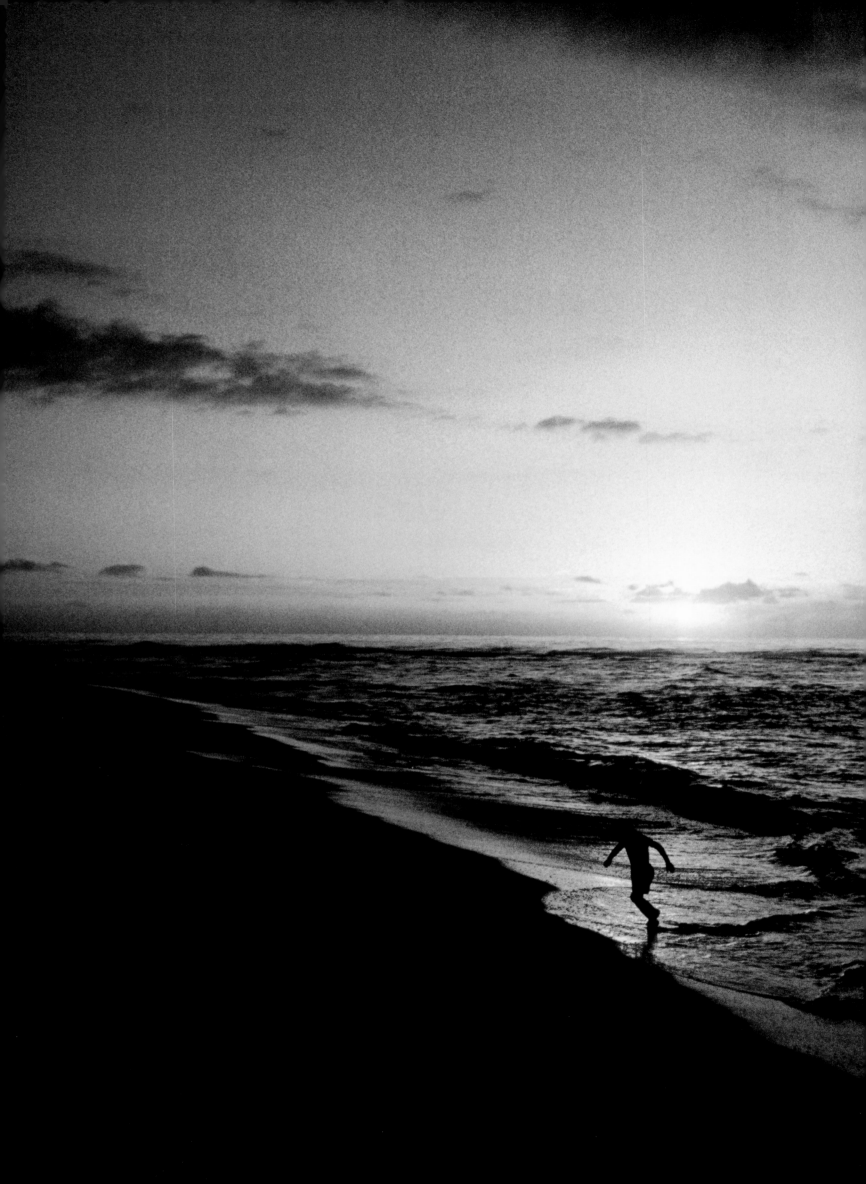

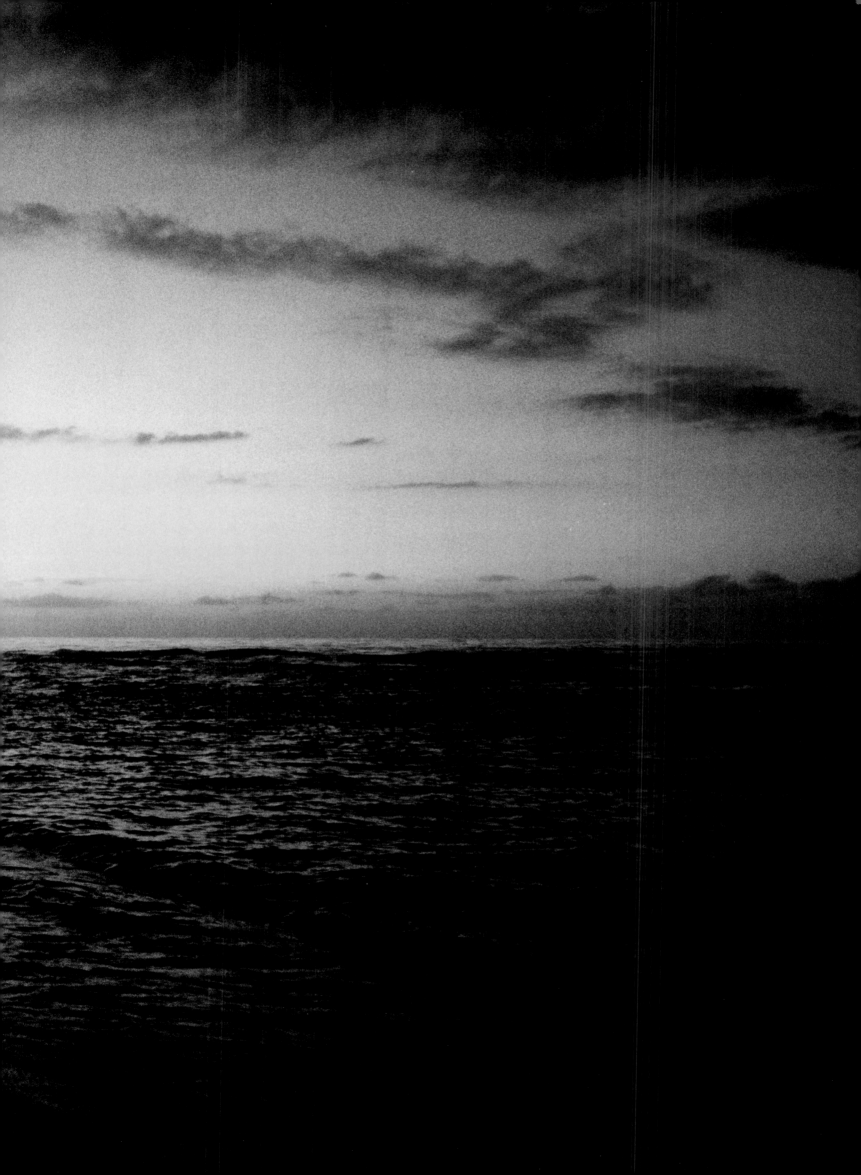

ACKNOWLEDGEMENTS

My Parents—Mario & Teresa Testino

Patrick Kinmonth Alfredo Fernandini Eric Bergère Gawain Rainey
Thomas Nützl Heron White Alexi Lubomirski Giovanni Testino

Chris Arvidson Amilcare Astone Andre Balazs Roman Barrett
Michael Beauplet Jocelyne and Jean Claude Bedel Paul Berends
Blake's Hotel Victoria Bryner Graydon Carter Luis Celdana
Lucinda Chambers Chateau Marmont Edibulga Chavez Robert Cowling
Copacabana Palace Andrea Dellal Ernesto Esposito Matthias Farnstrand
Victoria Fernandez Greg Foley Gonçalo Gaioso Felipe Guardiola Terry Hackford
Hotel Excelsior IMG Eric Jüssen Kees Kalk Renato Kerlakian Witman Kleipool
Sandra Klimt Felipe Kliot François and Christian Lacroix Edouard Lehmann
Carol Judy Leslie Janine Linberg Marc Lopez Quynh Mai Marta Mantero
Candice Marks Jake McCabe Patricia Medina Generoso di Meo Micah Miller
Lloyd Moore Blanquai Navarre Amber Olson Gwyneth Paltrow Vincente di Paulo
Tom Pecheux Nino Penaloza Elana Petraco Orlando Pita Picto Justine Potashnik
Umberto Raucci Carine Roitfeld Rosi Salinas Carlo Santamaria Raja Sethu Kevin Shalit
Alexandra Shulman Jeronimo Solis Sabina Spaldi Carla Testino Giuliana Testino
The Mercer The Royal Ballet Thomas Thurnauer Mark Wilson Anna Wintour
Laurence & Yola Zuanica

Special thanks to: Stephen Gan Christopher Scott Vann Huw Gwyther
Stephanie Rutherford Brigitte Sondag

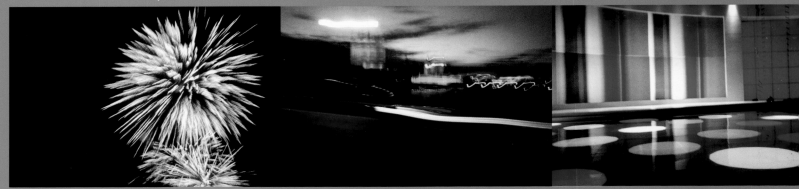

RIO DE JANEIRO LAMBETH BRIDGE, LONDON VH1/VOGUE AWARDS, NEW YORK

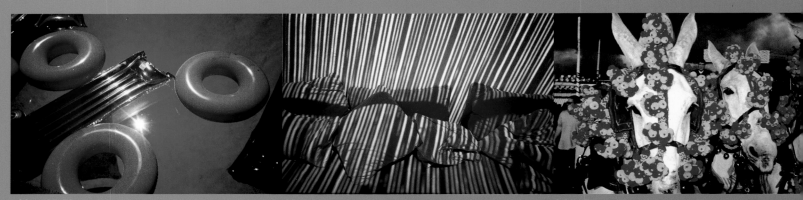

LOS ANGELES COMPORTA SEVILLE

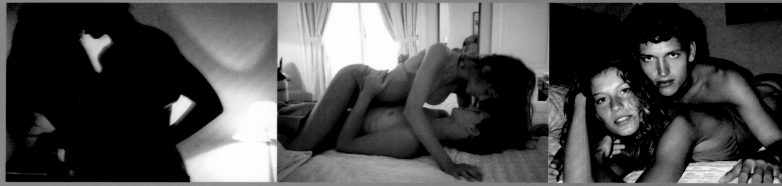

RIO DE JANEIRO RIO DE JANEIRO GISELE BUNDCHEN & CARLOS BOKELMAN,
RIO DE JANEIRO

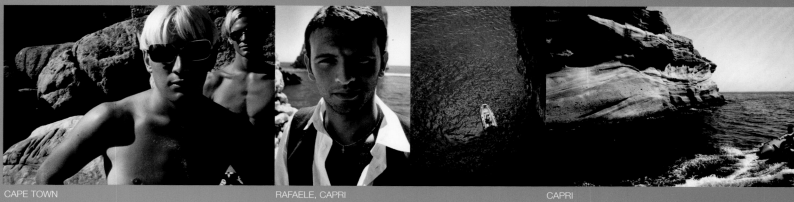

CAPE TOWN RAFAELE, CAPRI CAPRI
CAPRI

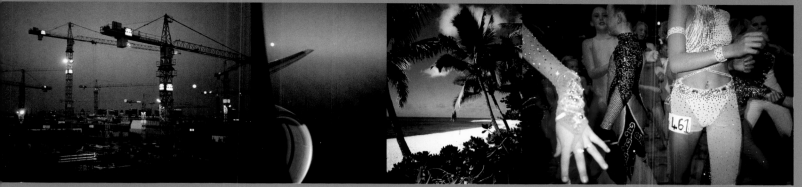

BERLIN

LIMA TO RIO DE JANEIRO
OAHU, HAWAII

DANCE COMPETITION, LONDON

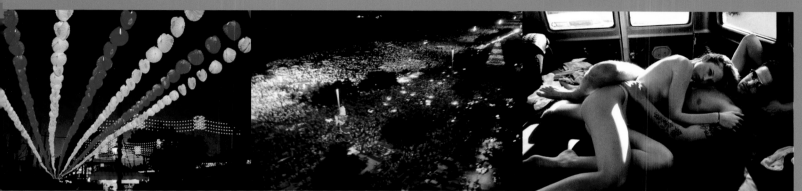

SEVILLE

RIO DE JANEIRO, NEW YEAR'S EVE

SARA FOSTER & ASHLEY HAMILTON, LOS ANGELES

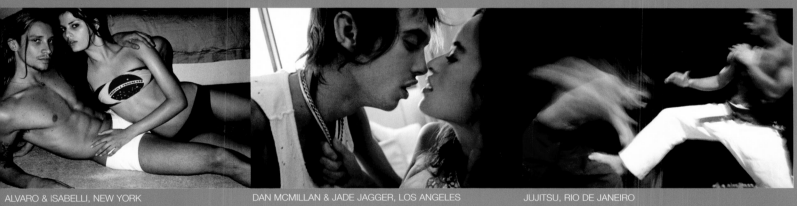

ALVARO & ISABELLI, NEW YORK

DAN MCMILLAN & JADE JAGGER, LOS ANGELES

JUJITSU, RIO DE JANEIRO

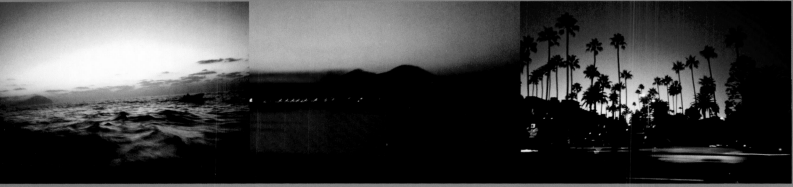

SALINA, EOLIE ISLANDS

VESUVIUS, NAPLES

BEVERLY HILLS

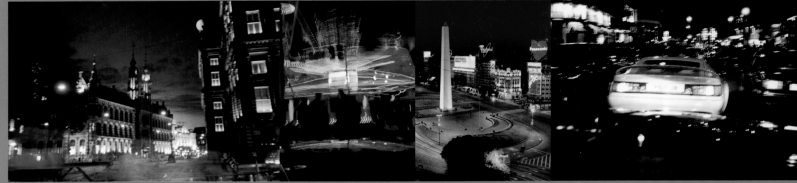

AMSTERDAM

AMSTERDAM
BUENOS AIRES

LONDON

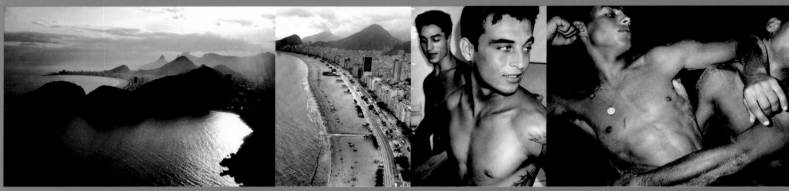

RIO DE JANEIRO

COPACABANA, RIO DE JANEIRO
ANDREAS & SERJIO, RIO DE JANEIRO

JUJITSU, RIO DE JANEIRO

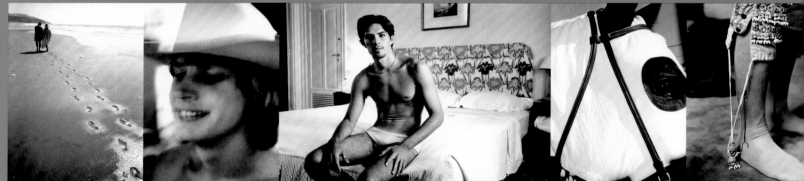

TANGIER
ROBERT COWLING, PARIS

DANIEL AGUIAR, RIO DE JANEIRO

BUENOS AIRES
SEVILLE

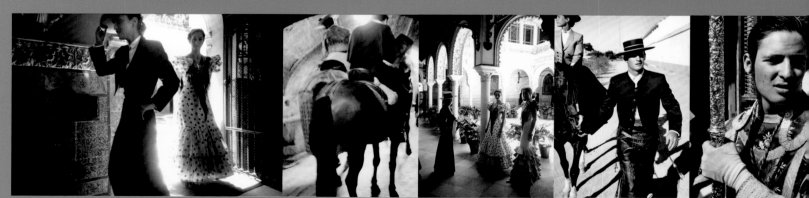

SEVILLE

SEVILLE
LAURA PARIAS, PATRICIA MEDINA & MARIA LEON, SEVILLE

NICOLAS ALVAREZ, SEVILLE
SEMANA SANTA, SEVILLE

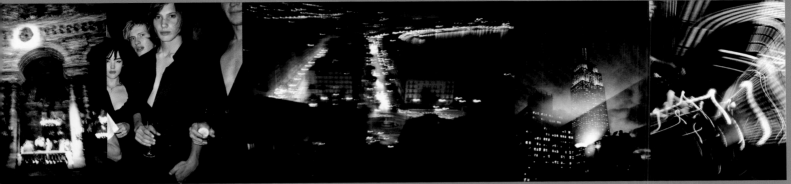

PALAIS GARNIER, PARIS

NAPLES

NEW YORK

VISIONAIRE PARTY, PARIS

LONDON

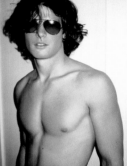

PIETRO, SALIM & GIOVANNI, NAPLES

RIO DE JANEIRO

LONDON

JOEL MCMILLIAN, LOS ANGELES

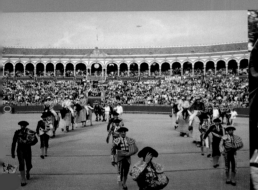

BEZIERS

PACHACAMAC, LIMA

PUERTA DE JEREZ, SEVILLE

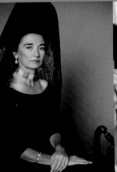
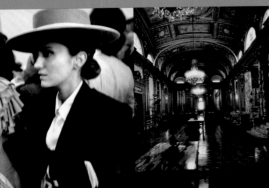
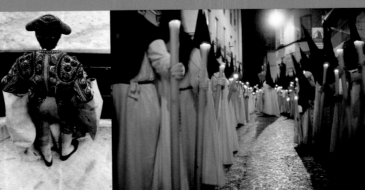

ANTONIA MEDINA, SEVILLE

LIMA

SEMANA SANTA, SEVILLE

LAURA PARIAS, SEVILLE

ARLES

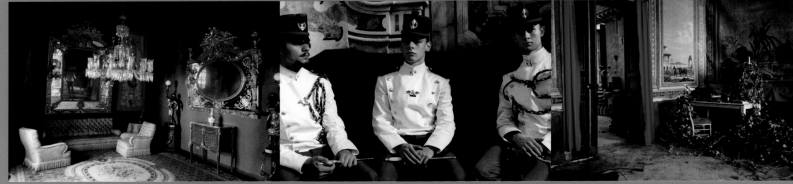

LIMA SCUOLA MILITARE NUNZIATELLA, NAPLES SAINT-RÉMY-DE-PROVENCE

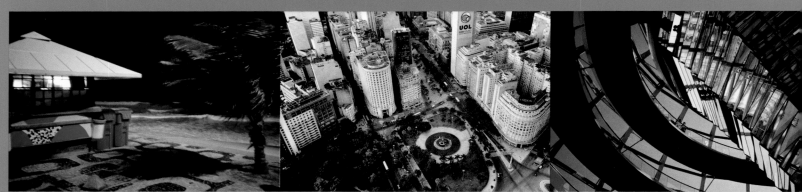

RIO DE JANEIRO RIO DE JANEIRO BERLIN

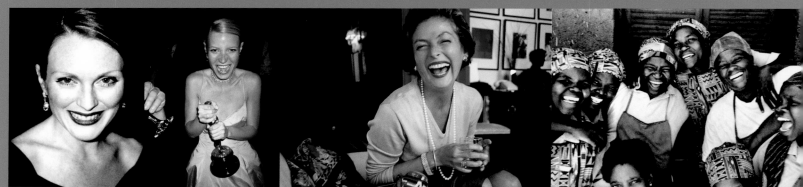

JULIANNE MOORE, *VANITY FAIR* OSCAR PARTY ALMA FELBER, PARIS JOHANNESBURG
GWYNETH PALTROW, *VANITY FAIR* OSCAR PARTY

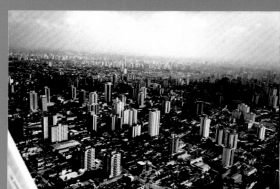

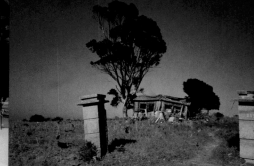

SÃO PAULO LOS ANGELES TANGIER

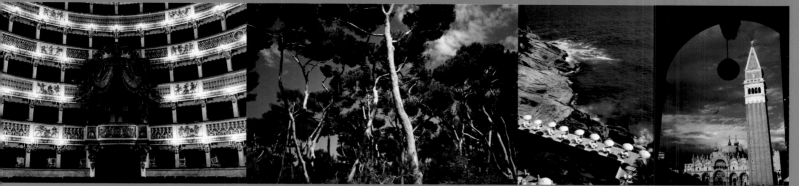

TEATRO SAN CARLO, NAPLES JOHANNESBURG RIO DE JANEIRO
VENICE

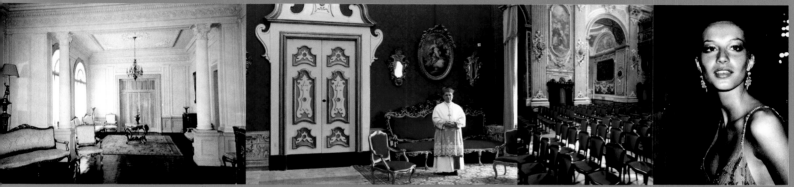

LIMA MONTEVERGINE NAPLES
GISELE BUNDCHEN, VH1/VOGUE AWARDS

AYACUCHO, PERU JOHANNESBURG GRONINGER MUSEUM, GRONINGEN

LIMA POMPEII LISBON
LIMA MACHU PICCHU NAPLES

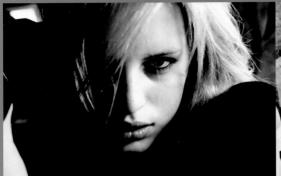
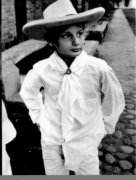
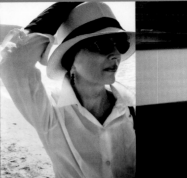

KAROLINA, PARIS

JOSÉ ALFREDO KOECHLIN, LIMA
LOTTA BURENIUS, TANGIER

RIO DE JANEIRO

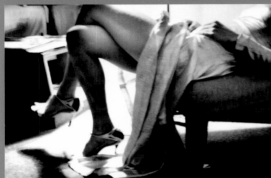
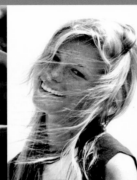
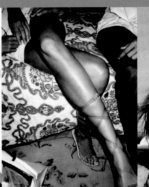

KATE MOSS, CHATEAU MARMONT, LOS ANGELES

MARISA, LOS ANGELES
GISELE BUNDCHEN, MONTE CARLO

MARISA, LOS ANGELES

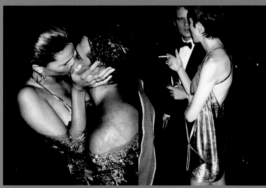
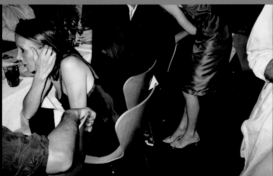
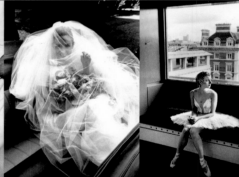

RIO DE JANEIRO
AMY FINE COLLINS, NEW YORK

CAMILLA NICKERSON, NEW YORK

BARONESS GEYR VON SCHWEPPENBURG,
SCHLOSSE RIMBOURG
THE ROYAL BALLET, LONDON

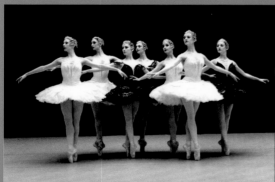
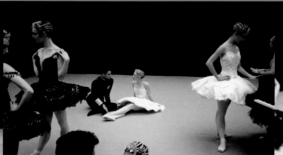
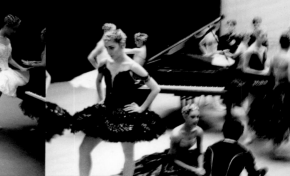

CORPS DE BALLET, THE ROYAL BALLET, LONDON

THE ROYAL BALLET, LONDON

THE ROYAL BALLET, LONDON

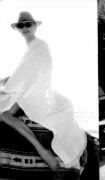
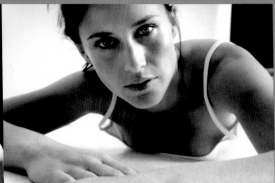

HAMISH BOWLES, TANGIER
VICTORIA FERNANDEZ, TANGIER

JOANNA, LOS ANGELES

PATRICIA ARQUETTE, NEW YORK

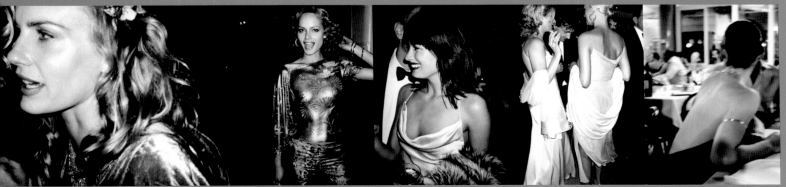

DARYL HANNAH, *VANITY FAIR* OSCAR PARTY

AMBER VALETTA, VH1/VOGUE AWARDS
RHEA DURHAM, *VANITY FAIR* OSCAR PARTY

JOELY RICHARDSON, JAMES TRUMAN & KYLIE BAX,
VANITY FAIR OSCAR PARTY
CECELIA DEAN, NAPLES

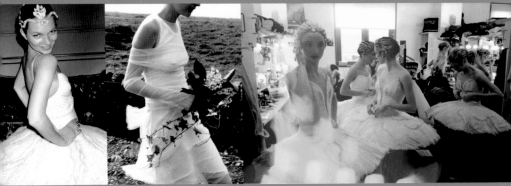
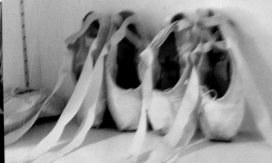

KATE MOSS, ROYAL OPERA HOUSE, LONDON
STELLA TENNANT, SCOTLAND

CORPS DE BALLET, THE ROYAL BALLET, LONDON

THE ROYAL BALLET, LONDON

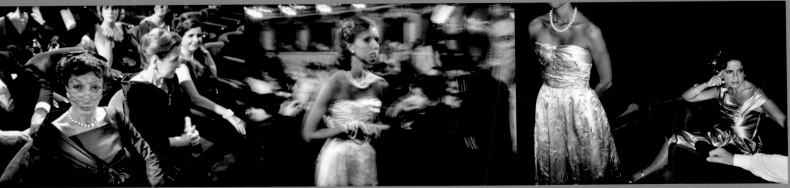

TEATRO SAN CARLO, NAPLES

TEATRO SAN CARLO, NAPLES

TEATRO SAN CARLO, NAPLES

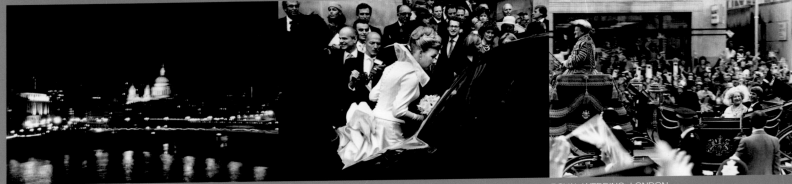

ST. PAUL'S, LONDON

DORA DELLA GHERADESCA, LONDON

ROYAL WEDDING, LONDON

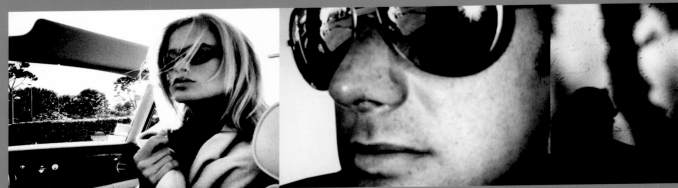

CAROLYN MURPHY, SAINT-TROPEZ

ERIC BERGÈRE, TANGIER

PETER KENT & HAMISH BOWLES, TANGIER

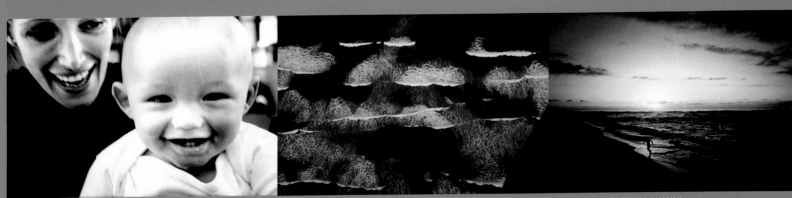

CAMILLA NICKERSON & ATTICUS WAKEFIELD, PARIS

LIMA, 1998

NORTH SHORE, OAHU, HAWAII

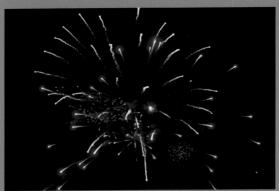

RIO DE JANEIRO

Edited by Patrick Kinmonth
Creative Consultants: Huw Gwyther & Christopher Scott Vann
Art Direction: Stephen Gan
Design: Greg Foley, Claudia Wu, and Terence Koh

First Edition
ISBN 0-8212-2736-X
Library of Congress Control Number 00-111116
Bulfinch Press is an imprint and trademark of Little, Brown and Company Inc.

PRINTED IN GERMANY

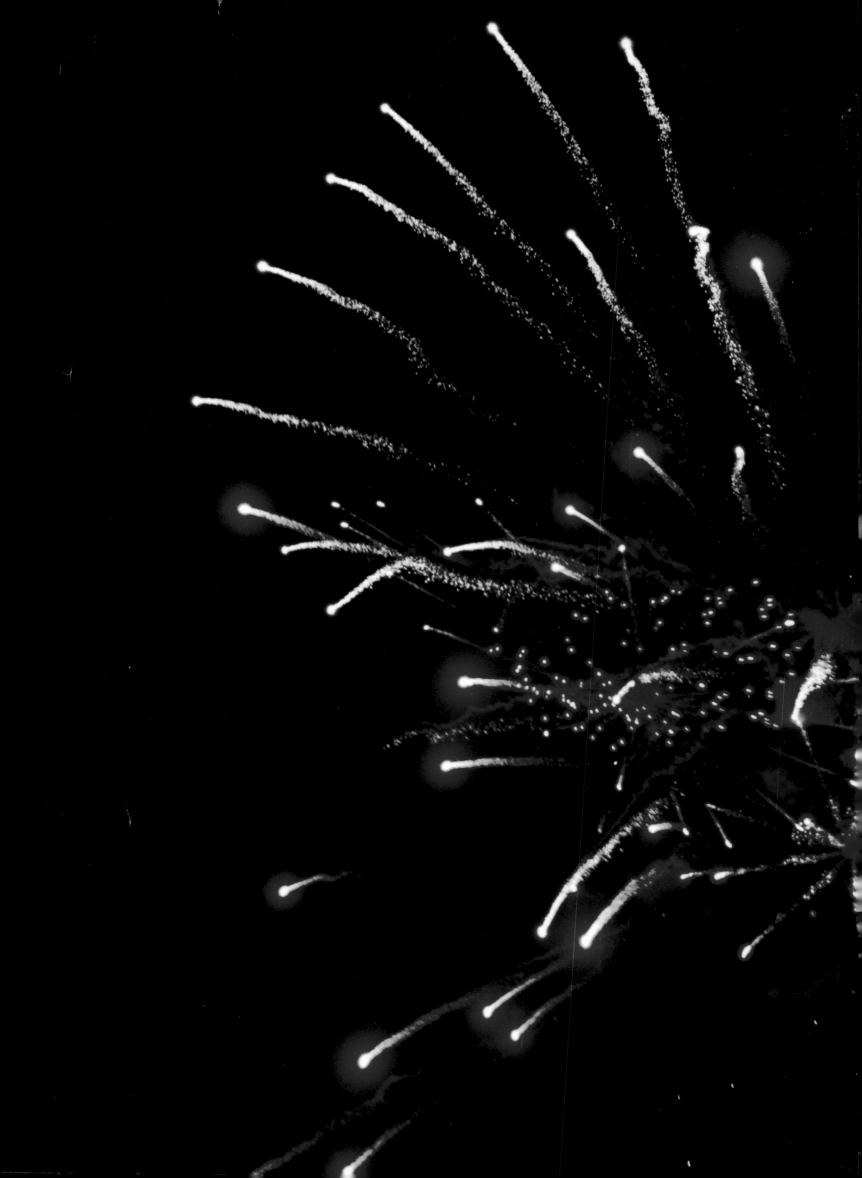